Russian Art of the Avant-Garde

Russian Art
of the Avant-Garde
Theory and Criticism
1902-1934

Edited and Translated
by John E. Bowlt

Revised and enlarged edition

with 105 illustrations

THAMES AND HUDSON

Acknowledgments: Harvard University Press and
Lund Humphries Publishers Ltd: "Realistic
Manifesto" from *Gabo* by Naum Gabo. Copyright
© 1957 by Lund Humphries. Reprinted by
permission.

This revised and enlarged edition first published in
paperback in the United States in 1988 by
Thames and Hudson Inc., 500 Fifth Avenue,
New York, New York 10110

Originally published by The Viking Press in *The
Documents of 20th-Century Art*, 1976, General Editor
Robert Motherwell, Documentary Editor Bernard
Karpel, Managing Editor Arthur A. Cohen.

Library of Congress Catalog Card Number 88-50249

Printed and bound in the German Democratic Republic

Preface

This collection of published statements by Russian artists and critics is intended to fill a considerable gap in our general knowledge of the ideas and theories peculiar to modernist Russian art, particularly within the context of painting. Although monographs that present the general chronological framework of the Russian avant-garde are available, most observers have comparatively little idea of the principal theoretical intentions of such movements as symbolism, neoprimitivism, rayonism, and constructivism. In general, the aim of this volume is to present an account of the Russian avant-garde by artists themselves in as lucid and as balanced a way as possible. While most of the essays of Vasilii Kandinsky and Kazimir Malevich have already been translated into English, the statements of Mikhail Larionov, Natalya Goncharova, and such little-known but vital figures as Vladimir Markov and Aleksandr Shevchenko have remained inaccessible to the wider public either in Russian or in English. A similar situation has prevailed with regard to the Revolutionary period, when such eminent critics and artists as Anatolii Lunacharsky, Nikolai Punin, and David Shterenberg were in the forefront of artistic ideas. The translations offered here will, it is hoped, act as an elucidation of, and commentary on, some of the problems encountered within early twentieth-century Russian art.

The task of selection was a difficult one—not because of a scarcity of relevant material, but on the contrary, because of an abundance, especially with regard to the Revolutionary period. In this respect certain criteria were observed during the process of selection: whether a given text served as a definitive policy statement or declaration of intent; whether the text was written by a member or sympathizer of the group or movement in question;

whether the text facilitates our general understanding of important junctures within the avant-garde. Ultimately, the selection was affected by whether translation of a given text was available in English, although such previously translated statements as Malevich's "From Cubism and Futurism to Suprematism" and Naum Gabo and Anton Pevsner's "Realistic Manifesto" have been deemed too important to exclude. In some cases, specifically in those of the symbolists and the "French" faction of the Knave of Diamonds, no group declaration was issued so that recourse was made to less direct, but still significant pronouncements.

Categorization presented a problem since some statements, such as David Burliuk's "The Voice of an Impressionist" or El Lissitzky's "Suprematism in World Reconstruction," are relevant to more than one chronological or ideological section. Similarly, the choice of part titles cannot be entirely satisfactory. In the context of Part III, for example, it might be argued that Olga Rozanova, in "The Bases of the New Creation," was not advocating a completely "abstract" art (as her own contemporaneous painting indicated) and was merely developing the ideas of Nikolai Kulbin and Vladimir Markov; but it was precisely because of such a legitimate objection that the term "nonobjective" rather than "abstract" or "nonrepresentational" was selected, i.e., it denotes not only the latter qualities but also the idea of the "subjective," which, in the context of Rozanova and Malevich, is of vital importance. Again, the inclusion of Pavel Filonov in the final part rather than in an earlier one might provoke criticism, but Filonov was one of the few members of the Russian avant-garde to maintain his original principles throughout the 1930s—and hence his stand against the imposition of a more conventional art form was a conclusive and symbolic gesture.

Unfortunately, many of the artists included here did not write gracefully or clearly, and David Burliuk and Malevich, notably, tended to ignore the laws of syntax and of punctuation. As the critic Sergei Makovsky remarked wryly in 1913: "they imagine themselves to be writers but possess no qualifications for this." [1] * However, in most cases the temptation to correct their grammatical oversights has been resisted, even when the original was marked by ambiguity or semantic obscurity.

Since this book is meant to serve as a documentary source and not as a general historical survey, adequate space has been given to the bibliography in order that scholars may both place a given statement within its general chronological and ideological framework and pursue ideas germane to it in a more detailed fashion. In this connection, it will be of interest to note that

* Superscript numbers refer to the Notes, beginning on p. 298.

photocopies of the original texts have been deposited in the Library of The Museum of Modern Art, New York.

Apart from the rendition of the Russian soft and hard signs, which have been omitted, the transliteration system is that used by the journal *Soviet Studies,* published by the University of Glasgow, although where a variant has already been established (e.g., Benois, not Benua; Burliuk, not Burlyuk; Exter, not Ekster), it has been maintained. Occasionally an author has made reference to something irrelevant to the question in hand or has compiled a list of names or titles; where such passages add nothing to the general discussion, they have been omitted, although both minor and major omissions have in every case been designated by ellipses. Dates refer to time of publication, unless the actual text was delivered as a formal lecture before publication. Wherever possible, both year and month of publication have been given. In the case of most books, this has been determined by reference to *Knizhnaya letopis* [Book Chronicle; bibl. R11; designated in the text by KL]; unless other reliable published sources have provided a more feasible alternative, the data in *Knizhnaya letopis* have been presumed correct.

Many artists, scholars, and collectors have rendered invaluable assistance in this undertaking. In particular, I would like to acknowledge my debt to the following persons: Mr. Troels Andersen; Mrs. Celia Ascher; the late Mr. Alfred Barr, Jr.; Mr. Herman Berninger; Dr. Milka Bliznakov; Miss Sarah Bodine; Mr. and Mrs. Nicholas Burliuk; Miss Mary Chamot; the late Lord Chernian; Professor Reginald Christian; Mr. George Costakis; Dr. Charlotte Douglas; Mr. and Mrs. Eric Estorick; the late Mr. Mark Etkind; the late Sir Naum Gabo; the late Mr. Evgenii Gunst; Mrs. Larissa Haskell; Mr. and Mrs. Leonard Hutton; the late Mme. Nina Kandinsky; the late Mme. Alexandra Larionov; Mr. and Mrs. Nikita D. Lobanov-Rostovsky; Professor Vladimir Markov; M. Alexandre Polonski; the late Mr. Yakov Rubinshtein; Dr. Aleksandr Rusakov and Dr. Anna Rusakova; Dr. Dmitrii Sarabyanov; the late Dr. Aleksei Savinov; Mr. and Mrs. Alan Smith; the late Mme. Anna Tcherkessova-Benois; and Mr. Thomas Whitney. In addition, a number of people should be thanked for their help in my revisions for the second edition: i.e. the late Frau Antonina Gmurzynska; Mr. Vladimir Kostin; Mr. Aleksei Korzukhin; Dr. Evgenii Kovtun; Professor Nicoletta Misler; and Mr. Aleksandr Parnis.

I am also grateful to the directors and staff of the following institutions for allowing me to examine bibliographical and visual materials: British Museum, London; Courtauld Institute, London; Lenin Library, Moscow; Library of Congress, Washington, D.C.; Museum of Modern Art, New York; New York Public Library; Radio Times Hulton Picture Library, London; Royal Institute of British Architects, London; Russian Museum, Leningrad; School of Slavonic and East European Studies, University of London; Solomon R. Guggenheim Museum, New York; Sotheby and Co., London; Taylor Institute, Oxford; Tretyakov Gallery, Moscow; Victoria and Albert Museum, London; Widener Library, Harvard.

Last but not least I would like to extend my gratitude and appreciation to my two editors, Barbara Burn and Phyllis Freeman, for without their patience, care, and unfailing cooperation this book would not have been possible.

JOHN E. BOWLT

Contents

V. Constructivism and the Industrial Arts

VI. Toward Socialist Realism

List of Illustrations

Introduction

Although it is fashionable and convenient to accept the period 1890–1930 as a cohesive unit in the history of Russian art and to regard it as encompassing the birth, life, and perhaps premature death of the Russian modern movement, these forty years of intense activity were essentially the culmination of a cultural evolution that found its genesis in the first radical movements of the 1850s. And however cursory, any survey of the achievements of the Russian avant-garde must be carried out not in isolation, but against the background of the key artistic attainments of the second half of the nineteenth century. This introduction, therefore, will examine briefly not only the tendencies within the period with which the book is concerned, but also the organic, evolutionary causes of their emergence and development.

". . . an authentic Russian art . . . began only around the fifties." [1]

The decade of the 1850s marks a significant turning point in the process of Russian culture and provides a justifiable date for establishing a division between what might be called the "classical" and "modern" eras of the Russian visual arts. Until the middle of the nineteenth century, the Russian school of easel painting, as opposed to the Moscow and provincial schools of icon painting, had been centered in St. Petersburg, where the Imperial Academy of Fine Arts had engendered a neoclassical, idealist movement. Divorced from the mainsprings of indigenous culture, Russian academism remained imitative of the models of the Western masters and based its artistic ideal on the technical skill and rigidity of canons inherent in the art of classical antiquity.

By the early 1850s, however, the academy was beginning to lose its cohesion and supremacy as a combination of disturbing circumstances gradually made itself felt. It became obvious that ecclesiastical and "salon" art, for which the academy received and executed commissions, had become moribund, devoid of inspiration. Students at the academy began to sense the evident discrepancy between what they were expected to depict and what they could depict—if they turned their attention to contemporary social reality. The advent of a democratic intelligentsia led by Nikolai Chernyshevsky assisted significantly in the formation of a new artistic consciousness: Chernyshevsky's tract *Esteticheskie otnosheniya iskusstva k deistvitelnosti* [The Aesthetic Relations of Art to Reality], published in 1855, attracted certain already dissident artists, such as Vasilii Perov, who suddenly found their own conceptions clearly mirrored in such tenets as "that object is beautiful which displays life in itself or reminds us of life."[2]

The practical extension of Chernyshevsky's doctrine was the action undertaken by fourteen students of the academy who, in 1863, protested against a set piece for an annual competition and withdrew from its sphere of influence. Seven years later it was some of this group who formed the nucleus of the famous Society of Wandering Exhibitions. Championed by the important critic Vladimir Stasov and later patronized by the collector Pavel Tretyakov, the Wanderers [from the Russian word *peredvizhniki*] erected a new artistic code founded not on pure aestheticism, but on social and political attributes. In this way, thanks particularly to such impressive painters as Ivan Kramskoi and Vasilii Surikov, the realist movement came to dominate the artistic arena of the 1870s and 1880s.

The Wanderers, although compared sometimes to apparently similar Western artists such as Courbet and Daumier, were a distinctive group somewhat isolated from Europe. Indeed, their domination of the progressive art scene in Russia, together with their own nonchalance toward, or even ignorance of, modern Western European trends, contributed, for example, to the sudden but anachronistic recognition that French impressionism enjoyed among Russian artists and collectors in the late 1890s. Conversely, their isolation contributed to the West's failure to recognize them, although their formal and stylistic uninventiveness would, in any case, have found little sympathy with a taste nurtured on the impressionists' unprecedented effects of light and color.

Because of their close affinities with their social and political environment, the Wanderers must be judged, inevitably, in such a context. One critic, writing in 1915, was able to sense this in his appraisal of Ilya Repin, perhaps the most famous of the realist Wanderers: "Repin outside Russia is

unthinkable. Accept him or reject him, he is outside personal evaluations, he is from the people and is popular in the real sense of the word.'' [3] But despite the revolutionary fervor of the initial Wanderers, their artistic system soon lost its trenchancy of purpose. Their positivist conception of the ideals of painting proved to be a double-edged weapon, since their attempt to observe and criticize concrete reality often discouraged individualistic superimposition and hence reduced spirituality and artistic flexibility to a minimum. By continually associating a picture with extrinsic factors, by aspiring to go beyond the confines of the frame—often witnessed by figures moving or pointing to something outside the canvas—the Wanderers neglected the picture as an independent work of art. The overall result was a noticeable weakening of technique and of painterly effect, especially as the original Wanderers were joined gradually by less gifted painters who reduced the philosophy of their elders to badly executed sentimental views of nature.

This decline in easel painting with regard both to technique and to aesthetic value was matched by a similar degeneration within the context of the applied and decorative arts. The impact of Russia's rapid industrialization after 1860 was felt appreciably in the countryside as peasants turned to the towns for employment and abandoned their traditional way of life. One of the consequences of this social transformation was the neglect of traditional peasant art by the peasant himself, and his methods of wood carving, dyeing, embroidery, and *lubok* making [4] were faced with extinction.

Aware of the impending crisis, a few people took measures to preserve and maintain the sources of peasant art. Paradoxically, the task of saving this national cultural heritage was undertaken by the very classes that had contributed to its erosion—industrialists and wealthy aristocrats. Chief among these were Savva Mamontov and Princess Mariya Tenisheva, both of whom were subsequently to contribute funds to Sergei Diaghilev's famous review, *Mir iskusstva* [The World of Art]. In 1870 Mamontov purchased an estate, Abramtsevo, and there founded the artists' colony of that name, where so many of Russia's *fin de siècle* artists lived and worked. Influenced by the teachings of William Morris and deeply interested in Russian peasant art, Mamontov aspired to revitalize the best traditions of his native culture by applying them to the production of ceramics, woodwork, and theatrical decor designed by professional artists, such as Viktor Vasnetsov and Mikhail Vrubel. Princess Tenisheva's estate and art colony, Talashkino, near Smolensk, was an enterprise essentially similar to Mamontov's in its ideals and output and was particularly active in the fields of furniture and fabric design. But although Talashkino witnessed the sojourn of many important artists and although its trading links stretched as far as London and Paris,

Talashkino remained dominated by Abramtsevo—mainly because of Mamontov's more expansive, more forceful personality. Nevertheless, with both ventures we can perceive the beginning of a rapprochement between Russian art and industry that would reach its creative zenith in the dynamic designs and projects of the early and mid-1920s.

In spite of their vital inspiration, the artistic achievements of both colonies, but more especially of Abramtsevo, were often versions of peasant art adulterated either by an unprecedented mixture of local styles or by elements of *art nouveau* that the artists of that age had inevitably assimilated. Such features were particularly manifest in the theater and opera sets displayed at performances of Mamontov's private troupe in the 1880s and 1890s in Moscow and other cities. Despite the difference in temperament, despite the fundamentally Muscovite character of Manontov and his colleagues, it was, however, the St. Petersburg World of Art group that more than any other absorbed and developed this artistic heritage: the innumerable theater sets, costume designs, and indeed the whole decorative, aesthetic production of the World of Art painters owed much of their stimulus to the stylization, formal simplification, and bold color scale of the Abramtsevo artists. Witness to this debt was the first issue of *Mir iskusstva* (November, 1898) which contained a controversial series of reproductions of Vasnetsov's work. Indeed, Vasnetsov and Vrubel were but two of a great number of artists whose peasant motifs, bright colors, simplified composition, and pictorial rhythm heralded the marked tendency toward "geometrization," stylization, and retrospective themes that figured prominently in both the World of Art and the neoprimitivist movement.

Despite the restoration of certain values of traditional art forms that took place at the instigation of Abramtsevo and Talashkino, the position of easel painting as such in the 1880s and 1890s had reached a state of prostration quickened only by the powerful figures of Isaak Levitan, Repin, and the remarkable Valentin Serov. The exhausted doctrines of both the academy and the Wanderers created an impasse that bore the fruits only of weak technique and repetitive theme. Just as forty years before, Russian art had needed, above all, a thematic and stylistic resuscitation, so now, on the threshold of the twentieth century, Russian art demanded a new discipline, a new school. This was provided by the World of Art group, led by Aleksandr Benois and Diaghilev, through its journal, its exhibitions, and its many general artistic and critical accomplishments.

Contrary to accepted opinion, however, the World of Art was not an avant-garde or radical group, and despite their dislike of the realists, such members as Benois, Lev Bakst, and Konstantin Somov were traditionalists

at heart, unready to accept the later achievements of the neoprimitivists and cubofuturists. Nevertheless, the World of Art painters did, in several ways, prepare the ground for the imminent progressive elements of Russian art—primarily in their inclination to consider the picture as a self-sufficient work rather than as a descriptive or tendentious essay. Even in their decorative art—book illustration, costume design, etc.—their conceptions were strikingly independent of extraneous functions, a principle maintained by the second generation of World of Art artists such as Sergei Chekhonin. On the other hand, their technical finesse in the art of depiction, however brilliant, was indicative of their conservative discipline, of their respect for an Alexandrine culture whose grace and symmetry did not allow for revolutionary innovation. At the same time their cult of Versailles, whose "theatricalization" of nature they counted as the eighth wonder of the world, oriented them directly toward the decor and costume designs for which they achieved renown. The fundamental doctrine, then, of World of Art might be formulated as "art for art's sake," although it must be emphasized that the group never published a manifesto or even a code of conduct. The aestheticism of the World of Art artists, their alienation from social and political reality (at least until 1905), and their flight to a subjective and individualistic world linked them closely to the symbolist literary movement, and this in turn stimulated that aspiration to synthesism so characteristic of Russan art during the first quarter of the twentieth century.

But apart from technical mastery in painting and graphics, the World of Art deserves recognition in other spheres, notably in those of ideological propagation and of art criticism. Diaghilev's series of exhibitions, which demonstrated the latest trends in national art, touched off that incredible boom in Russian art exhibitions that spanned the period 1900–30. Perhaps the most impressive of the World of Art exhibitions was the first, in 1899, at which not only group members, but also Western contemporaries such as Degas, Monet, and Puvis de Chavannes were represented; and perhaps the most avant-garde of the original series was the exhibition early in 1906 at which Alexei von Jawlensky, Pavel Kuznetsov (leader of the Blue Rose group), Mikhail Larionov, and other innovators were well represented—as indeed they were in the Russian section organized by Diaghilev at the Paris Salon d'Automne in the same year.

In its many theoretical and critical contributions, the World of Art merits distinctive acknowledgment even though its aesthetic criteria differed profoundly from those favored by the subsequent groups of the avant-garde. The World of Art members were able to apprehend and communicate the subtle changes not only in the art of their time, but also in their social and

cultural environment as a whole, to which Benois's many publications and Diaghilev's famous speech, "V chas itogov" [At the Hour of Reckoning],[5] bear convincing testimony. The gift of rational and incisive criticism that the World of Art members displayed was the result partly of their cultural universality and partly of their innate sense of measure; neither quality distinguished the theoretical contributions of the avant-garde, and in fact, it was their very extremism, irrationality, and ebullience that created the explosive and original ideas for which they are remembered. The moderns retained an energy, a primitive strength that the World of Art, in its "weary wisdom," [6] lacked desperately: it was the youthfulness, the wholehearted passion for painting, and the contempt for artistic norms possessed by the new artists outside the World of Art that ensured the dynamic evolution of Russian art after 1900 and turned Moscow into a center of avant-garde activity until well after 1917.

"Artists of the world, disunite!" [7]

Although at the very beginning of the twentieth century St. Petersburg was still the focal point of Russian art, outside the capital—particularly in Moscow and provincial centers in the south—a distinct movement opposed to the ideals of the academy, the Wanderers, and the World of Art alike was gathering momentum.

Indicative of this trend was the exhibition entitled the "Crimson Rose," which opened in Saratov in May 1904. This exhibition pointed to a new approach to painting, almost to a new school, for in contrast to the precise, refined works of the World of Art, it contained a series of pictures with "allusions to human figures" [8] representing a "sharp departure from the naturalistic study of nature into a world of fantasy and painterly fable." [9] Among the leaders were Kuznetsov, Nikolai Sapunov, and Martiros Saryan, who three years later were to form the nucleus of the "Blue Rose" exhibition in Moscow. The content of the "Crimson Rose" show demonstrated the direct influence of the symbolist painter Viktor Borisov-Musatov, whose retrospective fantasies of forgotten estates haunted by the illusive forms of aristocratic ladies recalled, in turn, the canvases of Maurice Denis and Puvis de Chavannes. It was the formal elasticity and emphasis on mass rather than on line peculiar to Borisov-Musatov that was developed by those young artists who in 1907 contributed to the "Blue Rose" exhibition. It is suggested sometimes that Larionov was the organizing force behind the Blue Rose group and its single exhibition, but this, in fact, was not the case, for although a close colleague of Kuznetsov and his circle, Larionov did not

adhere to their principles of mystical symbolism. Undoubtedly, he was, like them, influenced by Borisov-Musatov early in his career, as was his close collaborator, Natalya Goncharova, but by 1907 he had broken with the master's traditions and had already embarked on the path of innovation that was to lead him immediately to neoprimitivism. In any case, the essential direction had been given to the Blue Rose at the Saratov exhibition, to which, incidentally, Larionov had not been invited, and the success of the future Blue Rose members at major exhibitions of 1905 and 1906 in Moscow and St. Petersburg pointed to their cohesion as a group—especially in the face of the World of Art's decline. Their financial organizer, the banker Nikolai Ryabushinsky, although in no sense a paragon of taste, spared no effort to champion their cause and devoted much space in his journal, *Zolotoe runo* [The Golden Fleece], to reproductions of their pictures; above all, it was thanks to his generosity and enthusiasm in promoting them that the Blue Rose and, later, the neoprimitivists made the impact that they did.

For the Blue Rose artists, art was a theurgic force by which to move *per realia ad realiora*. Their resultant dismissal of concrete reality and their concentration on the spiritual and the mystical led to the "trembling silhouettes and blue diffusions" [10] of their delicate but distorted depictions. At the same time—and because of their neglect of representational value—the Blue Rose painters gave their attention to such intrinsic properties as color, mass, tension, and rhythm; this new conception of artistic purpose, combined with their conscious or unconscious neglect of technical accuracy, produced a series of unprecedented abstracted visions. It was relevant, therefore, that David Burliuk should praise them so highly at the "Link" exhibition in Kiev of the following year at which extreme elements were already present, for it was with the Blue Rose that the Russian avant-garde really began. But the "Blue Rose" exhibition itself marked the culmination of the group's collective search, and the very name, a horticultural fiction, proved to symbolize not only its philosophical aspirations, but also its inability to exist alienated from life.

The ideas and ideals of the Blue Rose, not formulated or published as such,[11] were quickly overshadowed as more assertive artists came to engage public attention with their new and provocative achievements. This is not to say that the highly subjective art of the Blue Rose provided no artistic legacy; the little-known but important so-called Impressionist group, supported by Nikolai Kulbin, Mikhail Matyushin, and others, and the more famous St. Petersburg Union of Youth movement, shared many of the Blue Rose tenets and favored a subjective, intuitive approach to art, as Kulbin's and Vladimir Markov's essays emphasized so readily. Their concentration

on the irrational, psychological conditions of the creative process can be linked, in turn, with a tentative, although untitled, expressionist movement in Russia to which one might assign David Burliuk and, perhaps, Pavel Filonov.

On a different level, the aspriation toward synthesism and the highly individualistic interpretation of art germane both to the Moscow symbolists and to the St. Petersburg "intuitivists" can, of course, be identified with Vasilii Kandinsky. And while Kandinsky had no direct contact with the Blue Rose—he was, in fact, nearer to the St. Petersburg stylists in the early and mid-1900s—he sympathized unquestionably with their spiritual search, as his essay "Content and Form" (see p. 17 ff.) would indicate. Furthermore, Kandinsky was in communication with Kulbin and his circle, witness to which was the fact that Kulbin read "On the Spiritual in Art" on Kandinsky's behalf at the St. Petersburg All-Russian Convention of Artists at the end of 1911; in addition, Kandinsky's ideas on color and form had much more in common with those of the Russian symbolists and, specifically, of Kulbin. In this respect the whole problem of symbolist art and its influence on the development of Russian abstract painting, particularly on the formation of synthetic/subjective abstraction (Kandinsky, Kazimir Malevich) as opposed to analytical/objective abstraction (El Lissitzky, Vladimir Tatlin), is one that deserves serious study.

Since the emergence of the Blue Rose group in the early 1900s (although it was not named formally until 1907), it had become increasingly evident that the evolution of Russian art would be maintained by provincial forces rather than by a sophisticated "capital" movement (to use David Burliuk's ironical term [12]). It is significant that most of the neoprimitivists and cubofuturists came from rural communities; and undoubtedly, their direct contact with traditional peasant art shaped much of their theoretical and practical work and instigated their discovery and advocacy of Russian national art and of the Russian primitives, such as Niko Pirosmanashvili. It was, in fact, at the regular Moscow Association of Artists' exhibition in April 1907 that the first definite tendencies toward a neoprimitivist style were presented: it was immediately clear from the vigorous canvases of such contributors as Goncharova, Larionov, Malevich, Aleksei Morgunov, Vasilii Rozhdestvensky, Aleksandr Shevchenko, and Georgii Yakulov (also, incidentally, Kandinsky) that the trend was away from nebulous shapes and allusive subjects, from subdued color scale and absence of narrative, toward new, vivid, and dynamic conceptions of form, mass, and color. The predominance of still lifes and portraits (the latter almost absent at the "Blue Rose") indicated

further the choice of genres that was to be favored by the new Russian painters at least until 1912.

These salient features of what came to be known as neoprimitivism dominated Russian avant-garde art between 1908 and 1912, the period that witnessed the sudden appearance of "wooden spoons instead of aesthetes' orchids." [13] The recognition and impact of such art forms as the *lubok,* signboard painting, and children's drawing had already been witnessed during the 1880s and 1890s as a result of the Abramtsevo and Talashkino activities, but the second wave of interest created a less stylized, less "nostalgic" product. The neoprimitivists, in fact, found in naïve art a complex of devices that had little in common with the basic aesthetic of Western idealist painting, and these they emphasized often to the detriment of mimetic value. Their disproportionate concentration on such specific artistic concepts as inverted perspective, flat rendition of figures, distinct vulgarization of form, outline by color rather than by line, and consequently, the shift in visual priorities began a process of reduction that one is tempted to relate ultimately to Malevich's *White on White* (1918).

In a lecture in 1938, the painter Kuzma Petrov-Vodkin summed up this period of artistic fragmentation: "There was no school. . . . In Moscow, *Zolotoe runo* was ending its days in languor . . . the banner raised by Shchukin began its revolutionary course. Young artists bristled up . . . became anarchistic, and rejected any teaching." [14] The banner raised by Sergei Shchukin—and, one should add, by Ivan Morozov—was a reference to the two large collections of contemporary Western painting that both men had accumulated by the mid-1900s.

The effect of canvases by Cézanne, Derain, Gauguin, Matisse, Van Gogh, etc., on the young Moscow artists was considerable, although not exclusive. The private showings of these collections undoubtedly influenced the aims of certain movements within the Russian avant-garde, but there was, after about 1910, an equally intense reaction against them, notably by Goncharova and Larionov, who declared their allegiance to indigenous traditions—as Goncharova indicated in her speech on "Cubism" of 1912 (see p. 77 ff.).

This dual attitude to the Western masters produced two distinct trends within the Russian neoprimitivist movement, a phenomenon noticeable especially in the framework of the Knave of Diamonds group. This important group, convoked by Larionov and Aristarkh Lentulov in 1910, divided quickly into "Russian" and "French" factions after its first exhibition, December 1910/January 1911. This inner divergence culminated in the de-

parture of Larionov and his sympathizers and their formation of the Donkey's Tail group later in 1911, while the more academic faction of the Knave of Diamonds retained the original name and changed the organization from a mere exhibition platform into a formal society. As such, the Knave of Diamonds maintained a cohesive, although increasingly eclectic front until 1918, and since it looked to Paris for inspiration, such highly competent members as Robert Falk, Petr Konchalovsky, Aleksandr Kuprin, Ilya Mashkov, and Rozhdestvensky were labeled variously as Cézannists and cubists. Larionov, on the other hand, attempted to base his new conception of art on indigenous and Eastern stimuli and hence disowned any relationship with Western painting; but in fact, as his futurist and rayonist statements reveal, Larionov was not averse to borrowing certain concepts from Italian futurism, but they did not form the basic substance of his artistic tracts. In contrast to the articulate Larionov, the "French" members of the Knave of Diamonds were comparatively reticent, an attitude paralleled in their more detached, more measured approach to painting. Although they did not issue a joint statement of intent, we can accept Ivan Aksenov's critique as their formal apologia and can summarize their artistic credo as the "deliberate simplification and coarsening of form and the resultant condensation of color and precision of line." [15] Under the influence of cubism, most members of the Knave of Diamonds moved from decorativeness and polychromy toward a more acute analysis of form and a more architectonic composition. But however distorted their pictorial interpretations, they never lost contact with the world of objects and remained at a stage before nonrepresentation. Even at the end of 1914, when French cubist influence was most pronounced, the critic Yakov Tugendkhold could write of their current exhibition that the "sense of reality . . . and the gravitation toward the beautiful flesh of objects has again been found." [16] Always opposed to caprice and debilitating psychological connotations in art, the majority of the "French" Knave of Diamonds artists were among the first to accept the realist principles of AKhRR [Association of Artists of Revolutionary Russia] in the early 1920s.

One of the most recognizable characteristics of the more derivative canvases of the Knave of Diamonds members is their lack of movement, their often monolithic heaviness. And it was this in particular that distinguished them from the "Russian" tendency of neoprimitivism favored by Goncharova, Larionov, et al. The latter artists' evident interest in the dynamic qualities of the canvas—tension, rhythm, contrast—led them immediately to the principles of Russian cubofuturism and rayonism. Although Filippo Marinetti's "Futurist Manifesto" was published in Russia in 1909, and ex-

tracts from similar Italian declarations appeared in the review *Soyuz molo-dezhi* [Union of Youth] in 1912,[17] Italian futurism as a whole was interpreted very freely by Russian artists and, while exerting a certain influence, did not constitute a key element of the Russian avant-garde. Suffice it to say that futurism in Russia came to embrace all extreme movements in art and literature from neoprimitivism to suprematism. It was because of this that Larionov managed to include both futurism and rayonism within a single manifesto. To a limited extent, the Italian and Russian versions of futurism did share one common essential, i.e., the concept of dynamism, of mechanical movement, and it was this in part that gave impetus to the extreme leftist painters, who quickly condemned the Knave of Diamonds as an academic flower. Futurism and rayonism, however diverse, reflected the new reality of urban civilization, of men dependent on machines: such famous canvases as Goncharova's *Cats* (1912), Larionov's *Glass* (1912–13), and Malevich's *Knife Grinder* (1912) are linked closely to the concepts of speed, light, and energy.

It is a curious paradox, however, that both Larionov and Malevich could have reacted against their own dynamic, industrial conceptions of art and subsequently have imbued rayonism and suprematism with spiritual, astral qualities. In a letter to Alfred Barr in 1930, for example, Larionov could describe rayonism in terms rather different from those in his "Rayonist Painting" (see pp. 91 ff.): "Ultimately, rayonism admits of the possibility of a definition and a physical measurement of love, ecstasy, talent—those spiritual qualities of the lyrical and epic state. . . ." [18] It was this marked tendency toward an intuitive, mystical fourth dimension (and not toward a Western, temporal one), this "painting of the soul" [19] that formed the genuine and original contribution to the international cubofuturist and abstract movements.

As the old traditions collapsed, numerous groups arose, for the most part intensifying the process of disintegration, while, inevitably, not always advancing valuable replacements. Such a criticism might be leveled at some of David Burliuk's theoretical and practical endeavors, which were often the product of unbridled enthusiasm rather than of systematic thinking. But Burliuk's saving grace was his elemental vitality and unflinching organizational support of progressive art. Even after the Revolution, on his emigratory journey to Japan and the United States, he found time to contribute to exhibitions and discussions of the new art in central and eastern Siberia.[20] Sensitive critics such as Benois tended to dismiss his work outright and even invented the verb *burliukat,* with its derogatory meaning of "to fool around." The verb was applied to many artists of the time who took advan-

tage of the contemporary cultural atomization to produce works outrageous and sensational, but capricious and ephemeral; on the other hand, there were many who searched dutifully for a style, a system that they attempted to base on definite, meaningful principles—such as Malevich and the neglected Shevchenko.

In this respect it would be erroneous to assume that those who tended toward complete abstraction were necessarily more gifted, more independent than those who pursued a middle or more conventional course. One of the distinctive features of post-1910 Russian art was its intricate complex of groups and subgroups whose ideologies and creative output were by no means always oriented exclusively toward abstract art. Apart from the Knave of Diamonds, the Impressionists or "intuitivists" of St. Petersburg, led by the "crazy doctor," Kulbin, made a valuable contribution to the development both of art theory and of actual creation without resorting to complete abstraction. Kulbin's theory of the triangle,[21] his lectures on free art (which, according to a contemporaneous observer, resembled a "fast gallop along . . . all kinds of aesthetic conceptions" [22]) were an attempt to regard art in nonliterary terms, i.e., to seek an aesthetic value system founded on artistic properties other than mimetic accuracy. In this way, Kulbin, together with David Burliuk, Markov, and Olga Rozanova, were already anticipating Nikolai Punin's call in 1919 for a purely "scientific" art criticism (see pp. 170 ff.).

To some, the theory and practice of Kulbin and his associates, such as Matyushin, were a fashionable gesture, an appendage to the postsymbolist decadence of spiritualist séances, table tapping, and erotic mysticism that had flowered on the heritage of the Blue Rose. Yet however controversial they were, Kulbin and his circle, some of whom moved within the wider context of the Union of Youth, played a considerable ideological and organizational role in the cultural arena as a whole: it was on Kulbin's invitation that Marinetti visited Russia for the first time in 1914, it was with Kulbin's encouragement that artists such as Filonov and Rozanova came to the fore and that, in turn, the whole synthesist endeavor of the avant-garde achieved its profound and permanent results.

The rapid development toward, and confirmation of, "art as an end in itself" was stimulated in particular by three exhibitions organized by Larionov—the "Donkey's Tail" (1912), the "Target" (1913), and "No. 4" (1914). Essentially, the first was a demonstration of Larionov's and Goncharova's latest achievements in neoprimitivism and futurism, exemplified by several of Larionov's *Soldier* pictures, and left comparatively little space for the no less exciting contributions of Marc Chagall, Malevich,

Tatlin, and the painter and critic Markov. Organizing the "Donkey's Tail" exhibition in direct opposition to the second "Knave of Diamonds" exhibition, which had just closed, Larionov voiced his disdain forcefully: "My task is not to confirm the new art, because after that it would cease to be new, but as far as possible to try to move it forward. After organizing the Knave of Diamonds two years ago . . . I did not realize that under that name would arise such a popularization of works that have nothing in common either with the new art or with the old. . . ." [23] The second exhibition, the "Target," was more precise in its ideological proclamation and, in visual terms, acted as the first public platform for the advocacy of rayonism. Moreover, the latter was represented not only in its figurative stage, e.g., Larionov's *Rayonist Sausage and Mackerel* (1912), but also in its abstract development, e.g., Goncharova's *Rayonist Perception—Blue and Brown* (1913). A year later, shortly before he and Goncharova left for Paris, Larionov staged the exhibition "No. 4," which, although subtitled "Exhibition of Futurist, Rayonist, and Primitivist Pictures," was primarily a display of rayonist and so-called pneumorayonist works. Larionov's preface to the catalogue underlined the contemporaneous orientation toward painting for painting's sake, even though most of the exhibits were still representational or at least thematic: " 'Exhibition No. 4' is the fourth in the cycle of exhibitions organized by a group of artists who have nothing in common except youth, a forward striving, the solution of mainly painterly problems, and a uniform mood of feeling and thought. . . ." [24] Apart from the "electric" and rayonist pictures by Larionov and Goncharova—some of which, significantly, were called "constructions" [*postroeniya*]—the ferroconcrete poems of Vasilii Kamensky and Shevchenko's essays in dynamism exemplified the fundamentals of cubofuturism.

Rayonism was again represented by Goncharova and Larionov during their reappearance in Moscow at the grand "Exhibition of Painting. 1915" in March of that year.[25] However, their efforts were overshadowed by other, more audacious contributions, and the whole exhibition proved to be a sensational scandal: "the Burliuks hung up a pair of trousers and stuck a bottle to them; . . . Mayakovsky exhibited a top hat that he had cut in two and nailed two gloves next to it. . . . Kamensky asked the jury persuasively to let him exhibit a live mouse in a mousetrap. . . ." [26] Such diverse artists as Natan Altman, Chagall, and Kandinsky added to the pictorial kaleidoscope; but perhaps the most original and valuable contribution was by Tatlin, an artist who, together with Malevich, would exert a profound influence on the remaining phases of the avant-garde movement. It was evident from Tatlin's exhibits, one of which consisted of a "leg knocked off a table, a sheet of

iron, and a broken glass jug,'' [27] that he was concerned with constructing a work of art by combining and contrasting the intrinsic properties of various materials. This move away from the surface of the canvas to a three-dimensional conception had, of course, already led Tatlin to the creation of his reliefs and counterreliefs; two of his painterly reliefs were presented at the parallel exhibition "Tramway V," organized by Ivan Puni in Petrograd. The year 1915, therefore, pinpointed two distinct tendencies within the avant-garde movement: one toward volume, the other toward plane. Tatlin and Malevich emerged as the respective leaders of these two fundamental but contradictory concepts.

Although Malevich was represented at the "Exhibition of Painting, 1915," it is not known precisely which works he showed because his contributions were not detailed either in the catalogue or in the reviews. It is doubtful that he sent examples of suprematism since at the concurrent "Tramway V" his canvases, such as *Portrait of M. V. Matyushin* (1913) and *Englishman in Moscow* (1913–14), were still representational. Although in his writings Malevich dated his formulation of suprematism in 1913, there is little concrete evidence in the form of exhibition catalogues and contemporaneous descriptions that would corroborate this assertion. On the other hand, it is entirely possible that by 1914 Malevich was already thinking in terms of the ''new painterly realism,'' since his paintings and graphics of the time had definite alogical, abstract elements. In any case, the idea of art as something beyond representational value was, of course, not new and had been propounded by Kandinsky, Markov, and Rozanova at least as early as 1913; undoubtedly Malevich relied on certain of their ideas, particularly those of Markov, and expanded them into his theory of suprematism, which saw its written and visual propagation at the very end of 1915. At the exhibition "0.10," organized by Puni (December 1915/January 1916), suprematist compositions occupied the center of attention, and their effect was augmented both by collective manifestoes (see pp. 110 ff.) and by a collective picture painted by Kseniya Boguslavskaya, Ivan Klyun, Malevich, Mikhail Menkov, and Puni, presumably according to suprematist principles. In addition, Malevich accompanied his own contribution by an independent declaration in the catalogue: ''In naming certain pictures, I do not wish to show that I have regarded real forms as heaps of formless painterly masses out of which a painterly picture was created having nothing common with the model.'' [28] It should, however, be noted that although many of the contributions were exercises in combinations of purely painterly elements, the word ''suprematist'' did not accompany any of them.

The "0.10" exhibition was memorable for publicizing a second innova-

tion—Tatlin's artistic method: not only was a whole room devoted to his reliefs, but a pamphlet on his reliefs and corner reliefs was published simultaneously. Unlike Malevich, however, Tatlin had previously exhibited his abstract works several times since his one-man show in May 1914 and had already influenced younger artists, such as Lev Bruni, so that their combinations of materials and textures on surface and in space were the dominant feature at the "Shop" exhibition, organized by Tatlin in February 1916. This exhibition served essentially as a vehicle for advancing both painterly and constructional reliefs (by Bruni, Klyun, Tatlin), but the ideological opponents (Malevich, Lyubov Popova, and Nadezhda Udaltsova) were well represented too, despite the fact that Malevich submitted no suprematist works.

Although the "Shop" was the last major exhibition of the leftists before the Revolution, Malevich, Tatlin, and their confrères did not diminish their artistic activities. But however much the developments of suprematism and the counterrelief constituted audacious advances in art and however far-reaching their effect, ultimately they questioned the very legality of easel art: it was felt that the absolute in art had been reached, and although Malevich beckoned us to the zero of form, he provided no function for art, no pragmatic justification. As early as 1909 Lentulov, in a letter to Benois, had voiced his reservations as to the ultimate purpose of the avant-garde: "You involuntarily ask yourself: 'What next? What's to be done with it all? Does anybody need it?' " [29] A temporary answer to such questions was provided by the Revolution of October 1917.

"Cubism and futurism were revolutionary movements in art, anticipating the revolution in the economic and political life of 1917." [30]

The Revolution of October 1917 affected Russian art immediately in two ways: on the one hand, it undermined or destroyed all cultural groupings; on the other, it gave impetus to the leftist currents that, in certain governmental circles, were accepted as both the herald and the mirror of the social metamorphosis.

This sudden formal recognition of such artists as Altman, Malevich, Aleksandr Rodchenko, and Tatlin stemmed from a variety of reasons: most of the leftists were convinced of their basic affinities with the Revolution itself; Anatolii Lunacharsky, head of the newly established Narkompros [People's Commissariat for Enlightenment], was sympathetic to the radicals both in art and in literature and hence acted as a vital link between them and

Lenin; their numbers were swelled, albeit briefly, by the return of colleagues from abroad—Chagall, Kandinsky, Naum Gabo, Anton Pevsner, David Shterenberg, et al. Such favorable circumstances enabled many of the avant-garde artists to take up positions of administrative and pedagogical authority within the new cultural hierarchy, and consequently, the leftist dictatorship in art became a definite, although ephemeral, reality. Specifically, the utopian ideas of this leftist dictatorship were disseminated both on a theoretical and on a practical level in three essential ways: through state exhibitions and state acquisition of leftist works, through infiltration into the reorganized art schools, and through the establishment of highly progressive research programs within various influential institutions. But because of this broad artistic tolerance, many divisions and conflicts concerning the direction and function of art arose among the leftists themselves. Some, like Altman, believed that Communist futurism [Komfut] was the only doctrine that could successfully transform all the ideological, creative, and organizational aspects of art. Others, like Rozanova, a member of Proletkult (the proletarian culture organization, led by Aleksandr Bogdanov), believed that only the proletariat (i.e., not the peasantry) could create a proletarian art and that much of Russia's cultural inheritance could be ignored. Of all the major art organizations, in fact, Proletkult was the only one that managed to maintain a degree of independence, perhaps because it had been established as a formal entity as early as February 1917—and this position worried Lenin considerably. By 1919 Proletkult had a substantial sphere of influence, operating its own studios in all the main urban centers, and its emphasis on industry allied it immediately with the emergent constructivist groups. Consequently, its formal annexation to Narkompros in 1922 and the automatic restriction of its activities was a political move that presaged the increasing government interference in art affairs during the mid- and late 1920s.[31]

Through the Visual Arts Section [IZO] of Narkompros,[32] the now "official" artists embarked on an ambitious program of reconstruction. In 1918, under the auspices of Tatlin in Moscow and Shterenberg (general head of IZO) in Petrograd, the Moscow Institute of Painting, Sculpture, and Architecture and the Stroganov Art School were integrated to form the Free State Art Studios [Svomas—later Vkhutemas/Vkhutein],[33] and the St. Petersburg Academy was abolished and replaced by the Petrograd State Free Art Educational Studios [Pegoskhuma—later Svomas, and then the academy again[34]]. Such studios provided a further dynamic impulse to the development of avant-garde art mainly because of their initially flexible structure and because of their radical teaching faculty: Klyun, Malevich, Rodchenko, Shevchenko, and Udaltsova were among those who worked at Svomas/Vkhu-

temas; Altman, Puni, Shterenberg, and Tatlin (initially in Moscow) worked at Pegoskhuma/Svomas. Symptomatic of the artistic license observed at these art schools during the early days was the resolution carried by art students at their conference in Petrograd in April 1918 that "art and artists must be absolutely free in every manifestation of their creativity . . . art affairs are the affairs of artists themselves. . . ." [35]

This attitude was shared by the members of Inkhuk [Institute of Artistic Culture], which during the short period of its autonomous existence attracted many important artists and critics. Inkhuk was formed in May 1920 and was based in Moscow originally under Kandinsky; later it had affiliations in Petrograd (under Tatlin and Punin) and in Vitebsk (under Malevich) and at one time boasted contact with Berlin (through Lissitzky and the journal *Veshch/Gegenstand/Objet* [Object]), Holland, Hungary, and even Japan. Essentially Inkhuk acted as a forum for the discussion and analysis of laboratory investigations into various properties and effects of art, and during its early phase Kandinsky's influence could be perceived in the institute's tendency to concentrate on the synthetic and psychological aspects of the artistic disciplines. Kandinsky compiled a long and intricate program for Inkhuk that was to have considered art from three basic standpoints: (1) the theory of individual aspects of art; (2) the theory of the interrelationship of individual aspects of art; (3) the theory of monumental art or art as a whole.[36] Kandinsky himself had the opportunity to observe activities concerned with this comparative approach: "musicians chose three basic chords, painters were invited to depict them first of all in pencil, then a table was compiled, and each artist had to depict each chord in color." [37] However, Kandinsky's psychological approach to art led to disagreements with his colleagues, who were more inclined to regard art as a material object devoid of subjective, intuitive connotations. Consequently, the program was rejected, and Kandinsky left Inkhuk at the end of 1920. After his departure, the Inkhuk administration was reorganized by Rodchenko, Varvara Stepanova, the sculptor Aleksei Babichev, and the musician Nadezhda Bryusova. To this end, Babichev drew up a new and rational plan based exclusively on theoretical and laboratory principles.[38] In turn, however, there was a reaction within Inkhuk against this pure "culture of materials," culminating in the fall of 1921 with the advocacy of industrial and applied art; and with the enrollment of supporters of industrial design, such as Boris Arvatov, Osip Brik, Boris Kushner, Popova, and Nikolai Tarabukin, Inkhuk became identified with the productional-art movement. At the end of 1921 Inkhuk was attached to the Russian Academy of Artistic Sciences, which had been formed during the summer of that year. It was while the Academy of Artis-

tic Sciences was being projected, in fact, that Kandinsky reworked his plan for Inkhuk and presented it in abbreviated form as a proposal for the program of the Physicopsychological Department within the academy (see pp. 196 ff.).

Equally innovative activities were being pursued by the Petrograd affiliation of Inkhuk, called IKhK, which arose in 1922 as an extension of the Museum of Painterly Culture. IKhK was divided into four sections: Painterly Culture, headed by Malevich; Organic Culture, headed by Matyushin; Material Culture, headed initially by Tatlin; and General Ideology, headed by Punin. Within their sections, Malevich and Tatlin devoted much time to the study of "new forms for the new life and for art industry," while Matyushin's experiments remained purely in the laboratory realm, oriented to such specific problems as "color fields" and "space and its significance for aesthetic value." [39] Although IKhK was smaller than its Moscow counterpart, it contained the most promising of Malevich's students, especially Ilya Chashnik and Nikolai Suetin, who had followed him from Vitebsk, as well as Matyushin's gifted assistants, led by Boris and Mariya Ender. Despite constant criticism, IKhK, like Inkhuk, managed to take a very active part in artistic affairs: it organized the large exhibition "Union of New Trends in Art" in 1922 and staged Velimir Khlebnikov's *Zangezi*, with sets by Tatlin, in 1923. IKhK was closed in 1926, and by 1929 Inkhuk, which lost its autonomy in 1924, had also ceased to function.

Despite the enthusiasm and intense activity peculiar to the Revolutionary period, comparatively little "pure art" was created between 1918 and 1920. This was due, in the main, to the deliberate orientation of artistic energies toward the so-called mass activities involving street decoration, designs for mass dramatizations, and agit-transport, to the economic and material uncertainty of the country (Tatlin, for example, experienced great difficulty in acquiring appropriate metals and plaster), [40] and to the underlying theoretical obscurity of the role of art in a socialist framework. Such reasons accounted for the large proportion of pre-Revolutionary works submitted to the sequence of state exhibitions of 1918–21 and to the famous Berlin exhibition of 1922; they accounted also for the temporary cessation of written manifestoes concerned with easel art. At the same time, many of the articles and proclamations that appeared in such journals as *Iskusstvo kommuny* [Art of the Commune] and *Izobrazitelnoe iskusstvo* [Visual Art] were rhetorical and florid, but deficient in practicable ideas. In any case, since politics had become suddenly an integral part of the artist's world view, his statements of the Revolutionary period were often correspondingly tendentious and extrinsic, and not until about 1922 do we once more find manifestoes concerned

specifically with the aesthetics of art. It was then that a second, but weaker, wave of interest in pure or easel art was voiced in declaration or in public debate.

Indicative of this renewed interest was the exhibition "5 × 5 = 25," organized in Moscow in September 1921 under the auspices of Inkhuk. The "five," each with five contributions, were Aleksandra Exter, Popova, Rodchenko, Stepanova, and Aleksandr Vesnin, who set as their task to examine "color, partially solving the problems of the interrelationships of color, its mutual tension, its rhythmization, and to pass on to color construction based on the laws of color itself." [41] Rodchenko gave his farewell to pure painting in three canvases painted respectively red, yellow, and blue. These he saw as the culmination of a process that he described in the catalogue:

1918 At the exhibition "Nonobjective Creation and Suprematism" in Moscow I proclaimed spatial *constructions* and, in painting, *Black on Black,* for the first time.

1920 At the Nineteenth State Exhibition I proclaimed *line* as a factor of construction for the first time.

1921 At this exhibition I have proclaimed three basic colors in art for the first time. [42]

But the 5 × 5 = 25 group disintegrated quickly with the realization that art as an end in itself had already run its course, a move that had been anticipated by Stepanova's statement that "technology and industry have confronted art with the problem of *construction* not as contemplative representation, but as an active function." [43] At a plenary session of Inkhuk on November 24, 1921, the majority of the group, together with their associates, condemned easel painting as outmoded and useless and advocated new artistic values in the "absoluteness of industrial art and constructivism as its only form of expression." [44] In accordance with this declaration many entered the world of industrial production: Popova and Stepanova turned to textile design, Rodchenko to photography, Vesnin to architecture, etc.

Although this was an abrupt and extreme measure, the more so since the majority of the artists concerned had been established painters, their action had already been foreshadowed by a group of young artists from the Moscow Svomas who were members of Obmokhu [Society of Young Artists]. As early as 1919, they had been provided with a studio equipped with metal-cutting machines and stamping machines and with welding apparatus, which indicated their fundamental conception of art as something applied and extra-aesthetic. They designed and produced stencils for postcards and badges, worked on theater sets, constructed traveling libraries, and de-

corated streets and squares. Prominent members of Obmokhu were Konstantin Medunetsky and the Stenberg brothers, Georgii and Vladimir, whose achievements were shown at the four exhibitions between 1919 and 1923; Rodchenko also joined the society in 1921. It was amid the ranks of Obmokhu that dissatisfaction with the eclectic policy of Narkompros was first voiced, for its members saw the grandiose Narkompros exhibitions, culminating in the Berlin showing of 1922, as a sure sign of artistic drift and debility. The reaction of the Obmokhu artists was to advance constructivism as the guideline of socialist art, an endeavor in which they were assisted by the propaganda resources of *Lef* [Levyi front iskusstv—Left Front of the Arts]. The Stenberg brothers, who became famous for their movie posters, and Medunetsky contributed as a constructivist group to the "First Discussional Exhibition of Associations of Active Revolutionary Art" in 1924 (see pp. 237 ff.), there confronting the ebullient Aleksei Gan and his rival group of constructivists.

However rhetorical Gan's formulation and apologia of constructivism published in 1922, the movement emerged clearly as "antiart," condemning art as the individualistic manifestation of a bourgeois consciousness and as alien to a collective society. The initial consequence for the early constructivists, Medunetsky and Rodchenko among them, had been to construct articles of "modern" materials such as aluminum, steel, and glass according to the precise laws of mechanics. Essentially, such compositions were as abstract and as "artistic" as the pre-Revolutionary achievements of Tatlin, and the constructivists were, in turn, accused of bourgeois tendencies. Soon, however, under pressure from Proletkult and Inkhuk, the ideas of constructivism came to be applied to technological design, a move that Tatlin foreshadowed, of course, in his Tower or Monument for the Third International of 1919–20; hence, in direct contrast to the purist pre-Revolutionary movements and, of course, to Gabo and Pevsner's arguments, constructivism became utilitarian. The immediate result of this revision was the dynamic development of architectural and mechanical projects, such as Grigorii Barkhin's *Izvestiya* building (1927), Yakov Chernikhov's industrial complexes (late 1920s–early 1930s), and on a rather different level, Malevich's experimental constructions, the so-called *arkhitektony* and *planity*. To a considerable extent, constructivist concepts were incorporated into designs for textiles (Exter, Popova, Stepanova), the theater (Exter, Popova, Aleksandr Vesnin), and typography (Rodchenko, Lissitzky).

What is often forgotten in this context is that not only artists but also art critics were affected by the trend toward constructivism. Punin's cycle of lectures, delivered in 1919, demonstrated his belief in the need to discover

the constant, rational laws of art so that art criticism, like constructivism, would become a science and leave behind its intuitive, literary principles. As Tugendkhold wrote in 1926: "The fundamental methodological aspiration of Marxist art criticism is the affirmation of a scientific approach to art." [45]

While in general, the most radical artists turned their attention to productional design and concentrated on this throughout the 1920s, some still concerned themselves with easel painting but began to reverse the trend from futurist to realist representations. This change in artistic thinking was inspired partly by the founding of several groups of easel artists in the early 1920s. One of these was NOZh [Novoe obshchestvo zhivopistsev—New Society of Painters], a group of former pupils of Exter, Malevich, and Tatlin who were quick to respond to the new mass taste, as they indicated in their declaration at their first exhibition in 1922: "We, former leftists in art, were the first to feel the utter rootlessness of further analytical and scholastic aberrations. . . . We have not taken the road tramped by the theory of constructivism, for constructivism, in proclaiming the death of art, conceives man as an automaton. . . . We want to create realistic works of art. . . ." [46] The force of such a declaration, diametrically opposed to statements of the preceding decade, stimulated the rapid development of similar organizations, especially AKhRR. The re-establishment of more conventional artistic values, reflected also in the resurrection of pre-Revolutionary associations such as the World of Art and the Union of Russian Artists, was strengthened by the declaration and creative output of AKhRR demonstrated at its first official exhibition in June/July 1922. And it was the 1922 manifesto of AKhRR that, with certain modifications, came to serve as the springboard for the formal advocacy of socialist realism in the early 1930s.

Although the AKhRR credo was the most influential and far-reaching within the context of Russian art in the 1920s and thereafter, it did not, at least initially, liquidate other artistic developments. With the establishment of NEP [New Economic Policy] in 1921, the private art market was reopened and was soon flourishing. As a direct result, the new bourgeois patron stimulated the development of a peculiar and highly interesting visual compromise between nonrepresentation and representation. This was noticeable within the framework of the short-lived Makovets society, formed in 1922, though the symbolic, apocalyptic visions of its greatest member, Vasilii Chekrygin, have yet to be "discovered." [47] A more subjective conception of reality was favored also by the members of OST [Society of Easel Artists], such as Aleksandr Deineka and Aleksandr Tyshler, who at times

supported an almost expressionist presentation. Four Arts, too, was concerned more with questions of form than with revolutionary, thematic content, as their provocative manifesto indicated (see p. 281). But none approached the stature and breadth of imagination possessed by Filonov, who throughout the 1920s continued to paint his fragmented, tormented interpretations of the proletarian city and other themes.

After 1925 increased attention was paid to the "realist" values of an artist's work, and nonrealist exhibitions, if staged at all, were reviewed harshly and accused of ideological alienation.[48] Experimental design in typography and film supported by the October group also came to be seen as asocial and, accordingly, was censured as "formalist"—a term that came to be applied indiscriminately to all art lacking in overt sociopolitical value, from expressionism to suprematism. But although the resolution of 1932 deprived the unorthodox artist of material and spiritual support (Filonov, for example, was represented at no official art exhibitions between 1933 and 1941), individual artists managed still to uphold the principles of their own convictions: Tatlin returned to painting with original and valuable results; Filonov and some of his students continued to concentrate on every formal detail of the canvas; Altman, Klyun, Shevchenko, Shterenberg, and others never abandoned completely their essential artistic ideals.

The formal proclamation of socialist realism at the First All-Union Writers' Conference in 1934 established the direction that Soviet art and literature were to follow for at least the next twenty years. Socialist-realist art with its depiction of society in its revolutionary, technological development was immediately intelligible and meaningful to the public at large, so forming a truly mass art. However autocratic and severe Stalin's measures in the early 1930s and however uniform their results, they did provide a sense of direction and a definite artistic style to artists perplexed by the many conflicting ideas of the preceding thirty years and conscious of an aesthetic impasse. In 1902, at the beginning of the avant-garde period, Benois had written: "Historical necessity . . . requires that an age that would absorb man's individuality in the name of public benefit . . . would again come to replace the refined epicureanism of our time, the extreme refinement of man's individuality, his effeminacy, morbidity, and *solitude.*" [49] Ironically, but inevitably, Benois's prophecy was proved by the advent of the monumental, synthetic style of the Stalin era.

I.
The Subjective Aesthetic:
Symbolism and the Intuitive

Cover of the catalogue of the "Blue Rose" exhibition, Moscow, March–April 1907. Designed by Nikolai Sapunov. The motif was suggested by the symbolist poet Valerii Bryusov.

ALEKSANDR BENOIS
History of Russian Painting
in the Nineteenth Century
[Conclusion], 1902

Born St. Petersburg, 1870; died Paris, 1960. 1898: cofounder of the World of Art; coeditor of its journal and of other art journals; 1900 and thereafter: active as a stage designer; 1908: designed costumes and decor for Sergei Diaghilev's production of *Boris Godunov* in Paris, the first of many contributions to ballet and opera presentations in the West; 1918: director of the Picture Gallery at the Hermitage; 1927: settled in Paris; author of many books and articles.

The translation is from Benois's *Istoriya russkoi zhivopisi v XIX veke* (St. Petersburg, June 1902), p. 274 [bibl. R26]. Benois's awareness of the disintegration of contemporaneous social and cultural values was shared by many members of the World of Art group, not least by Diaghilev (see his "V chas itogov" [At the Hour of Reckoning] in bibl. R44, 1905, no. 4, pp. 45–46) and by Lev Bakst [bibl. R243]. But unlike many of his colleagues, Benois was opposed to the cultivation of individualism (see his "Khudozhestvennye eresi" [Artistic Heresies] in bibl. R45, 1906, no. 2, pp. 80–88) and saw the regeneration of art to lie within a synthesist framework; hence his interest in the theater and the ballet.

Although not a symbolist in the same sense as his associates in the World of Art—Konstantin Balmont, Zinaida Gippius, Dmitrii Merezhkovsky, and later, Andrei Bely—Benois shared certain of their basic ideas. His search for a cohesive style in the face of his "spiritually tormented, hysterical time" [*Istoriya russkoi zhivopisi*, p. 271], his aesthetic devotion to bygone cultures (particularly that of seventeenth-century France), his reaction against the sociopolitical tendencies of realist art, and his very love of the theater and the ballet were elements central to the symbolist world view within the framework both of the World of Art and, later, of the Golden Fleece circles. In this respect, many of Benois's early writings can be interpreted as World of Art and even as symbolist declarations. Although Benois was quick to sense the emergence of the "new art," he was slow to accept it, as his censure of cubofuturism demonstrated [see pp. 69–70 and 103 and bibl. R262]. Stylistically, this piece demonstrates Benois's articulate and lucid mode of critical presentation, an ability not possessed by members of the avant-garde, such as David Burliuk and Malevich.

Lev Bakst: *Portrait of Aleksandr Benois,* 1898. Pastel, watercolor, paper on cardboard. 64.5 x 100.3 cm. Collection Russian Museum, Leningrad.

Aleksandr Benois: *L'Orangerie,* 1906. Gouache, paper mounted on cardboard, 67 x 70 cm. Collection Tretyakow Gallery, Moscow. The palace of Versailles, a frequent subject for World of Art, artists, served to emphasize their innate concern with classical proportion and harmony.

. . . Generally speaking, the whole art of our time lacks direction. It is very vivid, powerful, full of passionate enthusiasm, but while being entirely consistent in its basic idea, it is uncoordinated, fragmented into separate individuals. Perhaps we only imagine this, perhaps the future historian will see our general characteristics in perspective and will outline our general physiognomy. But for the time being, this cannot be done; any unsuccessful attempt would be pernicious because it would create a *theory,* a program, where, essentially, there should not be one. Moreover, it is quite probable that the future will not be on the side of individualism. Most likely a reaction stands on the other side of the door. After a period of freedom, a period of disorder, a new form of synthesis will ensue—although it will be equally far removed from the two kinds of artistic synthesis that have hitherto been dominant in Russian art: academism and social tendentiousness. Historical necessity, historical sequence requires that an age that would absorb man's individuality in the name of public benefit or of a higher religious idea would again come to replace the refined epicureanism of our time, the extreme refinement of man's individuality, his effeminacy, morbidity, and *solitude*. It is but left to us to wish that in the years remaining to the art of our generation, it be expressed as vividly and as loudly as possible. Then it could only be expected that both the reaction and the subsequent, probably contrasting, phase or art would be distinguished by strength and brilliance. In art there is nothing worse than weakness and languor, indifference and its concomitant ennui. But in fact, one of the most serious reproaches that can be cast at Russian art up till now is precisely the reproach of languor and indifference.

Although of course, the sin does not lie with the artists alone; it rests on the deepest foundations, on the whole of Russian society's attitude toward art. However, one can hardly expect any improvement in this direction as long as our drowsiness lasts, and this, in turn, arises from all the distinctive conditions of Russian culture. Only with the gradual change of these conditions can one expect the true awakening of our artistic life, the grand "Russian Renaissance" of which the finest Russian people have dreamed and still dream. Hitherto Russian spiritual life has been illumined, it is true, by dazzling lightning, sometimes menacing, sometimes wonderfully beautiful lightning that has promised a joyful, bright day. But in any case, we are now living not through this day, but through a grave, gloomy period of expectation, doubt, and even despair. Such an oppressive, suffocating atmosphere cannot favor the flowering of art. We should be surprised only that in spite of this situation, we can now observe, nevertheless, a kind of allusion

to our future flowering, a kind of veiled presentiment that we will still utter the great word within us.

[NIKOLAI RYABUSHINSKY]
Preface to
The Golden Fleece, 1906

Pseudonym: N. Shinsky. Born Moscow, 1876; died Côte d'Azur, 1951. Member of a rich Moscow banking family and playboy of extravagant tastes; provided funds for the Golden Fleece journal, of which he was editor; sponsored the "Blue Rose" and "Golden Fleece" exhibitions; patron and friend of many of the early avant-garde artists and a painter and poet in his own right; 1918: emigrated to Paris, where he lived as an antique dealer.

The text of this piece appeared, untitled, in *Zolotoe runo* [The Golden Fleece], Moscow, January 1906, no. 1, p. 4 [bibl. 99, R45]. The Golden Fleece was named after the Greek legend and also in opposition to the Argonauts, another Moscow symbolist group led by the writer Andrei Bely. Ryabushinsky was editor-in-chief of *Zolotoe runo,* and he contributed occasional articles. This unsigned preface was probably by him; it was printed in gold both in Russian and in French, but this practice of inserting parallel translations ceased in 1908. The journal, the most luxurious of all the Russian symbolist reviews, appeared regularly between 1906 and 1909, although the last two issues for 1909 (no. 10 and no. 11/12) did not appear until January and April 1910, respectively, because of financial problems.

This preface, appearing just after the civil disorders of 1905 and the disastrous Russo-Japanese War, expressed the general wish to escape the problems of social and political reality and coincided with the cult of spiritualism that began to corrode Moscow's intellectual salons. Such terms as "whole" and "free impulse" were very much part of the Russian symbolist aesthetic, especially among the so-called second generation of symbolist writers and artists. In this respect, *Zolotoe runo* during 1906 and 1907 acted as the doctrinal platform for the Blue Rose artists, led by Pavel Kuznetsov, and this preface was in keeping with their essential ideas. [For details on the formation of the Blue Rose and its relationship to *Zolotoe runo* see bibl. 87.]

Nikolai Ryabushinsky, ca. 1912. "Tall, fair-haired, a picture of health, a stalwart, self-assured figure dressed in a dinner jacket or suit from a stylish tailor—his pink face bordered by a red beard could always be seen at all theater premieres, at every preview, everywhere that Moscow's elite congregated" [bibl. R109, p. 179].

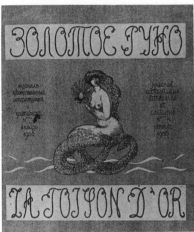

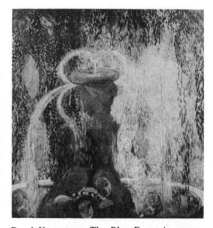

Cover of *Zolotoe runo* [The Golden Fleece], (Moscow), No. 1, 1906. Designed by Evgenii Lancéray. *Zolotoe runo* was the most luxurious and ambitious of all the Russian symbolist journals and played a vital role in the propagation of modernist ideas in art and literature, especially for the Blue Rose group.

Pavel Kuznetsov: *The Blue Fountain*, 1905. Tempera, 127 x 131 cm. Collection Tretyakov Gallery, Moscow. This canvas, with its fountain, embryonic figures, and subdued colors, was one of Kuznetsov's most compelling symbolist works.

We embark on our path at a formidable time.

Around us, like a raging whirlpool, seethes the rebirth of life. In the thunder of the fight, amid the urgent questions raised by our time, amid the bloody answers provided by our Russian reality, the Eternal, for many, fades and passes away.

We are in sympathy with all who work for the rebirth of life, we renounce no task of our contemporaneity, but we believe that life without Beauty is impossible, that together with our institutions we must attain a free and brilliant art for our descendants, one that is illumined by the sun and induced by tireless search; we believe that we must preserve for them the Eternal values forged by many generations. And in the name of this new life to come we, the seekers of the Golden Fleece, unfurl our banner:

Art is eternal for it is founded on the intransient, on that which cannot be rejected.

Art is whole for its single source is the soul.

Art is symbolic for it bears within it the symbol, the reflection of the Eternal in the temporal.

Art is free for it is created by the free impulse of creation.

DAVID BURLIUK
The Voice of an Impressionist:
In Defense of Painting
[*Extract*], 1908

Born Kharkov, 1882; died Long Island, New York, 1967. 1898–1904: studied at various institutions—Kazan, Munich, Paris; 1907: settled in Moscow; soon befriended by most members of the emergent avant-garde; 1911: entered the Moscow Institute of Painting, Sculpture, and Architecture but was expelled in 1913; ca. 1913: illustrated futurist booklets; 1910–15: contributed to the "Triangle," "Knave of Diamonds," "Union of Youth," "Exhibition of Painting. 1915," and other exhibitions; 1915: moved to the Urals; 1918–22: via Siberia, Japan, and Canada, arrived in the United States; active as a painter and critic until his death.

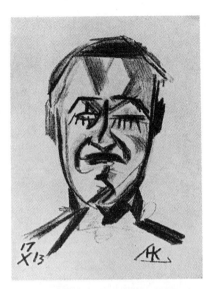

Nikolai Kulbin: *Portrait of David Burliuk,* 1913. Lithograph, 35 x 26 cm. From Kulbin's *Seriya litografii* [Series of Lithographs] (St. Petersburg, 1913) [bibl. R229]. David Burliuk was closely associated with Kulbin and contributed to two of his exhibitions, "Contemporary Trends in Art" (St. Petersburg, 1908) and "The Triangle" (St. Petersburg, 1910).

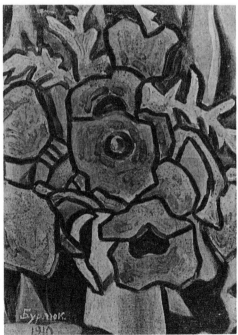

David Burliuk: *Flowers,* 1910. Oil on canvas, 28 x 42 cm. Part of a larger canvas called *The Garden of Life.* Collection Mr. and Mrs. Nicholas Burliuk, New York.

The complete text of this piece, "Golos Impressionista—v zashchitu zhivopisi," appeared with the catalogue to the "Link" exhibition, organized by David Burliuk in Kiev, November 2–30, 1908 [see bibl. R249 and also bibl. 58, pp. 285–87 for French translation of the catalogue list]. Part of the text was reprinted in the journal *V mire iskusstv* [In the World of Arts] (Kiev), no. 14/15, 1908, p. 20 [bibl. R43] and in the newspaper *Kievlyanin* [The Kievan], no. 332, 1908; this translation is made from these sources. The "Link," the first leftist exhibition staged by David Burliuk, included contributions by Aleksandr Bogomazov, Aleksandra Exter, Natalya Goncharova, and Mikhail Larionov.

The importance of Burliuk's text lies in its abrupt dismissal of conventional artistic norms, especially in the form espoused by the Wanderers, and in its enthusiastic support of the Blue Rose artists. Indicative of Burliuk's tendency to judge rashly and unreasonably is his condemnation of Mikhail Vrubel, an artist who exerted a definite influence on the Blue Rose and Golden Fleece artists. The Russian impressionists Burliuk has in mind are such painters as Exter, Goncharova, Larionov, Aristarkh Lentulov (also at the "Link"), and, of course, himself—all of whom were still under the distinct influence of the French postimpressionists. At this time there was a group of so-called Moscow impressionists, which included the painters Igor Grabar and Konstantin Korovin, but Burliuk was hardly referring to these artists since by then he considered them academic and outmoded. Earlier in 1908 Nikolai Kulbin had founded a group called the Impressionists (see p. 12), but it had nothing to do with the French movement of the same name; Burliuk contributed to its first exhibition, i.e., *Sovremennye techeniya v iskusstve* [Contemporary Trends in Art], in St. Petersburg in May 1908, and it is probable that he was thinking of it here. The grammatical mistakes and semantic obscurities are typical of Burliuk's literary style.

———

. . . I see exhibitions of pictures packed with noisy crowds.

The priests of art go off in their motorcars, carrying away their gold in tightly closed bags. Complacent bourgeois, your faces shine with the joy of understanding. You have fathomed the profound meaning of the pictures! I'm not worried for the true art burning in the canvases of geniuses. The crowd does not see, it smells, but the fire of art does not burn and does not exude the stench of lard. It burns lucidly just as the column of smoke blazes up bearing the soul away to the blue of purgatory!

Bitter lard, fumes, and stench are in the works of those whom the crowd loves and who have been fed so long with sweet praises that they have ceased to resemble living creatures.

The art of the past amounts to all that painting in which time has passed over with a delicate net of decrepit wrinkles!

The works of genius and mediocrity—the latter are justified because they have historic interest.

The painting of those who have long since decayed (who they were is forgotten, a riddle, a mystery)—how you upset the nineteenth century. Until the 1830s, the age of Catherine was enticing, alluring, and delightful: precise and classical.

Savage vulgarization. The horrors of the Wanderers—general deterioration—the vanishing aristocratic order—hooligans of the palette à la Makovsky [1] and Aivazovsky,[2] etc.

Slow development, new ideals—passions and terrible mistakes!

Since the first exhibition of the World of Art, in 1899, there has been a new era. Artists look to the West. The fresh wind blows away Repin's chaffy spirit, the bast shoe of the Wanderers loses its apparent strength. But it's not Serov, not Levitan, not Vrubel's [3] vain attempts at genius, not the literary Diaghilevans, but the Blue Rose, those who have grouped around *The Golden Fleece* and later the Russian impressionists nurtured on Western models, those who trembled at the sight of Gauguin, Van Gogh, Cézanne (the synthesis of French trends in painting)—these are the hopes for the rebirth of Russian painting. . . .

NIKOLAI KULBIN

Free Art as the Basis of Life:
Harmony and Dissonance
(On Life, Death, etc.)
[Extracts], 1908

Born St. Petersburg, 1868; died St. Petersburg, 1917. Professor at the St. Petersburg Military Academy and doctor to the General Staff; taught himself painting; 1908: organized the Impressionist group; lecturer and theoretician; 1909: group broke up, dissident members contributing to the founding of the Union of Youth, opened formally in February 1910; 1910 on: peripheral contact with the Union of Youth; close to the Burliuks, Vladimir Markov, Olga Rozanova; ca. 1913: illustrated futurist booklets and other publications; 1914: invited Filippo Marinetti to Russia.

This piece, "Svobodnoe iskusstvo, kak osnova zhizni. Garmoniya i dissonans. (O zhizni, smerti i prochem)," appeared in the miscellany *Studiya Impressionistov* [Studio of the Impressionists] (St. Petersburg, March 1910), pp. 3–14 [bibl. R224], and these extracts come from pp. 3, 4, 8–10, 13–14. The volume appeared just after the "Impressionist" exhibition [see bibl. R221] and at the same time as Kulbin's exhibition the "Triangle" [bibl. R241] was opened in St. Petersburg (March 1910). It also included poems by David and Nikolai Burliuk; Velimir Khlebnikov's famous poem "Zaklyatie smekhom" [Incantation by Laughter]; a so-called monodrama, "Predstavlenie lyubvi" [Presentation of Love], by Nikolai Evreinov (to which Kulbin contributed three illustrations); an essay by Kulbin's scientific colleague Aleksei Borisyak, "O zhivopisi muzyki" [On Musical Painting]; and Kulbin's "Free Music" (bibl. R227, a variant of which appeared in *Der Blaue Reiter* [The Blue Rider], bibl. 96). Essentially Kulbin was concerned with liberating art, literature, and music from conventional patterns and replacing these with the "intuitive principle": in music he followed closely the atonal theories of Arnold Schoenberg and was obviously influenced by the current interest in sound-color relationships manifested by Vasilii Kandinsky, Aleksandr Skryabin, and the St. Petersburg theosophist Aleksandra Unkovskaya; similarly, Kulbin later welcomed Aleksei Kruchenykh's transrational language (*zaum*) and in painting went so far as to presage the mandala theory by maintaining that "painting is the spontaneous projection of conditional signs from the artist's brain into the picture" [bibl. R101, p. 151]. One of these conditional signs that Kulbin saw as recurrent in history was the triangle, a sign that we can identify, of course, with theosophist philosophy, with Russian symbolist aesthetics, and with Kandinsky's *On the Spiritual in Art*. The triangle assumed such importance for Kulbin that he organized an artists' group of that name and began to sign his writings with its graphic representation. It was at the "Triangle" exhibition, in fact, and at similar shows organized by Kulbin, such as *Sovremennye techeniya v iskusstve* [Contemporary Trends in Art], in St. Petersburg in May 1908, that experiments in automatic or intuitive painting were presented: for example, a blind painter submitted canvases to "Contemporary Trends," the peasant primitive Petr Kovalenko ("discovered" by David Burliuk) contributed five canvases to the "Wreath" subsection at the "Triangle," where Kulbin himself was represented by several intuitive works bearing such intriguing titles as *Blue on White* and *White on Green*.

The present text echoes the intuitive, symbolist tone of Kulbin's Impressionist group (not to be confused with the French or Moscow impressionists) and of some members of the Union of Youth, one that can be perceived in the art and writings of Pavel Filonov, Markov, Rozanova, and Kazimir Malevich. Before publication, Kulbin had delivered the text as a lecture to the Society of People's Universities in St. Petersburg in 1908, and on February 12, 1912, he gave a similar talk under the title "The New Art as the Basis of Life" at a debate organized by the Knave of Diamonds [see pp. 69–70 and 77–78]. Part of the text is reprinted in bibl. R14, pp. 15–22.

———

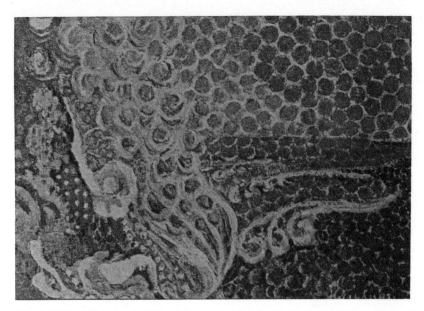

Nikolai Kulbin: Illustration for Nikolai Evreinov's play *Predstavlenie lyubvi* [Presentation of Love]. Kulbin and Evreinov were both involved in several theatrical enterprises in and around St. Petersburg, including the Association of Actors, Artists, Writers, and Musicians in Terioki. This play was not produced, but the text and illustrations appeared in *Studiya Impressionistov* [Studio of the Impressionists] (St. Petersburg, 1910) [bibl. R224] and as a separate publication (Petrograd, 1916).

Harmony and dissonance are the basic phenomena of the universe. They are universal and are common to the whole of nature. They are the basis of art.

Life is conditioned by the play of the mutual relationships between harmony and dissonance and by their struggle.

The life of nature, the common life of the House of God, is the life of great harmony, of beauty, of Him.

Complete harmony is Nirvana, and the weary I aspires toward it.

Complete harmony is death. . . .

In music, the plastic arts, and literature, concord calms the spectator, but discord excites him.

From my own researches I am convinced that it is possible to determine concords and discords in the spectrum, in the scales of colors, just as in musical scales.

In view of this, I have drawn attention to the very special significance that

combinations of adjacent colors in the spectrum and combinations of adjacent sounds in scales have for life and art. By scales I mean those with small intervals. . . .

At this point I may mention that by means of these phenomena that I call "close combinations" [1] and the processes of these close combinations, it is possible to depict all kinds of pictures of nature and of subjective experiences in painting, music, and other branches of art.*

The Meaning of the Theory of Art

Many people say:

"The theory of art? What does that have to do with us? That's something dry and bookish. Does it claim to be something? I want art, not arguments. The artist creates because there burns within him a sacred flame. He creates without reasoning, and I want to enjoy art without reasoning. The mortifying analysis of art kills art."

Those who say this do not notice that they have not departed from theory and that what they have said is their own theory of art.

Away as far away as possible from the dry, the abstract, and the mortifying!

We recognize only harmony, dissonance, rhythm, style, colors, joy, and grief!

The theory of art is the artist's song, his word, his music, his plastic art (embodiment, depiction).

So perhaps we don't need any theories then? We'll simply read poems, listen to symphonies, and look at pictures.

No! There are no poems, symphonies, or pictures that are devoid of ideas. Pictures, words, music, and the plastic arts are the artist's expression. Works of art are the living, vivid epistles of art.

Not everyone has the gift of reading these hieroglyphics. Anyone can say whether a photograph or an academic picture resembles his established conception of "nature." But there is no art in this.

In order that the spectator apprehend the real subjects of art and be able to enjoy the poetry that is inherent in them, the ideas of art must be aroused in him. In order that the artist create the subjects of art, the poet must be aroused in him.

The poetry of art is the theory of art.

* Incidentally, from my own experience I advise painters to depict light with the help of discords. The results are convincing. [2]

We, cells of the body of the living Earth, fulfill her desires, but not all of us hear her voice.

It is difficult, very difficult, to read spontaneously the hieroglyphics of life and of the structure of the crystal, the flower, and the beautiful animal.

Not everyone has the gift of reading the rudiments of the art created by the most beautiful of animals—primitive man and our children—although it is simpler.

There are few loving hearts capable of reading artistic ideas in the great works of bygone art. While contrasting the old artists with the new, the mob is still deaf to the ideas of the old artists. Those who love, think, and desire—such are the flower of the Earth. They desire poetry and hear it in the Good Book and in the thoughts of Leonardo da Vinci, Shakespeare, Goethe, and other literati great and small: these are the real theory of art.

This theory of artistic creation is the key to happiness because art is happiness. It is the philosopher's stone, the magic wand that turns life into a fairy tale. It is poetry.

This poetry represents the principles of life. Knowledge of them inspires the mood of art, sharpens vision.

He who knows these principles sees poetry in works of sincerity depicted by an artist—persecuted and, invariably, a newcomer; works about which the ignorant say: "Rubbish, daubing!"

Roger Bacon asks: which is better, to be able to draw an absolutely straight line by hand or to invent a ruler with the help of which anyone can draw a straight line?

For the artist this ruler is the theory of artistic creation. Without it every artist would have to remake our creative culture. All his strength would be spent on this, and he would have no chance of speaking his own new word. But why, then, do we see certified "artists" every day—artists who study anatomy, perspective, and the history of painting in the official academies—remaining bureaucrats of art? Conversely, street urchins and shepherds are sometimes artists and poets. The theory of art provides us with the answer:

The theory of artistic creation is not taught there.

Well-behaved bureaucrats and exhausted artists teach and learn there. They are nice people, but they have no wings, they cannot fly. If a real artist turns up in such an academy, then he suffers the fate of an eaglet amid a brood of hens. Either they will peck him to bits before his beak has developed, or he will hurt somebody himself.

The shepherd Giotto reads the theory of art freely in nature herself, studies color and line while driving his flock from one beautiful picture to another. Moving to the town, he examines works of art and takes from them

their own particular guidelines; he reads, converses about art, and thirstily imbibes the juice of the fruits of art, throwing away the peel and the mold. In his own creations Giotto puts into practice artistic truth, the truth of art.

The eagle's wings function not irregularly but by strict laws that represent the theory of eagles.

This is the theory of artistic creation. It is essential both for talent and for genius.

Tolstoi is the sun. But in his erudition disregards the sciences of Mephistofeles. And so, to the surprise of many, there are spots on the sun.

Chekhov to a lesser extent, but he studied the sciences of life. A doctor's knowledge [3] not only did not hinder him from creating, but also lent his creation an extraordinary force, a humaneness almost evangelical.

Ruisdael manifested artistic ability at fourteen years of age, but he first became a doctor and only later a painter; this helped him to establish a great new sphere of painting—the landscape.

The theory of artistic creation has taught man how to compose a poem, to discover colors, and to discover living harmony. This theory is inherent in pictures themselves and in discourses about pictures. . . .

I. Theory

Ideology. Symbol of the universe. Delight. Beauty and good. Love is gravity. Process of beauty. Art is the quest for gods. Creation is the myth and the symbol. Freedom. The struggle of Titans and Olympus. Prometheus and Hercules. Painting and servitude.
A single art—of the word, music, and the plastic arts.

Creation. Thought is the word. Feeling. Will. Individuality. Child. Artist. Talent. Temperament. Sensation. Contrast. Dynamic principle in psychology. Growth and decline. Associations. Revelation and consciousness. Search, imagination, realization. Artistic vision. Mastery of unconscious creation. Accumulation of impressions, processing of them (the throes of creation). Outbursts of creation (inspiration). Interchange of creation and self-criticism. Harmony. Dissonance. Peace and life. Harmony of sequence. Rhythm, Style.

Blue. Thought in word, sounds, and colors. Drawing is melody.

Red. Mood. The sounds of colors. The colors of the word. The colors of sounds. Scales. Ornament.

Artist, picture, and spectator.

Yellow. The plastic arts. Free creation. Illusion and form. The psychology of depiction. Mutual creation of artist and spectator.

Cognition. Sight and blindness. The psychology of the spectator. Sympathetic experience. Criticism.

Supplements. The life of the artist, of the picture, and of the spectator.

II. The History of Art

The sources of art. Nature. People. Nation.
Movement of the pendulum, realism—idealism. Ants. Spiders and bees. Translational movement. Evolution and revolutions in art. Cycles of art. Destruction, fertilization, decadence. Sowing. New styles. Flowers and fruits. School. Academism. Degeneration.

The Past. Primitive art. The periods of antiquity. The Middle Ages. The latest cycles.

The Present. Contemporary art trends.

New Tendencies. The revaluation of values.

VASILII KANDINSKY
Content and Form, 1910

Born Moscow, 1866; died Neuilly-sur-Seine, 1944. 1896: arrived in Munich; 1909: with Alexei von Jawlensky et al. founded the Neue Künstlervereinigung [New Artists' Association]; began *Improvisations;* 1909–10: Munich correspondent for *Apollon* [bibl. R41]; 1910: contributed to the first "Knave of Diamonds" exhibition; 1910 onwards: began to explore an abstract mode of painting; 1911–12: exhibitions of *Der Blaue Reiter* [The Blue Rider]; 1914–21: back in Russia; 1920: participated in the organization of Inkhuk; 1921: participated in the organization of the Russian Academy of Artistic Sciences; 1921: emigrated; 1922–33: taught at the Bauhaus.

The text of this piece, "Soderzhanie i forma," is from the catalogue for the second Salon exhibition, organized by Vladimir Izdebsky in Odessa, December 1910–

Vasilii Kandinsky, ca. 1912. Photograph courtesy the late Mme. Nina Kandinsky, Paris.

January 1911 [bibl. R133, pp. 14–16]. Apart from the list of exhibitors [French translation in bibl. 58, pp. 309–13] and this text, the catalogue included articles by Izdebsky, Nikolai Kulbin [bibl. R225], a certain "Dr. phil. A. Grinbaum, Odessa" (perhaps the philosopher Anton Grünbaum), a discourse on "Harmony in Painting and Music" by Henri Rovel, a long poem by Leonid Grossman (later to achieve fame as a literary critic), and Kandinsky's translation of Arnold Schoenberg's "Parallels in Octaves and Fifths." With such a synthetic composition and, moreover, with a cover designed after a Kandinsky woodcut, this catalogue might well have formed the prototype for *Der Blaue Reiter* almanac itself. Although most contemporary trends in Russian painting were represented at the exhibition—from neoprimitivism (David and Vladimir Burliuk; Mikhail Larionov, Vladimir Tatlin, etc.) to symbolism (Petr Utkin), from the St. Petersburg Impressionists (Kulbin) to the World of Art (Mstislav Dobuzhinsky)—the Munich artists (Jawlensky, Kandinsky, Gabriele Münter, Marianne von Werefkin) constituted an impressive and compact group. Indeed, the German contribution both to the exhibition and to the catalogue was indicative of Izdebsky's own interest in Kandinsky (he intended, for example,

to publish a monograph on him in 1911; see bibl. 97, pp. 186–89) and, generally, in the Neue Künstlervereiningung.

Kandinsky's text shares certain affinities with his article "Kuda idet 'novoe' iskusstvo" [Where the "New" Art Is Going; bibl. R223], which was published a few weeks later (also in Odessa) and in which he went so far as to assert that "any kind of content is unartistic and hostile to art. . . . Painting as such, i.e., as 'pure painting' affects the soul by means of its primordial resources: by paint (color), by form, i.e., the distribution of planes and lines, their interrelation (movement). . . ." Of course, both this article and the text below constituted previews of Kandinsky's *On the Spiritual in Art,* which was given as a lecture by Kulbin on Kandinsky's behalf at the All-Russian Convention of Artists in St. Petersburg on December 29 and 31, 1911 [see bibl. R222]. The present text reflects both Kandinsky's highly subjective interpretation of art and his quest for artistic synthesism, attitudes that were identifiable with a number of Russian artists and critics at this time, not least Kulbin, Aleksandr Skryabin, and of course, the symbolists. Kandinsky's attempts to chart the "artist's emotional vibration" and to think in comparative terms still evident in his programs for the Moscow Inkhuk and for the Russian Academy of Artistic Sciences (see pp. 196–98). Part of the text is reprinted in bibl. 45, pp. 281–82. The whole text is translated into English in bibl. 101x, pp. 87–90.

———

A work of art consists of two elements:
the inner and
the outer.
The inner element, taken separately, is the emotion of the artist's soul, which (like the material musical tone of one instrument that compels the corresponding tone of another to covibrate) evokes a corresponding emotional vibration in the other person, the perceptor.

While the soul is bound to the body, it can perceive a vibration usually only by means of feeling—which acts as a bridge from the nonmaterial to the material (the artist) and from the material to the nonmaterial (the spectator).

Emotion—feeling—work of art—feeling—Emotion.

As a means of expression, therefore, the artist's emotional vibration must find a material form capable of being perceived. This material form is the second element, i.e., the outer element of a work of art.

A work of art is, of necessity, an indissolubly and inevitably *cohesive* combination of inner and outer elements, *i.e., content and form.*

"Fortuitous" forms scattered throughout the world evoke their own inherent vibrations. This family is so numerous and diverse that the effect of "fortuitous" (e.g., natural) forms appears to us to be also fortuitous and indefinite.

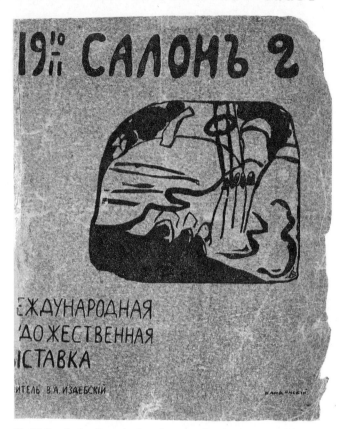

Vasilii Kandinsky: Reproduction after a woodcut for the cover of the catalogue of Vladimir Izdebsky's second "Salon" (Odessa, 1910–11). Collection The Museum of Modern Art, New York.

In art, form is invariably determined by content. And only that form is the right one which serves as the corresponding expression and materialization of its content. Any accessory considerations, among them the primary one— namely, the correspondence of form to so-called nature, i.e., outer nature— are insubstantial and pernicious, because they distract attention from the single task of art: the embodiment of its content. *Form is the material expression of abstract content.* Hence the quality of an artistic work can be appreciated *in toto* only by its author: content demands immediate embodiment, and the author alone is permitted to see whether the form that he has found corresponds to the content, and if so, to what extent. The greater or

lesser degree of this embodiment or correspondence is the measure of "beauty." *That work is beautiful whose form corresponds entirely to its inner content* (which is, as it were, an unattainable ideal). In this way the form of a work is determined essentially by its inner necessity.

The principle of inner necessity is the one invariable law of art in its essence.

Every art possesses one form that is peculiar to it and bestowed on it alone. This form, forever changing, gives rise to the individual forms of individual works. Hence, whether or not the same emotions are involved, every art will clothe them in its own peculiar form. In this way each art produces its own work, and therefore, it is impossible to replace the work of one art by another. Hence there arises both the possibility of, and the need for, the appearance of *a monumental art:* we can already sense its growth, and its color will be woven tomorrow.

This monumental art represents the unification of all the arts in a single work—in which (1) each art will be the coauthor of this work while remaining within the confines of its own form; (2) each art will be advanced or withdrawn according to the principle of direct or reverse contact.

Thus the principle of a work's construction will remain the one that is the single basis of creation in each individual art.

The great epoch of Spirituality is beginning, and even yesterday, during the apparent climax of materialism, it had already emerged in its embryonic state; it will provide, and is providing, the soil on which this monumental work must mature. A grand transvaluation of values is now taking place as if one of the greatest battles between spirit and matter were about to begin. The unnecessary is being rejected. The necessary is being studied in all its aspects. This is also taking place in one of the greatest spheres of the spirit—in everlasting and eternal art.

The means of expression of every art have been prescribed and bestowed on it from time immemorial and, essentially, cannot change; but just as the spirit is being "refined" continuously, divesting itself of the soul's materiality, so, correspondingly and partially beforehand, the means of art must be "refined" also, inflexibly and irrepressibly.

Therefore (1) every art is eternal and invariable, and (2) every art changes in its forms. It must guide the spiritual evolution by adapting its forms for greater refinement and lead the way prophetically. Its inner content is invariable. Its outer forms are variable. Therefore, *both the variability and the invariability of art constitute its law.*

These means, fundamental and invariable, are for

music—sound and time
literature—word and time
architecture—line and volume
sculpture—volume and space
painting—color and space.

In painting, color functions in the shape of paint. Space functions in the shape of the form confining it ("painterly" form) or in the shape of line. These two elements—*paint and line*—*constitute the essential, eternal, invariable language of painting.*

Every color, taken in isolation, in uniform conditions of perception, arouses the same invariable emotional vibration. But a color, in fact, cannot be isolated, and therefore its absolute inner sound always varies in different circumstances. Chief among these are: (1) the proximity of another color tone, (2) the space (and form) occupied by the given tone.

The task of pure painting or painterly form follows the first stipulation. *Painting is the combination of colored tones determined by inner necessity.* The combination is infinitely fine and refined, infinitely complex and complicated.

The task of drawing or drawn form follows from the second stipulation. *Drawing is the combination of linear planes determined by inner necessity.* Its refinement and complexity are infinite.

The first task is, in fact, indissolubly linked to the second and represents, generally speaking, the primary task in a composition of painting and drawing; it is a task that is now destined to advance with unprecedented force, and its threshold is the so-called new painting. It is self-evident that this innovation is not a qualitative one (fundamentally) but a quantitative one. This composition has been the invariable law of any art of any period, beginning with the primitive art of the "savages." The imminent Epoch of the Great Spirituality is emerging before our very eyes, and it is precisely now that this kind of composition must act as a most eminent prophet, a prophet who is already leading the pure in heart and who will be leading the whole world.

This composition will be built on those same bases already familiar to us in their embryonic state, those bases that will now, however, develop into the simplicity and complexity of musical "counterpoint." This counterpoint (for which we do not have a word yet) will be discovered further along the path of the Great Tomorrow by that same ever-faithful guide—Feeling. Once found and crystallized, it will give expression to the Epoch of the Great Spirituality. But however great or small its individual parts, they all

rest on the one great foundation—the PRINCIPLE OF INNER NECESSITY.

VLADIMIR MARKOV
The Principles
of the New Art, 1912

Pseudonym of Waldemars Matvejs. Born Riga, 1877; died St. Petersburg, 1914. Studied under Yan Tsionglinsky (who was also the tutor of the poet and painter Elena Guro and of Mikhail Matyushin); traveled widely in Western Europe; 1906–1907: edited *Vystavochnyi vestnik* [Exhibition Messenger], St. Petersburg; 1908: contributed to the "Link" exhibition; 1910 and after: close to the Union of Youth, contributing to its first exhibition and editing its first and second booklets [bibl. R237]; expecially interested in the art of China, Black Africa and Easter Island, researching this with his companion, the artist Varvara Bubnova; 1912: contributed to the "Donkey's Tail."

The text of this piece, "Printsipy novogo iskusstva," is from the first and second issues of *Soyuz molodezhi* [Union of Youth] (St. Petersburg), April and June 1912, pp. 5–14 and 5–18 respectively [bibl. R237]. As a complement to Markov's text, both booklets carried Russian translations of Chinese poetry rendered by Markov's friend Vyacheslav Egorev (who, together with Markov, compiled a book of Chinese verse [see bibl. R235]); moreover, the first issue contained reproductions of Oriental art and an essay on Persian art, and the second issue carried a Persian miniature on its cover. On a different level, although of direct relevance to Markov's interests, was the inclusion in the second issue of Henri Le Fauconnier's statement in the catalogue of the second Neue Künstlervereinigung exhibition (Munich, 1910) in Russian translation. This, in fact, pointed to the close connections maintained between St. Petersburg and Munich: Nikolai Kulbin and Markov, for example, had been represented at Vladimir Izdebsky's second Salon, Kulbin had read Kandinsky's *On the Spiritual in Art* in St. Petersburg in 1911 [see p. 19], and Eduard Spandikov (a founder of the Union of Youth) had translated Worringer's *Abstraktion und Einfühlung* [*Abstraction and Empathy*], which the Union intended to publish [see advertisement in no. 1, p. 24].

Markov's essay, in fact, while touching on the idea of construction in Occidental and Oriental art, reached conclusions quite contrary to those of Worringer and attempted

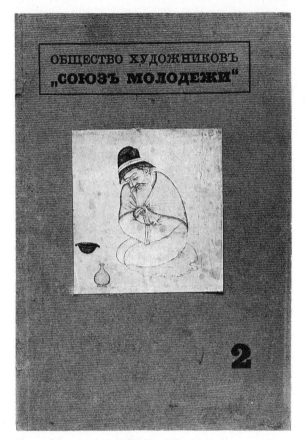

Cover of *Soyuz molodezhi* [Union of Youth] (St. Petersburg), No. 2, June 1912. The Persian miniature on the front cover both indicated the wide artistic concerns of this St. Petersburg "little magazine" and emphasized the deep interest in Eastern art on the part of Vladimir Markov, one of its most important contributors.

to establish the aesthetic value of primitive and Eastern art, where Worringer saw little or none at all. "Intuition" and "fortuitousness" were key words of Markov's vocabulary and indicated his proximity to Kulbin, Olga Rozanova, and even Vasilii Kandinsky, the more so since Markov was both a painter and a critic. His terminology and metaphors, e.g., "boundless horizons," recall the style of Kazimir Malevich, who undoubtedly was familiar with Markov's writings. Markov's recognition of primitive and "nonconstructive" art was apparent in his other writings, particularly in his book on Negro art [bibl. R234] published posthumously.

Markov's own art reflected a highly individualistic and apocalyptic vision, as indi-

cated by such titles as *Golgotha* (at the first "Union of Youth" exhibition), *Morning of Life* (at Izdebsky's second Salon), and *Spiritual Point of View* (at the "Donkey's Tail"). In the history of modern Russian art, Markov's link with the Baltic countries is not an isolated case. The painter and musician Mikalojaus Čiurlionis, who achieved a certain reputation in St. Petersburg in the late 1900s, had been a native of Lithuania, and in the general context of the Union of Youth, many ties were established with Riga and Vilnius: not only were the Union of Youth members Markov and Vasilii Masyutin natives of Riga, but also Kulbin's "Impressionist" exhibition traveled from St. Petersburg to Vilnius in late 1909, Izdebsky's first Odessa Salon opened in Riga in the summer of 1910, and the first "Union of Youth" show moved there from St. Petersburg in June of that year. It is tempting to propose that the presence of a Baltic influence within the St. Petersburg avant-garde acted as an immediate link with German and Nordic expressionism—and indeed, the darker, more Teutonic quality of Markov's drawings, Masyutin's etchings, or even Kulbin's paintings has certain affinities with Edvard Munch, or, more relevantly, with the Estonian Eduard Viiralt. Markov's advocacy of an art of chance, of "a world of unfathomed mystery" is therefore a logical outcome of this aesthetic ambience. For a French translation see bibl. 145i, pp. 53–57.

Where concrete reality, the tangible, ends, there begins another world—a world of unfathomed mystery, a world of the Divine.

Even primitive man was given the chance of approaching this boundary, where intuitively he would capture some feature of the Divine—and return happy as a child.

And he sought to introduce it into the confines of the tangible and to secure it there while finding forms to express it; at the same time he attempted to find ways by which he would be able to encounter and sense once again an analogous beauty.

The more of such features man captures, the more familiar becomes the Divine; the closer becomes the realization of some kind of religion.

Worldly beauty, created from ancient times by different peoples of both hemispheres, is a reflection and expression of the Divine insofar as it has hitherto revealed itself to people.

But, obliged for its origin to the intuitive faculties of the spirit, it reveals within itself the presence of those fundamentals that can be elevated into immutable truths, into the principles on which it is based.

These principles, these canons, which substantiate our intuitive perception, become the guide to all our actions in the achievement of beauty.

The more deeply and broadly mankind penetrates the divine principle of beauty, the richer and pithier become the religions of beauty, the more heterogeneous and numerous their principles and canons.

Many peoples have identical religions, uniform principles and canons; other peoples work out their own particular ones, but it often happens that separate peoples work them out along the same lines.

Principles already found sometimes generate, in their application, new principles that open up many beautiful possibilities that cannot be attained by intuitive means. And the wider, the deeper the horizons revealed by these principles, the higher, the more significant their inner value.

Without the love, often unconscious, of some principle, canon, or religion, there can be no national beauty.

Every impulse, every exploit, every movement of line and thought is carried out not fortuitously and not aimlessly; it is conditioned by an inner necessity, by a formulated principle, a canon, a religion. And it is these that compel us to commit many completely incomprehensible acts—to fast, to inflict torture on ourselves, to contort ourselves, to create idols, monstrous forms, incomprehensible melodies, harmonies, other worlds.

All that is sincere, all that is in good faith, all passion is for many affectation. Any depiction of ideal beauty, purity, baseness, the terror of man's soul, any colorful and melodic rapture is for many affectation.

Just take a game of chess. Try to follow the players without knowing the principles of the game, and you will see neither sense nor system in the moves of the pieces.

But if you know its principles, you will be filled with a sense of attained beauty.

There are principles with a very limited sphere of potential, and there are principles that open up boundless horizons.

Many peoples descended from the arena of history lost themselves in the obscurity and remoteness of the past; but their creative principles were preserved, and we inherited them in their original, or in a processed, form.

We of the twentieth century occupy a particularly fortunate position in being able to familiarize ourselves with all these principles and to evaluate their significance.

Means of communication, the press, excavations—all provide us with the opportunity of collecting together all man's achievements in the field of beauty, the achievements of all ages, countries, and nations. The range of our observations has expanded and broadened extraordinarily and has ceased to be confined to the art of our next-door neighbors.

All this prompts us to make comparisons, to contrast separate religions of beauty, to establish the character of their beauty, their merits, and the advantages of these over those.

Generally speaking, it should be noted that contemporary Europe, which

has made such major achievements in the field of science and technology, is very poor in regard to the development of the plastic principles bequeathed to us by the past.

It is quite striking that certain principles, especially the most worthless of them, have been selected by many peoples. But despite the fact that they are jejune in intrinsic content, they are being endlessly elaborated, they enclose art—by their very nature—in a narrow, vicious circle. Other principles with brilliant, infinite prospects, with inexhaustible potential, have appeared for a moment, but not finding the soil necessary for development, they have drooped and faded.

If we take a broad look at all the world's art, there arise before us clearly and vividly two diametrically opposed platforms, two basic trends hostile to each other. These two worlds are *constructiveness* and *nonconstructiveness*.

The first of these is expressed most vividly in Greece and the second in the East.

In Greek art and also in subsequent European art, everything is logical, rational, and has a scientific basis; gradations and transitions subordinate to the main factor are clearly expressed; in a word, everything is constructive.

And wherever Europe penetrates with its rigid doctrines, its orthodox realism, it corrodes national art, evens it out, paralyzes its development.

China, Japan, Byzantium, and other countries lost their acuity a long time ago and have been imbued to a greater or lesser extent with the ideals of the Italian Renaissance. This caps the delight of the historians and archaeologists who see as the high-water mark of this art—alien though it be to them: its assimilation of Hellenic canons and its analogous elaboration of them; hence they are always glad to note the appearance in it of the first signs of European constructiveness and its legitimated reality. . . .

The ancient peoples and the East did not know our scientific rationality. These were children whose feelings and imagination dominated logic. These were naïve, uncorrupted children who intuitively penetrated the world of beauty and who could not be bribed by realism or by scientific investigations into nature.

As one German writer said, "Die Logik hat uns die Natur entgöttert." [1]

And our prim nonchalance toward the "babble" of the East and our misunderstanding of it are deeply offensive.

Modern Europe does not understand the beauty of the naïve and the illogical. Our artistic taste, nurtured on severe rules, cannot reconcile itself to the disintegration of our existing world view, cannot renounce "this world," surrender itself to the world of feeling, love, and dream, imbue itself with

the anarchism that ridicules our elaborate rules, and escape into a nonconstructive world.

There is rhythm in the constructive, and there is rhythm in the nonconstructive, but which has more beauty is still to be investigated.

There is constructive ornament, and there is nonconstructive ornament; which of them is the more beautiful we still have to find out.

There is a perspective that is scientific, mathematically verified and substantiated—constructive; and there is a perspective that is nonconstructive—Chinese, Byzantine. But which of them displays more potential and more beauty is still a leading question.

The same can be said of lighting, relief, form, etc.

Europe's scientific apparatus hampers the development of such principles as the principle of weight, plane, dissonance, economy, symbols, dynamism, the leitmotif, scales, etc., etc. . . .

Let us turn to the discussion of certain principles.

Let us take *the principle of chance*.

Can chance be beauty?

Yes, and a beauty that you will not reveal, find, or grasp by constructive thought.

For example, in Chinese villages stand pagodas with many, many little bells of various tones on them. Only a scarcely noticeable gust of wind need spring up for their melodic music to softly waft over the village. . . . A second gust of wind and a second sound sequence. . . . And so it goes on time after time without end. . . . All these are accidental sound combinations that cannot be created by a deliberate selection of sounds—it is the beauty of chance.

Here is another example of the beauty of chance.

The Chinese liked to cover their vases with a glaze of copper oxide, but the results of this operation were completely subject to chance. Depending on how the gases circulated around the object, it could turn any color—from white to bright red, blue, or black. Because of this, the most unexpected, most beautiful combinations and distributions of colored areas sometimes occur. No rational combinations could create such beauty; it is beyond the means of rational, constructive creation.

The Chinese valued the beauty of chance very highly and reverently cherished these works, among which could be encountered rare, unexpected, and irresistibly charming specimens; even now they are objects of delight to the cultured eye.

And how much beauty is to be found in the fortuitous, unintelligible collection of spots and lines of Chinese letters, in the motley crowd, or in branches accidentally interlaced.

The Chinese likes the line to meander unconsciously and beautifully like a gangliform plant. Even the fanciful forms of clouds appear bare to him, and he tries still more to intensify their whimsicality. Unlike the Greek, the Chinese cannot honestly and diligently repeat a meander or geometrical form many times; once he takes hold of a form, he loosens it and repeats it in an infinite number of fortuitous combinations—in complete contrast to our academism, which organically does not tolerate chance in anything and is now trying to abolish it.

Yes, the East loves the accidental—searches for it, catches it, and in every way exploits it. The Chinese, for example, sings that the eyebrows of a woman are black and long like the wings of black swallows in flight. In the tree they encircle he sees a harp on whose strings sobs the wind. For him the falling snow is a cloud of white butterflies dropping to the ground.

Chance opens up whole worlds and begets wonders. Many wonders, unique harmonies and scales, the enchanting shades common to Chinese and Japanese pictures owe their existence only to the fact that they arose by chance, were appreciated by a sensitive eye, and were crystallized.

"That's all charlatanism," people will tell me. But I am not elevating chance into the sole principle of artistic creation, I am merely stating its use and reasonableness—qualities that do not permit it to be ignored and repressed.

There is much that is accidental in our life, and I doubt whether anyone would reject a fortunate and beautiful accident.

In any case, this principle of chance is applied much more frequently and willingly than the public suspects. I know many artists who daub their canvas just as God wills them to, and who then merely snatch from the chaos what they think is most successful and, depending on their power of fantasy, subject everything to their desires.

Those artists who devise scales, harmonies, and decorative motifs are especially inclined toward this.

Others search for amusing ways of painting—by blobs and *pointillés*. Some stick on paper before the work is dry; the next day they tear it off and discover accidental and sometimes beautiful patches on the work and attempt to make use of them.

And the way in which they use this principle gives a clear indication of the difference in spiritual structure between Europe and Asia.

For Europe, chance is a means of stimulation, a departure point for logical thought, whereas for Asia, it is the first step in a whole series of subsequent, nonconstructive works of beauty.

So, essentially the principle of chance is not the result of rational processes consciously oriented toward a certain aim and is not even a game played by a hand ungoverned by the apparatus of thought, but is the consequence of completely blind, extrinsic influences.

The Principle of Free Creation

The source of the beauty of chance can be found not only in blind, extrinsic, purely external factors, but also in the inmost recesses of man's very soul, in the unconscious movements of the artist's hand and thought. It is on this faculty of man's spirit, bestowed from above, that the principle of *free creation* is built.

How joyful it is, how good it is to set one's soul at liberty, to sketch and to work relying on fortune without constricting oneself by laws and rules, and how good it is to advance blindly, aimlessly, to advance into the unknown after complete surrender to free fulfillment, and to throw away, to scatter all our achievements and all our quasi values.

How good it is to be wild and primitive, to feel like an innocent child who rejoices equally at precious pearls and glittering pebbles and who remains alien and indifferent to their established values.

I shall not be carrying out subtle researches into the origin of creation, of beauty, etc.—into whether it is a game, a surplus of energy, the regulation of vital forces, etc.

But there is no doubt that while we play, we by chance alight upon examples of precious beauty that are so fascinatingly beautiful that we don't know how to keep them, and it grieves us when we are forced to sacrifice them to suit some principles or other that have received general recognition.

Playing a game compels us to forget about the direct, utilitarian purpose of things, and the artist, in realizing the principles of free creation, has a right to play with all worlds accessible to him: both the world of objects, and the world of forms, lines, colors, and light. He has a right to play with them as freely as a child who plays with pebbles, mixing them up and laying them out on the ground.

Every individual has his own instinctive wisdom, his own gestures, his own tuning fork.

What is more—every period in life has its own particular psychological makeup, so let it be manifested without hindrance or prohibition.

This is expressed most unconstrainedly and easily in children's actions and gestures, which enchant us generally because those hindrances and prohibitions that embarrass us are absent at their initial source.

Of course, free proportions in figures and faces can create caricature as well, but they can create a beauty too, prompted by an innate sense of measure.

In playing, we express our "I" more vividly and unconstrainedly and emerge no longer as the masters of forces hidden within us, but as their slaves.

And this free relation toward all that exists and surrounds us, this attraction and gracious relation toward the manifestations of our own "I," has created many national arts, has marked out and posed many problems for us.

And all these nuances of individual creation—nuances such as heavy, light, clumsy, graceful, cold, dry, vague, feminine, masculine, sharp, soft, etc.—are products of instinctive work, and they should be preserved and protected, and not persecuted and destroyed.

Why is the hand of man not given, as a photograph is, the ability to transmit forms and reproductions of "this world" precisely?

Why does man not possess an apparatus that, by desire or act of will, could be aimed at creation that would reflect neither the fortuitous, external conditions surrounding the artist nor the individual features of his own psychology?

Why does the art of so many peoples bear the character of apparent absurdity, coarseness, vagueness, or feebleness?

Art is like a two-edged weapon; it is like the two-faced Janus. One face is, as it were, coarse, absurd, and feeble; the other is, as it were, radiant with grace, refinement, and delicate, careful trimmings.

In which of these two faces is there more beauty? Which of them is capable of giving more enjoyment to man's soul? Or perhaps they are both, in equal degree, the custodians of the concept of beauty, and thereby justify their existence.

I shall not take the liberty of asserting that the art of primitive peoples is characterized by the first face of Janus.

Suffice it to remember even the misty lines of Chinese pictures, Turkistan frescoes, Egyptian reliefs, the surviving monuments of Cretan and Polynesian cultures to reject this. In no way can we establish elements of the coarse or vulgar in their lines and depictions. On the contrary, in appearance they are all very refined and delicate.

Monuments of the Stone Age, of hunting peoples, preserved in caves, Negro art, etc., convince us of the same.

But there are peoples who profoundly loved the simple, the naïve and apparently absurd and who, throughout many centuries, persistently exploited this world, discovering in it virgin deposits of beauty.

To be ugly and absurd externally does not mean to possess no inner values.

So, the principle of free art affords its ardent and passionate protection to all those absurd manifestations of man's soul, to that coarse and vulgar face, as it were, of art, which is so persecuted in Europe.

In general, one can say that this apparent coarseness, vulgarity, *lubok* [2] quality appeared, and began to be exploited, quite late in time and that it is the fate of only certain peoples.

For many peoples this is a completely closed area. However much they may struggle, they will always remain graceful and delicate and will never create that distinctive lyricism that is concealed beneath the cover of the absurd and simple: the lyricism that Byzantium discovered after penetrating this area and developing it in all directions.

And it was Byzantium that for many centuries guided the tastes of millions of people and dominated the artistic understanding in all Europe; it ruled for many centuries with boundless strength.

And all this happened after the grace of Hellas, after the canons of beauty of pure, mathematical proportions. All this happened not so long ago.

To be profoundly sincere is not so easy; artists are quite often accused of an absence of sincerity. This is an audacious and stupid accusation. I have met nobody who did not want to be sincere in his art.

The sincerity of idiots, fools, of underdeveloped and stupid people has no artistic value and is therefore void of any artistic interest.

In general, I call in question the possibility of expressing our true "I" in a pure form.

It often happens that the "I" that we have expressed turns out, after a little reflection, to be not our "I" at all.

I had a friend who once bought a depiction of Christ for a few farthings on the street. After he had arrived home, he went into raptures over his purchase. This was a Russian man, brought up in an ecclesiastical family, who from childhood had been surrounded by exclusively Russian impressions and who had known no other language besides Russian. He had been to a university.

In view of all these facts, his raptures seemed particularly strange to me,

and I asked him how he, a man who had grown up in a Russian environment with a Russian way of thinking, could go into raptures over a purely German depiction à la Hoffmann.[3]

And only when I had pointed out to him the inimitable, unique, age-old charm of the antique, tasteful Russian depictions of Christ, and all the vulgarity of this outwardly elegant depiction, did an element of doubt creep into his rapture, and he laid his purchase aside.

Now one asks, was he expressing his own opinion when he flew into raptures over his purchase? I am inclined to think not. In his rapture he was sincere, but in that superficial, shallow sense applicable to all the followers of fashion—that epidemic, that tyrant of men's opinions and tastes. I say in a superficial sense, because his raptures were not founded on the inward order of his soul created by the presence of all impressions from reality; they were founded merely on a simple order of feelings from the conception evoked, a conception that conceals and gradually corrodes the peculiar depths of the soul.

Only this can explain the fact that more and more depictions à la Hoffmann have begun to appear in our schools and churches alongside the artistic charm of the antique icons. These depictions are taken from German originals, and pictures are executed by the disciples of the academy along the same lines.

And wherever fashion appears, it drives deep down into the soul that which has grown and stratified over thousands of years and in its place foists on people its cheap, marketplace conception of beauty.

All this indicates that the free expression of our "I" has dangerous enemies, because of which it is very difficult for man to be sincere in the sense of freely expressing his inner essence and not some surrogate evoked by chance.

Hence it is interesting to ask: which expression of the "I" has more value? The expression of the "I" that bursts from us spontaneously or the "I" that is passed through the filter of thought?

I shall concern myself only with free art, i.e., the art in which chasing or processing is absent—elements that completely destroy the initial mirage and in which the artist has already ceased to be a creator and becomes more a critic of his own "I."

It sometimes happens, and not so rarely, that man feels within himself an influx of ideas, of sensations in his psychology that seem to him somehow alien, not his own, appearing, as it were, from without by some miracle, something unexpected but desired.

In religious ecstasy, in moments of inspiration, and even in ordinary moments of emotional peace, there occurs an influx of ideas that is not the result of conscious thinking directed toward an aim.

And because of this many people say not, "I think," but, "It seems to me."

Why do we think one thing, and not another, why does my glance slip into one direction and not another, why does my hand do this and not that? In all this there is sometimes no element of logic or actively directed will, and an audacious galloping about, striking changes of stimuli are always going on.

Thus, first, by some miracle a brilliant thought sometimes imprints itself on the chaos of thinking, an intuitive solution to a task, a problem that had beset us for such a long time. Where does it come from?

Second, there are occasions when ideas, colors, tones, melodies of a particular order simply thrust themselves on us, and we are unable to shake them off because, like a volcano, they require an outlet.

And with dynamic force they appear at the first opportunity.

And we cannot be responsible for these phenomena, we cannot be accused of their appearance, just as we cannot be accused of our dreams and fancies.

In the same way, we cannot be responsible for our ideas taking forms that in their embodiment seem, as it were, absurd and coarse but that demand their realization in precisely these forms.

Neither are we responsible for the fact that our soul demands "plagiarism," that we repeat old things. We grew up on them, strive toward them, vary them, elaborate them, and thereby afford ourselves enjoyment and peace.

The course of the development of world art clearly shows that folk arts have been created only by way of plagiarism.

Of course, plagiarism not in the sense of theft, robbery, or attempts to pass off ideas and images previously created by others as one's own personal creation. This suspicion should not arise of its own accord since the beauty of the past is known and beloved by all, is common property, and so the artist who draws on this rich treasure house must not be reproached with deceit or theft. It is a great pity that society is not acquainted with antiquity and is not fond of it—it therefore complains when artists do not present it with innovations but lean on the past, apparently out of impotence, and, so it seems, simply steal from it.

In China, a nation nurtured on art and educated in beauty, artists are imperiously required to produce variations on the art of the past, which has ex-

isted for three thousand years, and imitation and free copying are valued very highly.

I would go so far as to say that there is no art without plagiarism, and even the freest art is based on plagiarism in the above sense because beloved forms of the past instilled in our soul unconsciously repeat themselves.

Hence the demands to be sincere and individual in any special sense of the word are ridiculous.

It is not my task to analyze our "I" in all its diversity, in all its nuances—that is the province of psychology; but I would like to distinguish three characteristic stages in it that to a greater or lesser extent determine our creative work.

First, the hidden, subconscious "I," something that has appeared from one knows not where, often completely alien and fortuitous but at the same time, of course, individual, because in any case the right basis, whether temporary or permanent, has appeared within it.

Second, the "I," also hidden, but already mature, something that we are aware of, which is organically inherent to the individuum and transmitted to it atavistically: it is all those impulses, stimuli, that, like a ripe seed, demand an outlet, torment and cramp it.

Third, the "I" that presents the outward manifestation of these two hidden, individual "I"s mentioned above.

In free art, of course, it is the third "I" that interests us, but it does not emerge as the direct echo of the two preceding "I"s, it does not express the aggregate of the impressions and mysteries that accumulated in them, because much is lost through the effect of many outside factors encountered in the process of its manifestation that operate directly or indirectly.

Let us indicate just a few:

1. The outward function of the hands and, in general, of the body, which transmit that rhythm of the soul that it experiences at the moment of creation.

2. The state of the will.

3. Wealth of fantasy and of memory, reflectiveness.

4. Associations.

5. Experience of life creeping into the process of creation, subordinating it to its canons, laws, tastes, and habits and operating with a hand that finds it so pleasant to reiterate stereotyped devices; this reduces art to the level of handicraft, which has nowadays built itself such a warm and secure nest.

6. State of psychosis during creation; the interchange of feelings, joy, hope, suffering, failure, etc.

7. Struggle with material.

8. Appearance of "sensing into," desire to create style, symbol, allegory, and illusion.

9. Appearance of criterion and thought, etc., etc.

Hence free creation is not the absolutely free and pure echo of our inner worlds. It will always contain alien elements, surrogates.

Free creation is inherent to the artist not as a simple desire to be original, to play pranks, or to demonstrate ridiculous affectation, but as one of the means of satisfying the creative needs of man's soul.

Since there are a great many factors that influence the "I," it is difficult to establish which to exclude and which to contend with.

But, in any case, those factors that impede the free manifestation of our "I" and choke it with alien surrogates should be acknowledged as undesirable.

We can distinguish an alien "I" and any factors that impede our full manifestation of the "I" by criticism and other means.

Therefore those works that the public sees marked as free action painting and about which they imagine that their little Peter could daub ten such paintings at home are, as far as the artist is concerned, not works of overexuberant mischievousness or of a frolicsome brush; they are a product in which not a single spot, not one shade can be altered, a product that has appeared as a result of suffering, of long, persistent inner work, searching, and experience.

Hence free creation contains the essentials of true creation and stands high above simple imitation; in no way is it a game or mischief making, and by no means can it be called the simple need to liberate the self from an inner repletion of life-giving energy (dissimilation).

Forms attained by the application of the principle of free creation are sometimes a synthesis of complex analyses and sensations; they are the only forms capable of expressing and embodying the creator's intentions vis-à-vis nature and the inner world of his "I." From the point of view of naturalism they will appear as quite free and arbitrary, but this does not exclude the fact that they can be strictly constructive from the point of view of aesthetic requirements.

And it often seems that the absurd forms are not the echo and translation of nature but the echo of the creator's inner psychology.

"They are the swans of other worlds," as the Chinese sing.

The principle of free creation opens up the temple of art as widely and deeply as many other principles.

Free creation is a general principle; it is inherent in other principles as

their component part and is always giving rise to independent principles that are wholly derived from it.

The principle of symbols is a vivid example. This supposedly weird nonsense, this oppressive absurdity is life itself in its purest form, it is condensed life. The symbols that we find in Byzantine art, in the *lubok*, are flashes of beauty and divinity.

The principle of rhythm, movement, grandiosity is possible only with free creation, when the hand is held back in its impulse.

These examples will suffice.

The principle of free creation represents essentially the apogee in economy of resources and the least expenditure of technical devices; at the same time it provides the truest and most powerful echo of the divine beauty that man has sensed.

And all peoples used, are using now, and henceforth will use free creation.

And only narrow-minded doctrinaires and dunderhead philistines can demand that art should forever remain on safe, well-trodden paths, that it should not burst the dam of realism and depart for the endless horizons of free creation.

A man possesses an ocean of impressions. He often receives stimuli that he does not see but only feels: in creating freely, obedient to his feeling, he depicts an object quite contrary to how he sees it.

Behind the outer covering of every object, there hides its secret, its rhythm—and the artist is given the ability to divine this secret, to react to the object's rhythm, and to find forms to manifest this rhythm.

The lost image, word, melody, verse have often irrevocably sunk into oblivion, but the soul preserves and cherishes their rhythm, remaining in it as their eternal and indelible echo. And this rhythm guides the hand when the soul wishes to restore lost beauty. The outward expression is often completely unattained, but we hold it dear by virtue of its analogous rhythm, its beauty equivalent to the forgotten object.

And often in objects seemingly absurd and coarse, there lies a wealth of inner beauty, rhythm, and harmony that you will not encounter in objects constructed by the mind on principles of pure proportion and practical truth.

Distance toward objects is established; practical, constructive aspects of the object are forgotten.

Free creation is the mother of art. Free creation raises us above "this world"—this is its great prerogative.

And the opinion is quite without ground that people have sought and demanded illusions at all times. No, many peoples have not been satisfied with such cheap tricks as deceiving the poor spectator.

The aspiration to other worlds is inherent in man's nature. Man does not want to walk, he demands dancing; he does not want to speak, he demands song; he does not want the earth but strains toward the sky. The surest path to this sky is free creation.

From time immemorial, free creation has been an art for itself; the spectator, the public has been for it a completely fortuitous phenomenon. In olden times, music and singing were like this, and only subsequently did they become a means of gathering and entertaining an audience.

If in his attitude to art the artist becomes like the savage, then, like him, he will think only of himself.

He has the right to tell the public and critics: "Excuse me, but don't pester me with your demands; let me create according to my own inner impulses and criteria."

And he will be right because as soon as an artist begins to listen to extrinsic doctrines, he will be forced to violate the rhythms concealed within, the motive energy inherent in him; he will have to restrain himself, he will have to turn into a cart horse, he will grow dull.

Now let us turn to a discussion of the principle of texture.[4]

II.
Neoprimitivism
and Cubofuturism

Cover of the catalogue of the first ''Knave of Diamonds'' exhibition
(Moscow, December 1910–January 1911). The restrained, conven-
tional design gave little indication of the historical importance of the
exhibition in the evolution of the Russian avant-garde.

ALEKSANDR SHEVCHENKO
Neoprimitivism:
Its Theory, Its Potentials,
Its Achievements, 1913

Born Kharkov, 1882; died Moscow, 1948. 1898–1907: enrolled at the Stroganov Art School, Moscow; 1905–06: studied in Paris; 1907–09: studied at the Moscow Institute of Painting, Sculpture and Architecture; 1910–14: influenced by peasant art; close to Larionov; contributed to the "Donkey's Tail," "Target," "No. 4," and other avant-garde exhibitions; 1914–18: military service; 1918–30: professor at Svomas/Vkhutemas/Vkhutein; continued to paint and exhibit throughout the 1930s and 1940s.

The translation is of Schevchenko's *Neo-primitivizm. Ego teoriya. Ego vozmozh-nosti. Ego dostizheniya* (Moscow, November 1913 [dated June in the text]), and is one of two booklets written by Shevchenko in the same year, the other being *Print-sipy kubizma i drugikh sovremennykh techenii v zhivopisi vsekh vremen i narodov* [The Principles of Cubism and Other Contemporary Trends in Painting of All Ages and All Nations; bibl. R355]. The cover and text of *Neoprimitivism* were illustrated with examples of his work.

Because of its comparatively late date, Shevchenko's text shows considerable futurist influence; it reads more like a futurist manifesto than a lucid apologia of the neoprim-itivist movement. Shevchenko repeated many of his ideas on neoprimitivism in his booklet on cubism, which included among its illustrations a child's drawing.

Neoprimitivism was the only declaration as such of the neoprimitivists even though the movement had been in existence since 1908. They were not, however, the first to express interest in primitive art forms: at Abramtsevo and Talashkino professional artists had already been assimilating certain devices from Russian peasant art, and members of the World of Art, Lev Bakst and Aleksandr Benois among them, had given attention to children's drawings and to village crafts as art forms [see bibl. R243, R244]. After 1908 Russian and primitive art forms began to enjoy a vogue among Russian collectors and historians, and the year 1913, in fact, witnessed sev-eral events that focused public attention on the Russian icon and folk art, e.g., the "Second All-Russian Folk Art Exhibition" in St. Petersburg, and the large exhibi-tion of icons—including examples from the collections of Ilya Ostroukhov and Ste-pan Ryabushinsky (brother of Nikolai)—organized by the Institute of Archaeology in Moscow.

АЛЕКСАНДРЪ ШЕВЧЕНКО.

НЕО-ПРИМИТИВИЗМЪ.

ЕГО ТЕОРІЯ. ЕГО ВОЗМОЖНОСТИ
ЕГО ДОСТИЖЕНІЯ.

МОСКВА
1913.

Cover of Aleksandr Shevchenko's *Neoprimitivism* (Moscow, 1913). The picture reproduced is his *Musicians* (1913), now in the Russian Museum, Leningrad. Photograph courtesy M. Alexandre Polonski, Paris.

Throughout his life Shevchenko retained an interest in certain of the pictorial analyses he made during the years 1912–13, particularly with regard to the composition and effect of color. In 1918–19 he attempted to combine a scientific study of color properties with the results of his own observations on the *lubok* and the icon. To this end he established the group Color Dynamics and Tectonic Primitivism together with the painter Aleksei Grishchenko (who was particularly interested in icons and Byzantine art); this group, which held one exhibition in Moscow in 1919, sought to uphold its three principles of "structure, knowledge of the laws of color, and knowledge of the material with which we operate in creating the easel painting" [bibl. R16, p. 119]. Shevchenko's precise, logical analyses of color and other painterly elements anticipated the laboratory techniques of the Moscow Inkhuk and its affiliates in the 1920s. Although Shevchenko was not a formal member of this organization, he did establish direct contact with Aleksandr Rodchenko and the architects Vladimir Krinsky and Nikolai Ladovsky within the framework of the short-lived Zhivskulptarkh [Kollektiv zhivopisno-skulpturno-arkhitekturnogo sinteza—Collective of Painting-Sculpture-Architecture Synthesis] founded in Moscow in 1919/20 and represented as a group at the "Nineteenth State Exhibition" in Moscow in 1920. Shevchenko was not alone in his endeavor to apply scientific analysis to primitive art— Vasilii Kandinsky, for example, proposed the establishment of a subsection within the Academy of Artistic Sciences that would deal precisely with this (see pp. 196ff.). For a French translation see bibl. 145i, pp. 71–80.

To Art
Free and Eternal

The artist should not be too
timid, too sincere, and should
not be too subservient to na-
ture.

—Paul Cézanne, painter

The artist should be a brave,
sincere fighter for the ideas
of great Art, he should not be
subservient to nature, and only
by drawing material from it for
his experiences can he be
the creator and master of its
forms.

—A. S.

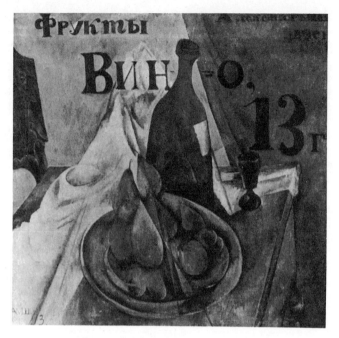

Aleksandr Shevchenko: *Still Life in Signboard Style: Wine and Fruit,* 1913. Oil on canvas, 82 x 86 cm. Collection Tretyakov Gallery, Moscow. Although indebted to Cézanne and to the cubists, Shevchenko attempted to combine these influences with a deliberate attention to the form, color, and texture of primitive art.

WE WHO ADVOCATE NEOPRIMITIVISM AS THE ARTIST'S RELIGION SAY:

The Earth and Nature no longer exist in their conventional sense. They have been turned into building foundations, into asphalt for pavements and roads. The Earth and Nature remain only a memory, like a fairy tale about something beautiful and long past.

The factory town rules over everything.

The movement, the never-ending commotion, the obscure nightmares and visions of the town are continually replacing each other. In the light of the daytime sun darkened by houses, in the bright light of the electric suns of night, life presents itself to us as quite different, replete with different forms new to us.

The world has been transformed into a single monstrous, fantastic, perpetually moving machine, into a single huge nonanimal, automatic organism, into a single gigantic whole constructed with a strict correspondence and balance of parts.

We and the whole world are the parts of this whole.

We, like some kind of ideally manufactured mechanical man, have grown used to living—getting up, going to bed, eating and working according to the clock—and the sense of rhythm and mechanical harmony, reflected in the whole of our life, cannot but be reflected in our thinking, and in our spiritual life: in Art.

We can no longer be satisfied with a simple organic copy of nature.

We have grown used to seeing it around us altered and improved by the hand of man the creator, and we cannot but demand the same of Art.

Such is our age.

Naturalistic painting does not exist for us either, just as nature does not exist without roadways swept clean and sprinkled with sand or spread with asphalt, without plumbing and electric light, without the telephone and the trolley.

We are striving to seek new paths for our art, but we do not reject the old completely, and of its previous forms we recognize above all—the primitive, the magic fable of the old East.

The simple, unsophisticated beauty of the *lubok,*[1] the severity of the primitive, the mechanical precision of construction, nobility of style, and good color brought together by the creative hand of the artist-ruler—that is our password and our slogan.

Life without movement is nothing—and therefore we always aspire not to enslave the forms of objects on one plane, but to impart their movement to them by means of the depiction of intermediate forms.

Beauty is only in the harmony of simple combinations of forms and colors. Recherché beauty is very close to the tawdry affectation of the market—the product of the mob's corrupted tastes.

Primitive art forms—icons, *lubki,* trays, signboards, fabrics of the East, etc.—these are specimens of genuine value and painterly beauty.[2]

The words *Art,* i.e., invention, and *nature,* i.e., reality, are at a crossroads called the "Creative Will of the Artist," and diverge along different paths; that is why we do not pursue a naturalistic resemblance to nature in our pictures.

Nature is the raw material that merely excites in our soul this or that emotion that we experience when we fulfill our conception of the picture's surface.

It is not necessary to copy nature and life, but it is necessary to observe and study them unceasingly. For Art, the observation and study of nature must have a subject of Art itself for a departure point.

For the point of departure in our art we take the *lubok,* the primitive art form, the icon, since we find in them the most acute, most direct perception of life—and a purely painterly one, at that.

We, like the primitivists and like Eastern artists, consider the most valuable and most productive work to be that which is guided by impression. This provides a broader field for displaying one's own world view and does not distract attention with unnecessary details, which always occurs in work done directly from nature.

But we also tolerate this kind of work as long as it is based on the judicious will of the artist-creator and not on servile submission to nature.

In this case our art, although executed from nature, will, as it were, serve us as a fulcrum.

For some this will seem like a copy of somebody else's work of art; for us this is a sketch of nature, a study of nature through the prism of Art.

In the literal sense of the word, there is no such thing as a copy; no artist is able to produce two completely identical works, but only a more or less exact imitation.

Painting is a visual art and, as such, can choose its object of imitation freely, i.e., nature or another work already in existence.

One should not be afraid of copying other people's pictures.

Painting is self-sufficient, and hence what the mob conventionally calls a copy is, in fact, not that; in two works of art that resemble each other in subject, there will be a different kind of painting, different texture, and different structure.

It's easy to convince ourselves of this if we take two works not just of two faces, but even done from the same model, from the same position: they are two different works of painting.

Art is for itself and not for the execution of a subject, and if it does appear to be the latter, then this is not the motive, but the consequence.

Neither can the primitive art form, like nature, restrict our freedom. We are merely fascinated by its simplicity, its harmony of style, and its direct, artistically true perceptiveness of life.*

We demand a good texture of our works, i.e., the visual impression from a picture that is created by its surface, its painting—by brushstroke, density of paint (color), character of the painted layer of the painting—in a word, by

* Of life and not of nature. Nature is the aggregate of those things of which the world consists; life is the aggregate of the forms of these things and of their movements.

everything that we see on the surface of the picture and that is related to its execution.

We demand good structure, i.e., a manner of execution that imparts a good density to the paint and to its disposition.

We demand good style of a work of art, i.e., a style that expresses itself in the composition of lines, masses, and colors.

Our art is free and electric—in this lies its contemporaneity.

We are not afraid of following the principles of this or that school of contemporaneity. They are inevitable in our scientific age.

The word *neoprimitivism* on the one hand testifies to our point of departure, and on the other—with its prefix, *neo*—reminds us also of its involvement in the painterly traditions of our age.

But in saying this, we are not imposing on ourselves any obligations that could bind us, or make us servile, to theory.

We are free, and in this lies our progress and our happiness,

Any attachment to a school, to a theory, already means stagnation, is already what in society is customarily designated by the word "academism."

The artist's vitality is determined by his search, and in searching lies perfection.

The mob says with reproach and even apparently with regret: "This artist has not defined himself yet," but in this lies his life, his authenticity. Of the artist about whom people say, "He has defined himself, he has found himself," one ought to say, "He has died," because "He has defined himself" means that he has no more experiences, that he is living by what, essentially, he has already lived through, i.e., he is following a definite theory, like a recipe. In this is stagnation, in this is death.

We are alive forever, young forever because we ignore the opinions of the idle mob. We live and work not to please its stagnant, depraved tastes; we work only in the name of Art—in this is our honor and our reward.

Cézanne said: "The artist's labor, by means of which he achieves perfection, is adequate reward for fools' misunderstanding of him."

We speak out harshly against the old school, the old academy, because it did not know how to preserve the most precious (for the art of painting) achievement of the ages—the traditions common to all genuine schools of all times—and without realizing this, it now inculcates in their place crude obviousness of manner and unnecessary, absurd ideological tendentiousness.

It forgets that subject is not the aim but merely a most insignificant means, and that painting consists only of itself.

"Art is in form," says Oscar Wilde, and in this he is right.

The very word neoprimitivism, as was said earlier, is a word that characterizes the trend of painterly achievements, their point of departure from the primitive, and also testifies to its relevance to our age.

There are, and can be, no phenomena that are born out of nothing.

There are no ideas that are born, only ones that are regenerated, and everything normal, of course, is successive and develops from preceding forms.

Such is our school—taking its genesis from the primitive but developing within contemporaneity.

Generally speaking, the word *primitive* is applied not only to the simplification and unskillfulness of the ancients, but also to peasant art—for which we have a specific name, the *lubok*. The word primitive points directly to its Eastern derivation, because today we understand by it a whole pleiad of Eastern arts—Japanese art, Chinese, Korean, Indo-Persian, etc.

In our school this term points to the character of the painting (not the subject), to the means of execution, and to the employment of the painterly traditions of the East.

But this does not involve simple imitation, i.e., something of which people would normally say: "This was done in an Eastern style," i.e., not what, for example, is being done by Stelletsky,[3] whose works in no way reveal old Russia, Byzantium, or icons. They are mere historicity—a resolution of high ideas by home-made, amateurish means, an imitation devoid of perception—whereas icons are saturated with the East, with Byzantium, and at the same time remain entirely original.

Neoprimitivism is a profoundly national phenomenon.

Russia and the East have been indissolubly linked from as early as the Tatar invasions, and the spirit of the Tatars, of the East, has become so rooted in our life that at times it is difficult to distinguish where a national feature ends and where an Eastern influence begins.

The whole of man's culture has, generally speaking, derived from Asia, and not vice versa, as some assert.

The whole of our culture is an Asiatic one, and foreign craftsmen, architects, weavers, artists, and people like them who came to our "barbaric" country from the West bearing with them the spark of European civilization, immediately fell under the influence of Tatar culture, of the East, of our more distinctive, more temperamental spirit, and Western civilization crumbled to dust before the culture of the East.

Let us take the painting of old Russia.

We have only to compare our grass writing [4] with Eastern carpets, our "spiritual-moral painting" and its direct continuation—folk pictures and

lubki—with Indo-Persian painting, to see quite clearly their common origin, their spiritual relationship.

In other countries the influence of the East is also no less obvious, no less grandiose.

The forms of Western art were shaped entirely from the forms of Byzantium, which adopted them, in its turn, from the more ancient art of Armenia and Georgia.

In this way a rotation, as it were, a procession of arts has resulted—from us, from the East, from the Caucasus to Byzantium, then to Italy, and thence, adopting a little oil-painting technique and easel-painting technique, it comes back to us.

That is where we obtain such epithets as "frenchified" painting, in which, if we investigate a little more deeply, we will again sense the splendor of our barbarity, the primitive of the East, more so than the West with its simple, naturalistic, and at times quite absurd imitation of nature.

All this can serve in sufficient degree as the justification for our enthusiasm for the art of the East. It becomes clear that there is no longer any point in using the products of the West, which has obtained them from the East, the more so since after their long, roundabout journey, they wind up pretty well deteriorated and rotted.

There is no point because we are daily in the most direct contact with Asia.

We are called barbarians, Asians.

Yes, we are Asia, and are proud of this, because "Asia is the cradle of nations," a good half of our blood is Tatar, and we hail the East to come, the source and cradle of all culture, of all arts.

Hence, neoprimitivism, while deriving its genesis from the East, is nevertheless not the repetition or popularization of it—which always so debases any art; no, it is entirely original. In it, to a great extent, is reflected the East, for example, in interpretation and in traditions, but one's own national art also plays a large part, just as children's art does—this unique, always profound, genuine primitivism; art in which our Asiatic origin is evident in its entirety.

Nor is neoprimitivism alien to Western forms, and we declare frankly: Asia has yielded us all the depths of her culture, all her primitiveness, and Europe has, in turn, supplemented this with certain features of her own civilization.

Hence neoprimitivism was formed from the fusion of Eastern and Western forms. . . .

Now we shall turn to those elements on which we base our school.

First and foremost, we demand of our works clear and well-balanced drawing expressed in delineation and silhouette. Delineation is not the line against which Cézanne warns *—delineation is the boundary between two colors. But we are not afraid of using line, and while recognizing that drawing and painting are indissoluble, we introduce line into the latter: not as a graphic element, but as a purely painterly fundamental, because line is not delineation (contour), but rather a narrow plane of greater or lesser length.

Delineation is invisible and therefore has no color. Line can be of greater or lesser width and can be painted as is necessary in different colors.

We demand good form; this inheres in the whole composition's harmony of drawing and in the correct distribution of reliefs in accordance with the weight of individual parts and colored quantities.

The depiction of objects is concrete but not naturalistic.

Realism consists of a conscious attitude to life and its understanding; naturalism consists of an unconscious, sometimes even senseless, contemplation of nature and copying of objects.

Realism is in the essence of objects; naturalism in painting is in the outward imitation of their form.

Objects are created not by simple copying but by the sensation of their forms and colors.

Chiaroscuro, like shading, does not exist, but serves merely as a pretext for distributing light and dark colors.

In order to display the essence of objects, we resort to the depiction of their intermediate forms. This enables us not to enslave them on the picture's surface in their isolated form, in a motionless state, but to depict them, as it were, at the moment of creation—in motion, i.e., in a more real, more complete form.

We simplify form, as such, but at the same time we enlarge, complicate the conception of it.

We destroy scientific perspective constructed, as it is, by looking at things with one eye—which is therefore a compromise, a falsity, and a hindrance—and replace it by a new, free, nonscientific artistic perspective. It allows us to introduce not one, but several points of linear contact so that it is possible to show one and the same object immediately from several points of view.

We consider that objects have not one, but several no less characteristic forms.

* ' More than anything beware of neoimpressionist underlining'' (Cézanne, *Letters*).

We introduce rhythmic periodicity of movements and resolve cubist displacements.

We apply the name "free perspective" to any modification in the inscription of figures on the surface depending on their location in space.

We completely reject aerial perspective since it is connected with space and deprives the picture's surface of its literal meaning. We replace it by linear construction and distribution of masses and reliefs.

We demand good composition; this inheres in the distribution both of movements and surfaces and of colored quantities, and in the inward content of each object and of the whole. Without all this, monumentality—the highest achievement of Art—is impossible.

We demand noble simplification but, at the same time, avoid synthetic schematization.

We demand good style, which inheres in the picture itself, both in its construction and coloring and in its texture and means of execution.

Style for any work of art is its very own, and we warn against confusing the two terms *stylism* and *historicity*. The former is in the work itself and in the whole work; the latter is only in the imitation of thematic character, of method of execution, and of interpretation.

We advocate color as such, i.e., as coloration, and restore painting not to impressionistic luminism or to the local colors of the academy, but to paint, in all its luster, in its self-sufficient meaning.

Objects are painted arbitrarily, and the artist's will imparts the primary meaning. This occurs because the object in a given case may interest us only by its form, and furthermore, its natural color may not suit our whole conception, the whole composition; so without any hesitation, we replace it by one more essential, more expressive, and hence sacrifice an insignificant detail in order to achieve the whole, general effect more fully.

In nature the colors of objects change because of reflections and light.

We abolish reflection, this academic bauble, and in place of it advance a new principle, the principle of flowing color. Flowing color, methodically reiterating the same color or its shade, indicates movement of color—and in movement is life.

Flowing color is encountered for the first time, as a quite definite painterly principle, in our icons, where it is expressed in the highlighting of the garments by colors flowing (passing) on into the background.

In the West this principle emerged in the art of the impressionists, but it was not properly understood or, rather, was not sensed properly and was diluted and, having lost its meaning, turned into the theory of supplementary

color tones. It lost its meaning, because in moving away from the meaning of color, *as paint,* it changed into a meaningless reflection—at first, into some sort of colored decorativeness and subsequently into mere coloration of insignificant bits of air.

We also recognize running color, i.e., color passing beyond the contour of an object (see Russian Old Believers' *lubki* [5]); but this is expressed not in a chaotic flow of paint, but in the form of a color's iridescence, which is based not on the theory of rayonism [6] and not on reflective iridescence, but on the iridescence of the bodies themselves at their intersections.

We oppose complementary color tones and replace their diversity—which because of the variegation has a torpid effect on the eye—by a more effective aggregate of uniform color tones.

In other words, we apply colors in practice not, for example, as the reflex of yellow on blue, but as an aggregate of greens of greater or lesser density, while distinguishing black from blue by a separate area; not as orange on violet, but as an aggregate of browns and yellows, while distinguishing red and black.

Finally, we change the color of objects in order to manifest their spiritual essence: for example, no one would paint a glass of poison some sort of frivolous color such as pink or blue, but obviously in such a case a color would be employed that had a more profound psychological effect.

We tolerate symbolism—as long as it is expressed in the construction and color of a work, in the depths of its content, and not in tawdry cabalism and cheap accessories.

We demand good texture and, while avoiding unnecessary obviousness of manner, we are not afraid to omit details subtly if, of course, this is necessary; thereby we achieve a great nobility of execution and, together with our demand for good composition, greater persuasiveness and monumentality.

We stand for complete freedom of Art and for the advantages of eclecticism as a renovating principle.

These are the theses from which our art, our craft, derives, but we use them as need and meaning dictate, as possibilities and not as ready-made recipes.

The meaning of painting is within painting itself. It is not inherent in the subject matter, but has its own content of a purely painterly character; it is inherent in texture, composition, and style.

These are the only demands that can be made of a picture.

Painting must not serve any or anyone's ideas apart from its own—

otherwise either it or the subject it serves, the idea, will destroy both, and they will lose their meaning and strength.

We consider philistine demands of art to be naïve and ludicrous, just as the praise and censure of small-time critics who judge painting only from the standpoint of its similarity or dissimilarity to nature are ludicrous and absurd.

We reject the significance of any criticism apart from self-criticism. Only the artist himself, who loves his art and concerns himself consciously with it, can precisely and correctly determine the merits, defects, and value of his work. The outsider, the spectator—if he falls in love with a certain work—can, biased as he is, neither elucidate nor evaluate it on its true merits; if he regards it impassively, indifferently, he therefore does not feel it or understand it and hence has no right to judge.

Art is the artist's experiences, his spiritual life, and nobody has the right to interfere with someone else's life.

People, like all other animals, can be divided into classes and species.

Art is for Art's sake. It is useless but at the same time it is capable of exciting sensations of the highest order in those people to whose class the artist himself belongs.

We are accused of imitating Western art. But this, in fact, is not true.

If Cézanne, Gauguin, Rousseau have played a role of no small importance in the development of our Russian art, and if we pay due homage to them, then it is precisely because they are not the type of contemporary Western artist whose work is exemplified by the pictures at conventional salons; on the contrary, they are the exception.

Indeed, what do they share in common? Nothing, of course!

The art of the salons is a typical leftover, the decadence of European art.

Cézanne partly, Gauguin, and especially Henri Rousseau represent the aspiration toward the East, its traditions and its forms.

They, like us, are in revolt, are searching, and in their own age were persecuted everywhere, just as we are.

We are accused of unnecessary academism, but the search for a more perfect style is not that at all; it is simply the aspiration toward monumentality.

And in general, no free, meaningful search can be called that since academism, strictly speaking, is applicable to narrow, soulless work, to the employment of conventional canons, to enslavement, and to the use of old forms deprived of the traditions of craftsmanship.

Our achievement lies in the fact that by working out just the general

theses for our school and without enslaving theory, we shall always concern ourselves with the renewal of traditions, both by way of logical succession and by personal experience.

We do not canonize forms, and by favoring eclecticism we are able constantly to extend our conception of them.

Our theses afford the opportunity of perpetual existence and endless self-perfection, whereas all existing theories inevitably lead to an impasse.

We have eternal life, eternal youth, and eternal self-perfection—and in this lie our honor and reward.

NATALYA GONCHAROVA
Preface to Catalogue
of One-Man Exhibition, 1913

Born near Tula, 1881; died Paris, 1962. 1898–1902: studied at the Moscow Institute of Painting, Sculpture, and Architecture, attending sculpture classes under Paolo Trubetskoi; thereafter turned to painting; 1910: one-man exhibition at the Society of Free Aesthetics in Moscow resulting in a scandal—works called pornographic [see M.L. (Mikhail Larionov?): "Gazetnye kritiki v roli politsii nravov" (Newspaper Critics in the Role of Morality Police) in bibl. R45, no. 11/12, 1909 (= 1910), pp. 97–98]; ca. 1913: illustrated futurist booklets; 1910–15: contributed to the "Knave of Diamonds," "Donkey's Tail," "Target," "No. 4," "Exhibition of Painting, 1915," and other exhibitions; 1914: went to Paris with Larionov; after outbreak of war, returned to Moscow briefly; 1915 joined Sergei Diaghilev in Lausanne; 1917 settled in Paris with Larionov.

The translation is of the preface to the catalogue of Goncharova's second one-man exhibition in Moscow, pp. 1–4 [bibl. R280]. This exhibition displayed 768 works covering the period 1900–13 and ran from August until October 1913; at the beginning of 1914 it opened in St. Petersburg, but on a smaller scale [see bibl. R281 and reviews R325 and R334]. This Moscow exhibition did not create the scandal associated with the 1910 show, although Goncharova's religious subjects were criticized as they had been at the "Donkey's Tail" [for details see bibl. R310, p. 90, or bibl. 131, pp. 93–94]. The catalogue saw two editions. The text is reprinted in bibl. R7, pp. 487–90, and translated into French in bibl. 114, pp. 114–16, and in bibl.

Natalya Goncharova, 1912. Photograph courtesy
the late Mme. Alexandra Larionov, Paris.

132, pp. 41–44. The preface was dated August 1913, Moscow. For reviews of this
exhibition see bibl. R261, R337, R344, R345. For details of the public awareness of
Russian and Eastern primitive art forms at this time see p. 41.

———

In appearing with a separate exhibition, I wish to display my artistic de-
velopment and work throughout the last thirteen years. I fathomed the art of
painting myself, step by step, without learning it in any art school (I studied
sculpture for three years at the Moscow Institute of Painting, Sculpture, and
Architecture and left when I received the small medal). At the beginning of
my development I learned most of all from my French contemporaries. They
stimulated my awareness and I realized the great significance and value of
the art of my country—and through it the great value of the art of the East.
Hitherto I have studied all that the West could give me, but in fact, my
country has created everything that derives from the West. Now I shake the
dust from my feet and leave the West, considering its vulgarizing signifi-
cance trivial and insignificant—my path is toward the source of all arts, the
East. The art of my country is incomparably more profound and important

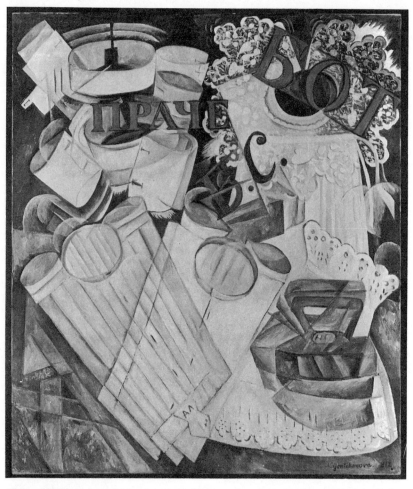

Natalya Goncharova: *The Laundry,* 1912. Oil on canvas, 89 x 70 cm. Collection The Tate Gallery, London. Goncharova's concern with the machine aesthetic, derived to a large extent from the Italian futurists, served as a brief point of transition between her neoprimitivist and rayonist periods.

than anything that I know in the West (I have true art in mind, not that which is harbored by our established schools and societies). I am opening up the East again, and I am certain that many will follow me along this path. We have learned much from Western artists, but from where do they draw

their inspiration, if not from the East? We have not learned the most important thing: not to make stupid imitations and not to seek our individuality, but to create, in the main, works of art and to realize that the source on which the West draws is the East and us. May my example and my words be a good lesson for those who can understand its real meaning.

I am convinced that modern Russian art is developing so rapidly and has reached such heights that within the near future it will be playing a leading role in international life. Contemporary Western ideas (mainly of France; it is not worth talking of the others) can no longer be of any use to us. And the time is not far off when the West will be learning openly from us.

If we examine art from the artistic monuments we have at our disposal without bearing time in mind, then I see it in this order:

The Stone Age and the caveman's art are the dawn of art. China, India, and Egypt with all their ups and downs in art have, generally speaking, always had a high art and strong artistic traditions. Arts proceeding from this root are nevertheless independent: that of the Aztecs, Negroes, Australian and Asiatic islands—the Sunda (Borneo), Japan, etc. These, generally speaking, represent the rise and flowering of art.

Greece, beginning with the Cretan period (a transitional state), with its archaic character and all its flowering, Italy right up to the age of the Gothic, represent decadence. Gothic is a transitional state. Our age is a flowering of art in a new form—a painterly form. And in this second flowering it is again the East that has played a leading role. At the present time Moscow is the most important center of painting.

I shake off the dust of the West, and I consider all those people ridiculous and backward who still imitate Western models in the hope of becoming pure painters and who fear literariness more than death. Similarly, I find those people ridiculous who advocate individuality and who assume there is some value in their "I" even when it is extremely limited. Untalented individuality is as useless as bad imitation, let alone the old-fashionedness of such an argument.

I express my deep gratitude to Western painters for all they have taught me.

After carefully modifying everything that could be done along these lines and after earning the honor of being placed alongside contemporary Western artists—in the West itself [1]—I now prefer to investigate a new path.

And the objectives that I am carrying out and that I intend to carry out are the following:

To set myself no confines or limitations in the sense of artistic achievements.

To make continuous use of contemporary achievements and discoveries in art.

To attempt to introduce a durable legality and a precise definition of what is attained—for myself and for others.

To fight against the debased and decomposing doctrine of individualism, which is now in a period of agony.

To draw my artistic inspiration from my country and from the East, so close to us.

To put into practice M. F. Larionov's theory of rayonism,[2] which I have elaborated (painting based only on painterly laws).

To reduce my individual moments of inspiration to a common, objective, painterly form.

In the age of the flowering of individualism, I destroy this holy of holies and refuge of the hidebound as being inappropriate to our contemporary and future way of life.

For art, individual perception can play an auxiliary role—but for mankind, it can play none at all.

If I clash with society, this occurs only because the latter fails to understand the bases of art and not because of my individual peculiarities, which nobody is obliged to understand.

To apprehend the world around us in all its brilliance and diversity and to bear in mind both its inner and outer content.

To fear in painting neither literature, nor illustration, nor any other bugbears of contemporaneity; certain modern artists wish to create a painterly interest absent in their work by rejecting them. To endeavor, on the contrary, to express them vividly and positively by painterly means.

I turn away from the West because for me personally it has dried up and because my sympathies lie with the East.

The West has shown me one thing: everything it has is from the East.*

I consider of profound interest that which is now called philistine vulgarity,

* The impressionists from the Japanese. The synthetists, Gauguin from India spoiled by its early renaissance. From the islands of Tahiti he apprehended nothing, apart from a tangible type of woman. Matisse—Chinese painting. The cubists—Negroes (Madagascar), Aztecs. As for the past—certain historians are sadly mistaken in deducing a Romanesque influence, even a German influence, on our icons. This is so only in isolated cases; generally speaking, what is the Romanesque style but the last stage of Byzantine development? Romanesque style is based on Grecianized, Eastern, Georgian, and Armenian models. If Eastern influence reached us in a roundabout way, then this does not prove anything—its path was from the East, and the West, as now, served merely as an intermediate point. Suffice it to consider Arabian and Indian depictions to establish the genesis of our icons and of the art that has hitherto existed among the common people.

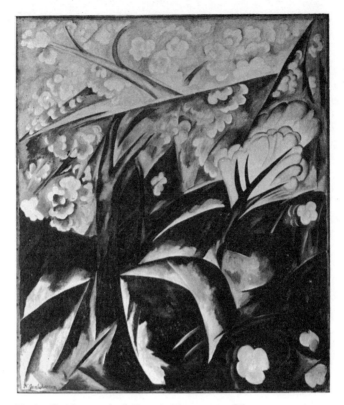

Natalya Goncharova: *Apple Trees in Bloom,* 1912. Oil on canvas, 105 x 84 cm. Collection Mrs. Morton E. Rome, Baltimore.

because it is untouched by the art of blockheads—their thoughts are directed exclusively to the heights only because they cannot attain them; and also because philistine vulgarity is predominant nowadays—contemporaneity is characterized by this. But there is no need to fear it; it is quite able to be an object of artistic concern.

Artistic vulgarity is much worse because it is inevitable; it is like the percentage of crime in the world, uniform at all times and in all arts.

My last word is a stone thrown at artistic vulgarity—ever aspiring to occupy the place of an achievement of genius.

P.S.: My aspiration toward the East is not my last development—I mean only to broaden my outlook; countries that value artistic traditions can help me in this.

For me the East means the creation of new forms, an extending and deepening of the problems of color.

This will help me to express contemporaneity—its living beauty—better and more vividly.

I aspire toward nationality and the East, not to narrow the problems of art but, on the contrary, to make it all-embracing and universal.

If I extol the art of my country, then it is because I think that it fully deserves this and should occupy a more honorable place than it has done hitherto.

IVAN AKSENOV
On the Problem
of the Contemporary State
of Russian Painting
[Knave of Diamonds], 1913

Born Putivl, Ukraine, 1884; died Moscow, 1935. 1905: finished Military Engineering Institute in Nikolaevo; 1910 and thereafter: close to the Knave of Diamonds group, especially to Aleksandr Exter; 1912: began to publish poetry; soon became known as a poet, critic, and translator; 1916: member of the Tsentrifuge group in Moscow which included Sergei Bobrov and Boris Pasternak; interested in Robert Delaunay and Pablo Picasso; 1921: rector of the State Higher Theater Workshop under Vsevolod Meierkhold; 1923: member of the Moscow Parnassus group; continued to publish until his death.

The text of this piece, "K voprosu o sovremennom sostoyanii russkoi zhivopisi," is from the collection of articles and reproductions *Bubnovyi valet* [Knave of Diamonds] (Moscow, February 1913), pp. 3–36 [bibl. R268]. Indicative of the Knave of Diamonds' orientation toward French cubism at this time was the fact that the collection also contained contributions by Henri Le Fauconnier and Guillaume Apollinaire. Le Fauconnier's essay, "Sovremennaya vospriimchivost i kartina" (pp. 41–51), was a translation of his introduction to the catalogue of his one-man exhibition at the Folkwang Museum, Hagen: *Die Auffassung unserer Zeit und das Gemälde* [Contemporary Perception and Painting] (Hagen, December 1912; Munich, 1913). Apollinaire's essay, "Fernan Lezhe" (pp. 53–61), was a modified translation of his section on Fernand Léger in *Les Peintres Cubistes* (Paris, 1913), pp. 64–68. The

collection was illustrated by reproductions of works by Le Fauconnier and the Knave of Diamonds group—Exter, Robert Falk, Petr Konchalovsky, Aleksandr Kuprin, Aristarkh Lentulov, Ilya Mashkov, and Vasilii Rozhdestvensky. Aksenov's text is an elaborated version of his lecture entitled "On Contemporary Art," which had been read for him at a public session organized by the Knave of Diamonds on February 24, 1913, in Moscow (and at which David Burliuk and Mayakovsky also spoke). It reflects Aksenov's close personal ties with the central members of the Knave of Diamonds at that time—none of whom issued any policy statement on behalf of the group, although one of its secondary members, Aleksei Grishchenko, did publish a long essay on it [bibl. R282; and see bibl. R156, bk. 6, 319–20, for short personal statements by Knave of Diamonds members]. Aksenov wrote comparatively little on painting, being more involved in literature [e.g., his book of poems with illustrations by Exter, bibl. R257] and the theater [see bibl. R372], although his book on Picasso is especially valuable [bibl. R258, cover by Exter].

The concept "the state of painting at a certain time" consists of ideas concerning the activity of all painters who are united within a certain period of time. However, the characteristics of painting within any specific period are to be found in the work of those artists whose talent is in a state of development. Hence, the state of Russian painting in the 1870s–80s was characterized by the activity of the Wanderers; the state of Russian painting in the 1900s by the art of the World of Art and later by the Golden Fleece; now the most expressive art of the time is the work of the artists united by the Knave of Diamonds society. The changes in artistic perception are, of course, not fortuitous and, for the lover of generalizations, present a temptation to fall into the dogmatism of the theory of dialectical development. But although we are excluding this theory, it does, nevertheless, preserve its fascination, and who knows, perhaps there will come a time when its apriority will be recognized? In any case, it is hard to expect a complete rejection of any preceding thesis; a thesis is too vital and has too great an influence on those who aim at deposing it. Are there many contemporary artists, connoisseurs of Derain or admirers of Picasso, who can honestly consider themselves unstained by a passion, albeit long past, for the World of Art? And the representatives of this group—didn't they in the days of their youth revere the pictures of Repin and Yaroshenko? [1] And one's first love does not pass without leaving its mark. With great passion the World of Art censured the Wanderers for the literariness that had generally replaced painting and drawing in their pictures. When this talented group was obliged to assert its opposition to its predecessors' literariness through action, it expressed this opposition merely in more skillful drawing; literature remained the basis of

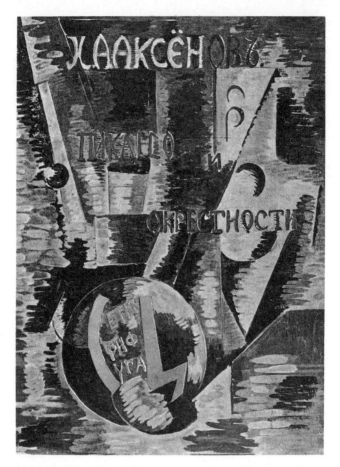

Aleksandra Exter: Cover of Ivan Aksenov's *Pikasso i okrestnosti* [Picasso and Environs] (Moscow, 1917). Aksenov was a great admirer of the work of Exter, who undertook several designs for avant-garde publications.

art, and only the subject matter was changed. But anyone is free to argue about the interest of the subject—without entering the realm of art; without understanding anything about painting, you can find a moral satisfaction in a visual interpretation of the problem of evil (a peasant being flogged) or of the problem of good (a policeman being beaten), of the problem of theomachy ("the demon is great and beautiful") or of the problem of eroticism ("women in the eighteenth century indulged in fornication"). Literariness forced artists to abandon painting. There have been exhibitions at which pic-

tures were absent, and articles have been written on the obsolescence and uselessness of pictures.

All this increases the significance that the work of the young artists of today holds for the contemporary state of Russian painting; they are not only contemporary but also, in the main, painters. True, the painterly aims that they have pursued have not prevented them from displaying their activities in the field of drawing: they have had the honor of liberating drawing from stylized lifelessness. Utamaro evoked the uniform density of line in the *kakemono* by the purely technical qualities of wood, of engraving plates; in their water colors the Japanese often diversified linear texture, and there is no need to go back to Ogata Korin for an example of this; it is enough to turn to the silk painting of the masters of that same eighteenth century. The Japanese line of European graphic artists, revived by the genius of Beardsley, is appallingly inexpressive in the works of all the various Secession artists. We are approaching the acute question of independence: if artists' technique in the preceding period was created by the influence of German prototypes, then how strong must be the influence of French prototypes on the work of artists of the present generation. There is no need to dispute the importance of this influence, but the whole evolution of the visual arts in Russia points to the inevitable appearance of problems that our contemporary artists must solve. The problems contain their own solution within themselves; the success or failure of the plastic expression of the results of the process depends on the personal gifts of him who solves them. And who would deny that our artists are talented? The rapid and brilliant development of the new movement in Russian painting has long since been confirmed by the clarity of its tasks. This organicness is expressed in the distinct folk character of the art of certain representatives of the movement—not the kind of folk character that requires a whole arsenal of ethnographic material to become manifest, but that direct sensation of folk character that penetrates the works of architects of the classical period of the nineteenth century and that leads Palladian traditions to the erection of façades in a profound folk tradition; certain of their motifs become the bases of new forms, of domestic, handicraft art.

It is difficult to deny the folk character in the wide-ranging, vivid temperament of Ilya Mashkov.[2] This artist is regarded as a version of Matisse; perhaps he himself thinks that, but at any rate, nobody would find any traces of that economical restraint, that geometrical deliberation of rhythm in painted planes that Matisse inherited from the creator of *Carnival*.[3] The monumental synthesis of colored bases, which are mutually intensified in a visual dissonance of colors, is possible only thanks to an extraordinary tem-

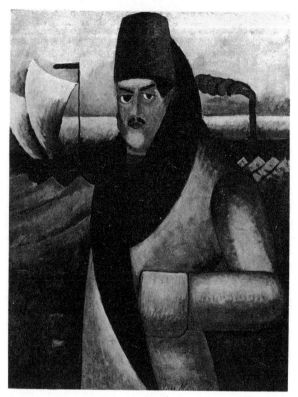

Ilya Mashkov: *Self-Portrait*, 1911. Oil on canvas, 137 x 107 cm. Collection Tretyakov Gallery, Moscow.

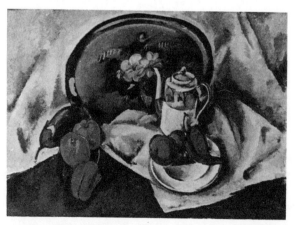

Aleksandr Kuprin: *Still Life with a Blue Tray*, 1914. Oil on canvas, 71 x 102.2 cm. Collection Tretyakov Gallery, Moscow.

perament and an innate (or cultivated?) art of controlling it. The intricate curvature of Matisse's lines is not to be found in Mashkov's pictures—he solves the problem of contour differentiation of colored groups with the aid of soft, lightly curved linear construction and curved, very simple combinations. The softness of contour in Mashkov's compositions does not threaten to fall into flabbiness—a danger that the popular Van Dongen has not avoided. Sharpness of line allows Mashkov to concentrate perceptions of the most varied forms within the confines of very simple, graphic combinations without destroying the general character or force of the coloristic rhythm.

An analogous problem is solved by A. Kuprin. His works reveal a very strong susceptibility to the characteristics of color perception, a strength, however, that does not cause any tendency toward conglomeration of contrasts or play on the symmetry of cold and warm tones. This applies to his very late works—his early ones were, evidently, not without the influence of painterliness, a sad reminder of the Pont-Aven school. Probably Kuprin and, moreover, Rozhdestvensky were attracted to Van Gogh by a natural delicacy of object perception. With Rozhdestvensky this delicacy develops more and more distinctly at the expense of force; with Kuprin there is a reverse process, and his pictures only gain from the concentration of this property. Delicacy and subtlety form the subbasis of these works, just as the brightly painted sublayer intensified the highlights of the old Dutch still-life painters.

We do not see this unified division of perception in Lentulov's pictures. One cannot say that this is connected with the painterly merits of his works, which, undoubtedly, are always significant precisely by virtue of their painterliness.

Lentulov's talent has matured and strengthened perhaps earlier than that of the other members of the group, and at first glance it would seem that it is precisely an excess of talent that harms his pictures. Too great a talent can sometimes be an artist's misfortune: an example from literature is Barbey d'Aurevilly. Aware of being quite able to work in different directions, justifiably confident of his ability to set himself the most varied tasks, and conscious of being in complete command of the technique essential for this—for Lentulov all this resembles those mirrors that can create artificial labyrinths of panopticons.

So it might seem; in practice, however, an analysis of the individual fragments of Lentulov's painting and, similarly, research into the composition of his pictures are powerless to disclose the reason for the elusiveness of their visual center. The reason is not to be found in his pictures—it is in the spectator's inability to extend the works into appropriate space, constricted as they are by their position.

An extreme concentration of colored planes leads to fragmentation of the whole, but the blame for this impression passes from the artist to the spectator and to those cultural conditions in which the men of modern art live. It is to be regretted that most of our artists are denied access to mural painting. Only certain lucky ones are given this opportunity.

To their small number belongs P. Konchalovsky: his decor for *The Merchant of Kalashnikov* [4] called forth warm approval in that same press that reported indignantly on the invitation of an "extreme" artist to decorate one of the most conservative of theaters. Apparently these reviewers were unaware of Konchalovsky's decorative painting for Markushev's house (Moscow Salon, 1911) [5] and his wonderful decorative works for the ball "A Night in Spain." [6] Partiality for intensity of color, which is common to almost all the members of the "young" exhibitions, has been replaced in this artist by an aspiration toward potential depth of color foundation and toward strength and value of the colors used. The deep scale of gray-brown colors in the portrait of Yakulov [7] is, in its consistency and intensity, one of the finest phenomena of our contemporary painting. Everyone is aware of the role that light and atmospheric conditions play in our visual impressions of painted objects; hence, the invariability of a picture's color expressiveness, when observed in different situations, is the best indicator of how absolute its value is.

Konchalovsky conceived and painted Yakulov's portrait in Moscow, but although it was exhibited last year at the Indépendants in Paris, it lost none of its coloristic force. This canvas, which opens up to Russian portrait painting a number of quite unexpected possibilities, shows that a lapidary limitation of means can be combined with piquant characterization and powerfully expressed coloristic rhythm—without in any way reducing the portrait's resemblance. In this work Konchalovsky already showed himself to be an artist in complete command of the means of his craft, decisively and joyfully applying them to the fulfillment of the task he had set himself. The joy of living is one of the most characteristic peculiarities of this artist's painting, and he never directs his activity into sharp polemics against the established canons of art. It would have been natural to expect polemics (active ones, of course—Konchalovsky is too much of a painter for literary ones), especially from an artist standing so close to old trends, an artist who saw the formation of the World of Art group.

For an explanation of this fact we must search within the character of the artist's creative personality: its development took place too deeply in his soul and came to be expressed in his art only when the painter's relation to the form of perception had been finally established. And confidence in one's

Vasilii Rozhdestvensky: *Still Life with Coffeepot and Cup,* 1913. Oil on canvas, 82.5 x 71 cm. Collection Tretyakov Gallery, Moscow.

Aristarkh Lentulov: *St. Basil's Cathedral, Red Square,* 1913. Oil with gold paper on canvas, 107 x 163 cm. Collection Tretyakov Gallery, Moscow. Lentulov was one of the most interesting members of the Knave of Diamonds group. Under the influence of cubism on the one hand, and of the traditional Russian arts on the other, he developed an acute sense of pictorial construction based on architectonic forms and color planes.

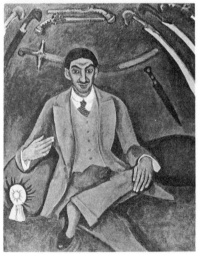

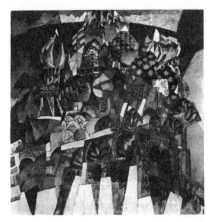

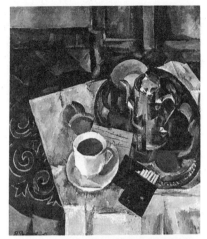

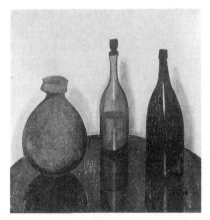

Petr Konchalovsky: *Portrait of Georgii Yakulov,* 1910. Oil on canvas, 178 x 143 cm. Collection Tretyakov Gallery, Moscow. In this portrait, Konchalovsky wished to ''oppose the pretty, well-groomed, smarmy portrait beloved by many artists with what was commonly regarded as ugly but what was actually extremely beautiful. I wanted to show the real character of Yakulov'' [bibl. R103, vol. 2, p. 62].

Robert Falk: *Bottles and a Pitcher,* 1912. Oil on canvas, 71 x 67 cm. Private collection, Moscow.

command of knowledge removes the possibility of polemics: one enters into the sharpest polemics with oneself. The ''I'' of the polemicist is his ideal opponent, and this opponent has still not been conquered by Falk, who is mounting an intense search for a convincing solution of the problem of painterly form. Falk's polemics rise sometimes to the sharpness of an Alcaeus, but his fervent efforts and the distinctiveness of his self-imposed conditions, coupled with an extensively developed technique, force the spectator to wish for as long an argument as possible. Evidently these wishes are destined to be realized: Falk is constantly extending his problem, making its final solution more distant, and would seem to be disposed toward Mazzini's choice [8]—the most perfect way of defining a search for principles.

As far as A. Exter's art is concerned, its polemical period is apparently over: its composition has acquired a positive calmness in spite of an increased complexity; the colors have become lighter, the quality of her painting has achieved a delicacy rarely encountered in the pictures of our artists. If the question of combining the surface characteristics of forms with coloristic modeling seems irrelevant, then the reason for this opinion is the erroneous view that most people have about the essence of the conception of color. Of course, the problems of easel painting demand methods of solution other than the questions that decorative work raises, and when judging an easel artist, we should change our criteria. It's high time we got used to operating in this way—a viewpoint must be changed depending on what is being examined; Exter's compositions are very instructive precisely in this aspect. As for the device itself of combined contours and displaced construction, well, of course, it would be more relative to call a method new that was widely practiced in paleolithic art; the regeneration of these methods shows that the basic views on the fundamental meaning of form are inherent to the same degree in the painters of the twentieth century as in the artists of Brassempouy.[9]

The return to such an ancient tradition testifies to a deep analysis, to an organicness of synthesis. The postulate of a religious generalization is inevitably felt in such a synthesis, and in their reverential treatment of chiaroscuro, certain of Exter's still lifes are reminiscent of a depiction of the Holy Night.

Generally speaking, contemporary painting is confronted with a new investigation into the relationships of illuminated surfaces. The rejection of chance, a rejection that is percolating more and more through the activities of the groups of young artists, has compelled them to reject the joke of ''illumination,'' but negative solutions are unable to give lasting satisfaction to those whose individuality is manifested in their work. Impressionism

perished because of a negative and exclusive solution to the question of shading.

Our age is obliged by force of circumstances to finish what our predecessors passed on to us. The path of search in this direction is broad, its bends are diverse, its forks numerous; the solutions will be many. Among them, those connected in our art with the name of A. Exter will remain as an example of courage, freedom, and subtlety. The upsurge of strength and courage in the plastic arts wanes neither beyond the Rhine nor at home, and it is expressed in the high level of pure painting unprecedented in our country, a phenomenon that is characteristic of its contemporary state.

DAVID BURLIUK
Cubism (Surface—Plane), 1912

For biography see p. 8.

The text of this piece, "Kubizm," is from an anthology of poems, prose pieces, and articles, *Poshchechina obshchestvennomu vkusu* [A Slap in the Face of Public Taste] (Moscow, December 1912 [according to bibl. R350, p. 17, although January 1913, according to KL], pp. 95–101 [bibl. R275]. The collection was prefaced by the famous declaration of the same name signed by David Burliuk, Velimir Khlebnikov, Aleksei Kruchenykh, and Vladimir Mayakovsky and dated December 1912. The volume also contained a second essay by David Burliuk on texture [bibl. R269], verse by Khlebnikov and Benedikt Livshits, and four prose sketches by Vasilii Kandinsky [for further details see bibl. 133, pp. 45–50]. Both the essay on cubism and the one on texture were signed by N. Burliuk, although it is obvious that both were written by David and not by Nikolai (David's youngest brother and a poet of some merit). David Burliuk was deeply interested in the question of cubism and delivered several lectures on the subject: on February 12, 1912, he gave a talk "On Cubism and Other Directions in Painting" at a debate organized by the Knave of Diamonds in Moscow [see pp. 12 and 77–78], and on the twenty-fourth of the same month, again under the auspices of the Knave of Diamonds, he spoke on the same subject under the title "The Evolution of the Concept of Beauty in Painting"; on November 20, 1912, he spoke on "What Is Cubism?" at a debate organized by the Union of Youth in St. Petersburg, which occasioned a scornful response by Aleksandr Benois [see

bibl. R262], which, in turn, occasioned a reply by Olga Rozanova [see p. 103]. Burliuk's references to the Knave of Diamonds members Vladimir Burliuk, Aleksandra Exter, Kandinsky, Petr Konchalovsky, and Ilya Mashkov, all of whom had contributed to the first and second "Knave of Diamonds" exhibitions (and Mikhail Larionov and Nikolai Kulbin, who had been at the first and second exhibitions, respectively), would indicate that the text is an elaboration of the Knave of Diamonds lecture; moreover, the Knave of Diamonds debate had been chaired by Konchalovsky, and it had witnessed a heated confrontation between the Knave of Diamonds group as such and Donkey's Tail artists [see p. 77–78]. As usual with David Burliuk's literary endeavors of this time, the style is clumsy and does not make for clarity; in addition, the text is interspersed somewhat arbitrarily with capital letters. For a French translation see bibl. 145i, pp. 57–66.

Painting is colored space.
Point, line, and surface are elements
of spatial forms.
the order in which they are placed arises
from their genetic connection.
the simplest element of space is the point.
its consequence is line.
the consequence of line is surface.
all spatial forms are reduced to these three
elements.
the direct consequence of line is plane.

It would perhaps not be a paradox to say that painting became art only in the twentieth century.

Only in the twentieth century have we begun to have painting as art—before there used to be the art of painting, but there was no painting Art. This kind of painting (up to the twentieth century) is called conventionally—from a certain sense of compassion toward the endless sums spent on museums—Old Painting, as distinct from *New* Painting.

These definitions in themselves show that everyone, even the most Ignorant and those with no interest in the Spiritual, perceives the eternal gulf that has arisen between the painting of yesterday and the painting of today. An eternal gulf. Yesterday we did not have art.

Today we do have art. Yesterday it was the means, today it has become the end. Painting has begun to pursue only Painterly objectives. It has begun to live for itself. The fat bourgeois have shifted their shameful attention

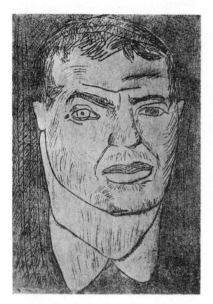

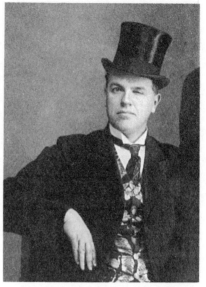

Vladimir Burliuk: *Portrait of David Burliuk,* 1911. Etching. Location unknown. Reproduced from B. Livshits: *Polutoraglazyi strelets* [The One-and-a-Half-Eyed Archer] (Leningrad, 1933). David Burliuk was, in fact, blind in his left eye.

David Burliuk, ca. 1913. Photograph courtesy Mr. and Mrs. Nicholas Burliuk, New York. In his futurist campaigns David Burliuk used to wear a top hat, just as Malevich used to wear a wooden spoon and Mayakovsky a yellow waistcoat.

from the artist, and now this magician and sorcerer has the chance of escaping to the transcendental secrets of his art.

Joyous solitude. But woe unto him who scorns the pure springs of the highest revelations of our day. Woe unto them who reject their *eyes,* for the Artists of today are the prophetic eyes of mankind. Woe unto them who trust in their own abilities—which do not excel those of reverend moles! . . . Darkness has descended upon their souls!

Having become an end in itself, painting has found within itself endless horizons and aspirations. And before the astounded eyes of the casual spectators roaring with laughter at contemporary exhibitions (but already with caution and respect), Painting has developed such a large number of different trends that their enumeration alone would now be enough for a big article.

It can be said with confidence that the confines of This art of Free Paint-

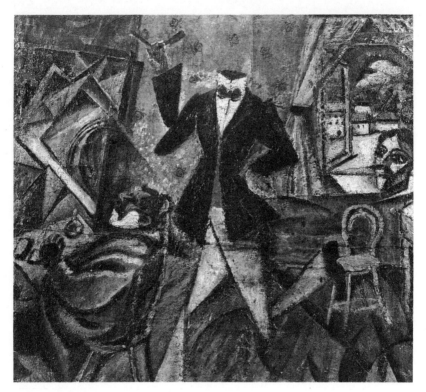

David Burliuk: *The Headless Barber,* 1912. Oil on canvas, 53.5 x 61 cm. Collection Mr. and Mrs. Max Granick, New York. Burliuk offers his own interpretation of Larionov's "barber" theme in a more cubist, analytical fashion, while maintaining the spontaneity and illogicality peculiar to Russian cubofuturism.

ing have been expanded during the first decade of the twentieth century, as had never been imagined during all the years of its previous existence!

Amid these trends of the New Painting the one that Shocks the spectator's eye most is the Direction defined by the word *Cubism*.

The theoretical foundation of which I want to concentrate on now— thereby Placing the erroneous judgment of the contemporary "admirer" of art on a firm, more or less correct footing.

In analyzing the art of former painters, e.g., Holbein and Rembrandt, we can infer the following tenets. These two artistic temperaments comprehend Nature: the first chiefly as line.

The second as a certain complex of chiaroscuro. If for the first, color is

something merely, but with difficulty, to be abolished—traditionally by the help of drawing (contour)—then for the second, drawing (contour) and line are an unpleasant feature of the art of his time. If Rembrandt takes up the needle, his hand hastens to build a whole forest of lines so that "the shortest distance between two points" would vanish in this smokelike patch of etching. The first is primarily a draftsman. Rembrandt is a painter.

Rembrandt is a *colorist,* an impressionist, Rembrandt senses *plane* and colors. But of course, both are the Blind Instruments of objects—both comprehend art as a means and not as an aim in itself—and they do not express the main bases of the Modern New Painting (as we see in our best modern artists).

The component elements into which the essential nature of painting can be broken down are:

 I. line
 II. surface
 (for its mathematical conception see epigraph)
 III. color
 IV. texture (the character of surface)

<div align="right">see article on texture [1]</div>

To a certain extent Elements I and III were properties, peculiarities of old painting as well. But I and IV are those fabulous realms that only our twentieth century has discovered and whose painterly significance Nature has revealed to us. Previously painting only Saw, now it Feels. Previously it depicted an object in two dimensions, now wider possibilities have been disclosed. . . .* I am not talking about what the near future will bring us (this has already been discovered by such artists as *P. P. Konchalovsky*)—a Sense of *Visual ponderability*—A Sense of color Smell. A sense of *duration of the colored* moment . . . (I. I. Mashkov).

I shall avoid the fascinating task of outlining the plan of this inspired march along the path of secrets now revealed. Instead, I shall return to my subject.

In order to understand Painting, the art of the New Painting, it is essential to take the same standpoint vis-à-vis Nature as the artist takes. One must feel ashamed of the fatuous adolescent's elementary view of Nature—an extremely literary, narrative standpoint. One must remember that Nature, for

* The Painting of Aleksandra Exter—hitherto little noticed by the Russian critics—provides interesting attempts at widening the usual methods of depiction.

 The questions she raises with such conviction—how to solve color orchestration, how to achieve a sense of plane—and her unceasing protest against redundant forms, place her among the most interesting of modern artists.

the Artist and for painting, is Exclusively an object of visual Sensation. Indeed, a visual sensation refined and broadened immeasurably (compared with the past) by the associative capacity of the human spirit, but one that avoids ideas of the coarse, irrelevant kind. Painting now operates within a sphere of Painterly Ideas and Painterly Conceptions that is accessible only to it; they ensue and arise from those Elements of visual Nature that can be defined by the 4 points mentioned above.

The man deprived of a Painterly understanding of Nature will, when looking at Cézanne's landscape *The House,*[2] understand it purely narratively: (1) "house" (2) mountains (3) trees (4) sky. Whereas for the artist, there existed I linear construction II surface construction (not fully realized) and III color orchestration. For the artist, there were certain lines going up and down, right and left, but there wasn't a house or trees . . . there were areas of certain color strength, of certain character. And that's all.

Painting of the past, too, seemed at times to be not far from conceiving Nature as Line (of a certain character and of a certain intensity) and colors (Nature as a number of colored areas—this applies Only to the Impressionists at the end of the nineteenth century). But it never made up its mind to analyze visual Nature from the viewpoint of the essence of its surface. The conception of what we see as merely a number of certain definite sections of different surface Planes arose only in the twentieth century under the general name of *Cubism.* Like everything else, Cubism has its history. Briefly, we can indicate the sources of this remarkable movement.

I. If the Greeks and Holbein were, as it were, the first to whom *line* (in itself) was accessible

II. If Chiaroscuro (as color), texture, and surface appeared fleetingly to Rembrandt

III. then Cézanne is the first who can be credited with the conjecture that Nature can be observed as a Plane, as a surface (surface construction). If line, Chiaroscuro, and coloration were well known in the past, then *Plane* and surface were discovered only by the new painting. Just as the whole immeasurable significance of Texture in painting has only now been realized.

In passing on to a more detailed examination of examples of a surface analysis of Nature in the pictures of modern artists, and in passing on to certain constructions of a theoretical type that ensue from this view of Nature— as plane and surface—I would like to answer the question that should now be examined at the beginning of any article devoted to the Theory of the New Painting: "Tell me, what is the significance of establishing definite

names for Definite Painterly Canons, of establishing the dimensions of all you call the Establishment of Painterly Counterpoint? Indeed, the pictures of modern artists don't become any better or more valuable because of this.'' And people like to add: "Oh, how I dislike talking about Painting" or "I like this art."

A few years ago artists wouldn't have forgiven themselves if they'd talked about the aims, tasks, and essence of Painting. Times have changed. Nowadays not to be a theoretician of painting means to reject an understanding of it. This art's center of gravity has been transferred. Formerly the spectator used to be the idle witness of a street event, but now he, as it were, presses close to the lenses of a Superior Visual Analysis of the Visible Essence surrounding us. Nobody calls Lomonosov [3] a crank for allowing poetic meter in the Russian language. Nobody is surprised at the "useless" work of the scientist who attempts in a certain way to strictly classify the phenomena of a certain type of organic or inorganic Nature. So how come you want me—me, for whom the cause of the New painting is higher than anything—as I stroll around museums and exhibitions looking at countless collections of Painting, not to attempt to assess the specimens of this pretty, pretty art by any means other than the child's categorization of pictures: Genre, portrait, landscape, animals, etc., etc., as Mr. Benois does? Indeed in such painting, photographic portraits should be relegated to the section with the heading "unknown artist." No, it's high time it was realized that the classification, the only one possible, of works of painting must be according to those elements that, as our investigation will show, have engendered painting and given it Life.

It has been known for a long time that what is important is not the *what*, but the *how*, i.e., which principles, which objectives, guided the artist's creation of this or that work! It is essential to establish on the basis of which canon it (the work) arose! It is essential to reveal its painterly nature! It must be indicated what the aim in Nature was that the artist of the given picture was So attracted by. And the analysis of painterly phenomena will then be a Scientific criticism of the subject. And the spectator will no longer be the confused enemy of the new art—this unhappy spectator who has only just broken out of the torture chamber of our newspapers' and magazines' cheap, presumptuous, and idiotic criticism, a criticism that believes that its duty is not to learn from the artist but to teach him. Without even studying art, many critics seriously believe that they can teach the artist What he must do and *how* he must do it! . . . I myself have personally encountered such blockheaded diehards.

Line is the result of the intersection of 2 planes. . . .

One plane can intersect another on a straight line or on a curve (surface).

Hence follow: I *Cubism* proper—and II *Rondism*.

The first is an analysis of Nature from the point of view of planes inter-secting on straight lines, the second operates with surfaces of a ball-like character.

> Disharmony is the opposite of harmony.
> dissymmetry is the opposite of symmetry.
> deconstruction is the opposite of construction.
> a canon can be constructive.
> a canon can be deconstructive.
> construction can be shifted or displaced
> *The canon of displaced construction.*

The existence in Nature of visual poetry—ancient, dilapidated towers and walls—points to the essential, tangible, and forceful supremacy of this kind of beauty.

Displacement can be linear.

Displacement can be planar.

Displacement can be in one particular place or it can be general.

Displacement can be coloristic—(a purely mechanical conception).

The canon of the Academy advocated: symmetry of proportion, fluency, or their equivalent harmony.

The New painting has indicated the existence of a second, parallel canon that does not destroy the first one—the canon of displaced construction.

> 1) disharmony (not fluency)
> 2) disproportion
> 4) coloristic dissonance
> 3) deconstruction

All these concepts follow from the examination of works of the New painting. Point 3) I placed out of sequence, and it has already been exam-ined above. Both Cubism and Rondism can be based on all these four basic concepts of the Canon of Displaced Construction.

But Cubism and Rondism can also live and develop in the soil of the Aca-demic Canon. . . .

Note. In the past there was also a counterbalance to the Academic Canon living on (fluency) harmony, proportion, symmetry: all barbaric Folk arts were based partly on the existence of this second canon (of displaced Con-

struction *). A definitive examination of our relation to these arts as raw material for the modern artist's creative soul would take us out of our depth.

* *Note to above note*. In contrast to the Academic Canon, which sees drawing as a definite dimension, we can now establish the canon—of Free drawing. (The fascination of children's drawings lies precisely in the full exposition in such works of this principle.) The pictures and drawings of V. V. Kandinsky. The drawings of V. Burliuk.

The portraits of P. Konchalovsky and I. Mashkov, the *Soldier* Pictures of M. Larionov, are the best examples of Free drawing . . . (as also are the latest works of N. Kulbin).

In poetry the apology is vers libre—the sole and finest representative of which in modern poetry is Viktor Khlebnikov.[4]

Note II. The examination of the wide field of (painting's) concepts does not fall into the scope of this article:

> Line
> Color orchestration
> which ought to be the subject
> of separate investigations.

―――――――――――――――――――――

NATALYA GONCHAROVA
Cubism, 1912

For biography see p. 54.

The text of this piece, "Kubizm," is part of an impromptu speech given by Goncharova at the Knave of Diamonds debate of February 12, 1912 [see pp. 12 and 69–70]. The text is from Benedikt Livshits, *Polutoraglazyi strelets* [The One-and-a-Half-Eyed Archer] (Leningrad, 1933), pp. 80–81 [bibl. R310; French translation in bibl. 131, p. 88]. Livshits mentions that Goncharova composed a letter on the basis of this speech and sent it the day after the debate to various newspaper offices in Moscow, but it was not published until the French translation in bibl. 132, pp.

21–23.Eli Eganbyuri (Ilya Zdañevich) in his book on Goncharova and Mikhail
Larionov [bibl. R356, pp. 18–19] quotes a very similar text and states that its source
is a letter by Goncharova, obviously the unpublished one to which Livshits refers [a
French translation of the Eganbyuri version is in bibl. 114, pp. 113–14]. Goncharova
spoke at the debate in answer to David Burliuk's presentation on cubism; Larionov
also spoke but was booed down. The tone of the speech reflects the rift that had oc-
curred between Larionov/Goncharova and Burliuk/Knave of Diamonds and that had
resulted in Larionov's establishment of the Donkey's Tail in late 1911. Two sources
[bibl. 58, p. 205, and bibl. 132, p. 20] put the date of the debate at February 12,
1911; although more reliable evidence points to 1912 [bibl. R310, pp. 58ff.; bibl.
131, pp. 71ff.; bibl. 114, p. 114]. The actual letter by Goncharova is preserved in
the manuscript section of the Lenin Library, Moscow.

––––––––––

Cubism is a positive phenomenon, but it is not altogether a new one. The
Scythian stone images, the painted wooden dolls sold at fairs are those same
cubist works. True, they are sculpture and not painting, but in France, too,
the home of cubism, it was the monuments of Gothic sculpture that served
as the point of departure for this movement. For a long time I have been
working in the manner of cubism, but I condemn without hesitation the posi-
tion of the Knave of Diamonds, which has replaced creative activity with
theorizing. The creative genius of art has never outstripped practice with
theory and has built theory on the basis of earlier works. If religious art and
art exalting the state had always been the most majestic, the most perfect
manifestation of man's creative activity, then this can be explained by the
fact that such art had never been guilty of theoreticalness. The artist well
knew *what* he was depicting, and *why* he was depicting it. Thanks to this,
his idea was clear and definite, and it remained only to find a form for it as
clear and as definite. Contrary to Burliuk, I maintain that at all times it has
mattered and will matter what the artist depicts, although at the same time it
is extremely important *how* he embodies his conception.

ILYA ZDANEVICH AND
MIKHAIL LARIONOV
Why We Paint Ourselves:
A Futurist Manifesto, 1913

Larionov—Born Tiraspol, 1881; died Paris, 1964. 1898: entered the Moscow Institute of Painting, Sculpture, and Architecture; 1906: went to Paris at Sergei Diaghilev's invitation for the Salon d'Automne; 1910: mainly responsible for establishment of the Knave of Diamonds, which he soon rejected; 1912–15: contributed to the "Donkey's Tail," "Target," "Exhibition of Painting. 1915," and other exhibitions; ca. 1913: illustrated futurist booklets; 1914: went to Paris to work for Diaghilev; at the outbreak of the war was forced to return to Moscow; 1915: wounded on the East Prussian front and hospitalized in Moscow; 1915: left Moscow to join Diaghilev in Lausanne; 1918: settled in Paris with Natalya Goncharova.

Zdanevich—Born Tiflis, 1894; died Paris, 1975. Brother of the artist and critic Kirill; 1911: entered the Law School of the University of St. Petersburg; 1912: with Kirill and Mikhail Le-Dantiyu discovered the primitive artist Niko Pirosmanashvili; 1913: under the pseudonym of Eli Eganbyuri (the result of reading the Russian handwritten form of Ilya Zdanevich as Roman characters) published a book on Goncharova and Larionov [bibl. R356; for his own comments on this book, see bibl. R101, p. 197]; 1914: met Marinetti in Moscow; 1917–18: with Kirill, Aleksei Kruchenykh, and Igor Terentev organized the futurist group 41° in Tiflis; 1921: settled in Paris.

The text of this piece, "Pochemu my raskrashivaemsya," appeared in the magazine *Argus* (St. Petersburg), Christmas number, 1913, pp. 114–18. The text is similar in places to the Italian futurist manifestoes *La pittura futurista* and *Gli espositori al pubblico*, both of which had appeared in Russian translation in *Soyuz molodezhi* [Union of Youth] (St. Petersburg), no. 2, 1912, pp. 23–28 and 29–35 [bibl. R339]. The text is reprinted in bibl. R14, pp. 173–74. The original text in *Argus* contains photo portraits of Goncharova, Larionov, Mikhail Le-Dantiyu, and Ilya Zdanevich with their faces decorated with futurist and rayonist designs, a practice that they and others (including David Burliuk) engaged in during some of their public appearances in 1912 and 1913. Several of these photographs had been reproduced already in connection with a court case involving Le-Dantiyu [see the journal *Zhizn i sud* (Life and Court) (St. Petersburg), May 9, 1913, p. 10]. *Argus* was by no means an avant-garde publication, and this piece was included evidently to satisfy the curiosity of its middle-class readers.

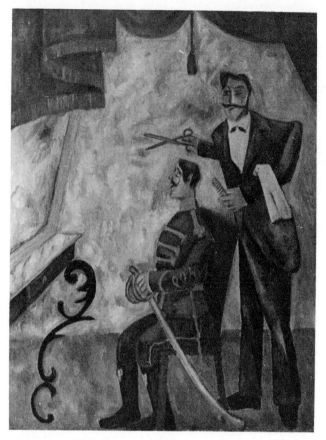

Mikhail Larionov: *Officer at the Hairdresser's.* 1909. Oil on canvas, 117 x 89 cm. Private collection, Paris. Larionov modeled his subject on the well-known eighteenth-century *lubok* entitled *Barber Cutting Off the Beard of an Old Believer.*

To the frenzied city of arc lamps, to the streets bespattered with bodies, to the houses huddled together, we have brought our painted faces; we're off and the track awaits the runners.

Creators, we have not come to destroy construction, but to glorify and to affirm it. The painting of our faces is neither an absurd piece of fiction, nor a relapse—it is indissolubly linked to the character of our life and of our trade.

The dawn's hymn to man, like a bugler before the battle, calls to victories over the earth, hiding itself beneath the wheels until the hour of vengeance; the slumbering weapons have awoken and spit on the enemy.

The new life requires a new community and a new way of propagation.

Our self-painting is the first speech to have found unknown truths. And the conflagrations caused by it show that the menials of the earth have not lost hope of saving the old nests, have gathered all forces to the defense of the gates, have crowded together knowing that with the first goal scored we are the victors.

The course of art and a love of life have been our guides. Faithfulness to our trade inspires us, the fighters. The steadfastness of the few presents forces that cannot be overcome.

We have joined art to life. After the long isolation of artists, we have loudly summoned life and life has invaded art, it is time for art to invade life. The painting of our faces is the beginning of the invasion. That is why our hearts are beating so.

We do not aspire to a single form of aesthetics. Art is not only a monarch, but also a newsman and a decorator. We value both print and news. The synthesis of decoration and illustration is the basis of our self-painting. We decorate life and preach—that's why we paint ourselves.

Self-painting is one of the new valuables that belong to the people as they all do in our day and age. The old ones were incoherent and squashed flat by money. Gold was valued as an ornament and became expensive. We throw down gold and precious stones from their pedestal and declare them value-less. Beware, you who collect them and horde them—you will soon be beggars.

It began in '05. Mikhail Larionov painted a nude standing against a background of a carpet and extended the design onto her. But there was no proclamation. Now Parisians are doing the same by painting the legs of their dancing girls, and ladies powder themselves with brown powder and like Egyptians elongate their eyes. But that's old age. We, however, join contemplation with action and fling ourselves into the crowd.

To the frenzied city of arc lamps, to the streets bespattered with bodies, to the houses huddled together, we have not brought the past: unexpected flowers have bloomed in the hothouse and they excite us.

City dwellers have for a long time been varnishing their nails, using eyeshadow, rouging their lips, cheeks, hair—but all they are doing is to imitate the earth.

We, creators, have nothing to do with the earth; our lines and colors ap-

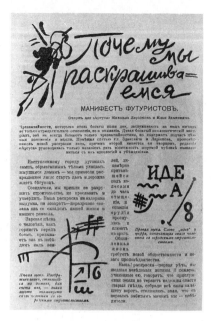

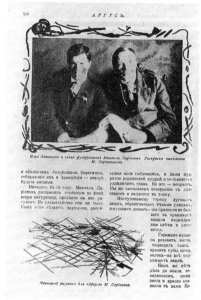

Title page of "Why We Paint Ourselves," from the journal *Argus* (St. Petersburg), Christmas issue, December 1913. It shows rayonist designs for cosmetic application.

Page from "Why We Paint Ourselves," from the journal *Argus* (St. Petersburg), December 1913. The photograph shows Ilya Zdanevich and Mikhail Larionov with faces painted after rayonist designs by Larionov.

peared with us. If we were given the plumage of parrots, we would pluck out their feathers to use as brushes and crayons.

If we were given immortal beauty, we would daub over it and kill it—we who know no half measures.

Tattooing doesn't interest us. People tattoo themselves once and for always. We paint ourselves for an hour, and a change of experience calls for a change of painting, just as picture devours picture, when on the other side of a car windshield shopwindows flash by running into each other: that's our faces. Tattooing is beautiful but it says little—only about one's tribe and exploits. Our painting is the newsman.

Facial expressions don't interest us. That's because people have grown accustomed to understanding them, too timid and ugly as they are. Our faces are like the screech of the trolley warning the hurrying passers-by, like the drunken sounds of the great tango. Mimicry is expressive but colorless. Our painting is the decorator.

Mutiny against the earth and transformation of faces into a projector of experiences.

The telescope discerned constellations lost in space, painting will tell of lost ideas.

We paint ourselves because a clean face is offensive, because we want to herald the unknown, to rearrange life, and to bear man's multiple soul to the upper reaches of reality.

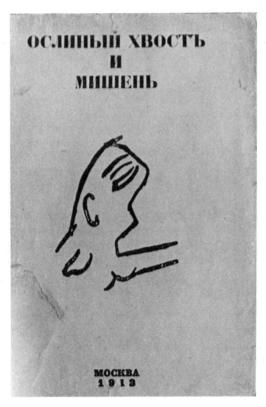

Title page of *Oslinyi khvost i mishen* [Donkey's Tail and Target] (Moscow, 1913). Designed by Mikhail Larionov. Photograph courtesy Mr. Thomas Whitney, Connecticut. This title derived from the notorious incident of 1910 when one Joachim-Raphael Boronali submitted a picture entitled *Et le soleil s'endormit sur l'Adriatique* [And the Sun Went Down over the Adriatic] to the Salon des Indépendants. Boronali turned out to be a donkey to whose tail art students had tied a paintbrush.

III.
Nonobjective Art

Poster announcing "The Last Futurist Exhibition of Pictures 0.10" (Petrograd, December 19, 1915–January 19, 1916). Photograph courtesy Mr. Herman Berninger, Zurich. The poster mentions that the exhibitors are those who showed at "Tramway V" (not altogether true) and that 50 percent of any clear profit will go toward a field hospital for art workers.

MIKHAIL LARIONOV AND
NATALYA GONCHAROVA
Rayonists and Futurists:
A Manifesto, 1913

For biographies see pp. 79 and 54.

The text of this piece, "Luchisty i budushchniki. Manifest," appeared in the miscel-
lany *Oslinyi khvost i mishen* [Donkey's Tail and Target] (Moscow, July 1913), pp.
9–48 [bibl. R319; it is reprinted in bibl. R14, pp. 175–78. It has been translated into
French in bibl. 132, pp. 29–32, and in part, into English in bibl. 45, pp. 124–26].
The declarations are similar to those advanced in the catalogue of the "Target"
exhibition held in Moscow in March 1913 [bibl. R315], and the concluding para-
graphs are virtually the same as those of Larionov's "Rayonist Painting." Although
the theory of rayonist painting was known already, the "Target" acted as the formal
demonstration of its practical achievements. Because of the various allusions to the
Knave of Diamonds, "A Slap in the Face of Public Taste," and David Burliuk, this
manifesto acts as a polemical response to Larionov's rivals. The use of the Russian
neologism *budushchniki,* and not the European borrowing *futuristy,* betrays
Larionov's current rejection of the West and his orientation toward Russian and East-
ern cultural traditions. In addition to Larionov and Goncharova, the signers of the
manifesto were Timofei Bogomazov (a sergeant-major and amateur painter whom
Larionov had befriended during his military service—no relative of the artist Alek-
sandr Bogomazov) and the artists Morits Fabri, Ivan Larionov (brother of Mikhail),
Mikhail Le-Dantiyu, Vyacheslav Levkievsky, Vladimir Obolensky, Sergei Romano-
vich, Aleksandr Shevchenko, and Kirill Zdanevich (brother of Ilya). All except Fabri
and Obolensky took part in the "Target" exhibition, and *Oslinyi khvost i mishen*
carried reproductions of some of their exhibits. For a French translation see bibl.
145x, pp. 74–78.

We, rayonists and futurists, do not wish to speak about new or old art,
and even less about modern Western art.

We leave the old art to die and leave the "new" art to do battle with it;
and incidentally, apart from a battle and a very easy one, the "new" art
cannot advance anything of its own. It is useful to put manure on barren
ground, but this dirty work does not interest us.

People shout about enemies closing in on them, but in fact, these enemies
are, in any case, their closest friends. Their argument with old art long since

Михаилъ Ларіоновъ.

Mikhail Larionov: *Rayonist Portrait of Goncharova,* 1913. Location and dimensions unknown. Reproduced from Mikhail Larionov: *Luchizm* [Rayonism] (Moscow, 1913).

Natalya Goncharova: *Portrait of Larionov,* 1912. Oil on canvas, 105 x 78 cm. Collection Centre Georges Pompidou, Paris.

departed is nothing but a resurrection of the dead, a boring, decadent love of paltriness and a stupid desire to march at the head of contemporary, philistine interests.

We are not declaring any war, for where can we find an opponent our equal?

The future is behind us.

All the same we will crush in our advance all those who undermine us and all those who stand aside.

We don't need popularization—our art will, in any case, take its full place in life—that's a matter of time.

We don't need debates and lectures, and if we sometimes organize them, then that's by way of a gesture to public impatience.

While the artistic throne is empty, and narrow-mindedness, deprived of its privileges, is running around calling for battle with departed ghosts, we push it out of the way, sit up on the throne, and reign until a regal deputy comes and replaces us.

We, artists of art's future paths, stretch out our hand to the futurists, in

spite of all their mistakes, but express our utmost scorn for the so-called egofuturists [1] and neofuturists, [2] talentless, banal people, the same as the members of the Knave of Diamonds, Slap in the Face of Public Taste, and Union of Youth groups.[3]

We let sleeping dogs lie, we don't bring fools to their senses, we call trivial people trivial to their faces, and we are ever ready to defend our interests actively.

We despise and brand as artistic lackeys all those who move against a background of old or new art and go about their trivial business. Simple, uncorrupted people are closer to us than this artistic husk that clings to modern art, like flies to honey.

To our way of thinking, mediocrity that proclaims new ideas of art is as unnecessary and vulgar as if it were proclaiming old ideas.

This is a sharp stab in the heart for all who cling to so-called modern art, making their names in speeches against renowned little old men—despite the fact that between them and the latter there is essentially not much difference. These are true brothers in spirit—the wretched rags of contemporaneity, for who needs the peaceful renovating enterprises of those people who make a hubbub about modern art, who haven't advanced a single thesis of their own, and who express long-familiar artistic truths in their own words!

We've had enough Knaves of Diamonds whose miserable art is screened by this title, enough slaps in the face given by the hand of a baby suffering from wretched old age, enough unions of old and young! We don't need to square vulgar accounts with public taste—let those indulge in this who on paper give a slap in the face, but who, in fact, stretch out their hands for alms.

We've had enough of this manure; now we need to sow.

We have no modesty—we declare this bluntly and frankly—we consider ourselves to be the creators of modern art.

We have our own artistic honor, which we are prepared to defend to the last with all the means at our disposal. We laugh at the words "old art" and "new art"—that's nonsense invented by idle philistines.

We spare no strength to make the sacred tree of art grow to great heights, and what does it matter to us that little parasites swarm in its shadow—let them, they know of the tree's existence from its shadow.

Art for life and even more—life for art!

We exclaim: the whole brilliant style of modern times—our trousers, jackets, shoes, trolleys, cars, airplanes, railways, grandiose steamships—is fascinating, is a great epoch, one that has known no equal in the entire history of the world.

We reject individuality as having no meaning for the examination of a work of art. One has to appeal only to a work of art, and one can examine it only by proceeding from the laws according to which it was created.

The tenets we advance are as follows:

Long live the beautiful East! We are joining forces with contemporary Eastern artists to work together.

Long live nationality! We march hand in hand with our ordinary house painters.

Long live the style of rayonist painting that we created—free from concrete forms, existing and developing according to painterly laws!

We declare that there has never been such a thing as a copy and recommend painting from pictures painted before the present day. We maintain that art cannot be examined from the point of view of time.

We acknowledge all styles as suitable for the expression of our art,[4] styles existing both yesterday and today—for example, cubism, futurism, orphism, and their synthesis, rayonism, for which the art of the past, like life, is an object of observation.

We are against the West, which is vulgarizing our forms and Eastern forms, and which is bringing down the level of everything.

We demand a knowledge of painterly craftsmanship.

More than anything else, we value intensity of feeling and its great sense of uplifting.

We believe that the whole world can be expressed fully in painterly forms:

Life, poetry, music, philosophy.

We aspire to the glorification of our art and work for its sake and for the sake of our future creations.

We wish to leave deep footprints behind us, and this is an honorable wish.

We advance our works and principles to the fore; we ceaselessly change them and put them into practice.

We are against art societies, for they lead to stagnation.

We do not demand public attention and ask that it should not be demanded from us.

The style of rayonist painting that we advance signifies spatial forms arising from the intersection of the reflected rays of various objects, forms chosen by the artist's will.

The ray is depicted provisionally on the surface by a colored line.

That which is valuable for the lover of painting finds its maximum expression in a rayonist picture. The objects that we see in life play no role here,

but that which is the essence of painting itself can be shown here best of all—the combination of color, its saturation, the relation of colored masses, depth, texture; anyone who is interested in painting can give his full attention to all these things.

The picture appears to be slippery; it imparts a sensation of the extratemporal, of the spatial. In it arises the sensation of what could be called the fourth dimension, because its length, breadth, and density of the layer of paint are the only signs of the outside world—all the sensations that arise from the picture are of a different order; in this way painting becomes equal to music while remaining itself. At this juncture a kind of painting emerges that can be mastered by following precisely the laws of color and its transference onto the canvas.

Hence the creation of new forms whose meaning and expressiveness depend exclusively on the degree of intensity of tone and the position that it occupies in relation to other tones. Hence the natural downfall of all existing styles and forms in all the art of the past—since they, like life, are merely objects for better perception and pictorial construction.

With this begins the true liberation of painting and its life in accordance only with its own laws, a self-sufficient painting, with its own forms, color, and timbre.

MIKHAIL LARIONOV
Rayonist Painting, 1913

For biography see p. 79.

The text of this piece, "Luchistskaya zhivopis," appeared in the miscellany *Oslinyi khvost i mishen* [Donkey's Tail and Target] (Moscow, July 1913), pp. 83–124 [bibl. R319] and was signed and dated Moscow, June 1912. It has been translated into French in bibl. 145x, pp. 65–73 (and without the Whitman quotations in bibl. 121, pp. 110–12), and into German [ibid., German edition, pp. 111–13]. A similar text had been published as a separate booklet in Moscow in April of the same year [bibl. R361; reprinted in bibl. R7, pp. 477–83]; this alternate version lacked the Whitman quotations and the short conclusion on pneumorayonism and omitted, inter al., the

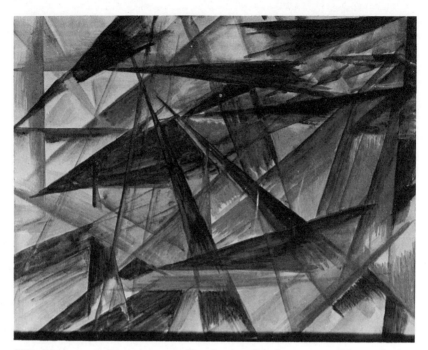

Mikhail Larionov: *Red Rayonism,* 1913. Gouache on cardboard, 27 x 33 cm. Private collection, Paris. Although to all intents and purposes this is a nonrepresentational work, it must not be forgotten that Larionov's rayonist theory retained a representational meaning: "in the space between them [objects] a certain form appears, and this is isolated by the artist's will."

curious references to Guillaume Apollinaire as an "artist" and to Natalya Goncharova as a "realist cubist." Both *Oslinyi khvost i mishen* and the booklet contained rayonist illustrations by Larionov and Goncharova, although the former also contained several lithographs mounted separately, as well as photographic reproductions of works by Mikhail Le-Dantiyu, Aleksandr Shevchenko, et al. (see p. 83, 88).

Larionov seems to have formulated rayonism in 1912, not before; no rayonist works, for example, figured at his one-man exhibition at the Society of Free Aesthetics in Moscow in December 1911, at least according to the catalogue and to contemporaneous reviews. According to bibl. 132, p. 28, Goncharova was the first to use the term rayonism, although Larionov's interest in science (manifested particularly while he was at high school) had obviously stimulated his peculiarly refractive conception of art. While rayonism had apparent cross-references with Franz Marc, the Italian futurists, and later, with Lyonel Feininger, the upsurge of interest in photography and cinematography in Russia at this time provided an undoubted stimulus to Larionov's concern with light and dynamics. It is of interest to note that in 1912/13 the Moscow

photographer A. Trapani invented the photographic technique of "ray gum" [*luchis-tyi gummi*]—a version of the gum-arabic process—which enabled the photographer to create the illusion of a radial, fragmented texture. Larionov himself exhibited several "photographic studies" at the "Donkey's Tail" in 1912, and his famous picture *Glass* (1912–13) at the Guggenheim Museum demonstrates an obvious interest in optics. Of possible relevance to Larionov's derivation of rayonism was the peculiarly "broken" texture that Mikhail Vrubel favored in so many of his works in the 1890s and 1900s—a technique admired by a number of young Russian artists. Moreover, Vrubel's theory of visual reality came very close to Larionov's formulation, as the following statement by Vrubel would indicate: "The contours with which artists normally delineate the confines of a form in actual fact do not exist—they are merely an optical illusion that occurs from the interaction of rays falling onto the object and reflected from its surface at different angles. In fact, at this point you get a 'complementary color'—complementary to the basic, local color . . ." (quoted in Nikolai Prakhov, *Stranitsy proshlogo* [Pages of the Past] [Kiev, 1958], pp. 159–60, where neither source nor date is given). Goncharova shared Larionov's interest in radiation and emanation and at her one-man exhibition in 1913 presented several works based on the "theory of transparency" formulated by her fellow artist Ivan Firsov.

Painting is self-sufficient;
it has its own forms, color,
and timbre.
Rayonism is concerned with
spatial forms that can
arise from the intersection
of the reflected rays of
different objects, forms
chosen by the artist's
will.

How they are provided for upon the earth, (appearing at intervals),
How dear and dreadful they are to the earth,
How they inure to themselves as much as to any—what a paradox appears
 their age,
How people respond to them, yet know them not,
How there is something relentless in their fate all times,
How all times mischoose the objects of their adulation and reward,
And how the same inexorable price must still be paid for the same great
 purchase.
 —Walt Whitman

I hear it was charged against me that I sought to destroy institutions,
But really I am neither for nor against institutions,
(What indeed have I in common with them? or what with the destruction of
 them?).

—Walt Whitman [1]

Throughout what we call time various styles have emerged. A temporal displacement of these styles would in no way have changed the artistic value and significance of what was produced during their hegemony. We have inherited Egyptian, Assyrian, Greek, Cretan, Byzantine, Romanesque, Gothic, Japanese, Chinese, Indian styles, etc. There is a great deal of such classification in art history, and in fact, there are infinitely more styles, not to mention that style that is peculiar to each work outside the general style of the time.

Style is that manner, that device by which a work of art has been created, and if we were to examine all art objects throughout the world, then it would transpire that they had all been created by some artistic device or other; not a single work of art exists without this.

This applies not only to what we call art objects, but also to everything that exists in a given age. People examine and perceive everything from the point of view of the style of their age. But what is called art is examined from the point of view of the *perception of artistic truths;* although these truths pass through the style of their age, they are quite independent of it. The fact that people perceive nature and their environment through the style of their age is best seen in the comparison of various styles and various ages. Let us take a Chinese picture, a picture from the time of Watteau, and an impressionist picture—a gulf lies between them, they examine nature from completely different points of view, but nevertheless the people who witnessed their creation understood them, just as the artists themselves did, and did not doubt for a moment that this was the same life and nature that surrounded them (at this juncture I am not concerned with connoisseurs of art as such). And often the artist Utamaro, whose age coincided with that of Watteau, is spurned by those who reject the age of Watteau, but who cannot surmount the difference of style between Japan and our eighteenth century. There are ages that are completely rejected, and even those who are interested in art ignore them. These are eras that are very remote, for example, the Stone Age. There are styles that are in the same position because of a considerable difference between the cultures of the people who created them and those who have to respond to them (Negro, Australasian, Aztec, Kolu-

shes, etc.)—despite the fact that whole nations have apprehended and embodied life only in that way, age after age.

Any style, the moment it appears, especially if it is given immediate, vivid expression, is always as incomprehensible as the style of a remote age.

A new style is always first created in art, since all previous styles and life are refracted through it.

Works of art are not examined from the point of view of time and are essentially different because of the form in which they are perceived and in which they were created. There is no such thing as a copy in our current sense of the word, but there is such a thing as a work of art with the same departure point–served either by another work of art or by nature.

In examining our contemporary art we see that about forty of fifty years ago in the heyday of impressionism, a movement began to appear in art that advocated the colored surface. Gradually this movement took hold of people working in the sphere of art, and after a while there appeared the theory of displaced colored surface and movement of surface. A parallel trend arose of constructing according to the curve of the circle—rondism. The displacement of surfaces and construction according to the curve made for more constructiveness within the confines of the picture's surface. The doctrine of surface painting gives rise naturally to the doctrine of figural construction because the figure is in the surface's movement. Cubism teaches one to expose the third dimension by means of form (but not aerial and linear perspective together with form) and to transfer forms onto the canvas the moment they are created. Of all techniques, chiaroscuro, in the main, is adopted by cubism. For the most part this trend has decorative characteristics, although all cubists are engaged in easel painting—but this is caused by modern society's lack of demand for purely decorative painting. A movement parallel to cubism is spherism.

Cubism manifests itself in almost all existing forms—classical, academic (Metzinger), romantic (Le Fauconnier, Braque), realist (Gleizes, Léger, Goncharova)—and in forms of an abstract kind (Picasso). Under the influence of futurism on the cubists, there appeared a transitory cubism of futurist character (Delaunay, Lévy, the latest works of Picasso, Le Fauconnier).

Futurism was first promoted by the Italians: [2] this doctrine aspires to make reforms not merely in the sphere of painting—it is concerned also with all kinds of art.

In painting, futurism promotes mainly the doctrine of movement—*dynamism.*

Painting in its very essence is static—hence dynamics as a style. The fu-

turist unfurls the picture—he places the artist in the center of the picture; he examines the object from different points of view; he advocates the translucency of objects, the painting of what the artist knows, not what he sees, the transference of the sum total of impressions onto the canvas and the transference of many aspects of one and the same object; he introduces narrative and literature.

Futurism introduces a refreshing stream into modern art—which to a certain extent is linked to useless traditions—but for modern Italy it really serves as a very good lesson. If the futurists had had the genuine painterly traditions that the French have, then their doctrine would not have become part of French painting, as it now has.

Of the movements engendered by this trend and dominant at present, the following are in the forefront: postcubism, which is concerned with the synthesis of forms as opposed to the analytical decomposition of forms; neofuturism, which has resolved completely to reject the picture as a surface covered with paint, replacing it by a screen—on which the static, essentially colored surface is replaced by a light-colored, moving one; and orphism, which advocates the musicality of objects—heralded by the artist Apollinaire.

Neofuturism introduces painting to the problems posed by glass [3] and, in addition, natural dynamics; this deprives painting of its symbolic origin and it emerges as a new kind of art.

Orphism is concerned with painting based on this musical sonority of colors, on color orchestration; it is inclined toward a literal correspondence of musical to light waves, which stimulate color sensation—and it constructs painting literally according to musical laws. In fact, painting must be constructed according to its own laws—just as music is constructed according to its own musical laws; the laws germane only to painting are:

Colored line and texture.

Any picture consists of a colored surface and texture (the state of this colored surface is its timbre) and of the sensation that arises from these two things.

Nobody would begin to assert that the art connoisseur turns his primary attention to the objects depicted in a picture—he is interested in how these objects are depicted, which colors are put on the canvas, and how they are put on. Therefore, he is interested in the one artist and appreciates him, and not another, despite the fact that both paint the same objects. But the majority of dilettanti would think it very strange if objects as such were to disappear completely from a picture. Although all that they appreciate would still remain—color, the painted surface, the structure of painted masses, texture.

They would think it strange simply because we are accustomed to seeing what is of most value in painting in the context of objects.

In actual fact, all those painterly tasks that we realize with the help of objects we cannot perceive even with the help of tangible, real objects. Our impressions of an object are of a purely visual kind—despite the fact that we desire to re-create an object in its most complete reality and according to its essential qualities. The aspiration toward the most complete reality has compelled one of the most astonishing artists of our time, Picasso, and others with him, to employ types of technique that imitate concrete life, create surfaces of wood, stone, sand, etc., and change visual sensations into tactile ones. Picasso, with the aim of understanding an object concretely, stuck wallpaper, newspaper clippings onto a picture, painted with sand, ground glass; made a plaster relief—modeled objects out of papier-mâché and then painted them (some of his ''violins'' are painted in this manner).

The painter can be expected to possess complete mastery of all existing types of technique (tradition plays a very important role in this) and to work according to the laws of painting, turning to extrinsic life only as a stimulant.

Chinese artists are allowed to take examinations only after they have learned to master the brush so well that brushstrokes in Indian ink on two transparent sheets of paper of the same size coincide when one sheet is placed on the other. From this it is obvious just how subtly the eye and hand must be developed.

The first to reduce a story to painterly form were the Hindus and Persians—their miniatures were reflected in the work of Henri Rousseau, the first in modern Europe to introduce a story into painterly form.

There are reasons to suppose that the whole world, in its concrete and spiritual totality, can be re-created in painterly form.

Furthermore, the qualities peculiar to painting alone are what we value in painting.

Now, it is necessary to find the point at which—having concrete life as a stimulant—painting would remain itself while its adopted forms would be transformed and its outlook broadened; hence, like music, which takes sound from concrete life and uses it according to musical laws, painting would use color according to painterly laws.

In accordance with purely painterly laws, rayonism is concerned with introducing painting into the sphere of those problems peculiar to painting itself.

Our eye is an imperfect apparatus; we think that our sight is mainly responsible for transmitting concrete life to our cerebral centers, but in fact, it

arrives there in its correct form not thanks to our sight, but thanks to other senses. A child sees objects for the first time upside down, and subsequently this defect of sight is corrected by the other senses. However much he desires to, an adult cannot see an object upside down.

Hence it is evident to what degree our inner conviction is important with regard to things existing in the outside world. If with regard to certain things, we know that they must be as they are because science reveals this to us, we do remain certain that this is as it should be and not otherwise despite the fact that we cannot apprehend this directly by our senses.

In purely official terms, rayonism proceeds from the following tenets:

Luminosity owes its existence to reflected light (*between objects in space this forms a kind of colored dust*).

The doctrine of luminosity.

Radioactive rays. Ultraviolet rays. Reflectivity.

We do not sense the object with our eye, as it is depicted conventionally in pictures and as a result of following this or that device; in fact, we do not sense the object as such. We perceive a sum of rays proceeding from a source of light; these are reflected from the object and enter our field of vision.

Consequently, if we wish to paint literally what we see, then we must paint the sum of rays reflected from the object. But in order to receive the total sum of rays from the desired object, we must select them deliberately—because together with the rays of the object being perceived, there also fall into our range of vision reflected reflex rays belonging to other nearby objects. Now, if we wish to depict an object exactly as we see it, then we must depict also these reflex rays belonging to other objects—and then we will depict literally what we see. I painted my first works of a purely realistic kind in this way. In other words, this is the most complete reality of an object—not as we know it, but as we see it. In all his works Paul Cézanne was inclined toward this; that is why various objects in his pictures appear displaced and look asquint. This arose partly from the fact that he painted literally what he saw. But one can see an object as flat only with one eye, and Cézanne painted as every man sees—with two eyes, i.e., the object slightly from the right and slightly from the left.

At the same time, Cézanne possessed such keenness of sight that he could not help noticing the reflex rubbing, as it were, of a small part of one object against the reflected rays of another. Hence there occurred not the exposure of the object itself, but as it were, its displacement onto a different side and a partial truncation of one of the object's sides—which provided his pictures with a realistic construction.

Picasso inherited this tradition from Cézanne, developed it, and thanks to Negro and Aztec art, turned to monumental art; finally, he grasped how to build a picture out of the essential elements of an object so as to ensure a greater sense of construction in the picture.

Now, if we concern ourselves not with the objects themselves but with the sums of rays from them, we can build a picture in the following way:

The sum of rays from object A intersects the sum of rays from object B; in the space between them a certain form appears, and this is isolated by the artist's will. This can be employed in relation to several objects, e.g., the form constructed from a pair of scissors, a nose, and a bottle, etc. The picture's coloration depends on the pressure intensity of dominant colors and their reciprocal combinations.

The high point of color tension, density, and depth must be clearly shown.

A picture painted in a cubist manner and a futurist picture provide a different kind of form (a rayonist one) when they radiate in space.

Perception, not of the object itself, but of the sum of rays from it, is, by its very nature, much closer to the symbolic surface of the picture than is the object itself. This is almost the same as the mirage that appears in the scorching air of the desert and depicts distant towns, lakes, and oases in the sky (in concrete instances). Rayonism erases the barriers that exist between the picture's surface and nature.

A ray is depicted provisionally on the surface by a colored line.

What has most value for every lover of painting is revealed in its most complete form in a rayonist picture—the objects that we see in life play no role here (except for realistic rayonism, in which the object serves as a point of departure); that which is the essence of painting itself can best be revealed here—the combination of colors, their saturation, the interrelation of colored masses, depth, texture; whoever is interested in painting can concentrate on all these things to the full.

The picture appears to be slippery; it imparts a sensation of the extratemporal, of the spatial. In it arises the sensation of what could be called the fourth dimension, because its length, breadth, and density of the layer of paint are the only signs of the outside world—all the sensations that arise from the picture are of a different order; in this way painting becomes equal to music while remaining itself. At this juncture a kind of painting emerges that can be mastered by following precisely the laws of color and its transference onto the canvas. Hence the creation of new forms whose significance and expressiveness depend exclusively on the degree of intensity of tone and the position that this occupies in relation to other tones. Hence the

natural downfall of all existing styles and forms in all the art of the past—for they, like life, are merely objects for the rayonist perception and pictorial construction.

With this begins the true liberation of painting and its own life according to its own rules.

The next stage in the development of rayonism is *pneumorayonism, or concentrated rayonism;* this is concerned with joining elements together into general masses between spatial forms present in a more sectional, rayonist background.[4]

MIKHAIL LARIONOV
Pictorial Rayonism, 1914

For biography see p. 79.

The text of this piece, "Le Rayonisme Pictural," appeared in French in *Montjoie!* (Paris), no. 4/5/6, April/May/June, 1914, p. 15. This was Larionov's first contribution to the French press and was printed just as the "Exposition de Natalie Gontcharowa et Michel Larionow" opened at the Galerie Paul Guillaume, Paris [see bibl. 119], at which rayonist works by both Goncharova and Larionov were presented. In places the text is similar to that of Larionov's "Rayonist Painting"; however, the occasional repetitions have been retained in order to preserve the original format of this, the first elucidation of rayonism to be published in the West. For a French reprint see bibl. 145x, pp. 83–85.

Every form exists objectively in space by reason of the rays from the other forms that surround it; it is individualized by these rays, and they alone determine its existence.

Nevertheless, between those forms that our eye objectivizes, there exists a real and undeniable intersection of rays proceeding from various forms. These intersections constitute new intangible forms that the painter's eye *can* see. Where the rays from different objects meet, new immaterial objects are created in space. Rayonism is the painting of these intangible forms, of these *infinite* products with which the whole of space is filled.

Rayonism is the painting of the collisions and couplings of rays *between*

objects, the dramatic representation of the struggle between the plastic emanations radiating from all things around us; rayonism is the painting of space revealed not by the contours of objects, not even by their formal coloring, but by the ceaseless and intense drama of the rays that constitute the unity of all things.

Rayonism might appear to be a form of spiritualist painting, even mystical, but it is, on the contrary, essentially plastic. The painter sees new forms created between tangible forms by their own radiation, and these are the only ones that he places on the canvas. Hence he attains the pinnacle of painting for painting's sake inspired by these real forms, although he would neither know how to, nor wish to, represent or even evoke them by their linear existence.

Pictorial studies devoted to a formal representation by no matter what kind of geometrical line—straight, curved, circular—still regard painting, in my opinion, as a means of representing forms. Rayonism wishes to regard painting as an end in itself and no longer as a means of expression.

Rayonism gives primary importance only to color. To this end, rayonism has come naturally to examine the problem of color depth.

The sensation a color can arouse, the emotion it can express is greater or lesser in proportion as its depth on the plane surface increases or decreases. Obviously, a blue spread evenly over the canvas vibrates with less intensity than the same blue put on more thickly. Hitherto this law has been applicable only to music, but it is incontestable also with regard to painting: *colors have a timbre* that changes according to the quality of their vibrations, i.e., of their density and loudness. In this way, painting becomes as free as music and becomes self-sufficient outside of imagery.

In his investigations the rayonist painter is concerned with variety of density, i.e., the depth of color that he is using, as much as with the composition formed by the rays from intervibrant objects.

So we are dealing with painting that is dedicated to the domination of color, to the study of the resonances deriving from the pure orchestration of its timbres.

Polychromy is not essential. For example, in a canvas painted in one color, a street would be represented by one flat, very brilliant and lacquered surface between houses depicted in relief with their projections and indentations; above would be a very smooth sky. These different masses would be combined by the intersections of the rays that they would reflect and would produce a supremely realistic impression—and just as dynamic—of how the street appeared in reality.

This example is actually rather clumsy and serves only to elucidate the question of color timbre, since in a rayonist canvas a street, a harvest scene, a sky exist only through the relationships between their intervibrations.

In rayonist painting the intrinsic life and continuum of the colored masses form a synthesis-image in the mind of the spectator, one that goes beyond time and space. One glimpses the famous fourth dimension since the length, breadth, and density of the superposition of the painted colors are the only signs of the visible world; and all the other sensations, created by images, are of another order—that superreal order that man must always seek, yet never find, so that he would approach paths of representation more subtle and more spiritualized.

We believe that rayonism marks a new stage in this development.

OLGA ROZANOVA

The Bases of the New Creation
and the Reasons
Why It Is Misunderstood, 1913

Born Vladimir Province, 1886; died Moscow, 1918. 1904–10: studied at the Bolshakov Art College and Stroganov Art School in Moscow; 1911: in St. Petersburg; close to the Union of Youth; 1911–17: contributed to the "Union of Youth," "Tramway V," "0.10," "Knave of Diamonds," and other exhibitions; ca. 1913: illustrated futurist booklets; married Aleksei Kruchenykh; 1918: member of IZO Narkompros and of Proletkult.

The text of this piece, "Osnovy novogo tvorchestva i prichiny ego neponimaniya," is from the third issue of *Soyuz molodezhi* [Union of Youth] (St. Petersburg), March 1913, pp. 14–22 [bibl. R339; part of the text is reprinted in the catalogue to the "Tenth State Exhibition," 1919 (see pp. 138ff.), and in bibl. R14, pp. 168–72]. This issue had been scheduled to appear in September 1912 (according to the back cover of the second issue), which might indicate that Rozanova wrote her essay earlier than 1913. As illustrations to Rozanova's text, the issue contained six of her drawings (as well as five by Iosif Shkolnik). Rozanova's emphasis on the intuitive element of the creative process was maintained by Mikhail Matyushin in his illuminating review

of Albert Gleizes and Jean Metzinger's *Du Cubisme* [ibid., pp. 25–34, in which he made frequent reference to Petr Uspensky's *Tertium Organum* and hence to the "fourth element and the highest—Intuition." As a member of the St. Petersburg avant-garde, Rozanova was a colleague of Nikolai Kulbin, Vladimir Markov, and Matyushin, whose ideas undoubtedly influenced her; to a certain extent, her thesis acted as an organic link between the somewhat nebulous ideas of the early Vasilii Kandinsky and Kulbin and the more definite, more emphatic theories of Kazimir Malevich. In fact, some of the ideas to be found in Malevich's "From Cubism and Futurism to Suprematism" (see pp. 116ff.)—e.g., the conventional artist as a prisoner of nature and intuitive reason—rely heavily on Rozanova's essay. Rozanova's more disciplined and more cerebral approach to the question of nonrepresentation was expressed above all in her own analytical painting, in which she reached a suprematist conclusion, and in her poetical experiments [see bibl. R332]. The text was written as a polemical response to Aleksandr Benois's article "Kubizm ili kukishizm?" [Cubism or Ridiculism?]—see p. 69–70. For a French translation see bibl. 145i, pp. 66–70.

––––––

The art of Painting is the decomposition of nature's ready-made images into the distinctive properties of the common material found within them and the creation of different images by means of the interrelation of these properties; this interrelation is established by the Creator's individual attitude. The artist determines these properties by his visual faculty. The world is a piece of raw material—for the unreceptive soul it is the back of a mirror, but for reflective souls it is a mirror of images appearing continually.

How does the world reveal itself to us? How does our soul reflect the world? In order to reflect, it is necessary to perceive. In order to perceive, it is necessary to touch, to see. Only the Intuitive Principle introduces us to the World.

And only the Abstract Principle—Calculation—as the consequence of the active aspiration to express the world, can build a Picture.

This establishes the following order in the process of creation:

1. Intuitive Principle
2. Individual transformation of the visible
3. Abstract creation

The fascination of the visible, the charm of the spectacle, arrests the eye, and the artist's primary aspiration to create arises from this confrontation with nature. The desire to penetrate the World and, in reflecting it, to reflect oneself is an intuitive impulse that selects the Subject—this word being understood in its purely painterly meaning.

In this way, nature is a "Subject" as much as any subject set for painting *in abstracto* and is the point of departure, the seed, from which a Work of

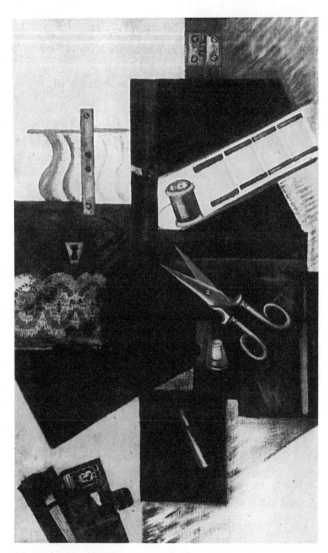

Olga Rozanova: *Workbox*, 1915. Oil, paper collage, lace on canvas, 58 x 33 cm. Collection Tretyakov Gallery, Moscow. Rozanova's analytical approach to the pictorial surface, stimulated in part by her awareness of Italian futurism and of Malevich's alogism, enabled her to reach her own version of suprematism in 1916.

Art develops; the intuitive impulse in the process of creation is the first psychological stage in this development. How does the artist use the phenomena of nature, and how does he transform the visible World on the basis of his relationship with it?

A rearing horse, motionless cliffs, a delicate flower, are equally beautiful if they can express themselves in equal degree.

But what can the artist express if he repeats them?

At best, an unconscious plagiarism of nature, for which the artist, not knowing his own objectives, could be forgiven; at worst, a plagiarism in the literal sense of the word, when people would refuse to reject it merely out of creative impotence.

—Because the artist must be not a passive imitator of nature, but an active spokesman of his relationship with her. Hence the question arises: to what extent and to what degree should nature's influence on the artist be expressed?

A servile repetition of nature's models can never express all her fullness.

It is time, at long last, to acknowledge this and to declare frankly, once and for all, that other ways, other methods of expressing the World are needed.

The photographer and the servile artist, in depicting nature's images, will repeat them.

The artist of artistic individuality, in depicting them, will reflect himself.

He will reveal the properties of the World and erect from them a New World—the World of the Picture, and by renouncing repetition of the visible, he will inevitably create different images; in turning to their practical realization on the canvas, he will be forced to reckon with them.

The Intuitive Principle, as an extrinsic stimulus to creation, and individual transformation—the second stage in the creative process—have played their role in advancing the meaning of the abstract.

The abstract embraces the conception of creative Calculation, and of expedient relations to the painterly task. It has played an essential role in the New Art by indissolubly combining the conception of artistic means and the conception of artistic ends. Modern art is no longer a copy of concrete objects; it has set itself on a different plane, it has upturned completely the conception of Art that existed hitherto.

The artist of the Past, riveted to nature, forgot about the picture as an important phenomenon, and. as a result, it became merely a pale reminder of what he saw, a boring assemblage of ready-made, indivisible images of nature, the fruit of logic with its immutable, nonaesthetic characteristics. Nature enslaved the artist.

And if in olden times, the individual transformation of nature found occasional expression when the artist changed it according to his individual conception (the works of archaic eras, of infant nations, the primitives), it was, nevertheless, an example of an unrealized property, attempts at free speech, and more often than not, the ready-made images triumphed as a result.

Only now does the artist create a Picture quite consciously not only by not copying nature, but also by subordinating the primitive conception of it to conceptions complicated by all the psychology of modern creative thought: what the artist sees + what he knows + what he remembers, etc. In putting paint onto canvas, he further subjects the result of this consciousness to a constructive processing that, strictly speaking, is the most important thing in Art—and the very conception of the Picture and of its self-sufficient value can arise only on this condition.

In an ideal state of affairs the artist passes spontaneously from one creative state to another, and the Principles—the Intuitive, the Individual, the Abstract—are united organically, not mechanically. I do not intend to analyze the individual trends of modern art but wish merely to determine the general character of the New creative World View. I shall touch on these trends only to the extent that they are the consequence of this New creative psychology and evoke this or that attitude in the public and critics nurtured on the psychology of the old conception of art. To begin with, the art of our time will be fatally incomprehensible to such people unless they make the effort to accept the required viewpoint.

For the majority of the public nurtured by pseudo artists on copies of nature, the conception of beauty rests on the terms "Familiar" and "Intelligible." So when an art created on new principles forces the public to awaken from its stagnant, sleepy attitudes crystallized once and for all, the transition to a different state incites protest and hostility since the public is unprepared for it.

Only in this way can the enormity of the reproaches cast at the whole of the Young Art and its representatives be explained.

—Reproaches made from self-interest, self-advertisement, charlatanism, and every kind of mean trick.

The disgusting roars of laughter at exhibitions of the leading trends can be explained only by a reluctance to be educated.

The bewilderment at pictures and titles expressed in technical language (directrix, color instrumentation, etc.) can be explained only by crass ignorance.

Undoubtedly, if a person came to a musical evening, read in the program

the titles of the pieces—"Fugue," "Sonata," "Symphony," etc.—and suddenly began to roar with laughter, indicating that these definitions were amusing and pretentious, his neighbors would shrug their shoulders and make him feel a fool.

In what way does the usual kind of visitor to current "Union of Youth" exhibitions differ from this type as he creases up with laughter when confronted with specific artistic terms in the catalogue and does not take the trouble to ascertain their true meaning?

But if the attitude of a certain section of the public is tactless, then that of the critics and their confrères in art toward its Young representatives is, unfortunately, not only no less tactless and ignorant, but is often even careless. Everyone who follows the art scene is familiar with A. Benois's articles on cubism:

"Cubism or Ridiculism?" [1] is a shameful stain on Russian criticism.

And if such a well-known art critic displays complete ignorance of questions of a specialized nature, then what can we expect from the newspaper judges who earn their bread and butter by looking for truths to please the mob's bigoted opinions!

When there is no possibility of averting your opponent's victory by disarming him, there is only one thing left—to depreciate his significance.

The opponents of the New Art resort to this onslaught by rejecting its self-sufficient significance, declaring it to be "transient"; they do not even understand properly the conception of this Art and dump cubism, futurism, and other manifestations of art life onto the same heap. Hence they elucidate neither their essential difference, nor their common cohesive theses.

Let us turn to the concepts *transient* and *self-sufficient*. Do these words denote a qualitative or a quantitative difference? In all the manifestations of cultural life and hence in art as well, only an epoch of Senility and Imitation—a period of life's mortification—can, according to the only correct definition, be called a "transient epoch."

Every new epoch in art differs from the preceding one in that it introduces many new artistic theses into its previously cultivated experience, and in following the path of this development, it works out a new code of artistic formulas. But in the course of time, creative energy begins inevitably to slacken.

New formulas cannot be cultivated—on the contrary, those cultivated previously develop artistic technique to an extraordinary level of refinement and reduce it to prestidigitation of the paintbrush; the extreme expression of this is a crystallization into the conditioned repetition of ready-made forms. And in this soil the putrid flowers of imitation thrive. Without going into the

depths of art history, we can cite examples of imitation from the not too distant past (it, too, has grown obsolete), namely, the exhibitions of the "World of Art" and especially the "Union of Russian Artists" [2] as they now stand: they give nothing to the treasure house of art and essentially are merely the epigones of the Wanderers. The only difference is that the servile imitation of nature with a smattering of Social-Populist ideology (the Wanderers) is replaced in this case by the imitation of an intimate aristocratic life with its cult of antiquity and sentimentality of individual experience (the cozy art of the "World of Art" exhibitions and their like).

I pointed out above that all previous art had touched on problems of a purely painterly nature only by allusion and that it had confined itself generally to the repetition of the visible; we can say therefore that only the nineteenth century, thanks to the school of the impressionists, advanced theses that had been unknown previously: the stipulation of a locale of air and light in the picture and color analysis.

Then followed Van Gogh, who hinted at the principle of dynamism, and Cézanne, who advanced the questions of construction, planar and surface dimension.

But Van Gogh and Cézanne are only the estuaries of those broad and impetuous currents that are most well defined in our time: futurism and cubism.

Proceeding from the possibilities to which I alluded (dynamism, planar and surface dimension), each of these currents has enriched art with a series of independent theses.

Moreover, although initially they were diametrically opposed to each other (Dynamics, Statics), they were enriched subsequently with a series of common theses. These have lent a common tone to all modern trends in painting.

Only modern Art has advocated the full and serious importance of such principles as pictorial dynamism, volume and equilibrium, weight and weightlessness, linear and plane displacement, rhythm as a legitimate division of space, design, planar and surface dimension, texture, color correlation, and others. Suffice it to enumerate these principles that distinguish the New Art from the Old to be convinced that they are the Qualitative—and not just the quantitative—New Basis that proves the "self-sufficient" significance of the New Art. They are principles hitherto unknown that signify the rise of a new era in creation—an era of purely artistic achievements.

—The era of the final, absolute liberation of the Great Art of Painting from the alien traits of Literature, Society, and everyday life. Our age is to

be credited with the cultivation of this valuable world view—an age that is not affected by the question of how quickly the individual trends it has created flash past.

After elucidating the essential values of the New Art, one cannot help noting the extraordinary rise in the whole creative life of our day, the unprecedented diversity and quantity of artistic trends.

Messrs. art critics and veterans of the old art are being true to themselves in their fatal fear of what is beautiful and continually renewing itself; they are frightened and tremble for the little caskets of their meager artistic achievements. In order to defend publicly this pitiful property and the positions they occupy, they spare no effort to slander the Young Art and to arrest its triumphant procession. They reproach it further with frivolity and instability.

It is high time that we realized that the future of Art will be assured only when the thirst for eternal renewal in the artist's soul becomes inexhaustible, when wretched individual taste loses its power over him and frees him from the necessity of continually rehashing.

Only the absence of honesty and of true love of art provides some artists with the effrontery to live on stale tins of artistic economies stocked up for several years, and year in, year out, until they are fifty, to mutter about what they had first started to talk about when they were twenty.

Each moment of the present is dissimilar to a moment of the past, and moments of the future will contain inexhaustible possibilities and new revelations!

How can one explain the premature spiritual death of the artists of the Old Art, if not by laziness?

They end their days as innovators before they are barely thirty, and then turn to rehashing.

There is nothing more awful in the World than repetition, uniformity.

Uniformity is the apotheosis of banality.

There is nothing more awful in the World than an artist's immutable Face, by which his friends and old buyers recognize him at exhibitions—this accursed mask that shuts off his view of the future, this contemptible hide in which are arrayed all the "venerable" tradesmen of art clinging to their material security!

There is nothing more terrible than this immutability when it is not the imprint of the elemental force of individuality, but merely the tested guarantee of a steady market!

It is high time that we put an end to the debauch of critics' ribaldry and

confessed honestly that only "Union of Youth" exhibitions are the pledges of art's renewal. Contempt should be cast on those who hold dear only peaceful sleep and relapses of experience.

SUPREMATIST STATEMENTS, 1915

The texts that follow were published on the occasion of the opening of the "Last Futurist Exhibition of Pictures 0.10" organized by Ivan Puni in Petrograd (December 19, 1915–January 19, 1916) [bibl. R364] and were distributed gratis as two separate leaflets (Puni/Kseniya Boguslavskaya as one, Kazimir Malevich/Ivan Klyun/Mikhail Menkov as the other) while the exhibition was in progress. [The texts are reprinted in bibl. 33, pp. 52–53; French translation, ibid., pp. 153–54.] The written contribution by Malevich was virtually the same as the first eight paragraphs of his book *From Cubism and Futurism to Suprematism* (see p. 118–19), the first edition of which was on sale at the exhibition.

The exhibition itself was the first public showing of suprematist works and judging by the newspaper *Obozrenie teatrov* [Theater Observer] (Petrograd) for January 9, 1916, this was the first time that suprematism as an art movement had been heard of. "0.10" witnessed the debut of Malevich's *Black Square on a White Background* (called *Square* in the catalogue, no. 39) and also of his *Red Square on a White Background* (called *Painterly Realism of Red Masses in Two Dimensions* in the catalogue, no. 47), a canvas that he contributed to many of his exhibitions. These, however, were not the only monochromatic paintings at the exhibition: according to one review (in *Vechernee vremya* [Evening] [Petrograd], January 20, 1916), Puni also submitted a "board . . . painted green" (no. 107 in the catalogue). Vladimir Tatlin was also represented at the exhibition, and his own manifesto [bibl. R447] had been published on the occasion of its opening, but in contrast to Malevich and Puni, he received little critical attention.

Malevich and Puni expanded the ideas set forth in their manifestoes at a public presentation that they organized at the Tenishev Institute, Petrograd, on January 12, 1916. Malevich expressed ideas similar to those in his book, illustrating his talk with his own pictures and with an "experimental demonstration . . . of a sketch according to the principle of cubofuturism" (from the poster advertising the event); Puni delivered a lecture that encompassed "academic trends . . . cubofuturism . . .

suprematism, and the fall of futurism" (ibid.); and Boguslavskaya read some of her own poetry. Both the manifestoes and the lectures underlined basic differences between Malevich and Puni: Malevich emerged as more individualistic, more irrational, yet more imaginative, whereas Puni tended toward a more impersonal, more rational, and more scientific conception. But whatever their differences, it was clear that thanks to their "philosophy of savagery and bestiality" (A[leksandr] Benois, "Poslednyaya futuristicheskaya vystavka" [The Last Futurist Exhibition], in *Rech* [Discourse] [Petrograd], January 9, 1916), they had indeed "conquered Raphael, Titian, and Michelangelo" (I[gor] Gr[abar]: "O skuchizme" [On Boringism] in *Den* [Day] [Petrograd], January 14, 1916). Apart from the Benois, all the above reviews are reproduced in bibl. 33, pp. 68–85. For a German translation of the Puni/ Boguslavskaya, Kliun and Menkov texts see bibl. 209viii, pp. 73, 74.

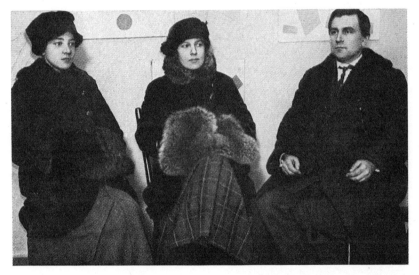

Photograph taken at the exhibition "0.10," 1915. Left to right: Olga Rozanova, Kseniya Boguslavskaya, Kazimir Malevich. The paintings hanging behind them are part of Malevich's contribution. Photograph courtesy Mr. Herman Berninger, Zurich.

IVAN PUNI AND
KSENIYA BOGUSLAVSKAYA

Puni—Also known as Jean Pougny. Born Kuokkala, 1894; died Paris, 1956. Received early education in St. Petersburg; 1909: first trip to Paris; 1912: back in St. Petersburg; contact with the Burliuks, Kazimir Malevich, and other members of the avant-garde; 1912–16; contributed to the "Union of Youth," organized "Tramway V" and "0.10"; 1913: married Boguslavskaya; 1918: professor at Pegoskhuma/Svomas; taught at Vitebsk; 1920: moved to Berlin; 1923: settled in Paris.

Xana Boguslavskaya—Born Kuokkala, 1892; died outside Paris, 1972. 1911–12: in Italy; 1912: in Paris; 1913; married Puni; 1915–16: contributed to "Tramway V" and "0.10"; student at Pegoskhuma/Svomas while Puni taught there; did street decoration; 1920: moved to Berlin; 1923: settled in Paris.

1) An object is the sum of real units, a sum that has a utilitarian purpose.
 (Utility is the purpose of the sum of real elements to depict *something*.
 Example: a certain sum of elements is a stone, another a man, etc.)
2) The substance of an object (reality) and the being of an object like a chair, a samovar, a house, etc., are not the same thing.
A) Freedom of the object from meaning, the destruction of utility.
B) A picture is a new conception of abstracted real elements, deprived of meaning.
3) 2 × 2 is anything you like, but not four.
C) (The aesthetic thing in itself.)
 An object (a world) freed from meaning disintegrates into real elements—the foundation of art.
B. 2) The correlation of elements discovered and revealed in a picture is a new reality, the departure point of the new painting.

Ivan Puni, 1918. Photograph courtesy Mr. Herman Berninger, Zurich.

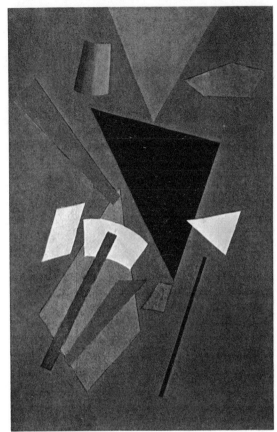

Ivan Puni: *Suprematist Composition*, 1915. Oil on canvas, 86.5 x 56.5 cm. Collection Mr. and Mrs. Herman Berninger, Zurich. This was exhibited at "0.10."

KAZIMIR MALEVICH

For biography and text see pp. 116ff.

IVAN KLYUN

Also known as Klyunkov. Born Kiev, 1873; died Moscow, 1942. Studied in Kiev, Moscow, and Warsaw; early 1900s: attended the private studios of Fedor Rerberg and Ilya Mashkov in Mosocow; 1910: cofounded the exhibition society Moscow Salon; close contact with Aleksei Kruchenykh, Kazimir Malevich, and Mikhail Matyushin; 1913–14: contributed to the last exhibition of the Union of Youth in St. Petersburg; 1915: supported Suprematism; 1916: joined the Knave of Diamonds; 1915–17: contributed to the "Tramway V," "0.10," "Shop," "Knave of Diamonds," and other exhibitions; 1918–21: professor at Svomas/Vkhutemas; 1921: member of Inkhuk; 1925: member of Four Arts; continued to exhibit during the 1930s.

Before us sculpture was a means of reproducing objects.

There was no sculptural art, but there was the art of sculpture.

Only we have become fully aware of the principle: Art as an end in itself.

Michelangelo carved a beautiful David out of marble—but in a purely sculptural sense this work is insignificant.

In it is the beauty of youth, but no beauty of sculpture. Our sculpture is pure art, free from any surrogates; there is no content in it, only form.

MIKHAIL MENKOV

Also known as Minkov. Born Moscow, dates unknown. 1915–16: contributed to "0.10"; 1917: contributed to the "Knave of Diamonds"; 1919: at the "Eighth State Exhibition" and "Tenth State Exhibition"; after 1919: stopped exhibiting in Russia.

Every art that is valued by its ability to repeat the visible is a defective art.

Color must live and speak for itself. Hitherto there was no such thing as pure painting; there were just copies of nature and of ideas.

Ivan Klyun, mid-1920s.

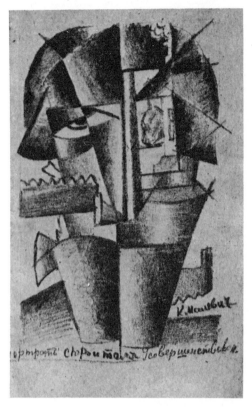

Kazimir Malevich: *Portrait of a Builder Completed.*
Lithograph illustration for Zina V. and Aleksei Kruchen-
ykh: *Porosyata* [Piglets] (St. Petersburg, 1913). This
lithograph is, in fact, a version of Malevich's *Portrait of
Ivan Klyun* (1912), now in the Russian Museum, Lenin-
grad. Courtesy Leonard Hutton Galleries, New York.

KAZIMIR MALEVICH
From Cubism and Futurism
to Suprematism:
The New Painterly Realism, 1915

Born near Kiev, 1878; died Leningrad, 1935. 1903: entered the Moscow Institute of Painting, Sculpture, and Architecture; ca. 1910: influenced by neoprimitivism; 1913: took part in a futurist conference in Uusikirkko, Finland [see bibl. R306]; designed decor for the Aleksei Kruchenykh–Mikhail Matyushin opera *Victory over the Sun*, produced in December in St. Petersburg; illustrated futurist booklets; 1914: met Filippo Marinetti on the latter's arrival in Russia; 1915–16: first showing of suprematist works at "0.10"; 1911–17: contributed to the "Union of Youth," "Donkey's Tail," "Target," "Tramway V," "Shop," "Knave of Diamonds," and other exhibitions; 1918: active on various levels within Narkompros; 1919–22: at the Vitebsk Art School, where he replaced Marc Chagall as head; organized Unovis [Uniya novogo iskusstva/Utverditeli novogo iskusstva—Union of the New Art/Affirmers of the New Art]; 1920 to late 1920s: worked on his experimental constructions—the so-called *arkhitektony* and *planity*; 1922: joined IKhK; 1927: visited Warsaw and Berlin with a one-man exhibition; contact with the Bauhaus; late 1920s: returned to a more representational kind of painting.

The translation is of Malevich's *Ot kubizma i futurizma k suprematizmu. Novyi zhivopisnyi realizm* (Moscow, 1916). This text, written in its original form in 1915, saw three editions: the first appeared in December 1915 in Petrograd under the title *Ot kubizma k suprematizmu. Novyi zhivopisnyi realizm* [From Cubism to Suprematism. The New Painterly Realism] and coincided with the exhibition "0.10"; the second followed in January 1916, also in Petrograd; the third, from which this translation is made, was published in November 1916, but in Moscow, and is signed and dated 1915. The text has already been translated into English but with some inaccuracies [bibl. 159, vol. 1, 19–40] and into French [bibl. 163, pp. 45–73; and bibl. 176xviii, pp. 185–203] and Italian [bibl. 176xix, pp. 173–90]. The first eight paragraphs of the text are similar to Malevich's statement issued at "0.10" (see p. 110ff.). The style is typical of Malevich's writings, and the grammatical eccentricities and somewhat arbitrary italicizing create occasional ambiguities. Certain ideas and expressions used in the text recall the writings of Nikolai Kulbin, Vladimir Markov, and Olga Rozanova, which Malevich undoubtedly knew.

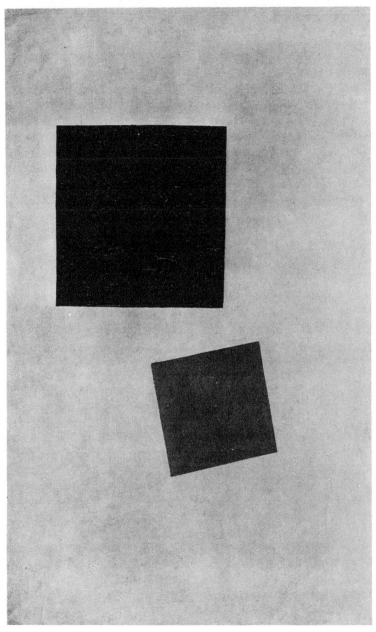

Kazimir Malevich: *Suprematist Painting: Black and Red Square,* 1915. Oil on canvas, 71.4 x 44.4 cm. Collection The Museum of Modern Art, New York. This was exhibited at ''0.10.''

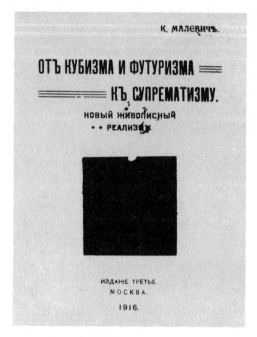

К. МАЛЕВИЧЪ.

ОТЪ КУБИЗМА И ФУТУРИЗМА ==
== КЪ СУПРЕМАТИЗМУ.
НОВЫЙ ЖИВОПИСНЫЙ
♦ ♦ РЕАЛИЗМЪ.

ИЗДАНІЕ ТРЕТЬЕ.
МОСКВА.
1916.

Cover of Kazimir Malevich's book *Ot kubizma i futurizma k suprematizmu* [From Cubism and Futurism to Suprematism], third edition. (Moscow, 1916).

Only when the conscious habit of seeing nature's little nooks, Madonnas, and Venuses in pictures disappears *will we witness a purely painterly work of art.*

I have transformed myself *in the zero of form* and have fished myself out of the *rubbishy slough of academic art.*

I have destroyed the ring of the horizon and got out of the circle of objects, the horizon ring that has imprisoned the artist and the forms of nature.

This accursed ring, by continually revealing novelty after novelty, leads the artist away from the *aim of destruction.*

And only *cowardly consciousness* and insolvency of creative power in an artist yield to this deception and establish *their art on the forms of nature,* afraid of losing the foundation on which the *savage and the academy* have based their art.

To produce favorite objects and little nooks of nature is just like a thief being enraptured by his shackled legs.

Only dull and impotent artists veil their work with *sincerity*. Art requires *truth*, not *sincerity*.

Objects have vanished like smoke; to attain the new artistic culture, art advances toward creation as an end in itself and toward domination over the forms of nature.

The Art of the Savage and Its Principles

The savage was the first to establish the principle of naturalism: in drawing a dot and five little sticks, he attempted to transmit his own image.

This first attempt laid the basis for the conscious imitation of nature's forms.

Hence arose the aim of approaching the face of nature as closely as possible.

And all the artist's efforts were directed toward the transmission of her creative forms.

The first inscription of the savage's primitive depiction gave birth to collective art, or the art of repetition.

Collective, because the real man with his subtle range of feelings, psychology, and anatomy had not been discovered.

The savage saw neither his outward image nor his inward state.

His consciousness could see only the outline of a man, a beast, etc.

And as his consciousness developed, so the outline of his depiction of nature grew more involved.

The more his consciousness embraced nature, the more involved his work became, and the more his experience and skill increased.

His consciousness developed in only one direction, toward nature's creation and not toward new forms of art.

Therefore his primitive depictions cannot be considered creative work.

The distortion of reality in his depictions is the result of weak technique.

Both technique and consciousness were only at the beginning of their development.

And his pictures must not be considered art.

Because unskillfulness is not art.

He merely pointed the way to art.

Consequently, his original outline was a framework on which the generations hung new discovery after new discovery made in nature.

And the outline became more and more involved and achieved its flowering in antiquity and the Renaissance.

The masters of these two epochs depicted man in his complete form, both outward and inward.

Man was assembled, and his inward state was expressed.

But despite their enormous skill, they did not, however, perfect the savage's idea:

The reflection of nature on canvas, as in a mirror.

And it is a mistake to suppose that their age was the most brilliant flowering of art and that the younger generation should at all costs aspire toward this ideal.

This idea is false.

It diverts young forces from the contemporary current of life and thereby deforms them.

Their bodies fly in airplanes, but they cover art and life with the old robes of Neros and Titians.

Hence they are unable to observe the new beauty of our modern life.

Because they live by the beauty of past ages.

That is why the realists, impressionists, cubism, futurism, and suprematism were not understood.

The latter artists cast aside the robes of the past, came out into modern life, and found new beauty.

And I say:

That no torture chambers of the academies will withstand the days to come.

Forms move and are born, and we are forever making new discoveries.

And what we discover must not be concealed.

And it is absurd to force *our* age into the old forms of a bygone age.

The hollow of the past cannot contain the gigantic constructions and movement of our life.

As in our life of technology:

We cannot use the ships in which the Saracens sailed, and so in art we should seek forms that correspond to modern life.

The technological side of our age advances further and further ahead, but people try to push art further and further back.

This is why all those people who follow their age are superior, greater, and worthier.

And the realism of the nineteenth century is much greater than the ideal forms found in the aesthetic experience of the ages of the Renaissance and Greece.

The masters of Rome and Greece, after they had attained a knowledge of human anatomy and produced a depiction that was to a certain extent realistic:

were overrun by aesthetic taste, and their realism was pomaded and powdered with the taste of aestheticism.

Hence their perfect line and nice colors.

Aesthetic taste diverted them from the realism of the earth, and they reached the impasse of idealism.

Their painting is a means of decorating a picture.

Their knowledge was taken away from nature into closed studios, where pictures were manufactured for many centuries.

That is why their art stopped short.

They closed the doors behind them, thereby destroying their contact with nature.

And that moment when they were gripped by the idealization of form should be considered the collapse of real art.

Because art should not advance toward abbreviation or simplification, but toward complexity.

The Venus de Milo is a graphic example of decline. It is not a real woman, but a parody.

Angelo's David is a deformation:

His head and torso are modeled, as it were, from two incongruent forms.

A fantastic head and a real torso.

All the masters of the Renaissance achieved great results in anatomy.

But they did not achieve veracity in their impression of the body.

Their painting does not transmit the body, and their landscapes do not transmit living light, despite the fact that bluish veins can be seen in the bodies of their people.

The art of naturalism is the savage's idea, the aspiration to transmit what is seen, but not to create a new form.

His creative will was in an embryonic state, but his impressions were more developed, which was the reason for his reproduction of reality.

Similarly it should not be assumed that his gift of creative will was developed in the classical painters.

Because we see in their pictures only repetitions of the real forms of life in settings richer than those of their ancestor, the savage.

Similarly their composition should not be considered creation, for in most cases the arrangement of figures depends on the subject: a king's procession, a court, etc.

The king and the judge already determine the places on the canvas for the persons of secondary importance.

Furthermore, the composition rests on the purely aesthetic basis of niceness of arrangement.

Hence arranging furniture in a room is still not a creative process.

In repeating or tracing the forms of nature, we have nurtured our consciousness with a false conception of art.

The work of the primitives was taken for creation.

The classics also.

If you put the same glass down twenty times, that's also creation.

Art, as the ability to transmit what we see onto a canvas, was considered creation.

Is placing a samovar on a table also really creation?

I think quite differently.

The transmission of real objects onto a canvas is the art of skillful reproduction, that's all.

And between the art of creating and the art of repeating there is a great difference.

To create means to live, forever creating newer and newer things.

And however much we arrange furniture about rooms, we will not extend or create a new form for them.

And however many moonlit landscapes the artist paints, however many grazing cows and pretty sunsets, they will remain the same dear little cows and sunsets. Only in a much worse form.

And in fact, whether an artist is a genius or not is determined by the number of cows he paints.

The artist can be a creator only when the forms in his picture have nothing in common with nature.

For art is the ability to create a construction that derives not from the interrelation of form and color and not on the basis of aesthetic taste in a con-

struction's compositional beauty, *but on the basis of weight, speed, and direction of movement.*

Forms must be given life and the right to individual existence.

Nature is a living picture, and we can admire her. We are the living heart of nature. We are the most valuable construction in this gigantic living picture.

We are her living brain, which magnifies her life.

To reiterate her is theft, and he who reiterates her is a thief—a nonentity who cannot give, but who likes to take things and claim them as his own. (Counterfeiters.)

An artist is under a vow to be a free creator, but not a free robber.

An artist is given talent in order that he may present to life his share of creation and swell the current of life, so versatile.

Only in absolute creation will he acquire his right.

And this is possible when we free all art of philistine ideas and subject matter and teach our consciousness to see everything in nature not as real objects and forms, but as material, as masses from which forms must be made that have nothing in common with nature.

Then the habit of seeing Madonnas and Venuses in pictures, with fat, flirtatious cupids, will disappear.

Color and texture are of the greatest value in painterly creation—they are the essence of painting; but this essence has always been killed by the subject.

And if the masters of the Renaissance had discovered painterly surface, it would have been much nobler and more valuable than any Madonna or Gioconda.

And any hewn pentagon or hexagon would have been a greater work of sculpture than the Venus de Milo or David.

The principle of the savage is to aim to create art that repeats the real forms of nature.

In intending to transmit the living form, they transmitted its corpse in the picture.

The living was turned into a motionless, dead state.

Everything was taken alive and pinned quivering to the canvas, just as insects are pinned in a collection.

But that was the time of Babel in terms of art.

They should have created, but they repeated; they should have deprived

forms of content and meaning, but they enriched them with this burden.

They should have dumped this burden, but they tied it around the neck of creative will.

The art of painting, the word, sculpture, was a kind of camel, loaded with all the trash of odalisques, Salomes, princes, and princesses.

Painting was the tie on the gentleman's starched shirt and the pink corset drawing in the stomach.

Painting was the aesthetic side of the object.

But it was never an independent end in itself.

Artists were officials making an inventory of nature's property, amateur collectors of zoology, botany, and archaeology.

Nearer our time, young artists devoted themselves to pornography and turned painting into lascivious trash.

There were no attempts at purely painterly tasks as such, without any appurtenances of real life.

There was no realism of painterly form as an end in itself, and there was no creation.

The realist academists are the savage's last descendants.

They are the ones who go about in the worn-out robes of the past.

And again, as before, some have cast aside these greasy robes.

And given the academy rag-and-bone man a slap in the face with their proclamation of futurism.[1]

They began in a mighty movement to hammer at the consciousness as if at nails in a stone wall.

To pull you out of the catacombs into the speed of contemporaneity.

I assure you that whoever has not trodden the path of futurism as the exponent of modern life is condemned to crawl forever among the ancient tombs and feed on the leftovers of bygone ages.

Futurism opened up the "new" in modern life: the beauty of speed.

And through speed we move more swiftly.

And we, who only yesterday were futurists, have reached new forms through speed, new relationships with nature and objects.

We have reached suprematism, abandoning futurism as a loophole through which those lagging behind will pass.

We have abandoned futurism, and we, bravest of the brave, *have spat on the altar of its art.*

But can cowards spit on their idols—

As we did yesterday!!!

I tell you, you will not see the new beauty and the truth until you venture to spit.

Before us, all arts were old blouses, which are changed just like your silk petticoats.

After throwing them away, you acquire new ones.

Why do you not put on your grandmothers' dresses, when you thrill to the pictures of their powdered portraits?

This all confirms that your body is living in the modern age while your soul is clothed in your grandmother's old bodice.

This is why you find the Somovs, Kustodievs,[2] and various such rag merchants so pleasant.

And I hate these secondhand-clothes dealers.

Yesterday we, our heads proudly raised, defended futurism—

Now with pride we spit on it.

And I say that what we spat upon will be accepted.

You, too, spit on the old dresses and clothe art in something new.

We rejected futurism not because it was outdated, and its end had come. No. The beauty of speed that it discovered is eternal, and the new will still be revealed to many.

Since we run to our goal through the speed of futurism, our thought moves more swiftly, and whoever lives in futurism is nearer to this aim and further from the past.

And your lack of understanding is quite natural. Can a man who always goes about in a cabriolet really understand the experiences and impressions of one who travels in an express or flies through the air?

The academy is a moldy vault in which art is being flagellated.

Gigantic wars, great inventions, conquest of the air, speed of travel, telephones, telegraphs, dreadnoughts are the realm of electricity.

But our young artists paint Neros and half-naked Roman warriors.

Honor to the futurists who forbade the painting of female hams,[3] the painting of portraits and guitars in the moonlight.

They made a huge step forward: they abandoned meat and glorified the machine.

But meat and the machine are the muscles of life.

Both are the bodies that give life movement.

It is here that two worlds have come together.

The world of meat and the world of iron.

Both forms are the mediums of utilitarian reason.

But the artist's relationship to the forms of life's objects requires elucidation.

Until now the artist always followed the object.

Thus the new futurism follows the machine of today's dynamism.

These two kinds of art are the old and the new—futurism: they are behind the running forms.

And the question arises: will this aim in the art of painting respond to its existence?

No!

Because in following the form of airplanes or motorcars, we shall always be anticipating the new cast-off forms of technological life. . . .

And second:

In following the form of things, we cannot arrive at painting as an end in itself, at spontaneous creation.

Painting will remain the means of transmitting this or that condition of life's forms.

But the futurists forbade the painting of nudity not in the name of the liberation of painting and the word, so that they would become ends in themselves.

But because of the changes in the technological side of life.

The new life of iron and the machine, the roar of motorcars, the brilliance of electric lights, the growling of propellers, have awakened the soul, which was suffocating in the catacombs of old reason and has emerged at the intersection of the paths of heaven and earth.

If all artists were to see the crossroads of these heavenly paths, if they were to comprehend these monstrous runways and intersections of our bodies with the clouds in the heavens, then they would not paint chrysanthemums.

The dynamics of movement has suggested advocating the dynamics of painterly plasticity.

But the efforts of the futurists to produce purely painterly plasticity as such were not crowned with success.

They could not settle accounts with objectism,[4] which would have made their task easier.

When they had driven reason halfway from the field of the picture, from the old calloused habit of seeing everything naturally, they managed to make a picture of the new life, of new things, but that is all.

In the transmission of movement, the cohesiveness of things *disappeared* as their flashing parts hid themselves among other running bodies.

And in constructing the parts of the running objects, they tried to transmit only the impression of movement.

But in order to transmit the movement of modern life, one must operate with its forms.

Which made it more complicated for the art of painting to reach its goal.

But however it was done, consciously or unconsciously, for the sake of movement or for the sake of transmitting an impression, the cohesion of things was violated.

And in this breakup and violation of cohesion lay the latent meaning that had been concealed by the naturalistic purpose.

Underlying this destruction lay primarily not the transmission of the movement of objects, but their destruction for the sake of pure painterly essence, i.e., toward attainment of nonobjective creation.

The rapid interchange of objects struck the new naturalists—the futurists—and they began to seek means of transmitting it.

Hence the construction of the futurist pictures that you have seen arose from the discovery of points on a plane where the placing of real objects during their explosion or confrontation would impart a sense of time at a maximum speed.

These points can be discovered independently of the physical law of natural perspective.

Thus we see in futurist pictures the appearance of clouds, horses, wheels, and various other objects in places not corresponding to nature.

The state of the object has become more important than its essence and meaning.

We see an extraordinary picture.

A new order of objects makes reason shudder.

The mob howled and spat, critics rushed at the artist like dogs from a gateway.

(Shame on them.)

The futurists displayed enormous strength of will in destroying the habit of the old mind, in flaying the hardened skin of academism and spitting in the face of the old common sense.

After rejecting reason, the futurists proclaimed intuition as the subconscious.

But they created their pictures not out of the subconscious forms of intuition, but used the forms of utilitarian reason.

Consequently, only the discovery of the difference between the two lives of the old and the new art will fall to the lot of intuitive feeling.

We do not see the subconscious in the actual construction of the picture.

Rather do we see the conscious calculation of construction.

In a futurist picture there is a mass of objects. They are scattered about the surface in an order unnatural to life.

The conglomeration of objects is acquired not through intuitive sense, but through a purely visual impression, while the building, the construction, of the picture is done with the intention of achieving an impression.

And the sense of the subconscious falls away.

Consequently, we have nothing purely intuitive in the picture.

Beauty, too, if it is encountered, proceeds from aesthetic taste.

The intuitive, I think, should manifest itself when forms are unconscious and have no response.

I consider that the intuitive in art had to be understood as the aim of our sense of search for objects. And it followed a purely conscious path, blazing its decisive trail through the artist.

(Its form is like two types of consciousness fighting between themselves.)

But the consciousness, accustomed to the training of utilitarian reason, could not agree with the sense that led to the destruction of objectism.

The artist did not understand this aim and, submitting to this sense, betrayed reason and distorted form.

The art of utilitarian reason has a definite purpose.

But intuitive creation does not have a utilitarian purpose. Hitherto we have had no such manifestation of intuition in art.

All pictures in art follow the creative forms of a utilitarian order. All the naturalists' pictures have the same form as in nature.

Intuitive form should arise out of nothing.

Just as reason, creating things for everyday life, extracts them from nothing and perfects them.

Thus the forms of utilitarian reason are superior to any depictions in pictures.

They are superior because they are alive and have proceeded from material that has been given a new form for the new life.

Here is the Divine ordering crystals to assume another form of existence.

Here is a miracle. . . .

There should be a miracle in the creation of art, as well.

But the realists, in transferring living things onto the canvas, deprive their life of movement.

And our academies teach dead, not living, painting.

Hitherto intuitive feeling has been directed to drag newer and newer forms into our world from some kind of bottomless void.

But there has been no proof of this in art, and there should be.

And I feel that it does already exist in a real form and quite consciously.

The artist should know what, and why, things happen in his pictures.

Previously he lived in some sort of mood. He waited for the moonrise and twilight, put green shades on his lamps, and all this tuned him up like a violin.

But if you asked him why the face on his canvas was crooked, or green, he could not give an exact answer.

"I want it like that, I like it like that. . . ."

Ultimately, this desire was ascribed to creative will.

Consequently, the intuitive feeling did not speak clearly. And thereafter its state became not only subconscious, but completely unconscious.

These concepts were all mixed together in pictures. The picture was half-real, half-distorted.

Being a painter, I ought to say why people's faces are painted green and red in pictures.

Painting is paint and color; it lies within our organism. Its outbursts are great and demanding.

My nervous system is colored by them.

My brain burns with their color.

But color was oppressed by common sense, was enslaved by it. And the spirit of color weakened and died out.

But when it conquered common sense, then its colors flowed onto the repellent form of real things.

The colors matured, but their form did not mature in the consciousness.

This is why faces and bodies were red, green, and blue.

But this was the herald leading to the creation of painterly forms as ends in themselves.

Now it is essential to shape the body and lend it a living form in real life.

And this will happen when forms emerge from painterly masses; that is, they will arise just as utilitarian forms arose.

Such forms will not be repetitions of living things in life, but will themselves be a living thing.

A painted surface is a real, living form.

Intuitive feeling is now passing to consciousness; no longer is it subconscious.

Even, rather, vice versa—it always was conscious, but the artist just could not understand its demands.

The forms of suprematism, the new painterly realism, already testify to the construction of forms out of nothing, discovered by intuitive reason.

The cubist attempt to distort real form and its breakup of objects were aimed at giving the creative will the independent life of its created forms.

Painting in Futurism

If we take any point in a futurist picture, we shall find either something that is coming or going, or a confined space.

But we shall not find an independent, individual painterly surface.

Here the painting is nothing but the outer garment of things.

And each form of the object was painterly insofar as its form was necessary to its existence, and not vice versa.

The futurists advocate the dynamics of painterly plasticity as the most important aspect of a painting.

But in failing to destroy objectivism, they achieve only the dynamics of things.

Therefore futurist paintings and all those of past artists can be reduced from twenty colors to one, without sacrificing their impression.

Repin's picture of Ivan the Terrible could be deprived of color, and it will still give us the same impressions of horror as it does in color.

The subject will always kill color, and we will not notice it.

Whereas faces painted green and red kill the subject to a certain extent, and the color is more noticeable. And color is what a painter lives by, so it is the most important thing.

And here I have arrived at pure color forms.

And suprematism is the purely painterly art of color whose independence cannot be reduced to a single color.

The galloping of a horse can be transmitted with a single tone of pencil.

But it is impossible to transmit the movement of red, green, or blue masses with a single pencil.

Painters should abandon subject matter and objects if they wish to be pure painters.

The demand to achieve the dynamics of painterly plasticity points to the impulse of painterly masses to emerge from the object and arrive at color as an end in itself, at the domination of purely painterly forms as ends in themselves over content and things, at nonobjective suprematism—at the new painterly realism, at absolute creation.

Futurism approaches the dynamism of painting through the academism of form.

And both endeavors essentially aspire to suprematism in painting.

If we examine the art of cubism, the question arises what energy in objects incited the intuitive feeling to activity; we shall see that painterly energy was of secondary importance.

The object itself, as well as its essence, purpose, sense, or the fullness of its representation (as the cubists thought), was also unnecessary.

Hitherto it has seemed that the beauty of objects is preserved when they are transmitted whole onto the picture, and moreover, that their essence is evident in the coarseness or simplification of line.

But it transpired that one more situation was found in objects—which reveals a new beauty to us.

Namely: intuitive feeling discovered in objects the energy of dissonance, a dissonance obtained from the confrontation of two constrasting forms.

Objects contain a mass of temporal moments. Their forms are diverse, and consequently, the ways in which they are painted are diverse.

All these temporal aspects of things and their anatomy (the rings of a tree) have become more important than their essence and meaning.

And these new situations were adopted by the cubists as a means of constructing pictures.

Moreover, these means were constructed so that the unexpected confrontation of two forms would produce a dissonance of maximum force and tension.

And the scale of each form is arbitrary.

Which justifies the appearance of parts of real objects in places that do not correspond to nature.

In achieving this new beauty, or simply energy, we have freed ourselves from the impression of the object's wholeness.

The millstone around the neck of painting is beginning to crack.

An object painted according to the principle of cubism can be considered finished when its dissonances are exhausted.

Nevertheless, repetitive forms should be omitted by the artist since they are mere reiterations.

But if the artist finds little tension in the picture, he is free to take them from another object.

Consequently, in cubism the principle of transmitting objects does not arise.

A picture is made, but the object is not transmitted.

Hence this conclusion:

Over the past millennia, the artist has striven to approach the depiction of an object as closely as possible, to transmit its essence and meaning; then in our era of cubism, the artist destroyed objects together with their meaning, essence, and purpose.

A new picture has arisen from their fragments.

Objects have vanished like smoke, for the sake of the new culture of art.

Cubism, futurism, and the Wanderers differ in their aims, but are almost equal in a painterly sense.

Cubism builds its pictures from the forms of lines and from a variety of painterly textures, and in this case, words and letters are introduced as a confrontation of various forms in the picture.

Its graphic meaning is important. It is all for the sake of achieving dissonance.

And this proves that the aim of painting is the one least touched upon.

Because the construction of such forms is based more on actual superimposition than on coloring, which can be obtained simply by black and white paint or by drawing.

To sum up:

Any painted surface turned into a convex painterly relief is an artificial, colored sculpture, and any relief turned into surface is painting.

The proof of intuitive creation in the art of painting was false, for distortion is the result of the inner struggle of intuition in the form of the real.

Intuition is a new reason, consciously creating forms.

But the artist, enslaved by utilitarian reason, wages an unconscious struggle, now submitting to an object, now distorting it.

Gauguin, fleeing from culture to the savages, and discovering more freedom in the primitives than in academism, found himself subject to intuitive reason.

He sought something simple, distorted, coarse.

This was the searching of his creative will.

At all costs not to paint as the eye of his common sense saw.

He found colors but did not find form, and he did not find it because com-

mon sense showed him the absurdity of painting anything except nature.

And so he hung his great creative force on the bony skeleton of man, where it shriveled up.

Many warriors and bearers of great talent have hung it up like washing on a fence.

And all this was done out of love for nature's little nooks.

And let the authorities not hinder us from warning our generation against the clothes stands that they have become so fond of and that keep them so warm.

The efforts of the art authorities to direct art along the path of common sense annulled creation.

And with the most talented people, real form is distortion.

Distortion was driven by the most talented to the point of disappearance, but it did not go outside the bounds of zero.

But I have transformed myself in the zero of form and through zero have reached creation, that is, suprematism, the new painterly realism—nonobjective creation.

Suprematism is the beginning of a new culture: the savage is conquered like the ape.

There is no longer love of little nooks, there is no longer love for which the truth of art was betrayed.

The square is not a subconscious form. It is the creation of intuitive reason.

The face of the new art.

The square is a living, regal infant.

The first step of pure creation in art. Before it there were naïve distortions and copies of nature.

Our world of art has become new, nonobjective, pure.

Everything has disappeared; a mass of material is left from which a new form will be built.

In the art of suprematism, forms will live, like all living forms of nature.

These forms announce that man has attained his equilibrium; he has left the level of single reason and reached one of double reason.

(Utilitarian reason and intuitive reason.)

The new painterly realism is a painterly one precisely because it has no realism of mountains, sky, water. . . .

Hitherto there has been a realism of objects, but not of painterly, colored units, which are constructed so that they depend neither on form, nor on color, nor on their position vis-à-vis each other.

Each form is free and individual.

Each form is a world.

Any painterly surface is more alive than any face from which a pair of eyes and a smile protrude.

A face painted in a picture gives a pitiful parody of life, and this allusion is merely a reminder of the living.

But a surface lives; it has been born. A coffin reminds us of the dead; a picture, of the living.

This is why it is strange to look at a red or black painted surface.

This is why people snigger and spit at the exhibitions of new trends.

Art and its new aim have always been a spittoon.

But cats get used to one place, and it is difficult to house-train them to a new one.

For such people, art is quite unnecessary, as long as their grandmothers and favorite little nooks of lilac groves are painted.

Everything runs from the past to the future, but everything should live in the present, for in the future the apple trees will shed their blossoms.

Tomorrow will wipe away the vestige of the present, and you are too late for the current of life.

The mire of the past, like a millstone, will drag you into the slough.

This is why I hate those who supply you with monuments to the dead.

The academy and the critics are this millstone round your neck. The old realism is the movement that seeks to transmit living nature.

They carry on just as in the times of the Grand Inquisition.

Their aim is ridiculous because they want at all costs to force what they take from nature to live on the canvas.

At the same time as everything is breathing and running, their frozen poses are in pictures.

And this torture is worse than breaking on the wheel.

Sculptured statues, inspired, hence living, have stopped dead, posed as running.

Isn't this torture?

Enclosing the soul in marble and then mocking the living.

But you are proud of an artist who knows how to torture.

You put birds in a cage for pleasure as well.

And for the sake of knowledge, you keep animals in zoological gardens.

I am happy to have broken out of that inquisition torture chamber, academism.

I have arrived at the surface and can arrive at the dimension of the living body.

But I shall use the dimension from which I shall create the new.

I have released all the birds from the eternal cage and flung open the gates to the animals in the zoological gardens.

May they tear to bits and devour the leftovers of your art.

And may the freed bear bathe his body amid the flows of the frozen north and not languish in the aquarium of distilled water in the academic garden.

You go into raptures over a picture's composition, but in fact, composition is the death sentence for a figure condemned by the artist to an eternal pose.

Your rapture is the confirmation of this sentence.

The group of suprematists—*K. Malevich, I. Puni, M. Menkov, I. Klyun, K. Boguslavskaya, and Rozanova* [5]—*has waged the struggle for the liberation of objects from the obligations of art.*

And appeals to the academy to renounce the inquisition of nature.

Idealism and the demands of aesthetic sense are are the instruments of torture.

The idealization of the human form is the mortification of the many lines of living muscle.

Aestheticism is the garbage of intuitive feeling.

You all wish to see pieces of living nature on the hooks of your walls.

Just as Nero admired the torn bodies of people and animals from the zoological garden.

I say to all: Abandon love, abandon aestheticism, abandon the baggage of wisdom, for in the new culture, your wisdom is ridiculous and insignificant.

I have untied the knots of wisdom and liberated the consciousness of color!

Hurry up and shed the hardened skin of centuries, so that you can catch up with us more easily.

I have overcome the impossible and made gulfs with my breath.

You are caught in the nets of the horizon, like fish!

We, suprematists, throw open the way to you.

Hurry!

For tomorrow you will not recognize us.

IVAN KLYUN
Primitives
of the Twentieth Century, 1915

For biography see p. 114.

The text of this piece, "Primitivy XX veka," appeared in the collection of articles *Tainye poroki akademikov* [Secret Vices of the Academicians] (Moscow, August 1915 but dated on the cover 1916), pp. 29–30; the volume was subtitled *Sonnye svistuny* [Sleepy Whistlers; bibl. R304]. It also contained a forceful attack on symbolism by Aleksei Kruchenykh and an untitled piece by Malevich [see bibl. 159, vol. 1, 17–18, for English translation] in which he rejected reason as an artistic ingredient— an ideological parallel to his alogical paintings of the same time. Malevich's ideas of 1914–15 exerted a considerable influence on Klyun, and he owed many of his theoretical and pictorial ideas to Malevich's proximity. While containing an obvious and pejorative reference to the neoprimitivists, the title of Klyun's essay demonstrates the realization by so many of the avant-garde at this time that art should "begin again." Klyun's advocacy of the "straight line as a point of departure" betrayed his wish to create a supremely logical and rational art form, a move whereby he very soon clashed with Malevich. Yet despite Klyun's scientific analyses of painting [e.g., bibl. R289] and his condemnation of what he considered to be Malevich's thematic suprematism (see pp. 142 ff), he himself evolved toward "cosmic abstraction" in the 1920s before returning to a more representational kind of painting after 1930.

———

To turn back is to acknowledge one's impotence in creative work.

We think that, at last, in the twentieth century, the time has come to finish with the principles of Hellenic art for good and to begin to create a different art on completely new bases.

We are striving to dislodge art from its dead position.

We are extending and deepening the conception of concrete reality.

In our artistic communication we do not halt life, as has been done hitherto, but all phenomena and ideas in our depictions move within a prism, interweaving and self-refracting. Hence our art is many-faceted and universal.

But since any change in an artistic idea results, of necessity, in a change of its form, so for us, its previous form becomes unsuitable.

In constructing our new art form we did not wish to repeat the fateful mis-

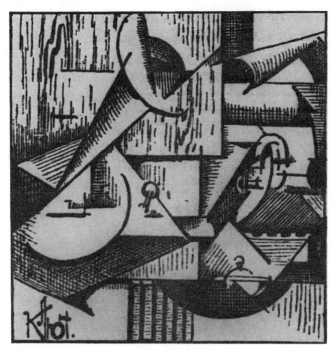

Ivan Klyun: Illustration for the booklet *Tainye poroki akademikov* [Secret Vices of the Academicians] (Moscow, 1915).

take of all art revivals and restorers—we did not turn to the Old Masters and to the *principles of antiquity* that, quickly and inevitably, have always led art into an impasse. Neither did we wish to return to the *lubok*,[1] to the primitives of old, or to feign near illiteracy; before us in all its grandeur the great task has arisen of creating a form *out of nothing*.

After accepting the straight line as a point of departure, we have arrived at an ideally simple form: straight and circular planes (sounds and letters in words). The depth and complexity of our tasks also dictates simplicity of form.

Those who suppose that we are working (in our own way, of course) within the artistic framework of a given period are profoundly mistaken. No, we have left this framework behind and already stand on the threshold of a new era, of new ideas; in our works you will no longer find a single familiar feature. For you they are enigmatic pictures, but for us they are an entirely real language for expressing our new sensations and ideas.

WE ARE PRIMITIVES IN THE TWENTIETH CENTURY

And while the whole of society experiences a supreme crisis and while its art remains flabby and hysterical, we are filled with the greatest enthusiasm and creativity. The attacks of the orthodox critics, who obviously no longer believe in what they themselves are defending, the taunts of the crowd, only increase our strength and energy tenfold; conscious of the grandeur of our tasks and knowing that the path we have chosen is the correct one, we are governed by a profound belief in our work, surrounded, as we are, by unbelievers.

STATEMENTS FROM THE
CATALOGUE OF THE
"TENTH STATE
EXHIBITION:
NONOBJECTIVE CREATION
AND SUPREMATISM," 1919

The texts of the pieces that follow are from the catalogue of "X Gosudarstvennaya vystavka. Bespredmetnoe tvorchestvo i suprematizm" (Moscow, 1919) [bibl. R358; the texts are reprinted in bibl. R16, pp. 110–17; extracts from Malevich's statement are translated into English in bibl. 45, pp. 282–84; the catalogue name list is reprinted in bibl. R152, p. 43]. The "Tenth State Exhibition" opened in January 1919 in Moscow. The nine contributors, in addition to those mentioned here, included Natalya Davydova who did not contribute a statement. Two hundred twenty works were shown, all purporting to be abstract. Although this was one of the last major collective avant-garde exhibitions, its influence was considerable, for example, inspiring El Lissitzky to create his first Prouns (see p. 151–53). The tone of most of the statements, with their emphasis on analysis rather than on synthesis, demonstrated a fundamental deviation from Malevich's more intuitive, individualistic conception of abstract art; moreover, the linear and architectonic qualities of the works themselves pointed to the imminent concern with construction and constructivism, at least on the part of Aleksandr Rodchenko, Varvara Stepanova, and Aleksandr Vesnin. The precise, mathematical formulation of the pictorial art, favored especially by Lyubov Popova, was indicative of the general trend toward formalism in literary and artistic evaluation—which was supported by such critics

as Nikolai Punin (see pp. 170ff.) and developed within the framework of Inkhuk especially during 1920–22. All the texts have been translated into German in bibl. 209viii, pp. 75–82. The Malevich text has been translated into French in bibl. 176xviii, pp. 213–15, and into Italian in bibl. 176xix, pp. 191–93.

═══════════════════════════════════

VARVARA STEPANOVA [1]
Concerning My Graphics
at the Exhibition

Born Kovno, 1894; died Moscow, 1958. Studied at the Kazan Art School, where she met Aleksandr Rodchenko, whom she married subsequently; 1912: moved to Moscow; studied under Konstantin Yuon; 1913–14: worked at the Stroganov Art School; gave private lessons; 1914: contributed to the Moscow Salon; 1920–25: closely involved with IZO Narkompros; member of Inkhuk; contributed to "5 × 5 = 25"; with Lyubov Popova and Rodchenko entered the First State Textile Print Factory, Moscow, as a designer; designed costumes for Aleksandr Sukhovo-Kobylin's *Death of Tarelkin*, produced by Vsevolod Meierkhold; 1923–28: closely associated with *Lef* and *Novyi lef;* 1924: professor in the Textile Faculty at Vkhutemas; late 1920s and 1930s: worked on typography, book design, posters.

———

I am linking the new movement of nonobjective poetry—sounds and letters—with a painterly perception that instills a new and vital visual impression into the sound of poetry. I am breaking up the dead monotony of interconnected printed letters by means of painterly graphics, and I am advancing toward a new kind of artistic creation.

On the other hand, by reproducing the nonobjective poetry of the two books *Zigra ar* and *Rtny khomle* [2] by means of painterly graphics, I am introducing sound as a new quality in graphic painting, and hence I am increasing its quantitative potentials (i.e., of graphics).

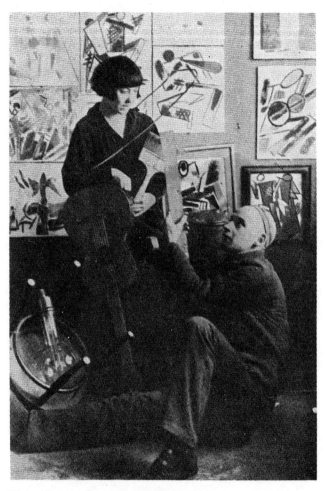

Varvara Stepanova and Aleksandr Rodchenko in their studio, Moscow,
1922. Photograph courtesy Fratelli Fabbri, Milan.

VARVARA STEPANOVA
Nonobjective Creation

The text below is one of several statements that Stepanova compiled on nonobjective creativity in 1919–21, including "Nonobjectivity in Painting," "On the Possibilities of Understanding Art," and "On Texture." Concentrating on collage and visual poetry at this time, Stepanova was especially interested in the correlation and combination of formal elements—rhythm, color, linear intersection—on the picture surface. To a considerable extent, Stepanova's analysis of such components anticipated the emphasis on geometric, abstract forms in her textile and painting designs of the 1920s.

The stage after cubofuturism in the world art movement was revealed by nonobjective creation; this should be regarded as a world view—and not simply as a painterly trend—that has embraced all aspects of art and life itself. This movement is the spirit's protest against the materialism of modern times. Painters apprehended it before others did. In passing, I would note that in spite of all the "funeral dirges" with which "avowed critics" accompany painting, it is occupying an ever greater place in world culture.

The first slogans of nonobjective creation were proclaimed in 1913.[3] From the very beginning, nonobjective creation has proceeded along the path of analysis and, a new movement, has not yet revealed its own synthesis. In this lies its value at the present moment—a moment of terrible disseverance, when art having lost its old traditions, is ready to sink into academism for the sake of providing a new synthesis. But it is not synthesis that will open up the new path, but analysis and inventiveness.

If we investigate the process of nonobjective creation in painting, we will discover two aspects: the first is a spiritual one—the struggle against subject and "figurativeness" and for free creation and the proclamation of creativity and invention; the second aspect is the deepening of the professional demands of painting. After losing its literary subject matter, nonobjective painting was obliged to raise the quality of its works, which, in those of its predecessors, was often redeemed by the picture's subject matter. The painter came to be presented with high—and, I would say, scientific, professional—demands with regard to texture, craftsmanship, and technique. It is

by virtue of these that the picture in nonobjective creation is placed on the famed pedestal of painterly culture.

Of course, the ordinary "cultured" spectator who is slow to evolve in his understanding of new achievements finds it difficult to keep up with the development of the nonobjectivists, for they move along a revolutionary path of new discoveries and have behind them the transitional attainments of futurism and cubism. But if we accept "continuity" as an axiom, then nonobjective creation becomes the logical and legitimate consequence of the preceding stages of painterly creation. However, the same spectator—not being corrupted by pictorial subject matter and not being "cultured" enough to demand always and everywhere figurativeness in art—should, through his feeling and uncorrupted intuition, conceive this creation as a new beauty, the beauty of explosion, the beauty of painting's liberation from the age-old curse: from subject and depiction of the visible.

In nonobjective creation you will not find anything "familiar," anything "comprehensible," but don't be put off by this, grow fond of art, understand what it is to "live art," and don't just investigate it and analyze it, don't just admire it casually, don't just search for intelligible subjects in it or depictions of themes you like.

Nonobjective creation is still only the beginning of a great new epoch, of an unprecedented Great Creation, which is destined to open the doors to mysteries more profound than science and technology.

In passing, one should note that nonobjective creation has not created its own doctrinal system and perhaps, as distinct from its forebears, will never create it; it contains within itself numerous possibilities and great scope for ever new achievements.

IVAN KLYUN
Color Art [1]

For biography see p. 114.

The painterly art, which for centuries has delighted the spectator with views of nature's cozy nooks, with a repeat experience of passions already experienced, has at long last died.

After beginning with the savage's depictions of the deer, the lion, and the fish, painting resolutely preserved the savage's testament and, throughout a whole series of continuously changing trends, aspired to express nature as pictorially as possible (hence the name "picture"); and the forms of this art changed in accordance with the demands made of nature by the culture of a given time.

After exhausting realism, naturalism, all kinds of stylization, various syntheses, nature's moods and artists' experiences—painting reached a state of decrepitude and found its end in suprematism.

The nature that was ornamented by the neorealists and neoimpressionists was torn to pieces by futurism. Suprematism has carefully painted these benumbed forms with different colors and presents them as new art (*Boy with Samovar* [2]).

Now the corpse of painterly art, the art of daubed nature, has been laid in its coffin, sealed with the Black Square of Suprematism, and its sarcophagus is now exhibited for public view in the new cemetery of art—the Museum of Painterly Culture.[3]

But if the art of painting, the art of expressing nature, has died, then color, paint, as the basic elements of this art, have not died. Liberated from the centuries-old bond of nature, they have begun to live their own life, to develop freely, and to display themselves in the New Art of Color—and our color compositions are subject only to the laws of color, and not to the laws of nature.

In Color Art the colored area lives and moves, affording color the utmost force of intensity.

And the congealed, motionless forms of suprematism do not display a new art but reveal the face of a corpse with its eyes fixed and dead.

KAZIMIR MALEVICH
Suprematism

For biography see p. 116.

———

A plane in the form of a square was the ancestor of suprematism, of a new color realism—of nonobjective art (see first, second, and third editions of the booklet *Cubism, Futurism, and Suprematism*, 1915 and 1916 [1]).

Suprematism appeared in 1913 [2] in Moscow, and its first works were shown at an exhibition of painting in Petrograd; [3] it provoked the indignation of the "venerable newspapers of those days" and of the critics, and also of professional people—the masters of painting.

In mentioning nonobjectivism, I wanted merely to point out that suprematism does not treat of things, of objects, etc., and that's all; nonobjectivism, generally speaking, is irrelevant. Suprematism is a definite system, and within this system, color has made its substantial development.

Painting arose out of a mixture of colors and changed color into a chaotic confusion of tones of aesthetic warmth, and with great artists, objects themselves served as painterly frameworks. I have found that the closer the framework to the culture of painting, the more it loses its system, breaks down, and establishes a different order, which painting then legitimizes.

It became clear to me that new frameworks of pure color painting should be created that would be constructed according to the needs of color; second, that color in its turn should proceed from a painterly confusion into an independent unit—into construction as an individual part of a collective system and as an individual part per se.

A system is constructed in time and space independent of any aesthetic beauty, experience, or mood, and emerges rather as a philosophical color system of realizing the new achievements of my imagination, as a means of cognition.

At present, man's path lies across space—across suprematism, the semaphore of color in its fathomless depths.

The blue of the sky has been conquered by the suprematist system, has been breached, and has passed into the white beyond as the true, real conception of eternity, and has therefore been liberated from the sky's colored background.

This system, cold and durable, is mobilized unsmilingly by philosophical thought, or at least, its real force is already moving within that system.

All colorations of utilitarian purpose are insignificant, are of little spatial value, and contain a purely applied, accomplished aspect of what was discovered by the cognition and inference of philosophical thought within the compass of our view of those cozy nooks that serve the philistines' task or create a new one.

Suprematism at one stage has a purely philosophical movement cognizable through color; at a second stage, it is like form that can be applied and that can create a new style of suprematist decoration.

But it can appear in objects as the transformation or incarnation in them of space, thereby removing the object's intactness from consciousness.

Suprematist philosophical color thought has demonstrated that the will can manifest its creative system precisely when the object has been annulled as a painterly framework in the artist; and while objects serve as the framework and means, the artist's will moves in a compositional circle of object forms.

Everything we can see has arisen from a colored mass that has been transformed into plane and volume: any car, house, man, table—they are all painterly volumetrical systems destined for definite objectives.

The artist should also transform painterly masses and form a creative system, but he should not paint nice pictures of sweet-scented roses because that would be a dead depiction reminiscent of the living.

And even if his depiction is constructed abstractly, but based on color interrelations, his will will be locked up amid the walls of aesthetic planes, instead of being able to penetrate philosophically.

I am free only when—by means of critical and philosophical substantiation—my will can extract a substantiation of new phenomena from what already exists.

I have breached the blue lampshade of color limitations and have passed into the white beyond: follow me, comrade aviators, sail on into the depths—I have established the semaphores of suprematism.

I have conquered the lining of the colored sky, I have plucked the colors, put them into the bag I have made, and tied it with a knot. Sail on! The white, free depths, eternity, is before you.

===

MIKHAIL MENKOV

For biography see p. 114.

One should not look at a picture with the preconceived aim of gaining a definite impression from it. Its painted surface gives us a visual sensation that at first glance is hardly perceptible. One should not ask for more.

When you have cultivated your taste for the colored surface, then your enjoyment of it will become more definite.

LYUBOV POPOVA

Born near Moscow, 1889; died Moscow, 1924. 1907–1908: attended the studio of Stanislav Zhukovsky in Moscow; 1912–13: worked in Paris in the studios of Henri Le Fauconnier and Jean Metzinger; met Nadezhda Udaltsova there; 1913: returned to Russia; close to Vladimir Tatlin, Udaltsova, and Aleksandr Vesnin; 1915–16: contributed to "Tramway V," "0.10," and the "Shop"; 1918: joined the faculty of Svomas/Vkhutemas; 1921: member of Inkhuk; gave up easel painting; 1922: did the set and costume designs for Vselovod Meierkhold's production of Fernand Crommelynck's *Magnanimous Cuckold;* 1923–24: worked at the First State Textile Print Factory, Moscow.

———

(+)
Painting

I. *Architectonics*
 (a) Painterly space
 (cubism)
 (b) Line
 (c) Color (suprematism)
 (d) Energetics
 (futurism)
 (e) Texture

II. The necessity for
transformation by
means of the
omission of
parts of
form
(began in
cubism)

(−)
Not painting but
the depiction of reality

 I. *Aconstructiveness*
 (a) Illusionism
 (b) Literariness
 (c) Emotions
 (d) Recognition

Construction in painting = the sum of the energy of its parts.

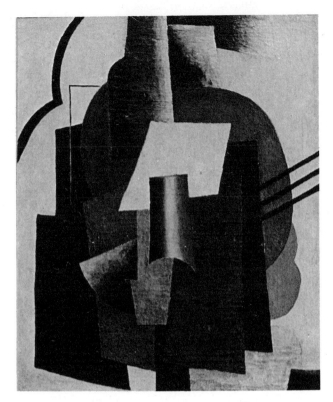

Lyubov Popova: *Painterly Architectonics,* 1917–18. Oil on canvas, 105.5 x 90 cm. Private collection, Moscow.

Surface is fixed but forms are volumetrical.

Line as color and as the vestige of a transverse plane participates in, and directs the forces of, construction.

Color participates in energetics by its weight.

Energetics = direction of volumes + planes and lines or their vestiges + all colors.

Texture is the content of painterly surfaces.

Form is not of equal value throughout its whole sequence. The artistic consciousness must select those elements indispensable to a painterly context, in which case all that is superfluous and of no artistic value must be omitted.

Hence depiction of the concrete—artistically neither deformed nor trans-formed—cannot be a subject of painting.

Images of "painterly," and not "figurative," values are the aim of the present painting.

<hr>

OLGA ROZANOVA (1918)
Extracts from Articles [1]

For biography see p. 102.

———

We propose to liberate painting from its subservience to the ready-made forms of reality and to make it first and foremost a creative, not a reproductive, art.

The aesthetic value of an abstract picture lies in the completeness of its painterly content.

The obtrusiveness of concrete reality has hampered the artist's work, and as a result, common sense has triumphed over visions fancy free; but visions fainthearted have created unprincipled works of art—the mongrels of contradictory world views.

—*Supremus* magazine, no. 1 [2]

<hr>

ALEKSANDR RODCHENKO
Rodchenko's System

Born St. Petersburg, 1891; died Moscow, 1956. 1910–14: attended the Kazan Art School, where he met Varvara Stepanova, whom he married; 1916: contributed to

the "Shop"; 1917: worked with Vladimir Tatlin and Georgii Yakulov on designs for the Café Pittoresque, Moscow; 1918: occupied several positions within Narkompros; 1920: founding member of Inkhuk; 1921: gave up easel painting and turned to textile and typographical design; 1923–28: closely associated with *Lef* [*Levyi front is-kusstv*—Left Front of the Arts] and *Novyi lef* [New Lef], which published some of his articles and photographs; 1925: designed a workers' club for the Soviet Pavilion at the Exhibition of Decorative Arts, Paris [bibl. 237]; 1930: professor and dean of the Metalwork Faculty at Vkhutein; subsequent work concentrated on typography, photography, and book design.

———

At the basis of my cause I have placed nothing.
—M. Stirner, "The Sole One" [1]

Colors disappear—everything merges into black.
—A. Kruchenykh, *Gly-Gly*. [2]

Muscle and pluck forever!
What invigorates life invigorates death,
And the dead advance as much as the living advance.
—Walt Whitman, *Leaves of Grass* [3]

Murder serves as a self-justification for the murderer; he thereby aspires to prove that nothing exists.
—Otto Weininger, *Aphorisms* [4]

. . . I devour it the moment I advance the thesis, and I am the "I" only when I devour it.

. . . The fact that I devour myself shows merely that I exist.
—M. Stirner [5]

Gliding o'er all, through all,
Through Nature, Time, and Space,
As a ship on the waters advancing,
The voyage of the soul—not life alone,
Death, many deaths I'll sing.
—Walt Whitman, *Leaves of Grass* [6]

The downfall of all the "isms" of painting marked the beginning of my ascent.

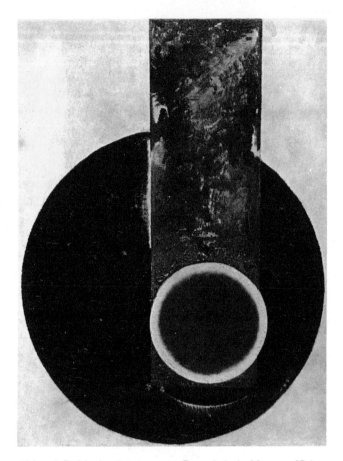

Aleksandr Rodchenko: *Painting,* 1919. Formerly in the Museum of Painterly Culture, Petrograd; present location unknown. (Photograph courtesy Mr. Alfred H. Barr, Jr., New York).

To the sound of the funeral bells of color painting, the last ''ism'' is accompanied on its way to eternal peace, the last love and hope collapse, and I leave the house of dead truths.

The motive power is not synthesis but invention (analysis). Painting is the body, creativity the spirit. My business is to create something new from painting, so examine what I practice practically. Literature and philosophy are for the specialists in these areas, but I am the inventor of new discoveries in painting.

Christopher Columbus was neither a writer nor a philosopher; he was merely the discoverer of new countries.

EL LISSITZKY
Suprematism in World Reconstruction, 1920

Real name Lazar M. Lisitsky. Born near Smolensk, 1890; died Moscow, 1941. 1909–14: at the Technische Hochschule in Darmstadt; also traveled in France and Italy; 1914: returned to Russia; 1918–19: member of IZO Narkompros; professor at the Vitebsk Art School; close contact with Kazimir Malevich; 1920: member of Inkhuk; 1921: traveled to Germany; 1922: in Berlin, edited *Veshch/Gegenstand/Objet* [Object] with Ilya Ehrenburg [bibl. R61]; 1925: returned to Moscow; taught interior design at Vkhutemas.

The text of this piece is from a typescript in the Lissitzky archives and, apart from the notes, is reproduced from Sophie Lissitzky-Küppers, *El Lissitzky* (London and Greenwich, Conn., 1968), pp. 327–30 [bibl. 247], with kind permission of Thames and Hudson and New York Graphic Society. Despite its title, this essay acts as a retrospective commentary on Malevich's original formulation of suprematism and advances a far wider concept with its emphasis on such ideas as visual economy and the universal application of suprematism (ideas also developed by Malevich in his *O novykh sistemakh v iskusstve* [On New Systems in Art] [Vitebsk, 1919]; English translation in bibl. 159, vol. 1, 83–119).

Both for Lissitzky and for Malevich, but more so for the former, the architectural discipline presented itself as an obvious vehicle for the transference of basic suprematist schemes into life itself. In this respect, Lissitzky's so-called Prouns [*proekty ustanovleniya (utverzhdeniya) novogo*—projects for the establishment (affirmation) of the new], which he designed between 1919 and 1924 were of vital significance since they served as intermediate points between two- and three-dimensional forms or, as Lissitzky himself said, "as a station on the way to constructing a new form" [bibl. R450, p. 85].

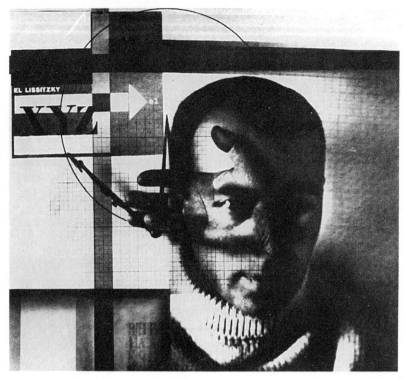

El Lissitzky: *The Constructor*, 1924. A triple-exposure self-portrait.

In a wider context, the spatial graphics of Petr Miturich, the linear paintings of Aleksandr Vesnin, and the mono- and duochromatic paintings of Aleksandr Rodchenko, all done about 1919, symbolized the general endeavor to project art into life, to give painting a constructive dimension. More obviously, the suprematist constructions—the so-called *arkhitektony* and *planity*—modeled as early as 1920 by Malevich and the *unovisovtsy* (members of the Unovis group organized by Malevich in Vitebsk) also supported this trend, thereby proving Ilya Ehrenburg's assertion that the "aim of the new art is to fuse with life" [bibl. R450, p. 45]. Lissitzky's description of the radio transmitting tower as the "centre of collective effort" is therefore in keeping with this process and anticipates the emergence of constructivism and the emphasis on industrial design a few months later. In this context, Lissitzky's references to the "plumbline of economy" and the "counterrelief" remind us of Naum Gabo and Vladimir Tatlin, respectively (see their declarations, pp. 208ff. and 205ff.), and of course, reflect the general concern with *veshch* [the object as such] on the one

hand, and the contrary call for its utilitarian justification on the other, manifested in Inkhuk in the course of 1920.

———

at present we are living through an unusual period in time a new cosmic creation has become reality in the world a creativity within ourselves which pervades our consciousness.

for us SUPREMATISM did not signify the recognition of an absolute form which was part of an already-completed universal system. on the contrary here stood revealed for the first time in all its purity the clear sign and plan for a definite new world never before experienced—a world which issues forth from our inner being and which is only now in the first stages of its formation. for this reason the square of suprematism became a beacon.

in this way the artist became the foundation on which progress in the reconstruction of life could advance beyond the frontiers of the all-seeing eye and the all-hearing ear. thus a picture was no longer an anecdote nor a lyric poem nor a lecture on morality nor a feast for the eye but a sign and symbol of this new conception of the world which comes from within us. many revolutions were needed in order to free the artist from his obligations as a moralist as a story-teller or as a court jester, so that he could follow unhindered his creative bent and tread the road that leads to construction.

the pace of life has increased in the last few decades just as the speed of the motor bicycle has been exceeded many times over by the aeroplane.

after art passed through a whole series of intermediate stages it reached cubism where for the first time the creative urge to construct instinctively overcame conscious resolve. from this point the picture started to gain stature as a new world of reality and in this way the foundation stone for a new representation of the shapes and forms of the material world was laid. it proved to be essential to clear the site for the new building. this idea was a forerunner of futurism which exposed the relentless nature of its motivating power.

revolutions had started undercover. every thing grew more complicated. painting economical in its creative output was still very complicated and uneconomical in its expression. cubism and futurism seized upon the purity of form treatment and colour and built a complicated and extensive system with them combining them without any regard for harmony.

the rebuilding of life cast aside the old concept of nations classes patriotisms and imperialism which had been completely discredited.

the rebuilding of the town threw into utter confusion both its isolated

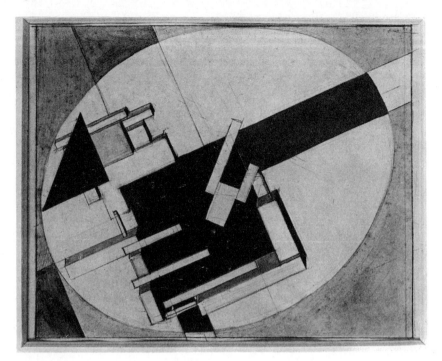

El Lissitzky: *Proun Study*, ca. 1920. Watercolor, 18.1 x 22.9 cm. Collection Grosvenor Gallery, London. "Proun" is an abbreviation of "proekt ustanovleniya (utverzhdeniya) novogo (v iskusstve)" [project for the establishment (affirmation) of the new (in Art)]. This was one of Lissitzky's earliest Prouns.

elements—houses streets squares bridges—and its new systems which cut across the old ones—underground metro underground monorail electricity transmitted under the ground and above the ground. this all developed on top of a new powerhouse whose pumps sucked in the whole of creation.

technology which in its achievements took the most direct route from the complexity of the train to the simplicity of the aeroplane from the basic primitiveness of the steam boiler to the economy of the dynamo from the chaotic hubbub of the telegraphic network to the uniformity of radio was diverted by the war from the path of construction and forced on to the paths of death and destruction.

into this chaos came suprematism extolling the square as the very source of all creative expression. and then came communism and extolled work as the true source of man's heartbeat.

and amid the thunderous roar of a world in collision WE, ON THE LAST STAGE OF THE PATH TO SUPREMATISM BLASTED ASIDE THE OLD WORK OF ART LIKE A BEING OF FLESH AND BLOOD AND TURNED IT INTO A WORLD FLOAT-ING IN SPACE. WE CARRIED BOTH PICTURE AND VIEWER OUT BEYOND THE CONFINES OF THIS SPHERE AND IN ORDER TO COMPREHEND IT FULLY THE VIEWER MUST CIRCLE LIKE A PLANET ROUND THE PICTURE WHICH REMAINS IMMOBILE IN THE CENTRE.

the empty phrase ''art for art's sake'' had already been wiped out and in suprematism we have wiped out the phrase ''painting for painting's sake'' and have ventured far beyond the frontiers of painting.

first of all the artist painted the natural scene which surrounded him. then this was obscured by towns roads canals and all the products of man for this reason the artist began to paint artificial nature—but involuntarily he referred in his works to the method for depicting this new nature. suprematism itself has followed the true path which defines the creative process consequently our picture has become a creative symbol and the realization of this will be our task in life.

when we have absorbed the total wealth of experience of painting when we have left behind the uninhibited curves of cubism when we have grasped the aim and system of suprematism—then we shall give a new face to this globe. we shall reshape it so thoroughly that the sun will no longer recog-nize its satellite. in architecture we are on the way to a completely new con-cept. after the archaic horizontals the classical spheres and the gothic ver-ticals of building styles which preceded our own we are now entering upon a fourth stage as we achieve economy and spatial diagonals.

we left to the old world the idea of the individual house individual bar-racks individual castle individual church. we have set ourselves the task of creating the town. the centre of collective effort is the radio transmitting mast [1] which sends out bursts of creative energy into the world. by means of it we are able to throw off the shackles that bind us to the earth and rise above it. therein lies the answer to all questions concerning movement.

this dynamic architecture provides us with the new theatre of life and because we are capable of grasping the idea of a whole town at any moment with any plan the task of architecture—the rhythmic arrangement of space and time—is perfectly and simply fulfilled for the new town will not be as chaotically laid out as the modern towns of north and south america but clearly and logically like a beehive. the new element of treatment which we have brought to the fore in our painting will be applied to the whole of this still-to-be-built world and will transform the roughness of concrete the

smoothness of metal and the reflection of glass into the outer membrane of the new life. the new light will give us new colour and the memory of the solar spectrum will be preserved only in old manuals on physics.

this is the way in which the artist has set about the construction of the world—an activity which affects every human being and carries work beyond the frontiers of comprehension. we see how its creative path took it by way of cubism to pure construction but there was still no outlet to be found here. when the cubist had pressed forward and reached the very limits of his canvas his old materials—the colours on his palette—proved to be too pale and he put into his picture cement and concrete and home-made iron constructions. not content with that he started to build a model of the structure he had depicted on canvas and then it was only a short step to transform the abstract cubistic still-life into a contre-relief which was complete in itself.

the short step then required to complete the stride consists in recognition of the fact that a contre-relief is an architectonic structure. but the slightest deviation from the plumbline of economy leads into a blind alley. the same fate must also overtake the architecture of cubist contre-relief. cubism was the product of a world which already existed around us and contre-relief is its mechanical offspring. it does however have a relative that took the straight path of economy which led to a real life of its own. the reference is to the narrow technical discoveries for example the submarine the aeroplane the motors and dynamos of every kind of motive power in each part of a battle-ship. contre-relief is instinctively aware of their legitimate origin their economy of form and their realism of treatment.

by taking these elements FROM THEM for itself it wants to become equally entitled to take its place alongside them as a new creation. it seeks to demonstrate its modernity by surrounding itself with all the devices of modern life although this is really nothing other than a decoration of its own self but with intestines stomach heart and nerves on the outside.

in this fragment of TECHNICAL INVENTIVENESS we can see the construction of these pattern systems in the artist's materials. there is iron and steel copper tin and nickel glass and guttapercha straight and curved areas and volumes of every description and colour nuance. it is being made by several master-craftsmen who well know the work of their colleagues but not the beauty of their materials. this complicated structure taken as a whole represents a UNIFIED organism. is it not therefore for that very reason ''artistic''?

there is one element to which special importance attaches—scale. the scale gives life to relationships in space. it is that which determines whether every organism remains whole or is destroyed—it holds all the parts together. the index for the growth of modern man is the ability to see and

appreciate the relative scales of everything that has been made. it is right that this perceptivity shall pass judgment on man's concept of space on the way he reacts in time. cubism demonstrated in its constructions its modernity in relation to scale. but in painting and contre-relief we have in front of us an absolute scale which is this—forms in their natural size in the ratio 1 : 1. if however we wish to transform the contre-relief into an architectural structure and therefore enlarge it by one hundred times, then the scale ceases to be absolute and becomes relative in the ratio of 1 : 100. then we get the american statue of liberty in whose head there is room for four men and from whose hand the light streams out.

seven years ago suprematism [2] raised aloft its black square but no one sighted it for at that time a telescope for this new planet had not yet been invented. the mighty force of its movement however caused a succession of artists to focus on it and many more were influenced by it. yet neither the former nor the latter possessed sufficient inner substance to be held fast by its attractive power and to formulate a complete world system from the new movement. they loosed their hold and plunged like meteorites into irrelevancy extinguishing themselves in its chaos. but the second much-improved phase is already following and the planet will soon stand fully revealed.

those of us who have stepped out beyond the confines of the picture take ruler and compasses—following the precept of economy—in our hands. for the frayed point of the paintbrush is at variance with our concept of clarity and if necessary we shall take machines in our hands as well because in expressing our creative ability paintbrush and ruler and compasses and machine are only extensions of the finger which points the way.

this path into the future has nothing in common either with mathematics and scientific studies or with raptures over sunset and moonlight—or indeed with the decline of the subject with its plague-ridden aura of individualism—rather is it the path leading from creative intuition to the increased growth of foodstuffs for which neither paintbrush nor ruler neither compasses nor machine were required.

we must take note of the fact that the artist nowadays is occupied with painting flags posters pots and pans textiles and things like that. what is referred to as "artistic work" has on the vast majority of occasions nothing whatever to do with creative effort: and the term "artistic work" is used in order to demonstrate the "sacredness" of the work which the artist does at his easel. the conception of "artistic work" presupposes a distinction between useful and useless work and as there are only a few artists buyers can be found even for their useless products.

the artist's work lies beyond the boundaries of the useful and the useless.

it is the revolutionary path along which the whole of creation is striding forward and along which man must also bend his steps. ''artistic work'' is but an obstacle on this path and in consequence a counter-revolutionary concept. the private property aspect of creativity must be destroyed all are creators and there is no reason of any sort for this division into artists and nonartists.

by this reckoning the artist ceases to be a man who is not producing useful things and must not strive to attain his title to creative activity by painting posters in the prescribed form and colour on which any attempt to pass judgment shows a GROSS LACK OF FEELING. such work now belongs to the duty of the artist as a citizen of the community who is clearing the field of its old rubbish in preparation for the new life.

therefore THE IDEA OF ''ARTISTIC WORK'' MUST BE ABOLISHED AS A COUNTER-REVOLUTIONARY CONCEPT OF WHAT IS CREATIVE and work must be accepted as one of the functions of the living human organism in the same way as the beating of the heart or the activity of the nerve centres so that it will be afforded the same protection.

it is only the creative movement towards the liberation of man that makes him the being who holds the whole world within himself. only a creative work which fills the whole world with its energy can join us together by means of its energy components to form a collective unity like a circuit of electric current.

the first forges of the creator of the omniscient omnipotent omnific constructor of the new world must be the workshops of our art schools. when the artist leaves them he will set to work as a master-builder as a teacher of the new alphabet and as a promoter of a world which indeed already exists in man but which man has not yet been able to perceive.

and if communism which set human labour on the throne and suprematism which raised aloft the square pennant of creativity now march forward together then in the further stages of development it is communism which will have to remain behind because suprematism—which embraces the totality of life's phenomena—will attract everyone away from the domination of work and from the domination of the intoxicated senses. it will liberate all those engaged in creative activity and make the world into a true model of perfection. this is the model we await from kasimir malevich.

AFTER THE OLD TESTAMENT THERE CAME THE NEW—AFTER THE NEW THE COMMUNIST—AND AFTER THE COMMUNIST THERE FOLLOWS FINALLY THE TESTAMENT OF SUPREMATISM.

IV.
The Revolution
and Art

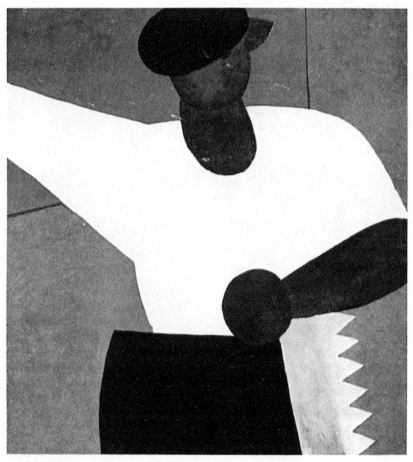

Vladimir Lebedev: *Apotheosis of the Worker,* 1920. Powder paint, 72 x 68 cm. Collection Saltykov-Shchedrin Library, Leningrad. This was one of many posters executed by Lebedev for the Okna ROSTA (the display windows of the Russian Telegraph Agency) in Petrograd. Vladimir Kozlinsky, Aleksei Radakov, and others were also involved in poster work for the Petrograd Okna ROSTA; Vladimir Mayakovsky worked for the Moscow branch.

NATAN ALTMAN
"Futurism"
and Proletarian Art, 1918

Born Vinnitsa, 1889; died Leningrad, 1970. 1901–1907: studied painting and sculpture at the Odessa Art School; 1910–12: in Paris; attended Vasileva's Académie Russe; 1912–16: contributed to the "Union of Youth," "Exhibition of Painting. 1915," "0.10," "Knave of Diamonds," and other exhibitions; 1912–17: contributed to the satirical journal *Ryab* [Ripple] in St. Petersburg; 1918: professor at Pegoskhuma/Svomas; member of IZO Narkompros; designed decoration for Uritsky Square, Petrograd; 1919: leading member of Komfut; 1921: designed decor for Vladimir Mayakovsky's *Mystery-Bouffe;* 1922: member of Inkhuk; 1929–35: lived in Paris; 1935: returned to Russia; 1936: settled in Leningrad.

The text of this piece, " 'Futurizm' i proletarskoe iskusstvo," is from the journal *Iskusstvo kommuny* [Art of the Commune] (Petrograd), no. 2, December 15, 1918, p. 3 [bibl. R73]; the text is reprinted in bibl. R16, pp. 167–68. *Iskusstvo kommuny* was the weekly journal of IZO Narkompros [Visual Arts Section of Narkompros], and during its short life (December 1918–April 1919) it published many radical articles by such artists and critics as Altman, Osip Brik, Boris Kushner, and Nikolai Punin [see bibl. R499, p. 509, for some bibliographical details]. The futurists—and, as Altman indicates in his note to the title: "I am using 'futurism' in its everyday meaning, i.e., all leftist tendencies in art," the term is a general one here—considered themselves to be at one with the revolutionary government. Like many other avant-garde artists at this time, Altman believed, albeit briefly, that individual easel painting was outmoded and that art should have a collective basis; essentially this meant that the artist was to turn to mass art forms such as monuments and bas-reliefs, to social and cultural heroes, street decoration, and book, postage-stamp, and stage design. Apart from Altman's futurist panels and his decorations for Uritsky Square, perhaps the finest example of his mass art was his album of sketches of Lenin published in Petrograd in 1920. For a German translation see bibl. 209viii, pp. 47, 48.

———

Certain art circles and private individuals who not so long ago abused us in various "cultural publications" for working with the Soviet government and who knew no other name for us than "bureaucrats" and "perfunctory artists" would now rather like to take our place.

And so a campaign has begun against futurism, which, they say, is a mill-

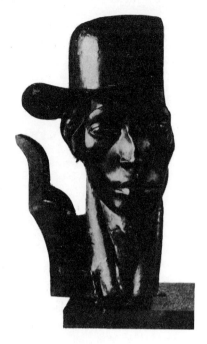

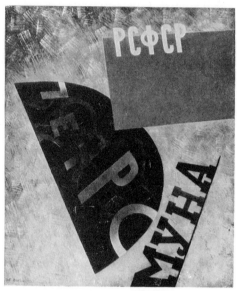

Natan Altman: *Self-Portrait,* 1916. Plaster of Paris, wood, bronze, 48 x 29 x 22 cm. Collection Russian Museum, Leningrad.

Natan Altman: *Petrokommuna* [Petrocommune], 1919. Oil on canvas with enamel, 104.5 x 88.5 cm. Private collection, Leningrad. During the Civil War period, Petrograd was also called Petro[grad]commune. In his painting, Altman attempted to synthesize easel and poster art by resorting to mimetic detail (the depiction of the Neva in the semicircle) and to symbolic detail (the Russian characters for R.S.F.S.R.—Russian Soviet Federated Socialist Republic—on a red ground in the upper right).

stone around the worker's neck and whose claims to "being the art of the proletariat" are "ridiculous," etc. . . .

But are they so ridiculous?

Why did it need a whole year of proletarian government and a revolution that encompassed half the world for the "silent to speak up"?

Why did only revolutionary futurism march in step with the October Revolution?

Is it just a question of outward revolutionary fervor, just a mutual aversion to the old forms, that joins futurism with the proletariat?

Not even they deny that futurism is a revolutionary art that is breaking all the old bonds and in this sense is bringing art closer to the proletariat.

We maintain that there is a deeper link between futurism and proletarian creation.

People naïve in matters of art are inclined to regard any sketch done by a worker, any poster on which a worker is depicted, as a work of proletarian art.

A worker's figure in heroic pose with a red flag and an appropriate slogan—how temptingly intelligible that is to a person unversed in art and how terribly we need to fight against this pernicious intelligibility.

Art that depicts the proletariat is as much proletarian art as the *Chernoso-tenets* [1] who has gotten into the Party and can show his membership card is a Communist.

Just like anything the proletariat creates, proletarian art will be collective:

The principle that distinguishes the proletariat as a class from all other classes.

We understand this, not in the sense that one work of art will be made by many artists, but in the sense that while executed by one creator, the work itself will be constructed on collectivist bases.

Take any work of revolutionary, futurist art. People who are used to seeing a depiction of individual objects or phenomena in a picture are bewildered. You cannot make anything out. And indeed, if you take out any one part from a futurist picture, it then represents an absurdity. Because each part of a futurist picture acquires meaning only through the interaction of all the other parts; only in conjunction with them does it acquire the meaning with which the artist imbued it.

A futurist picture lives a *collective life:*

By the same principle on which the proletariat's whole creation is constructed.

Try to distinguish an individual face in a proletarian procession.

Try to understand it as individual persons—absurd.

Only in conjunction do they acquire all their strength, all their meaning.

How is a work of the old art constructed—the art depicting reality around us?

Does every object exist in its own right? They are united only by extrinsic literary content or some other such content. And so cut out any part of an old picture, and it won't change at all as a result. A cup remains the same cup, a figure will be dancing or sitting pensively, just as it was doing before it was cut out.

The link between the individual parts of a work of the old art is the same as between people on Nevsky Prospekt. They have come together by chance, prompted by an external cause, only to go their own ways as soon as possible. Each one for himself, each one wants to be distinguished.

Like the old world, the capitalist world, works of the old art live an individualistic life.

Only futurist art is constructed on collective bases.

Only futurist art is right now the art of the proletariat.

KOMFUT

Program Declaration, 1919

Komfut (an abbreviation of *Com*munists and *fut*urists) was organized formally in Petrograd in January 1919 as an act of opposition to the Italian futurists, who were associating themselves increasingly with Fascism. According to the code of the organization [bibl. R73, no. 8, January 26, 1919, p. 3; reprinted in bibl. R16, p. 160], would-be members had to belong to the Bolshevik Party and had to master the principles of the "cultural Communist ideology" elucidated at the society's own school. Prominent members of Komfut were Boris Kushner (chairman), Osip Brik (head of the cultural ideology school), Natan Altman, Vladimir Mayakovsky, and David Shterenberg. Komfut prepared for publication several brochures including "The Culture of Communism," "Futurism and Communism," "Inspiration," and "Beauty," but none, apparently, was published.

The text of this piece, "Programmnaya deklaratsiya," is from *Iskusstvo kommuny* [Art of the Commune] (Petrograd), no. 8, January 26, 1919, p. 3 [bibl. R73; the text is reprinted in bibl. R16, pp. 159–60]. A second Komfut statement giving details of proposed lectures and publications was issued in *Iskusstvo kommuny,* no. 9, February 2, 1919, p. 3. The destructive, even anarchical intentions of Komfut, while supported just after 1917 by many of the leftist artists, including Kazimir Malevich, were not, of course, shared by Lenin or Anatolii Lunacharsky, who believed, for the most part, that the pre-Revolutionary cultural heritage should be preserved. In its rejection of bourgeois art, Komfut was close to Proletkult (see pp. 176ff.), although the latter's totally proletarian policy excluded the idea of any ultimate ideological consolidation of the two groups. Altman's, Kushner's, and Nikolai Punin's articles of 1918–19 can, in many cases, be viewed as Komfut statements.

Cover of *Iskusstvo kommuny* [Art of the Commune] (Moscow), no. 8, January 26, 1919. Designed by Natan Altman. Photograph courtesy The Library, Hermitage, Leningrad.

A Communist regime demands a Communist consciousness. All forms of life, morality, philosophy, and art must be re-created according to Communist principles. Without this, the subsequent development of the Communist Revolution is impossible.

In their activities the cultural-educational organs of the Soviet government show a complete misunderstanding of the revolutionary task entrusted to them. The social-democratic ideology so hastily knocked together is incapa-

ble of resisting the century-old experience of the bourgeois ideologists, who, in their own interests, are exploiting the proletarian cultural-educational organs.

Under the guise of immutable truths, the masses are being presented with the pseudo teachings of the gentry.

Under the guise of universal truth—the morality of the exploiters.

Under the guise of the eternal laws of beauty—the depraved taste of the oppressors.

It is essential to start creating our own Communist ideology.

It is essential to wage merciless war against all the false ideologies of the bourgeois past.

It is essential to subordinate the Soviet cultural-educational organs to the guidance of a new cultural Communist ideology—an ideology that is only now being formulated.

It is essential—in all cultural fields, as well as in art—to reject emphatically all the democratic illusions that pervade the vestiges and prejudices of the bourgeoisie.

It is essential to summon the masses to creative activity.

BORIS KUSHNER
"The Divine Work of Art"
(Polemics), 1919

Born Minsk, 1888; died 1937. 1914: made his literary debut with a book of verse, *Semafory* [Semaphores]; 1917–18: wrote several articles and futurist prose; 1919: leading member of Komfut; 1923: on the editorial board of *Lef;* close to constructivists and formalists; mid- and late 1920s: wrote a series of sketches on Western Europe, America, and the northern Caucasus; died in a prison camp.

The text of this piece, " 'Bozhestvennoe proizvedenie,' " is from *Iskusstvo kommuny* [Art of the Commune] (Petrograd), no. 9, February 2, 1919, p. 1 [bibl. R73; the text is reprinted in bibl. R16, pp. 169–71]. Kushner's anarchical tone betrays his keen support of the general ideas of Komfut (see pp. 164ff.) and his ideological proximity to Natan Altman, Osip Brik, Vladimir Mayakovsky, and Nikolai Punin at

this time. Kushner's rejection of the subjective and idealist interpretation of art was shared by many critics and artists just after the Revolution and was an attitude identifiable particularly with *Iskusstvo kommuny;* moreover, Kushner's conclusion (reiterated in many articles in that journal) that the work of art was no more than an object produced by a rational process prepared the ground for the formal advocacy of industrial constructivism in 1921/22.

――――――

They used to think that art was beauty.

They defined art as divination.

Revelation, incarnation, transubstantiation.

Art ensconced itself like a great, unshakable god in their heads, empty and bemused.

It was served by the trivial godlings of ecstasy, intuition, and inspiration.

During the whole historical process endured by mankind, when the power of violence and oppression was being transferred constantly from one kind of democracy, aristocracy, and bourgeoisie to another, nobody dreamed of assuming that art was simply work: know-how, craft, and skill.

To King Solomon, art appeared in the guise of his regal wisdom.

To the iron feudal lord, art served as a kind of Roland's trumpet of victory. Or it frightened him in the form of the black monk armed mightily with his weapon—but a weapon not made with iron.

To the romantics and theoreticians of the young, contemplative bourgeoisies—sentimental and afraid of the devil and brimstone—to create works of art seemed to be an affair of mystery like medieval alchemy.

In the bloom of its strength the bourgeoisie scorned wisdom, victory, and mystery.

Amid the glitter of power and glory it was tormented by an insatiable greed, by an eternal mania for acquisition and accumulation.

The merchant and the industrialist entwined themselves greedily around the whole earthly globe like boa constrictors bloated with the whole brilliant visible world of objects.

The bourgeoisie acquired.

Everything that became its property bowed to it.

But suddenly on its fabulous path of advance, it came across a certain obstacle.

It could not buy nature, the invisible world, the world in its immensity, the sky, the stars, eternity.

They are not available for personal possession; they are nontransferable into private property.

Boris Kushner, ca. 1927.

And a feeling of dissatisfaction, of a cold vacuum, stole into the sensitive heart of the bourgeoisie. It was consumed by a feeling of insatiable hunger.

Tormented by the grief of the property owner who has been unjustly insulted, tortured by the bitter disappointment of the industrialist who has realized that his business cannot encompass everything, the bourgeoisie sought ways to oblivion.

Narcotics became a must.

Refreshing illusion was required.

They thought of a surrogate, of their own creation of genius, of their favorite *Wunderkind* of industrial ingenuity. They examined the world from all sides. Nowhere did they find the protective label, ''made in eternity.'' So fakes were not prohibited and were not prosecuted by the law. They decided to prepare a surrogate for the universe.

And so, to this end, a very chic and remarkable theory was made and elaborated that saw the real and the unreal worlds, the visible and the invisible worlds, as incarnated in the divine work of art.

Aesthetes and poets (those who could not mind their own business) vied with each other in their endeavors to dramatize the mystery of this incarnation.

They dressed up the artist in the dunce's cap of the medieval magician, wizard, and alchemist. They forced him to perform a kind of sorcery, a supernatural divination, a magic transubstantiation.

And an ulterior force was ascribed to all the things that were made by this kind of duped artist.

They asserted and professed conscientiously:

"The eternal harmony of the builder of the universe is reflected in the eternal beauty of artistic forms. Works of art reflect the world, the outer, material, inner, spiritual, and ideal nature of things, the essence and latent meaning of things."

This splendid theory was elaborated beautifully by the great experts. The ends were carefully concealed. All contradictions were hidden. It did not occur to anybody that this was not the genuine product, but merely a surrogate, and a jolly good fake.

The highest goal of bourgeois aspirations had been attained.

The philosopher's stone had been found.

The right of private property had been extended to the extreme limits of eternity. It crawled all over the planets, all over the stars near and far. It flowed throughout the Milky Way. Like sugar icing, it glossed all over the belly of eternity.

An unprecedented, world-wide achievement had been wrought.

The bourgeoisie had colonized the "ulterior world."

The ecstatic triumph of world imperialism had been achieved. Henceforth everyone who acquired a work of art prepared by the firm of the appropriately patented artist would acknowledge and feel himself the happy and assured possessor of a solid piece of the universe—moreover, in a pocket edition, very convenient and portable.

And the bourgeoisie coddled and warmed itself in the soft and gentle pillows of its consciousness of total power.

Such, briefly, is the history of the prostitution of art, solicited to serve all the incorporeal forces of religion and mythology.

Step by step we are depriving the imperialist bourgeoisie of its global annexations. Only so far the proletariat has not lifted its hand against this most wonderful annexation of the spirit.

Because the bourgeoisie had put this valuable and prosperous colony under the lock and key of mysterious, mystical forces, and even the revolutionary spirit of our time retreats before them.

It is time to shake off this shameful yoke.

Are we going to endure the interference of heavens and hells in our internal, earthly affairs?

I think it is time to tell the gods and devils:

Take your hands off what is ours, what belongs to mankind.

Socialism must destroy the black and white magic of the industrialists and merchants.

Socialism will not examine things exclusively from the point of view of the right to ownership.

It can afford the luxury of leaving nature and the world in peace, can be content with them the way they are, and will not drag them by the scruff of the neck into its storerooms and elevators.

To the socialist consciousness, a work of art is no more than an object, a thing.

=======================================

NIKOLAI PUNIN
Cycle of Lectures
[*Extracts*], 1919

Born St. Petersburg, 1888; died Leningrad, 1953. 1899–1907: attended the Classical Gymnasium at Tsarskoe Selo; 1907: entered University of St. Petersburg to study law, then history; 1913 onwards: close to the *Apollon* circle [see bibl. R41 for his published contributions]; 1918: member of IZO Narkompros [Visual Arts Section of Narkompros]; 1918–30: many lectures and articles on modern art; 1918–19: coeditor of *Iskusstvo kommuny* [Art of the Commune, bibl. R73]; 1919: coeditor of *Izobrazitelnoe iskusstvo* [Visual Art, bibl. R66]; leading member of Komfut; 1921: founder member of the Museum of Painterly Culture and of IKhK; 1919–25: taught at Svomas/Academy of Arts; ca. 1925–38: married to the poetess Anna Akhmatova [for a letter to her in translation see *Russian Literature Triquarterly* (Ann Arbor), no. 2, 1972, pp. 453–57]; 1932: coorganized the exhibition "Artists of the RSFSR over the Last XV Years" at the Russian Museum, Leningrad; 1935: arrested and briefly detained; 1944: appointed head of the Department of Russian Art History at the University of Leningrad; 1949: arrested and imprisoned for three years; throughout the 1930s and 1940s he continued to write, concentrating on the work of Aleksandr Ivanov and on his own memoirs.

The extracts are part of the fifth and sixth lectures in a series that Punin gave in Petrograd in the summer of 1919 at a crash course for student teachers of drawing. In May of the following year the lectures were published in Petrograd in a booklet called *Pervyi tsikl lektsii* [First Cycle of Lectures], with covers designed by Kazimir Malevich [reproduced in bibl. 160, p. 154]. The extracts are from this booklet, pp. 44–46, 54, 57–58.

N. N. Punin, 1921/2 Private collection, Leningrad.

Punin's assertion that "modern art criticism must be . . . a scientific criticism" served as a logical conclusion to a process evident in avant-garde theory and criticism since about 1910 whereby the aesthetic balance had shifted increasingly from a narrative, literary criterion to a formal, medium-oriented one. The emphasis on material and on the work of art as an entity that we encounter in the writings of David Burliuk, Malevich, Vladimir Markov, Lyubov Popova, Ivan Puni, et al., therefore acted as an important precedent to Punin's conception. The general tone of Punin's lectures betrays his tentative support of the formalist method in literary and art criticism, which was identifiable with many of the theoretical discussions of Inkhuk and *Lef*. Much in the formalist spirit, Punin even succeeded in reducing the creative process to a mathematical formula:

$$S(Pi + Pii + Piii + \ldots P\pi)Y = T$$

where S equals the sum of the principles (P), Y equals intuition, and T equals artistic creation [Punin, op. cit., p. 51, and see bibl. 189 for some commentary]. In this respect it is logical that Punin should have preferred the "engineer" Vladimir Tatlin to the artist Malevich, concluding that Malevich was far too subjective to examine material in a scientific and impartial manner [see bibl. R418]. Although perhaps the most radical and innovative of the early Soviet art critics, Punin was not alone in his analytical approach to art; similar methods can be found in the writings of Nikolai Tarabukin and, to a much lesser extent, in those of Boris Arvatov and Osip Brik.

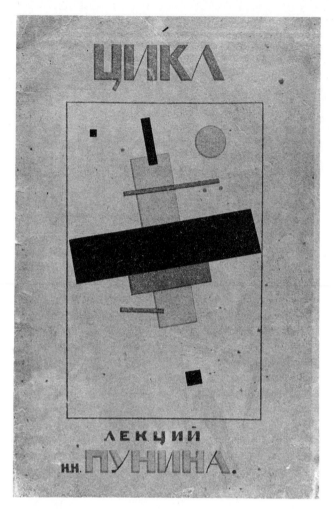

Kazimir Malevich: Front cover of Nikolai Punin's *Tsikl lektsii* [Cycle of Lectures] (Petrograd, 1920). This is one of the few examples of Malevich's application of suprematism to book design.

From Lecture 5

. . . to speak of an artist's world view means either to speak all sorts of subjective trash, to acquaint you with my various personal impressions, experiences, emotions apropos of this or that work of art, or to speak of the

general socioeconomic, material, and cultural conditions of artistic creation. We will speak of the latter, and inasmuch as we will concern ourselves with these general conditions on which this or that individual world view is based, we will be able to speak of the new artists' world view: to do this, we will first of all have to proceed once more from the purely material aspect of the issue at hand.

The closer the link between material and creative consciousness, the more lasting the work of art, the more beautiful it is—and the less popular: that is how one of our young critics (Aksenov) defines the interdependence of the material and spiritual aspects of works by this or that artist; he places this interdependence within a certain set of conditions vis-à-vis the durability and even the popularity of works of art. And indeed, when we come to study art history, when we study our contemporary life and art, we convince ourselves time and again that the material aspect of life is joined closely to the spiritual, and this the mob cannot forgive the artist. The mob cannot endure this close interdependence, the mob strives continuously to escape this purity of method—pure insofar as the artist's whole spiritual essence is expressed by distinct material elements; the mob does not like purity and comprehends better works of art whose material construction is diluted by all kinds of other elements not deriving directly from the sensation of painting or the sensation of plasticity. For the mob, painting as a pure art form, painting as an element, is unintelligible unless it is diluted with literary and various other aspects of artistic creation. That is why works of mixed composition, works that are impure, are so successful with our contemporaries, and often this success lasts for many years until, ultimately, some expert or other discloses the essence of this success and shows—what this or that artist could have become or what he has become in the historical perspective. . . . In this respect the critics' role is extremely important and extremely pernicious, because first and foremost, critics are essentially literary people. Generally speaking, the critic throughout art history has been an artist or a writer *manqué*. But unfortunately, in the fields of painting, sculpture, and often architecture, critics are normally not artists *manqués,* but literati *manqués*. They introduce into their appreciation of works of art the sum total of their literary convictions that one way or another they did not manage to realize in works of literature. Hence we can understand that works of art that contain some literary elements or pseudo literature in general are glorified most by critics, since these are the works that are, above all, intelligible to these literati *manqués*. Almost always critics pass judgment not on the work of art but in connection with it, even in those cases where these critics are gifted representatives of their profession. That is why

among our new men of art we see and often hear the most extraordinary and biting attacks on art critics. Artists, of course, are not always right in this respect. Their immediate task, their immediate interest, is to cleanse themselves of these literary critics, but artists would find it useful to have near them professional art scholars, i.e., people who would approach works of art not by virtue of their literary incentives, but from the point of view of those theoretical data with which modern science has provided them. And that is why modern art criticism must be, and probably will become, first and foremost a scientific criticism. This will not consist of those popular little articles with their various attacks and personal impressions with which we are familiar in most of our art journals, but it will consist of very careful, very objective studies of works of art, models for which we can find in our so-called leftist literature. . . .

From Lecture 6

First and foremost—we consider science to be a principle of culture. I have already spoken of science: I said that modern art criticism in general and any modern judgment on art must once and for all finish with those arbitrary, individual, and often capricious impressions that spectators get from a work of art. If modern man wants to assimilate fully all the forces affecting the creation of this or that work of art, he must approach the work by studying and analyzing it by means of scientific method. Science is not a symptom but precisely a principle. There have been many brilliant civilizations, including our European one of the last century, when the sciences prospered and developed. But the prosperity and development of the sciences is one thing, and the construction of the whole social, communal, and cultural life on the principles of science is another. We do not strive for science to develop and prosper in our world; we strive primarily in order that our whole world view, our social structure, and our whole artistic, technological, and communal culture should be formed and developed according to a scientific principle. In this lies the characteristic difference between culture and civilization. . . .

We should dwell on one other factor, namely, the principle of organization. Understandably, as soon as we stop wanting to act individually and take into consideration the whole latitude of mass sentiments, the whole latitude of elemental movements from below, we must stop applying these or those forces casually and organize them so that individual persons will not be afforded the opportunity of caprice or arbitrary rule. We must create a cohesion and reciprocity between the individual person and individual

groups of people so that relations between them will be organized. Besides, organization is a new factor on which the conception of culture is founded.

First and foremost—mechanization, i.e., the transference of attention to mechanical production in the creative process. Man is a technological animal, i.e., in the new arrangement of European society—which has not yet come about, but which is in evidence—man must as far as possible economize his energy and must in any event coordinate all his forces with the level of modern technology. In this respect the role of the machine, as a factor of progress, is, of course, immense in the modern artist's development. The effect of the machine shows not only in the change of his psychical complex, in this or that digression of his interests, but also in the artist's aspiration to regulate his own artistic, creative forces. The machine has revealed to him the possibility of working with precision and maximum energy; energy must be expended in such a way that it is not dissipated in vain—this is one of the basic laws of contemporaneity that Ernst Mach formulated; [1] the economy of energy and the mechanization of creative forces—these are the conditions that guarantee us the really intensive growth of European culture. The artist cannot avoid these new factors of our world; he must reckon with them, react upon them in this or that way, transform them in his consciousness. Insofar as the artist strives to approach the machine in his creative process, insofar as he wishes to regulate, to mechanize his forces in accordance with the contemporary order, with the contemporary trends of progress, mechanization becomes the general stimulus for creating a new artistic culture. Hence naturally, there arises the acute question of the new artist's attitude toward nature, because nature is something that contradicts mechanization. Nature is something that introduces into the modern world that peculiarity, that fortuity which is inherent in herself. Hence, the new artist's attitude toward nature is the touchstone of his world view. . . .

None of us is surprised that music is music, but many are surprised that painting is painting because many of you are accustomed to seeing in painting literature, philosophy, mysticism, religion, journalism—everything that from time immemorial has accompanied man on his paths of creation. Music is music because it is concerned with a single definite material—sound. One would wish that henceforth painting would be only painting, that it would be concerned only with a single material—the painterly element. People say: there is limited content in modern art. How can a painter's content be limited when he is possessed by the elemental feeling of painting? How can a painter's content be limited when he has grasped with such fullness and diversity the distinctions of character in the painterly elements? How can an

artist's content be limited if he has discovered and shown the whole wealth of the painterly element? It is quite possible that many of you would like to read something more in modern artists' pictures than they can and should give. That is understandable because there still dwells in you, and probably will dwell for a long time yet, the desire to see in the artist a man of letters, a philosopher, and a moralist. . . . And often, when critics are examining modern works of art by the leftists artists, they begin to discover in them mystical abysses that not one of these artists intended. I have quite often had dealings with spectators of this kind. On the surface of a Picasso canvas, which contains only what is put on to it, i.e., pure painterly elements, they look for goodness knows what kind of religious, mystical ideas. . . . We are formal.[2] Yes, we are proud of this formalism because we are returning mankind to those peerless models of cultural art that we knew in Greece. Isn't that sculptor of antiquity formal, doesn't he repeat in countless, diverse forms the same gods who ultimately for him are equally alien, equally remote, inasmuch as he is an artist? And nonetheless, we love these antique statues and delight in them—and we do not say they are formal. This formalism is that of a classical, sound organism rejoicing in all forms of reality and aspiring only to one thing: to reveal all its wealth, all the tension of its creative, elemental forces in order to realize them in works of art that would contain only signs of great joy—of that great creative tension that is latent in us and bestowed on each of us, each of those who are born to be, and must be, artists.

ALEKSANDR BOGDANOV
The Proletarian and Art, 1918

Pseudonym of Aleksandr Aleksandrovich Malinovsky. Born Grodno Province, 1873; died Moscow, 1928. 1896: joined the Social-Democratic Party; 1899: graduated from the medical faculty of Kharkov University; 1903: joined the Bolsheviks; 1905: took an active part in the first revolution; 1907: arrested and exiled to Western Europe; 1909: with Anatolii Lunacharsky and Maxim Gorky organized the *Vpered* [Forward] group; with Gorky and Lunacharsky organized the Bolshevik training school on Capri; 1914–18: internationalist; 1917 on: played a major role in the organization and

propagation of Proletkult; member of the Central Committee of the All-Russian Proletkult and coeditor of *Proletarskaya kultura* [Proletarian Culture] [bibl. R80]; maintained close contact with Proletkult in Germany, where several of his pamphlets were published; 1921: became less active in politics and returned to medicine; 1926: appointed director of the Institute of Blood Transfusion, Moscow; 1928: died there while conducting an experiment on himself.

The text of this piece, "Proletariat i iskusstvo," is from *Proletarskaya kultura* [Proletarian Culture] (Moscow), no. 5, 1918, p. 32 [bibl. R80; it is reprinted in bibl. R16, p. 187]. The text formed a resolution proposed by Bogdanov at the First All-Russian Conference of Proletarian Cultural and Educational Organizations (i.e., Proletkult) in Moscow in September 1918 and, as such, presented a succinct statement of Proletkult policy. Its basic ideas—that concrete reality could be changed by art and hence by the artistic will and that the art of the past was of little or no value to the new proletarian order—were ultimately unacceptable to many Marxists, Lenin and Anatolii Lunacharsky among them. By 1920 Lenin was openly criticizing Proletkult for its rejection of the pre-Revolutionary cultural heritage and for its ideological separatism.

1. Art organizes social experiences by means of living images with regard both to cognition and to feelings and aspirations. Consequently, art is the most powerful weapon for organizing collective forces in a class society—class forces.

2. To organize his forces in his social work, his struggle and construction, the proletarian needs a new class art. The spirit of this art is collectivism of labor: it assimilates and reflects the world from the viewpoint of the labor collective, it expresses the relevance of its feelings, of its fighting spirit, and of its creative will.

3. The treasures of the old art should not be accepted passively; in those days they would have educated the working class in the cultural spirit of the ruling classes and thereby in the spirit of subordination to their regime. The proletarian should accept the treasures of the old art in the light of his own criticism, and his new interpretation will reveal their hidden collective principles and their organizational meaning. Then they will prove to be a valuable legacy for the proletarian, a weapon in his struggle against the same old world that created them and a weapon in his organization of the new world. The transference of this artistic legacy must be carried out by proletarian critics.

4. All organizations, all institutions, dedicated to developing the cause of the new art and of the new criticism must be based on close collaboration, one that will educate their workers in the direction of the Socialist ideal.

Aleksandr Bogdanov, mid-1920s.

ALEKSANDR BOGDANOV
The Paths of
Proletarian Creation, 1920

For biography see pp. 176–77.

The text of this piece, "Puti proletarskogo tvorchestva," is from *Proletarskaya kultura* [Proletarian Culture] (Moscow), no. 15/16, 1920, pp. 50–52 [bibl. R80; it is reprinted in bibl. R4, pp. 136–41]. This text demonstrates Bogdanov's ability to argue in terms both of art and of science and testifies to Proletkult's fundamental aspiration to conceive art as an industrial, organized process. The text also reveals Bogdanov's specific professional interest in neurology and psychology. He wrote several similar essays.

1. *Creation,* whether technological, socioeconomic, political, domestic, scientific, or artistic, represents a kind of *labor* and, like labor, is composed of organizational (or disorganizational) human endeavors. It is exactly the same as labor, the product of which *is not* the repetition of a ready-made stereotype, but is something "new." There is not and cannot be a strict delineation between creation and ordinary labor; not only are there all the points of interchange, but often it is even impossible to say with certainty which of the two designations is the more applicable.

Human labor has always relied on collective experience and has made collective use of perfected means of production; in this sense human labor has always been *collective;* this was so even in those cases where its aims and outer, immediate form were narrowly individual (i.e., when such labor was done by one person and as an end in itself). This, then, is creation.

Creation is the highest, most complex form of labor. Hence its methods derive from the methods of labor.

The old world was aware neither of this social nature germane to labor and creation, nor of their methodological connection. It dressed up creation in mystical fetishism.

2. All methods of labor, including creation, remain within the same framework. Its first stage is the combined effort and its second the selection of results—the removal of the unsuitable and the preservation of the suitable. In "physical" labor, material objects are combined; in "spiritual" labor, images are combined. But as the latest developments in psychophysiology show us, the nature of the efforts that combine and select are the same—neuromuscular.

Creation combines materials in a new way, not according to a stereotype, and this leads to a more complicated, more intensive selection. The combination and selection of images take place far more easily and quickly than those of material objects. Hence creation takes place very often in the form of "spiritual" labor—but by no means exclusively. Almost all "fortuitous" and "unnoticeable" discoveries have been made through a selection of material combinations, and not through a preliminary combination and selection of images.

3. The methods of proletarian creation are founded on the methods of proletarian labor, i.e., the type of work that is characteristic for the workers in modern heavy industry.

The characteristics of this type are: (1) the unification of elements in "physical" and "spiritual" labor; (2) the transparent, unconcealed, and unmasked collectivism of its actual form. The former depends on the *scientific* character of modern technology, in particular on the transference of mechan-

ical effort to the machine: the worker is turning increasingly into a "master" of iron slaves, while his own labor is changing more and more into "spiritual" endeavor—concentration, calculation, control, and initiative; accordingly, the role of muscular tension is decreasing.

The second characteristic depends on the concentration of working force in mass collaboration and on the association between specialized types of labor within mechanical production, an association that is transferring more and more direct physical, specialist's work to machines. The objective and subjective uniformity of labor is increasing and is overcoming the divisions between workers; thanks to this uniformity the practical compatibility of labor is becoming the basis for *comradely,* i.e., consciously collective, relationships between them. These relationships and what they entail—mutual understanding, mutual sympathy, and an aspiration to work together—are extending beyond the confines of the factory, of the professions, and of production to the working class on a national and, subsequently, a universal scale. For the first time the collectivism of man's struggle with nature is being thought of as a *conscious* process.

4. In this way, methods of proletarian labor are developing toward *monism* and *collectivism.* Naturally, this tendency contains the methods of proletarian creation.

5. These aspects have already managed to express themselves clearly in the methods peculiar to those areas in which the proletariat has been most creative—in the economic and political struggle and in scientific thought. In the first two areas, this was expressed in the complete unity of structure in the organizations that the proletariat created—party, professional, and cooperative organizations: one type, one principle—comradeship, i.e., conscious collectivism; this was expressed also in the development of their programs, which in all these organizations tended toward one ideal, namely, a socialist one. In science and philosophy Marxism emerged as the embodiment of monism of method and of a consciously collectivist tendency. Subsequent development on the basis of these same methods must work out a universal organizational science, uniting monistically the whole of man's organizational experience in his social labor and struggle.

6. The proletariat's domestic creation, inasmuch as it derives from the framework of the economic and political struggle, has progressed intensely and, moreover, in the same direction. This is proved by the development of the proletarian family from the authoritarian structure of the peasant or bourgeois family to comradely relationships and the universally established form of courtesy—"comrade." Insofar as this creation will advance consciously, it is quite obvious that its methods will be assimilated on the same

principles; this will be creation by a harmonically cohesive, consciously collective way of life.

7. With regard to artistic creation, the old culture is characterized by its indeterminate and unconscious methods ("inspiration," etc.) and by the alienation of these methods from those of labor activity and of other creative areas. Although the proletarian is taking only his first steps in this field, his general, distinctive tendencies can be traced clearly. Monism is expressed in his aspiration to fuse art and working life, to make art a weapon for the active and aesthetic transformation of his entire life. Collectivism, initially an elemental process and then an increasingly conscious one, is making its mark on the content of works of art and even on the artistic form through which life is perceived. Collectivism illuminates the depiction not only of human life, but also of the life of nature: nature as a field of collective labor, its interconnections and harmonies as the embryos and prototypes of organized collectivism.

8. The technical methods of the old art have developed in isolation from the methods of other spheres of life; the techniques of proletarian art must seek consciously to utilize the materials of all those methods. For example, photography, stereography, cinematography, spectral colors, phonography, etc., must find their own places as mediums within the system of artistic techniques. From the principle of methodological monism it follows that there can be no methods of practical work or science that cannot find a direct or indirect application in art, and vice versa.

9. Conscious collectivism transforms the whole meaning of the artist's work and gives it new stimuli. The old artist sees the revelation of his individuality in his work; the new artist will understand and feel that within his work and through his work he is creating a grand totality—collectivism.

For the old artist, originality is the expression of the independent value of his "I," the means of his own exaltation; for the new artist, originality denotes a profound and broad comprehension of the collective experience and is the expression of his own active participation in the creation and development of the collective's life. The old artist can aspire half-consciously toward truth in life—or deviate from it; the new artist must realize that truth, objectivity support the collective in its labor and struggle. The old artist need or need not value artistic clarity; for the new artist, this means nothing less than collective accessibility, and this contains the vital meaning of the artist's endeavor.

10. The conscious realization of collectivism will deepen the mutual understanding of people and their emotional bonds; this will enable spontaneous collectivism in creation to develop on an incomparably broader scale

than hitherto, i.e., the direct collaboration of many people, even of the masses.

11. In the art of the past, as in science, there are many concealed collectivist elements. By disclosing them, the proletarian critics provide the opportunity for creatively assimilating the best works of the old culture in a new light, thereby adding immensely to their value.

12. The basic difference between the old and the new creation is that now, for the first time, creation understands itself and its role in life.

ANATOLII LUNACHARSKY and
YUVENAL SLAVINSKY
Theses of the Art Section
of Narkompros and the
Central Committee of the Union
of Art Workers Concerning Basic
Policy in the Field of Art, 1920

Lunacharsky—Born Poltava, 1875; died France, 1933. 1892: joined a Marxist group; entered Zurich University; 1898: returned to Russia; joined the Social Democrats; 1899: arrested for political activities; 1904: in Geneva; met Lenin; joined the Bolsheviks; 1905: in St. Petersburg; 1906: arrested, again on political grounds; 1908: with Maxim Gorky on Capri; 1909: with Aleksandr Bogdanov and Gorky organized the *Vpered* [Forward] group; 1911–15: in Paris; 1917: returned to Russia; 1917–29: People's Commissar for Enlightenment; 1933: appointed Soviet ambassador to Spain but died en route to the post.

Slavinsky—Born 1887, died 1936. 1911–18: conductor of the Moscow Grand Opera; 1916: founded the Society of Orchestral Musicians; 1917: member of the Bolsheviks; 1919: president of the Soyuz rabotnikov iskusstv [abbreviated to Sorabis or Rabis—Union of Art Workers]; 1929: founded Vsekokhudoznik [Vserossiiskii kooperativ khudozhnikov—All-Russian Cooperative of Artists]; 1930s: active as an administrator and critic.

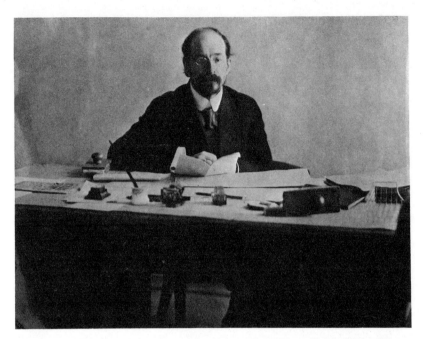

Anatolii Lunacharsky, ca. 1925. Photograph courtesy Radio Times Hulton Picture Library, London.

The text of this piece, "Tezisy khudozhestvennogo sektora NKP i TsK Rabis ob os-novakh politiki v oblasti iskusstva," is from *Vestnik teatra* [Theater Herald] (Moscow), no. 75, November 30, 1920, p. 9. [The text appears also in bibl. R60, no. 2/3, 1920, pp. 65–66; R68, no. 1, 1921, p. 20; and R16, pp. 57–58]. Rabis, founded in May 1919, acted as a trade union for workers connected with the arts, concerning it-self with such problems as social security, education courses, accessibility of li-braries, etc. [for details see bibl. R60, especially no. 4/5, 1921]. The significance of the "Theses" was twofold: on the one hand, they stated very clearly certain basic principles of artistic policy, and on the other, they constituted an attempt to find common agreement on such matters between the various organizations within the cultural hierarchy, in this case between Narkompros and Rabis. The program ad-vanced here shares certain ideas with Proletkult (e.g., the desire to create "purely proletarian art forms" and to "open workers' departments in all higher institu-tions"), of which Lunacharsky was an active member, although a dissident one, especially after 1920. If anything, the text betrays Lunacharsky's attempt to steer a middle course between the extreme right and the extreme left, between, broadly speaking, preservation and destruction—a course difficult to maintain in view of the inordinate number of radicals in IZO Narkompros [the Visual Arts Section of Nar-

kompros]. Certain sections of this policy, therefore, appear to be formulated in a de-
liberately rhetorical and imprecise fashion: the ambiguities of the first stipulation, for
example, found their tangible result in the slow and unsuccessful implementation of
Lenin's famous plan of monumental propaganda (1918 onwards); furthermore, the def-
inition of a proletarian art is sufficiently vague as to allow a very free interpretation.
Of course, it was thanks to the flexible and eclectic policies of IZO Narkompros that,
paradoxically, the dictatorship of leftist art could exist in the early years and that
even in the mid-1920s a large number of conflicting tendencies and groups could still
dominate the artistic arena. Lunacharsky was convinced that the ''Theses'' consti-
tuted an important document and regretted that they had not been publicized more
widely [for his own comments see bibl. R402, vol. 7, 501]. For a German translation
see bibl. 209viii, pp. 62, 63.

———

While recognizing that the time for establishing indisputable principles of
a proletarian aesthetics has not yet come, the Art Section of Narkompros and
the Central Committee of All Art Workers consider it essential, neverthe-
less, to elucidate adequately and accurately the basic principles by which
they are guided in their activities.

1. We acknowledge the proletariat's absolute right to make a careful re-
examination of all those elements of world art that it has inherited and to af-
firm the truism that the new proletarian and socialist art can be built only on
the foundation of all our acquisitions from the past. At the same time we ac-
knowledge that the preservation and utilization of the genuine artistic values
that we have acquired from the old culture is an indisputable task of the So-
viet government. In this respect the legacy of the past must be cleared
ruthlessly of all those admixtures of bourgeois degeneration and corruption;
cheap pornography, philistine vulgarity, intellectual boredom, antirevolu-
tionary [1] and religious prejudices—insofar as such admixtures are contained
in our legacy from the past—must be removed. In those cases where dubi-
ous elements are linked indissolubly with genuine artistic achievements, it is
essential to take steps to ensure that the new young, mass proletarian public
evaluate critically the spiritual nourishment provided it. In general, the pro-
letariat must assimilate the legacy of the old culture not as a pupil, but as a
powerful, conscious, and incisive critic.

2. Besides this, our Soviet and professional cultural and artistic activities
must be directed toward creating purely proletarian art forms and institu-
tions; these would, in every way, assist the existing and emergent workers'
and peasants' studios, which are seeking new paths within the visual arts,
music, the theater, and literature.

3. In the same way all fields of art must be utilized in order to elevate and
illustrate clearly our political and revolutionary agitational/propaganda work;

this must be done in connection with both shock work demonstrated during certain weeks, days, and campaigns, and normal, everyday work. Art is a powerful means of infecting those around us with ideas, feelings, and moods. Agitation and propaganda acquire particular acuity and effectiveness when they are clothed in the attractive and mighty forms of art.

However, this political art, this artistic judgment on the ideal aspirations of the revolution can emerge only when the artist himself is sincere in surrendering his strength to this cause, only when he is really imbued with revolutionary consciousness and is full of revolutionary feeling. Hence, Communist propaganda among the actual votaries of art is also an urgent task both of the Art Section and of the Union of Art Workers.

4. Art is divided up into a large number of directions. The proletariat is only just working out its own artistic criteria, and therefore no state authority or any professional union should regard any one of them as belonging to the state; at the same time, however, they should render every assistance to the new searches in art.

5. Institutions of art education must be proletarianized. One way of doing this would be to open workers' departments in all higher institutions concerned with the plastic, musical, and theatrical arts.

At the same time particular attention must be given to the development of mass taste and artistic creativity by introducing art into everyday life and into industrial production at large, i.e., by assisting in the evolution of an artistic industry and in the extensive development of choral singing and mass activities.

In basing themselves on these principles—on the one hand, under the general control of Glavpolitprosvet [2] and through it of the Communist Party and, on the other, linked indissolubly with the professionally organized proletariat and the All-Russian Soviet of Unions—the Art Section of Narkompros and the All-Russian Union of Art Workers will carry out in sympathy and in concord its work of art education and artistic industrialism throughout the country.

DAVID SHTERENBERG

Our Task, 1920

Born Zhitomir, 1881; died Moscow, 1948. 1903: entered the Bundist Party; 1906: went to Paris; 1912: began to exhibit regularly at the Salon d'Automne; contact with Guillaume Apollinaire and many others of the French avant-garde, especially of the Café Rotonde; 1917: returned to Russia; 1918–21: head of IZO Narkompros [Visual Arts Section of Narkompros]; held special responsibility for the preservation and restoration of works of art in Moscow and Petrograd; 1919: leading member of Komfut; 1920: professor at Vkhutemas; 1921: head of the Art Department in Glavprofobr [Glavnoe upravlenie professionalnogo obrazovaniya—Chief Administration for Professional Education] within Narkompros; 1922: helped to organize the Russian art exhibition in Berlin at the Van Diemen Gallery [see bibl. 197, 206]; 1925: founding member of OST (see p. 279ff.); 1927: one-man show in Moscow [bibl. R434]; 1930 and after: active as a book illustrator, especially of children's literature.

The text of this piece, "Nasha zadacha," is from *Khudozhestvennaya zhizn* [Art Life] (Moscow), no. 1/2, January/February 1920, pp. 5–6 [bibl. R86]. This journal was published by the Art Section [Khudozhestvennaya sektsiya] of Narkompros. Like many other expatriates who returned from Western Europe to Russia in 1917, Shterenberg welcomed the Revolution enthusiastically and felt that, among other things, it would make art education universally accessible. As an artist and an art teacher in his own right, Shterenberg was particularly interested in the problems of art instruction and was closely involved in the reorganization of the country's art schools. His conception of the "new art" was, however, a very indefinite one, and like many of his colleagues, he failed to determine what a "proletarian art" should stand for or even whether it should exist.

Shterenberg's own painting was representational, although influenced by cubism—a fact that did not detract from its originality—and his agit-decorations for Petrograd in 1918 were highly successful. In the 1920s Shterenberg was particularly interested in "objectness," or the essential matter of each separate object, and hence painted isolated objects on a single plane, often resorting to primitive forms and emphatic colors. But there was, of course, little sociopolitical significance in such aesthetic works. Lunacharsky thought very highly of Shterenberg both as an artist and as an administrator, and their friendship, which had begun in the Paris days, ended only with Lunacharsky's death.

David Shterenberg, ca. 1925. Photograph courtesy Mrs. Louis Lozowick, New Jersey.

The artistic culture of Soviet Russia is developing in breadth and depth despite the difficult conditions of the present time. The dead academy of art, which both during tsarism and in the subsequent Kerensky [1] period consisted of talentless art officials, remained apart from artistic life and neither reflected nor influenced our country's art. Despite the vast reserves of creative strength inherent in the Russian people, art education in Russia and the connected development of artistic industry were benumbed by this handful of individuals who took advantage of the academy's celebrated name. And for Russian art to be emancipated, it required only the removal of prestige and power from this group of people. This was done by the decree of the Soviet of People's Commissars at the beginning of the Revolution, and the business of art education rapidly moved forward. [2] In the field of art, the slogan of the People's Commissariat for Enlightenment was equality of all artistic trends. The elimination of all forms of coercion in art at the time of the Revolution was the best possible decision, and now we can already see a definite result. Western art had experienced this process long ago and, despite the existence there of official and dead academies, had embarked on a new life, thanks to public support. It is characteristic that the official museums of Paris do not have such valuable collections of Western art as our Shchukin and Morozov museums [3] or similar collections in Germany. The same thing happened with us: the best young artists and the young Russian

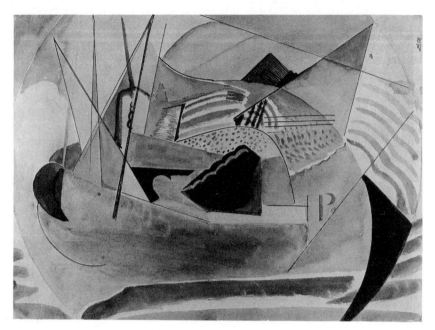

David Shterenberg: *Composition,* ca. 1918. Water color and India ink, 24 x 33 cm. Collection Grosvenor Gallery, London. This piece has a formal and thematic rssemblance to Shterenberg's agit designs for Petrograd in 1918, and may have been·one of his projects for the facade of the Hermitage.

art were valued abroad, whereas our museum workers recognized them only after their death, living artists not being represented in museums.

New ideas in the field of schoolteaching also remained outside the official academic schools and found refuge in the private schools of certain young artists. Paris owes its extremely rich development in the arts mainly to such schools, a development that made it the only city in Europe that virtually dictates new laws to the whole of Europe and exerts an immense influence on the art of all nations. England, Germany, and America, despite the high standard of their material culture, hardly possess their own art in the broad sense of the word. But Russia, thanks to the peculiar position it occupies in relation to the East and thanks to all the untapped resources of its culture, as yet in an embryonic state, has its own definite path on which it has only just embarked. That is why the new art schools, the State Free Studios and the art institutes that draw most of their students from among the workers and peasants, have developed with extraordinary speed. The new artistic forces

that introduced new methods of teaching into schools have yielded quite distinctive results that will now—at the end of the civil war and at the beginning of our life of labor and Communist construction—provide us with new instructors and new artists for our artistic-industry schools and enterprises.

Of the fifty schools in our section, almost half are working very well, despite the cold and hunger and neediness of the students; if our transport and Russia's general economic situation can right themselves even just for a while, then our schools will very shortly be in a splendid position. At the same time the new body of Russian artists will differ significantly from the old one because—and there is no use hiding it—nowhere is competition so developed as among artists; there are substantial grounds to assume that the State Free Studios will provide us with new artists linked together by greater solidarity—which significantly lightens the task of the cultural construction of the arts. The students' trying position during the civil war cleared their ranks of untalented groups. Only those remained who live for art and who cannot exist without it, such as the students of the First and Second State Free Studios in Moscow: during the present fuel crisis they used to go on foot into the woods, chop down firewood, and bring it back themselves on sledges so as to heat the studios where they could devote themselves to artistic work. These hardened workers are already serving the provinces now—in fact, the demands of various local Soviets and cultural organizations are growing, and we are having to take the best students out of our schools in order to send them to different places as instructors. At present the section's task consists mainly of putting the social security of our schools on a proper footing. From towns everywhere we receive letters from young artists, almost always talented (judging by models and drawings), with requests to be sent to our art schools, but not being able to provide for their subsistence, the section has to advise them to wait a little longer. I think that our present task is to give food allowances to all students, not only of art schools, but also of all schools of higher education throughout the Republic. This is essential, as essential as it was to create the Red Army. It must not be postponed because it will be the same Red Army—of Culture. Similarly, specialists who work with them in schools of higher education should be given food allowances; only in this way will we rehabilitate our industry by enriching it with the cultural element of the workers and peasants.

These new forces will give us the chance to carry out those mass art creations that the state now needs. Objectives of an agitational and decorative nature (it is essential to transform the whole face of our cities and the furnishings of our buildings) are creating that basis without which no art can exist.

The old art (museum art) is dying. The new art is being born from the new forms of our social reality.

We must create it and will create it.

<hr>

ANATOLII LUNACHARSKY
Revolution and Art, 1920–22

For biography see p. 182.

The first half of this text, "Revolyutsiya i iskusstvo," was written in October 1920 and published in *Kommunisticheskoe prosveshchenie* [Communist Enlightenment] (Moscow), 1920, no. 1; the second half was the result of an interview given in Petrograd on the occasion of the fifth anniversary of the October Revolution and was published in *Krasnaya gazeta* [Red Newspaper] (Moscow), no. 252, November 5, 1922. Both pieces appeared in a collection of Lunacharsky's articles on art, *Iskusstvo i revolyutsiya* [Art and Revolution] (Moscow, 1924), pp. 33–40, from which this translation is made. [They are reprinted in bibl. R402, vol. 7, 294–99.] The text, of course, reflects certain topical events, not least the enactment of Lenin's plan of monumental propaganda (based substantially on the measures of the revolutionary government in France in the early 1790s—hence the reference to the French Revolution) and the renewal of the private art market in 1921. Lunacharsky's personal artistic tastes are also evident in the text, e.g., his love of music and the theater.

———

I.

For a revolutionary state, such as the Soviet Union, the whole question of art is this: can revolution give anything to art, and can art give anything to revolution? It goes without saying that the state does not intend to impose revolutionary ideas and tastes on artists. From a coercive imposition of this kind only counterfeit revolutionary art can emerge, because the prime quality of true art is the artist's sincerity.

But there are other ways besides those of coercion: persuasion, encouragement, and appropriate education of new artists. All these measures

should be used for working, as it were, toward the revolutionary inspiration of art.

Complete absence of content has been very characteristic of bourgeois art of recent times. If we still did have some sort of art then, it was, so to say, the last progency of the old art. Pure formalism was exuberant everywhere: in music, painting, sculpture, and literature. Of course, style suffered as a result. In fact, the last epoch of the bourgeoisie was unable to advance any style at all—including a life style or a style of architecture—and advanced merely a whimsical and absurd eclecticism. Formal searches degenerated into eccentricities and tricks or into a peculiar, rather elementary pedantry tinged with various, puzzling sophistications, because true perfection of form is determined, obviously, not by pure formal search, but by the presence of an appropriate form common to the whole age, to all the masses, by a characteristic sensation, and by ideas.

Bourgeois society of the last decades has seen no such sensations and ideas worthy of artistic expression.

The Revolution is bringing ideas of remarkable breadth and depth. Everywhere it kindles feelings—tense, heroic, and complex.

Of course, the old artists have not the slightest understanding of this content and stand quite helplessly before it. They even interpret it as a kind of barbaric torrent of primitive passions and small ideas, but they think that only because of their own myopia. To many of them, especially the talented ones, this can be explained, and they can be, so to say, disenchanted; their eyes can be opened. But in particular, we must count on the young people, who are much more receptive and who can be, so to speak, nurtured in the very waves of the Revolution's fiery torrent. Hence I anticipate a great deal from the influence of the Revolution on art; to put it simply, I expect art to be saved from the worst forms of decadence and from pure formalism by its aspiration toward the real objective and by its infectious expression of great ideas and great experiences.

But in addition to this the state has another continuous task within its cultural activity, namely, to diffuse the revolutionary image of ideas, sensations, and actions throughout the country. From this standpoint the state asks itself: can art be of use to it in this? And the answer inevitably suggests itself: if revolution can give art its soul, then art can give revolution its mouthpiece.

Who is not aware of the full force of agitation? But what is agitation, how is it distinguished from clear, cold, objective propaganda in the sense of elucidating facts and logical constructions germane to our world view? Agitation can be distinguished from propaganda by the fact that it excites the

feelings of the audience and readers and has a direct influence on their will. It, so to say, brings the whole content of propaganda tó white heat and makes it glow in all colors. Yes, propagators—we, of course, are all propagators. Propaganda and agitation are simply the ceaseless propagation of a new faith, a propagation springing from profound knowledge.

Can it be doubted that the more artistic such propagation, the more powerful its effect? Don't we know that the artistic public speaker or journalist finds his way to the people's hearts more quickly than those lacking in artistic strength? But the collective propagandist is the collective propagator of our age; the Communist Party, from this point of view, should arm itself with all the organs of art, which in this way will prove itself to be of great use to agitation. Not only the poster, but also the picture, the statue—in less volatile forms and with more profound ideas, stronger feelings—can emerge as graphic aids to the assimilation of Communist truth.

The theater has so often been called a great tribune, a great rostrum for propagation, that it is not worth dwelling on this. Music has always played an enormous role in mass movements: hymns, marches, form an indispensable attribute of them. We have only to unfurl this magic strength of music above the hearts of the masses and to bring it to the utmost degree of definition and direction.

For the moment we are not in a position to make use of architecture on a wide scale for propaganda purposes, but the creation of temples was, so to say, an ultimate, maximum, and extremely powerful way of influencing the social soul—and perhaps, in the near future, when creating the houses of our great people, we will contrast them with the people's houses of the past— the churches of all denominations.

Those art forms that have arisen only recently as, for example, the cinema or rhythmics, can be used with very great effect. It is ridiculous to enlarge upon the propaganda and agitational strength of the cinema—it is obvious to anyone. And just think what character our festive occasions will take on when, by means of General Military Instruction,[1] we create rhythmically moving masses embracing thousands and tens of thousands of people—and not just a crowd, but a strictly regulated, collective, peaceful army sincerely possessed by one definite idea.

Against the background of the masses trained by General Military Instruction, other small groups of pupils from our rhythm schools will advance and will restore the dance to its rightful place. The popular holiday will adorn itself with all the arts, it will resound with music and choirs and that will express the sensations and ideas of the holiday by spectacles on several

stages, by songs, and by poetry reading at different points in the rejoicing crowd: it will unite everything in a common act.

This is what the French Revolution dreamed of, what it aspired to; this is what passed by the finest people of that most cultured of democracies—Athens; this is what we are approaching already.

Yes, during the Moscow workers' procession past our friends of the Third International, during the General Military Instruction holiday declared after this,[2] during the great mass action at the Stock Exchange colonnade in Petrograd,[3] one could sense the approach of the moment when art, in no way debasing itself and only profiting from this, would become the expression of national ideas and feelings—ideas and feelings that are Revolutionary and Communist.

2.

The Revolution, a phenomenon of vast and many-sided significance, is connected with art in many ways.

If we take a general look at their interrelation before the Revolution and now, in the fifth year of its existence, we will notice its extraordinary influence in many directions. First and foremost, the Revolution has completely altered the artist's way of life and his relation to the market. In this respect, certainly, artists can complain about, rather than bless, the Revolution.

At a time when war and the blockade were summoning the intense force of military Communism, the private art market was utterly destroyed for artists. This placed those who had a name and who could easily sell their works in such a market in a difficult position and made them, along with the bourgeoisie, antagonistic toward the Revolution.

The ruin of the rich Maecenases and patrons was felt less, of course, by the young, unrecognized artists, especially the artists of the left who had not been successful in the market. The Revolutionary government tried immediately, as far as possible, to replace the failing art market with state commissions and purchases. These commissions and purchases fell, in particular, to those artists who agreed willingly to work for the Revolution in the theater, in poster design, in decorations for public celebrations, in making monuments to the Revolution, concerts for the proletariat, and so forth.

Of course, the first years of the Revolution, with their difficult economic situation, made the artist's way of life more arduous, but they provided a great stimulus to the development of art among the young.

More important, perhaps, than these economic interrelationships were the psychological results of the Revolution.

Here two lines of observation can be made. On the one hand, the Revolution as a grand, social event, as a boundless and multicolored drama, could, of itself, provide art with vast material and to a great extent could formulate a new artistic soul.

However, during the first years of the Revolution, its influence on art in this respect was not very noticeable. True, Blok's *The Twelve* [4] was written and other things such as, say, Mayakovsky's *Mystery-Bouffe;* [5] many fine posters, a certain quantity of quite good monuments, were produced, but all this in no way corresponded to the Revolution itself. Perhaps to a great extent this can be explained by the fact that the Revolution, with its vast ideological and emotional content, requires a more or less realistic, self-evident expression saturated with ideas and feelings. Whereas the realist artists and those following similar trends—as I observed above—were less willing to greet the Revolution than those following new trends, the latter—whose nonrepresentational methods were very suitable for artistic industry and ornament—proved to be powerless to give psychological expression to the new content of the Revolution. Hence we cannot boast that the Revolution—and, I repeat, in the first years when its effect was strongest and its manifestation most striking—created for itself a sufficiently expressive and artistic form.

On the other hand, the Revolution not only was able to influence art, but also *needed* art. Art is a powerful weapon of agitation, and the Revolution aspired to adapt art to its agitational objectives. However, such combinations of agitational forces and genuine artistic depth were achieved comparatively rarely. The agitational theater, to a certain extent music, in particular the poster, undoubtedly had, during the first years of the Revolution, a great success in the sense that they were disseminated among the masses. But of this only very little can be singled out as being entirely satisfactory artistically.

Nevertheless, in principle, the thesis had remained correct: the Revolution had a great deal to *give* artists—a new content—and the Revolution *needed* art. Sooner or later a union had to come about between it and the artists. If we now turn to the present moment, we will notice a significant difference in a comparison of 1922 with 1918 and 1919. First of all, the private market appears again. The state, compelled to finance art on a niggardly, systematic budget, has virtually ceased buying and ordering for about the next two years. From this point of view, because of NEP, [6] the wheel appears to have turned full circle; and in fact, we can see, almost side by side with the

complete disappearance of the agitational theater, the emergence of a corruptive theater, the emergence of the obscene drinking place, which is one of the poisons of the bourgeois world and which has broken out like a pestilential rash on the face of Russia's cities together with the New Economic Policy. In other fields of art, albeit to a lesser degree, this same return to the sad past is noticeable.

However, there is no need to be pessimistic, and we should turn our attention to something else. Indeed, together with this, the improvement in living conditions, which has come about during the calm time of late, reveals how powerfully the Revolution has affected the artist's soul. The Revolution advanced, as we now see, a whole phalanx of writers who, in part, call themselves apolitical, but who nonetheless celebrate and proclaim precisely the Revolution in its Revolutionary spirit. Naturally the ideological and emotional element of the Revolution is reflected primarily in the most intellectual of the arts—in literature—but it does, of course, aspire to spread to other arts. It is characteristic that it is precisely now that magazines and anthologies are being created, that societies of painters and sculptors are being organized, and that work of architectural conception is being undertaken in the area where previously we had only demand and almost no supply.

Similarly, the second thesis, that the Revolution needs art, will not force us to wait long for its manifestation. Right now we are being told about an all-Russian subscription to the building of a grand monument to the victims of the Revolution on the Field of Mars [7] and about the desire to erect a grand Palace of Labor in Moscow.[8] The Republic, still beggarly and unclothed, is, however, recovering economically, and there is no doubt that soon one of the manifestations of its recovery will be the new and increasing beauty of its appearance. Finally, the last thing—what I began with—the artists' living conditions and economic position. Of course, with the rise of NEP, the artist is again pushed into the private market. But for how long? If our calculations are correct, and they are, then will the state, like a capitalist, with its heavy industry and vast trusts in other branches of industry, with its tax support, with its power over issue of currency, and above all, with its vast ideological content—will the state not prove ultimately to be far stronger than any private capitalists, big or small? Will it not draw unto itself all that is vital in art, like a grand Maecenas, truly cultured and truly noble?

In this short article I could sketch only with a couple of strokes the peculiar zigzag line of the relationships between revolution and art that we have hitherto observed. It has not been broken off. It continues even further.

As for the government, it will endeavor as before, as far as possible, to preserve the best of the old art, because recognition of it is essential to the further development of our renewed art. Besides this, it will endeavor to give active support to any innovation that is obviously of benefit to the masses, and it will never prevent the new—albeit dubious—from developing so as to avoid making a mistake in this respect by killing off something worthy of life while it is still young and weak. In the very near future, art in revolutionary Russia will have to live through a few more very bitter moments because the state's resources are still small and are growing slowly. We cannot allow ourselves the luxury of widespread artistic plenitude, but these difficult times are coming to an end. My predictions in this article of the Revolution's increased influence on art, the Revolution's increased demands on artists, and the increased coordination between the two will shortly begin to be justified.

VASILII KANDINSKY
Plan for the Physicopsychological Department of the Russian Academy of Artistic Sciences, 1923

For biography see p. 17

The text of this piece, untitled on its original publication, is from *Iskusstvo. Zhurnal Rossiiskoi Akademii khudozhestvennykh nauk* [Art. Journal of the Russian Academy of Artistic Sciences] (Moscow), no. 1, Summer 1923, pp. 415–16 [bibl. R69]. The manuscript of this text is in the Central State Archive of Literature and Art, Moscow (f. 941. op. 1, ed. khr. 3). Kandinsky presented his plan for the Physicopsychological Department of RAKhN [Russian Academy of Artistic Sciences; later GAKhN or Gosudarstvennaya Akademiya khudozhestvennykh nauk—State Academy of Artistic Sciences] in June of 1921, and it was accepted by the academy commission on July 21 although the academy itself was not formally established until October 7, under the presidency of Petr Kogan and the general auspices of Narkompros. The academy was divided into three main sections: the Physicomathematical and Physicopsychological Department, headed by Kandinsky; the Philosophical Department, headed by Gustav Shpet; and the Sociological Department, headed by Vladimir Friche. Within these basic divisions functioned

subsections devoted to literature, music, the theatre, the visual arts (toward which Kandinsky's plan was oriented), architecture, etc. The broad basis of the academy encouraged interest in extremely diverse topics, and between June 16, 1921, and January 1, 1923, for example, no less than forty-seven lectures were given at plenary sessions—including such stimulating titles as "Style and Stylization as Socio-organizational Phenomena" (Boris Arvatov), "The Organizational Role of Art" (Aleksandr Bogdanov), and "The Basic Elements of Painting" (Kandinsky).

Kandinsky's plan was an abbreviated version of the comprehensive program that he had drawn up for Inkhuk and its own proposed Psychophysiological Laboratory but that had encountered hostile opposition from the supporters of *veshch* (the object as such). Moreover, with Kandinsky's departure for Berlin at the end of 1921, the plan was not put into effect—at least not without substantial changes—although Shpet, Leonid Sabaneev, et al., set up a Psychophysical Laboratory in GAKhN in September 1924, thereby drawing on Kandinsky's experience. Despite the concise format of Kandinsky's plan, its aims were ambitious. To a certain extent its wide coverage can be seen as rivaling the broad scope of research interests maintained within the Inkhuk organization, particularly at the Petrograd IKhK; in fact, Mikhail Matyushin's investigations into the "perception of painterly elements by the human organism" [bibl. R21, p. 25], which he instigated at IKhK in 1923, had much in common with Kandinsky's own ideas and proposals. Kandinsky, of course, later implemented at least part of his Inkhuh/RAKhN plans within the framework of the Bauhaus. [For the text of the Inkhuk plan see bibl. R16,, pp. 126–39, for further ideas connected with Kandinsky's proposal for RAKhN see bibl. R393; for published results of Matyushin's research based on IKhK see bibl. R404–405; for details of RAKhN consult R69, especially no. 1, 1923, and R385.]

———

The department sets as its task to disclose the inner, positive laws on the basis of which aesthetic works are formed within every sphere of art and, in connection with the results obtained, to establish the principles of synthetic artistic expression. This task can be reduced to a number of concrete objectives: (1) the study of artistic elements as the material from which a work of art is formed, (2) the study of construction in creation as a principle whereby the artistic purpose is embodied, (3) the study of composition in art as a principle whereby the idea of a work of art is constructed.

The work of the department must be carried out in two directions: (a) a series of lectures based on the established program and (b) experimental research. We have not managed to pursue this experimental research owing to a lack of funds essential for the organization of laboratories.

The series of lectures "Elements of Art" has been given, and now certain of their materials, observations, and ideas are being processed. The series of

lectures on construction in nature, art, and technology is being developed. The series "Composition" is being prepared.

In accordance with these aims and tasks, the department's scientific plan for 1922–23 consists of the following:

I. The completion of a session of preliminary research work concerning the problem of construction in art. To this end, the following lectures on the problem of construction should be given at plenary meetings: (a) construction in extraaesthetic creation (utilitarian-productional construction), (b) architecture, (c) sculpture, (d) painting, (e) printing industry, (f) music, (g) plastic rhythm, (h) literature, (i) theater, (j) productional art.

II. Research into primitive art and into all the aesthetic concepts that give primitive art its style. In this respect a number of specific tasks have been formulated: (1) Research into the laws of the statics and dynamics of primitive art: (a) in an individual or typical/group context; (b) in the evolution of one form from another. (2) Methods: (a) a formal, positive, art historians' approach, inasmuch as the research is connected with the formal and descriptive study of art objects; (b) a psychological approach, inasmuch as the research will concern the psychology of artistic creation and perception. (3) Materials: children's art, the art of primitive and backward peoples, primordial art, the primitives of early Christian and medieval art; primitivism in modern art; aesthetic concepts that characterize primitive art found, for the most part, in the art of the ancient East. (4) The materials can be developed with regard to (a) specific branches of art and (b) artistic groupings organically interconnected, and (c) they can be directed toward a synthetic summary of general inferences.

The research plan concerning the problem of primitive art and the aesthetic concepts that give art its style in the sphere of the spatial (visual) arts and vis-à-vis the material mentioned and outlined above can be defined thus: (1) Art that develops a plane or surface (so-called painting): (a) color, (b) line, (c) spatial expression, (d) material, (e) means of processing the surface, (f) laws of construction, (g) concept. (2) Art that organizes volumes (so-called sculpture): (a) material, (b) mass, (c) volume, (d) chiaroscuro, (e) color, (f) line, (g) surface, (h) laws of construction, (i) concept. (3) Art that organizes actual three-dimensional space (so-called architecture): (a) architectural mass, (b) space, (c) light and shade, (d) line, (e) surface, (f) color, (g) construction, (h) concept. (4) Types and phases of development of the general artistic concept in primitive art, their positive and aesthetic bases. (5) The psychology of aesthetic expression and perception (within the framework of primitive art).

Lef
Declaration: Comrades,
Organizers of Life!, *1923*

The journal *Lef* [*Levyi front iskusstv*—Left Front of the Arts] existed from 1923 until 1925 and then resumed as *Novyi lef* [Novyi levyi front iskusstv—New Left Front of the Arts] in 1927 and continued as such until the end of 1928 [bibl. R76]. Among the founders of *Lef* were Boris Arvatov, Osip Brik, Nilolai Chuzhak, Boris Kushner, Vladimir Mayakovsky, and Sergei Tretyakov. Its editorial office was in Moscow. In 1929 the group changed its name to Ref [Revolyutsionnyi front—Revolutionary Front]. In 1930 the group disintegrated with Mayakovsky's entry into RAPP [Rossiiskaya assotsiatsiya proletarskikh pisatelei—Revolutionary Association of Proletarian Writers; see p. 288] and with the general change in the political and cultural atmosphere. *Lef* was especially active during its early years and had affiliates throughout the country, including Yugolef [Yuzhnyi lef—South Lef] in the Ukraine. As a revolutionary platform, *Lef* was particularly close to the constructivists and formalists; *Novyi lef* devoted much space to aspects of photography and cinematography, Aleksandr Rodchenko playing a leading part. [For comments and translations see *Form* (Cambridge, Eng.), no. 10, 1969, pp. 27–36, and *Screen* (London), vol. 12, no. 4, 1971–72, 25–100.]

The text of this piece, "Tovarishchi, formovshchiki zhizni!," appeared in *Lef* (Moscow), no. 2, April–May 1923, pp. 3–8, in Russian, German, and English [bibl. R76]. This translation is based on the English version, pp. 7–8. This was the fourth declaration by *Lef,* the first three appearing in the first number of the journal: "Za chto boretsya *Lef?*" [What Is *Lef* Fighting for?," pp. 1–7], "V kogo vgryzaetsya *Lef?*" ["What Is *Lef* Getting Its Teeth into?," pp. 8–9] and "Kogo predosteregaet *Lef?*" ["Whom Is *Lef* Warning?," pp. 10–11]. However, they were concerned chiefly with literature and with history and had only limited relevance to the visual arts. [The first and fourth declarations are reprinted in bibl. R16, pp. 291–95, and all of them are translated into French in bibl. 139, pp. 61–78.] For a German translation of this text see bibl. 209viii, pp. 213–18. This declaration sets forth the utilitarian, organizational conception of art that *Lef/Novyi lef* attempted to support throughout its short but influential life.

Today, the *First of May,* the workers of the world will demonstrate in their millions with song and festivity.

Five years of attainments, ever increasing.

Five years of slogans renewed and realized daily.

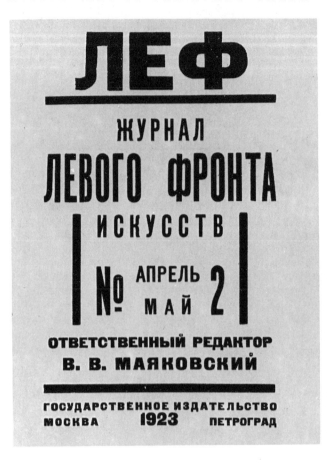

Title page of *Lef*, (Moscow), no. 2, 1923. Designed by Aleksandr Rodchenko.

Five years of victory.
And—
Five years of monotonous designs for celebrations.
Five years of languishing art.

So-called Stage Managers!
How much longer will you and other rats continue to gnaw at this theatrical sham?
Organize according to real life!
Plan the victorious procession of the Revolution!

So-called Poets!

When will you throw away your sickly lyrics?

Will you ever understand that to sing praises of a tempest according to newspaper information is not to sing praises about a tempest?

Give us a new *Marseillaise* and let the *Internationale* thunder the march of the victorious Revolution!

So-called Artists!

Stop making patches of color on moth-eaten canvases.

Stop decorating the easy life of the bourgeoisie.

Exercise your artistic strength to engirdle cities until you are able to take part in the whole of global construction!

Give the world new colors and outlines!

We know that the "priests of art" have neither strength nor desire to meet these tasks: they keep to the aesthetic confines of their studios.

On this day of demonstration, the First of May, when proletarians are gathered on a united front, we summon you, organizers of the world:

Break down the barriers of "beauty for beauty's sake"; break down the barriers of those nice little artistic schools!

Add your strength to the united energy of the collective!

We know that the aesthetics of the old artists, whom we have branded "rightists," revive monasticism and await the holy spirit of inspiration, but they will not respond to our call.

We summon the "leftists" the revolutionary *futurists,* who have given the streets and squares their art; the *productivists,* who have squared accounts with inspiration by relying on the inspiration of factory dynamos; the *constructivists,* who have substituted the processing of material for the mysticism of creation.

Leftists of the world!

We know few of your names, or the names of your schools, but this we do know—wherever revolution is beginning, there you are advancing.

We summon you to establish a single front of leftist art—the "Red Art International."

Comrades!

Split leftist art from rightist everywhere!

With leftist art prepare the European Revolution; in the U.S.S.R. strengthen it.

Keep in contact with your staff in Moscow (Journal *Lef,* 8 Nikitsky Boulevard, Moscow).

Not by accident did we choose the First of May as the day of our call.

Only in conjunction with the Workers' Revolution can we see the dawn of future art.

We, who have worked for five years in a land of revolution, know:

That only October has given us new, tremendous ideas that demand new artistic organization.

That the October Revolution, which liberated art from bourgeois enslavement, has given real freedom to art.

Down with the boundaries of countries and of studios!

Down with the monks of rightist art!

Long live the single front of the leftists!

Long live the art of the Proletarian Revolution!

V.
Constructivism and the Industrial Arts

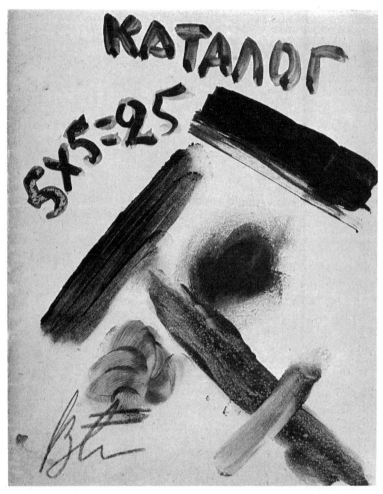

Design for the cover of the catalogue of the exhibition "5 × 5 = 25" (Moscow, September 1921). Designed by Varvara Stepanova. Oil on canvas, 17.5 x 14 cm. Photograph courtesy of the late Mr. Alfred H. Barr, Jr., New York. Since each catalogue of "5 × 5 = 25" was handmade, with typed text, the cover varied: sometimes it was by Aleksandr Rodchenko, sometimes by Stepanova. In addition, each of the participants contributed an original work of art to the catalogue—Lyubov Popova, a collage; Rodchenko, a drawing; etc.

VLADIMIR TATLIN
The Work Ahead of Us, 1920

Born Moscow, 1885; died Moscow, 1953; 1902–03: attended the Moscow Institute of Painting, Sculpture and Architecture; 1904–10: attended the Penza Art Institute; 1904-ca. 1908: made several voyages as a sailor through the Mediterranean countries; 1909–10: again attended the Moscow Institute of Painting, Sculpture and Architecture; 1908–11: close to the Burliuk brothers, Mikhail Larionov and other members of the nascent avant-garde; 1911: with Mikhail Le-Dantiyu et al., designed costumes for the play *Emperor Maximilian and His Disobedient Son Adolph*; close to the Union of Youth; 1914: traveled to Berlin and Paris, where he met Picasso; on his return to Russia began to work on his reliefs; at this time worked closely with Aleksei Grischchenko, Lyubov Popova, Nadezhda Udaltsova, and Aleksandr Vesnin; 1912–16: contributed to the "Donkey's Tail," "Union of Youth," "Tramway V," "0.10," "Shop," and other exhibitions; 1918: head of IZO Narkompros [Visual Arts Section of Narkompros] in Moscow; 1919: head of the Painting Department at Svomas, Moscow; then moved to Svomas, Petrograd; 1919–20: worked on the model of his Monument for the Third International; 1921: close to Inkhuk; cofounder of IKhK; 1925–27: headed the Department of Theater and Cinema at the Kiev Art Institute; 1929–32; designed and exhibited his Letatlin glider; 1930s and 1940s: worked on theater decor and turned back to easel painting.

The text of this piece, "Nasha predstoyashchaya rabota," is from *Ezhednevnyi byulleten VIII-go sezda sovetov* [Daily Bulletin of the Eighth Congress of Soviets] (Moscow), no. 13, January 1, 1921, p. 11. Cosignatories with Tatlin were Tevel Shapiro, Iosif Meerzon, and P. Vinogradov, who assisted him on the project. The text, which was dated December 31, 1920, has been translated into French in bibl. 145i, and English in the catalogue to the exhibition *Vladimir Tatlin* (Stockholm, 1968), p. 51 [bibl. 230], and except for the notes, which have been added, this translation is reproduced here with the kind permission of the Modern Museet, Stockholm. The text acts as a commentary on the model of Tatlin's Monument for the Third International, which had been transferred from Petrograd and erected in Moscow on the occasion of the Eighth Congress of Soviets, in December 1920; in general terms, the text provides an elucidation of, and justification for, the construction of such an innovative and provocative project. Tatlin's Monument (or Tower), like Lissitzky's Prouns (see p. 151), signalized a new constructive conception by presenting an "organic synthesis of architectural, sculptural, and painterly principles" [bibl. R444, p. 1] and, of course, provided an essential stimulus

to the development of a constructivist architecture. While Tatlin's Monument stood at a crossroads between the purist art of his reliefs and counterreliefs and the practical application of his ideas to productional design (clothes, furniture, his domestic stove, etc.), the interest in the object as such remained, at least among his fellow artists and critics: Aleksandra Exter and Ignatii Nivinsky, for example, used counterreliefs in their decorations for the "First Agricultural and Handicraft-Industrial Exhibition," in Moscow in 1923, and in December 1925 GAKhN (see p. 196ff.) organized a lecture and discussion entitled "On the Counterrelief." Tatlin himself, however, became convinced of the need for art to be utilitarian and functional, a view that was at least implicit in the closing lines of the present text and was emphasized clearly in his essay "Art Out into Technology" of 1932 [in bibl. 230, pp. 75–76].

———

The foundation on which our work in plastic art—our craft—rested was not homogeneous, and every connection between painting, sculpture and architecture had been lost: the result was individualism, i.e. the expression of purely personal habits and tastes; while the artists, in their approach to the material, degraded it to a sort of distortion in relation to one or another field of plastic art. In the best event, artists thus decorated the walls of private houses (individual nests) and left behind a succession of "Yaroslav Railway Stations" [1] and a variety of now ridiculous forms.

What happened from the social aspect in 1917 was realized in our work as pictorial artists in 1914, [2] when "materials, volume and construction" were accepted as our foundations.

We declare our distrust of the eye, and place our sensual impressions under control.

In 1915 [3] an exhibition of material models on the laboratory scale was held in Moscow (an exhibition of reliefs and contre-reliefs). An exhibition held in 1917 [4] presented a number of examples of material combinations, which were the results of more complicated investigations into the use of material in itself, and what this leads to: movement, tension, and a mutual relationship between.

This investigation of material, volume and construction made it possible for us in 1918, in an artistic form, to begin to combine materials like iron and glass, the materials of modern Classicism, comparable in their severity with the marble of antiquity.

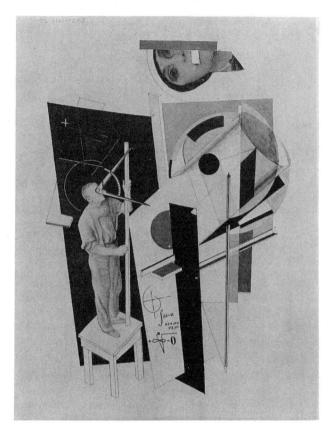

El Lissitzky: *Tatlin at Work on the Third International,* ca. 1920. Pencil, gouache, photomontage, 33 x 24.5 cm. Collection Grosvenor Gallery, London.

In this way an opportunity emerges of uniting purely artistic forms with utilitarian intentions. An example is the project for a monument to the Third International [5] (exhibited at the Eighth Congress).

The results of this are models which stimulate us to inventions in our work of creating a new world, and which call upon the producers to exercise control over the forms encountered in our new everyday life.

Vladimir Tatlin: *Model for Letatlin* (without sheathing fabric), 1932. Letatlin was a one-man glider designed by Tatlin and so called from the combination of the verb *letat* [to fly] and Tatlin. Tatlin was not the only Soviet artist to think in terms of aerospace engineering; Petr Miturich, for example, designed an "undulating dirigible" in 1931. Photograph courtesy private collector, Moscow.

NAUM GABO and
ANTON PEVSNER
The Realistic Manifesto, 1920

Gabo—Pseudonym of Naum Neemia Pevzner. Born Briansk, 1890; died Connecticut, 1977. Brother of Anton. 1910: graduated from Kursk Gymnasium; entered the medical faculty of Munich University; 1912: transferred to the Polytechnicum Engineering School, Munich; 1913: traveled in Italy; 1913–14: visited Paris where his brother Anton was studying; 1914: traveled to Scandinavia; 1915: first constructions; 1917: returned to Russia; 1920: with Anton published his *Realist Manifesto* in Moscow; 1922: left Russia for Berlin; 1926–27: with Anton designed the decor for Sergei Diaghilev's production of *La Chatte*; 1932: moved to Paris; 1946: settled in the United States; 1971: knighted by Queen Elizabeth II.

Pevsner—Real name Noton Pevzner. Born Orel, 1886; died Paris, 1962. Brother of Naum. 1902–1909: attended the Kiev Art School; influence of Isaak Levitan and Mikhail Vrubel; 1909–11: attended the St. Petersburg Academy; 1911–14: worked in Paris; contact with Alexander Archipenko and Amedeo Modigliani; 1914–15: in

Moscow; 1917–22: professor at Svomas/Vkhutemas; 1923: emigrated to Paris; 1926–27 with Gabo designed the decor for Diaghilev's production of *La Chatte*.

The text of this piece, *Realisticheskii manifest,* was published in August 1920 in Moscow. An open-air exhibition of Gabo's and Pevsner's work was organized simultaneously. The term "realistic," of course, does not imply a concern with realist, representational depiction, but with the essential or absolute quality of reality—a meaning that many Russian artists had favored (see, for example, the use of the term by Larionov in his "Rayonist Painting" or by Puni and Boguslavskaya in their "Suprematist Manifesto"). It might be argued, in fact, that the main function of "The Realistic Manifesto" was to consolidate various ideas that had been supported by the Russian avant-garde long before 1920, rather than to advance totally new ones; furthermore, the manifesto itself exerted little influence on the actual development of Russian constructivism or of Russian art in general and had much more significance in the context of Western constructivisim. The text has been translated into English by Gabo in *Gabo* (London: Lund Humphries; Cambridge, Mass.: Harvard University Press, 1957), pp. 151–52 [bibl. 216]; except for the notes, which have been added, this translation is reproduced here with kind permission of Naum Gabo, who requested that I insert the following statement: "I am the sole author of this Manifesto. The translation of it into English was also done by me. My brother, Antoine Pevsner, asked permission to add his signature to it, to which I agreed." Another English translation of the manifesto was published by Camilla Gray in *The Structurist* (Saskatoon), no. 8, 1968, pp. 43–47. For a modern Soviet discussion of this manifesto see V. Tasalov, *Prometei ili Orfei* [Prometheus or Orpheus] (Moscow, 1967), pp. 237–45.

Above the tempests of our weekdays,

Across the ashes and cindered homes of the past,

Before the gates of the vacant future,

We proclaim today to you artists, painters, sculptors, musicians, actors, poets . . . to you people to whom Art is no mere ground for conversation but the source of real exaltation, our word and deed.

The impasse into which Art has come to in the last twenty years must be broken.

The growth of human knowledge with its powerful penetration into the mysterious laws of the world which started at the dawn of this century,

The blossoming of a new culture and a new civilization with their unprecedented-in-history surge of the masses towards the possession of the riches of Nature, a surge which binds the people into one union, and last, not least, the war and the revolution (those purifying torrents of the coming epoch), have made us face the fact of new forms of life, already born and active.

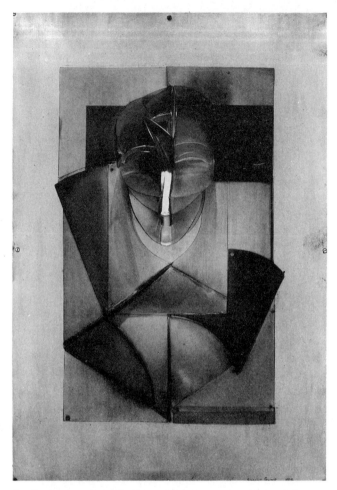

Antoine Pevsner: *Portrait of Marcel Duchamp,* 1926. High relief construction, celluloid on copper (zinc), 65.4 x 94 cm. Yale University Art Gallery, gift of Collection Société Anonyme.

What does Art carry into this unfolding epoch of human history?

Does it possess the means necessary for the construction of the new Great Style?

Or does it suppose that the new epoch may not have a new style?

Or does it suppose that the new life can accept a new creation which is constructed on the foundations of the old?

In spite of the demand of the renascent spirit of our time, Art is still nourished by impression, external appearance, and wanders helplessly back and forth from Naturalism to Symbolism, from Romanticism to Mysticism.

The attempts of the Cubists and the Futurists to lift the visual arts from the bogs of the past have led only to new delusions.

Cubism, having started with simplification of the representative technique ended with its analysis and stuck there.

The distracted world of the Cubists, broken in shreds by their logical anarchy, cannot satisfy us who have already accomplished the Revolution or who are already constructing and building up anew.

One could heed with interest the experiments of the Cubists, but one cannot follow them, being convinced that their experiments are being made on the surface of Art and do not touch on the bases of it seeing plainly that the end result amounts to the same old graphic, to the same old volume and to the same decorative surface as of old.

One could have hailed Futurism in its time for the refreshing sweep of its announced Revolution in Art, for its devastating criticism of the past, as in no other way could have assailed those artistic barricades of "good taste" . . . powder was needed for that and a lot of it . . . but one cannot construct a system of art on one revolutionary phrase alone.

One had to examine Futurism beneath its appearance to realize that one faced a very ordinary chatterer, a very agile and prevaricating guy, clad in the tatters of worn-out words like "patriotism," "militarism," "contempt for the female," and all the rest of such provincial tags.

In the domain of purely pictorial problems, Futurism has not gone further than the renovated effort to fix on the canvas a purely optical reflex which has already shown its bankruptcy with the Impressionists. It is obvious now to every one of us that by the simple graphic registration of a row of momentarily arrested movements, one cannot re-create movement itself. It makes one think of the pulse of a dead body.

The pompous slogan of "Speed" was played from the hands of the Futurists as a great trump. We concede the sonority of that slogan and we quite see how it can sweep the strongest of the provincials off their feet. But ask any Futurist how does he imagine "speed" and there will emerge a whole arsenal of frenzied automobiles, rattling railway depots, snarled wires, the clank and the noise and the clang of carouselling streets . . . does one really need to convince them that all that is not necessary for speed and for its rhythms?

Look at a ray of sun . . . the stillest of the still forces, it speeds more than 300 kilometres in a second . . . behold our starry firmament . . . who

hears it . . . and yet what are our depots to those depots of the Universe? What are our earthly trains to those hurrying trains of the galaxies?

Indeed, the whole Futurist noise about speed is too obvious an anecdote, and from the moment that Futurism proclaimed that "Space and Time are yesterday's dead," it sunk into the obscurity of abstractions.

Neither Futurism nor Cubism has brought us what our time has expected of them.

Besides those two artistic schools our recent past has had nothing of importance or deserving attention.

But Life does not wait and the growth of generations does not stop and we go to relieve those who have passed into history, having in our hands the results of their experiments, with their mistakes and their achievements, after years of experience equal to centuries . . . we say . . .

No new artistic system will withstand the pressure of a growing new culture until the very foundation of Art will be erected on the real laws of Life.

Until all artists will say with us . . .

All is a fiction . . . only life and its laws are authentic and in life only the active is beautiful and wise and strong and right, for life does not know beauty as an aesthetic measure . . . efficacious existence is the highest beauty.

Life knows neither good nor bad nor justice as a measure of morals . . . need is the highest and most just of all morals.

Life does not know rationally abstracted truths as a measure of cognizance, deed is the highest and surest of truths.

Those are the laws of life. Can art withstand these laws if it is built on abstraction, on mirage, and fiction?.

We say . . .

Space and time are re-born to us today.

Space and time are the only forms on which life is built and hence art must be constructed.

States, political and economic systems perish, ideas crumble, under the strain of ages . . . but life is strong and grows and time goes on in its real continuity.

Who will show us forms more efficacious than this . . . who is the great one who will give us foundations stronger than this?

Who is the genius who will tell us a legend more ravishing than this prosaic tale which is called life?

The realization of our perceptions of the world in the forms of space and time is the only aim of our pictorial and plastic art.

In them we do not measure our works with the yardstick [1] *of beauty, we do not weigh them with pounds of tenderness and sentiments.*

The plumb-line in our hand, eyes as precise as a ruler, in a spirit as taut as a compass . . . we construct our work as the universe constructs its own, as the engineer constructs his bridges, as the mathematician his formula of the orbits.

We know that everything has its own essential image; chair, table lamp, telephone, book, house, man . . . they are all entire worlds with their own rhythms, their own orbits.

That is why we in creating things take away from them the labels of their owners . . . all accidental and local, leaving only the reality of the constant rhythm of the forces in them.

1. *Thence in painting we renounce colour as a pictorial element, colour is the idealized optical surface of objects; an exterior and superficial impression of them; colour is accidental and has nothing in common with the innermost essence of a thing.*

We affirm *that the tone of a substance, i.e. its light-absorbing material body is its only pictorial reality.*

2. We renounce *in a line, its descriptive value; in real life there are no descriptive lines, description is an accidental trace of a man on things, it is not bound up with the essential life and constant structure of the body. Descriptiveness is an element of graphic illustration and decoration.*

We affirm *the line only as a direction of the static forces and their rhythm in objects.*

3. We renounce *volume as a pictorial and plastic form of space; one cannot measure space in volumes as one cannot measure liquid in yards: look at our space . . . what is it if not one continuous depth?*

We affirm *depth as the only pictorial and plastic form of space.*

4. We renounce *in sculpture, the mass as a sculptural element.*

It is known to every engineer that the static forces of a solid body and its material strength do not depend on the quantity of the mass . . . example a rail, a T-beam etc.

But you sculptors of all shades and directions, you still adhere to the age-old prejudice that you cannot free the volume of mass. Here (in this exhibition) we take four planes and we construct with them the same volume as of four tons [2] *of mass.*

Thus we bring back to sculpture the line as a direction and in it we affirm depth as the one form of space.

5. We renounce *the thousand-year-old delusion in art that held the static rhythms as the only elements of the plastic and pictorial arts.*

We affirm *in these arts a new element the kinetic rhythms as the basic forms of our perception of real time*.

These are the five fundamental principles of our work and our constructive technique.

Today we proclaim our words to you people. In the squares and on the streets we are placing our work convinced that art must not remain a sanctuary for the idle, a consolation for the weary, and a justification for the lazy. Art should attend us everywhere that life flows and acts . . . at the bench, at the table, at work, at rest, at play; on working days and holidays . . . at home and on the road . . . in order that the flame to live should not extinguish in mankind.

We do not look for justification, neither in the past nor in the future.

Nobody can tell us what the future is and what utensils does one eat it with.

Not to lie about the future is impossible and one can lie about it at will.

We assert that the shouts about the future are for us the same as the tears about the past: a renovated day-dream of the romantics.

A monkish delirium of the heavenly kingdom of the old attired in contemporary clothes.

He who is busy today with the morrow is busy doing nothing.

And he who tomorrow will bring us nothing of what he has done today is of no use for the future.

Today is the deed.

We will account for it tomorrow.

The past we are leaving behind as carrion.

The future we leave to the fortune-tellers.

We take the present day.

ALEKSEI GAN

Constructivism [Extracts], 1922

Born 1893; died 1942. 1918–20: attached to TEO Narkompros [Teatralnyi otdel Narkomprosa—Theater Section of Narkompros] as head of the Section of Mass Presentations and Spectacles; end of 1920: dismissed from Narkompros by Anatolii Luna-

Aleksei Gan, mid-1920s. Riding a motorcycle,
wearing cyclist's goggles, was Gan's favorite
pastime.

charsky because of his extreme ideological position; close association with Inkhuk;
cofounder of the First Working Group of Constructivists; early 1920s: turned to
designing architectural and typographical projects, movie posters, bookplates;
1922–23 editor of the journal *Kino-fot* [Cine-Photo]; 1926–30: member of OSA
[Obedinenie sovremennykh arkhitektorov—Association of Contemporary Archi-
tects] and artistic director of its journal, *Sovremennaya arkhitektura* [*SA*—
Contemporary Architecture; bibl. R84]; 1928: member of October group; during
1920s: wrote articles on art and architecture; died in a prison camp.

The translation is of extracts from Gan's book *Konstruktivizm* (Tver, October–
December 1922 [according to KL, advertised as appearing in May in bibl. R59,
no. 5, p. 26]). The first extract, "Revolutionary Marxist Thought," is from pp.
13–19; the second, "From Speculative Activity," is from pp. 48–49; and the third,
"Tectonics, Texture, Construction," is from pp. 55—56. [Part of the text has been
translated into English in bibl. 45, pp. 284–87.] The book acted as a declaration of
the industrial constructivists and marked the rapid transition from a purist conception
of a constructive art to an applied, mechanical one; further, it has striking affinities
with the enigmatic "Productivist" manifesto published in bibl. 216, p. 153. It is log-
ical to assume that the book's appearance was stimulated by the many debates on
construction and production that occurred in Inkhuk during 1921 and in which Boris
Arvatov, Osip Brik, El Lissitzky, Aleksandr Rodchenko, Varvara Stepanova, Niko-
lai Tarabukin, et al., took an active part, and also by the publication of the influential
collection of articles *Iskusstvo v proizvodstve* [Art in Production] in the same year
[bibl. R454]. Moreover, the First Working Group of Constructivists, of which Gan

Cover of Aleksei Gan's *Konstruktivizm* [Constructivism] (Tver, 1922). Designed by Gan.

Page from *Konstruktivizm*. Designed by Gan.

was a member, had been founded in 1920 (see p. 241ff). However, the book, like Gan himself, was disdained by many contemporary constructivists, and the significance of the book within the context of Russian constructivism has, perhaps, been overrated by modern observers.

In keeping with its tenets, the book's textual organization and imagery are highly "industrial": the elaborate typographical layout designed by Gan and the book's cover (designed allegedly by Gan but suggested probably by Rodchenko [cf. the definitive cover with the project by Rodchenko illustrated in bibl. R76, no. 1, 1923, p. 106]) were intended, of course, to support the basic ideas of the text itself. Such terms as *tektonika* [tectonics], *faktura* [texture], and *konstruktsiya* [construction] were vogue words during the later avant-garde period, especially just after the Revolution, and implied rather more than their direct English translations. The concepts of texture and construction had been widely discussed as early as 1912–14, stimulating David Burliuk and Vladimir Markov, for example, to devote separate essays to the question of texture [see bibl. R269, R233]; and the concept of construction was, of course, fundamental to Markov's "The Principles of the New Art" (see pp. 23ff.). The term "texture" was also used by futurist poets, and Aleksei Kruchenykh published a booklet entitled *Faktura slova* [Texture of the Word] in 1923 [see bibl. 133, p. 341, for details]. The term "tectonics" was, however, favored particularly by the constructivists and, as the so-called "Productivist" manifesto explained, "is derived from the structure of communism and the effective exploitation of industrial matter"

[bibl. 216, p. 153]. But nonconstructivists also used the term; to Aleksandr Shevchenko, for example, a tectonic composition meant the "continual displacement and modification of tangible forms of objects until the attainment of total equilibrium on the picture's surface" [bibl. R16, p. 119]. To confuse matters further, Gan's own explanation of tectonics, texture, and construction was not at all clear: "Tectonics is synonymous with the organicness of thrust from the intrinsic substance. . . . Texture is the organic state of the processed material. . . . Construction should be understood as the collective function of constructivism . . ." (*Konstruktivizm,* pp. 61–62). Nevertheless, despite Gan's rhetoric and obscurity, the value of his book lies in the fact that it crystallized, as it were, certain potential ideas in evidence since at least 1920 and presented them as what can be regarded as the first attempt to formulate the constructivist ideology. The inconsistencies and pretentiousness of Gan's style of writing leave much to be desired. For extracts in French translation see bibl. 145i, pp. 205–11.

From "Revolutionary Marxist Thought in Words and Podagrism in Practice"

Year in year out, like a soap bubble, Narkompros fills out and bursts after overloading its heart with the spirits of all ages and peoples, with all systems and with all the "sinful" and "sinless" *values* (!) of the living and the dead.

And under the auspices of the quasi Marxists work the black thousands of votaries of art, and in our revolutionary age the "spiritual" culture of the past still stands firmly on the stilts of reactionary idealism.

Artistic culture—as one of the formal exponents of the "spiritual"—does not break with the values of Utopian and fanciful visions, and its fabricators do not reject **the priestly functions of formalized hysterics.**

The Communists of Narkompros in charge of art affairs are hardly distinguishable from the non-Communists outside Narkompros. They are just as fascinated by the beautiful as the latter are captivated by the divine.

Seduced by priestliness, **the transmitters and popularizers** reverently serve the past, while **promising the future by word of mouth.** This impels them toward the most reactionary, *déclassé* maniacal artists: of painting, sculpture, and architecture. On the one hand, they are Communists ready to fall in open battle with capitalism at the slightest attempt at restoration; on the other hand, like conservatives, they fall voluntarily, without striking a blow, and liturgically revere the art of those very cultures **that they regard so severely when mentioning the theory of historical materialism.**

Our responsible, very authoritative *leaders* are unfortunately dealing confusedly and unscrupulously with the art not only of yesterday, but also of today; and they are creating conditions in which there can be no possibility of putting the problems of intellectual-material production on the rails of practical activity in a collective and organized fashion.

And no wonder; they are of one flesh with those same putrid aesthetics against which the materialist innovators of leftist art rebelled.

That is why a campaign is being waged both in the open and in secret against the "nonideaists" and the "nonobjectivists." And the more thematic the latter, the more graphically reality supports them, the less stringently the priests of the old art carry on the struggle with them.

Now officially they are everything; they set the tone and, like clever actors, paint themselves up to resemble Marx.

It is only the proletariat with its sound Marxist materialism that does not follow them, but for all that, the vast masses do: the intellectuals, agnostics, spiritualists, mystics, empiriocritics, eclectics, and other podagrics and paralytics.

That is who is now the defender

of artistic values

in the name of Communism.

The priest-producers of these "artistic values" understand this situation and take it into account. It is they who are weaving the threads of falsehood and deception. Like the rotten heritage of the past, they continue **to parasitize and ventriloquize,** using the resources of that same proletariat that, writhing in agony, heroically, implements the slogans, **the promises of mankind's liberation from every supernatural force encroaching on his freedom.**

The priest-hireling

—that is who might become an aesthetic depicter and produce a lot of palliative forms

of the intellectual-material culture of Communism.

The proletariat and the proletarianized peasantry take absolutely no part in. art.

The character and forms in which art was expressed and the "social" meaning that it possessed affected them in no way whatsoever.

The proletariat developed and cultivated itself independently as a class within the concrete conditions of the struggle. Its ideology was formulated precisely and clearly. It tightened the lower ranks of its class not by play-acting, not by the artificial means of abstraction, not by abstruse fetishism, but by the concrete means of revolutionary action, by thematic propaganda and factual agitation.

Art did not consolidate the fighting qualities of the proletarian revolutionary class; rather it decomposed the individual members of its vanguard. **On the whole it was alien and useless to a class that had its own and only its own cultural perspective.**

The more vividly the artistic-reactionary wave of restoration manifests itself—the more distinctly will the sound, authentic elements of the proletariat dissociate themselves from this sphere of activity.

During the whole time of the proletarian revolution, neither the department in charge of art affairs, nor organizations, nor groups have justified their promises in practice.

From the broadcast of revolutionary calls to the future, they turned off into the reactionary bosom of the past and built their practice on the theory of "spiritual" continuity.

But practice showed that "spiritual" continuity is hostile to the tasks of a proletarian revolution by which we advance toward Communism.

THE COUNTERREVOLUTIONISM OF THE BOURGEOIS VOTARIES OF ART WHO HAVE WANDERED CASUALLY FROM ART TO REVOLUTION HAS CREATED AN INCREDIBLE CONFUSION IN ITS VAIN ATTEMPTS TO "REVOLUTIONIZE" THE FLABBY SPIRIT OF THE PAST BY AESTHETICS.

BUT THE SENTIMENTAL DEVOTION TO THE REVOLUTION OF THE IDEOLOGISTS OF THE PETIT-BOURGEOIS TENDENCY HAS PRODUCED A SHARP CRACK IN THE ATTEMPTS TO DECAPITATE THE MATERIALISM OF REVOLUTIONARY REALITY BY THE OLD FORMS OF ART.

But the victory of materialism in the field of artistic labor is also on the eve of its triumph.

The proletarian revolution is not a word of flagellation but a real whip, which expels parasitism from man's practical reality in whatever guise it hides its repulsive being.

The present moment within the framework of objective conditions obliges us to declare that the current position of social development is advancing with the omen that the artistic culutre of the past is unacceptable.

The fact that all so-called art is permeated with the most reactionary idealism is the product of extreme individualism; this individualism shoves it in the direction of new, unnecessary amusements with experiments in refining subjective beauty.

Art

is indissolubly linked:

with theology,

metaphysics,

and mysticism.

It emerged during the epoch of primeval cultures, when technique existed in "the embryonic state of tools," and forms of economy floundered in utter primitiveness.

It passed through the forge of the guild craftsmen of the Middle Ages.

It was artificially reheated by the hypocrisy of bourgeois culture and, finally, crashed against the mechanical world of our age.

Death to art!

It arose naturally

developed naturally

and disappeared naturally.

MARXISTS MUST WORK IN ORDER TO ELUCIDATE ITS DEATH SCIENTIFICALLY AND TO FORMULATE NEW PHENOMENA OF ARTISTIC LABOR WITHIN THE NEW HISTORIC ENVIRONMENT OF OUR TIME.

In the specific situation of our day, a gravitation toward the technical acme and social interpretation can be observed in the work of the masters of revolutionary art.

Constructivism is advancing—the slender child of an industrial culture.
For a long time capitalism has let it rot underground.
It has been liberated by—the Proletarian Revolution.
A new chronology begins

with October 25, 1917.

From "From Speculative Activity of Art to Socially Meaningful Artistic Labor"

. . . When we talk about social technology, this should imply not just one kind of tool, and not a number of different tools, but a system of these tools, their sum total in the whole of society.

It is essential to picture that in this society, lathes and motors, instruments and apparatuses, simple and complex tools are scattered in various places, but in a definite order.

In some places they stand like huge sockets (e.g., in centers of large-scale industry), in other places other tools are scattered about. But at any given moment, if people are linked by the bond of labor, if we have a society, then all the tools of labor will also be interlocked: all, so to say, "technologies" of individual branches of production will form something whole, a united social technology, and not just in our minds, but objectively and concretely.

The technological system of society, the structure of its tools, creates the structure of human relationships, as well.

The economic structure of society is created from the aggregate of its productional relationships.

The sociopolitical structure of society is determined directly by its economic structure.

But in times of revolution peculiar contradictions arise.

We live in the world's first proletarian republic. The rule of the workers is realizing its objectives and is fighting not only for the retention of this rule, but also for absolute supremacy, for the assertion of new, historically necessary forms of social reality.

In the territory of labor and intellect, there is no room for speculative activity.

In the sphere of cultural construction, only that has concrete value which is indissolubly linked with the general tasks of revolutionary actuality.

Bourgeois encirclement can compel us to carry out a whole series of strategic retreats in the field of economic norms and relationships, but in no way must it distort the process of our intellectual work.

The proletarian revolution has bestirred human thought and has struck home at the holy relics and idols of bourgeois spirituality. *Not only the ecclesiastical priests have caught it in the neck, the priests of aesthetics have had it too.*

Art is finished! It has no place in the human labor apparatus.

Labor, technology, organization!

THE REVALUATION OF THE FUNCTIONS OF HUMAN ACTIVITY, THE LINKING OF EVERY EFFORT WITH THE GENERAL RANGE OF SOCIAL OBJECTIVES—

that is the ideology of our time.

And the more distinctly the motive forces of social reality confront our consciousness, the more saliently its sociopolitical forms take shape—the more the masters of artistic labor are confronted with the task of:

Breaking with their speculative activity (of art) and of finding the paths to concrete action by employing their knowledge and skill for the sake of true living and purposeful labor.

Intellectual-material production establishes labor interrelations and a productional link with science and technology by arising in the place of art—art, which by its very nature cannot break with religion and philosophy and which is powerless to leap from the exclusive circle of abstract, speculative activity.

From "Tectonics, Texture, Construction"

A productive series of successful and unsuccessful experiments, discoveries, and defeats followed in the wake of the leftist artists. By the second decade

of the twentieth century, their innovational efforts were already known. Among these, precise analysis can establish vague, but nevertheless persistent tendencies toward the principles of industrial production: texture as a form of supply, as a form of pictorial display for visual perception, and the search for constructional laws as a form of surface resolution. Leftist painting revolved around these two principles of industrial production and persistently repulsed the old traditions of art. The suprematists, abstractionists, and "nonideaists" came nearer and nearer to the pure mastery of the artistic labor of intellectual-material production, but they did not manage to sever the umbilical cord that still held and joined them to the traditional art of the Old Believers.[1]

Constructivism has played the role of midwife.

Apart from the material-formal principles of industrial production, i.e., of texture and of constructional laws, constructivism has given us a third principle and the first discipline, namely, tectonics.

We have already mentioned that the leftist artists, developing within the conditions of bourgeois culture, refused to serve the tastes and needs of the bourgeoisie. In this respect they were the first revolutionary nucleus in the sphere of cultural establishments and canons and violated their own sluggish well-being. Even then they had begun to approach the problems of production in the field of artistic labor. But those new social conditions had not yet arisen that would have allowed for their social interpretation and thematic expression in the products of their craft.

The Proletarian Revolution did this.

Over the four years of its triumphant advance the ideological and intellectual representatives of leftist art have been assimilating the ideology of the revolutionary proletariat. Their formal achievements have been joined by a new ally—the materialism of the working class. Laboratory work on texture and constructions—within the narrow framework of painting, sculpture, and senseless architecture unconnected with the reconstruction of the whole of the social organism—has, for them, the true specialists in artistic production, become insignificant and absurd.

AND WHILE THE PHILISTINES AND AESTHETES, TOGETHER WITH A CHOIR OF LIKE-MINDED INTELLECTUALS, DREAMED THAT THEY WOULD "HARMONICALLY DEAFEN" THE WHOLE WORLD WITH THEIR MUSICAL ART AND TUNE ITS MERCANTILE SOUL TO THE SOVIET PITCH,

WOULD REVEAL WITH THEIR SYMBOLIC-REALISTIC PICTURES OF ILLITERATE AND IGNORANT RUSSIA THE SIGNIFICANCE OF SOCIAL REVOLUTION, AND

WOULD IMMEDIATELY DRAMATIZE COMMUNISM IN THEIR PROFESSIONAL
THEATERS THROUGHOUT THE LAND—
 The positive nucleus of the bearers of leftist art began to line up along
the front of the revolution itself.
 From laboratory work the constructivists have passed to practical ac-
tivity.

 Tectonics ■■■■■■■■■■■■■■■■■■

 Texture ■■■■■■■■■■■■■■■■■■■■■

 and Construction ■■■■■■■■■■■■■■■■■■■

—these are the disciplines through whose help we can emerge from
the dead end of traditional art's aestheticizing professionalism onto the
path of purposeful realization of the new tasks of artistic activity in the
field of the emergent Communist culture.
 WITHOUT ART, BY MEANS OF INTELLECTUAL-MATERIAL PRODUCTION, THE
CONSTRUCTIVIST JOINS THE PROLETARIAN ORDER FOR THE STRUGGLE WITH
THE PAST, FOR THE CONQUEST OF THE FUTURE.

BORIS ARVATOV
The Proletariat
and Leftist Art, 1922

Born Kiev, 1896; died Moscow, 1940. Ca. 1908: attended high school in Riga;
1911: member of the Union of Social Democratic Youth; ca. 1915: attended Pet-
rograd University, studying physics and mathematics; 1918: member of Proletkult;
1920: member of the Communist Party; 1921: commissar on the Polish front; early
1920s: member of Proletkult; member of Inkhuk and the Russian Academy of
Artistic Sciences; closely associated with *Lef* [Levyi front iskusstv—Left Front of
the Arts], with the constructivists and formalists; author of books and many articles
on modern art and literature; died in a prison camp.

The text of this piece, "Proletariat i levoe iskusstvo," is from *Vestnik iskusstv* [Art
Herald] (Moscow), no. 1, January 1922, pp. 10–11 [bibl. R59]; no. 2, pp. 3–5,

carried an answer to Arvatov by one V. T. entitled "Eshche o levom iskusstve" [More on Leftist Art]. *Vestnik iskusstv* was the journal of the Art Section of Glavpolitprosvet/Glavnyi politiko-prosvetitelnyi komitet [Central Committee of Political Enlightenment], a department established within Narkompros in November 1920 to take charge of adult education; it lasted until 1930 and compiled several publications, e.g., *Glavpolitprosvet: rabota i teatr* [Glavpolitprosvet: Work and Theater] (Moscow, 1927). This text by Arvatov, who was a member of Glavpolitprosvet, reflects his ambiguous attitude to leftist art: from an aesthetic standpoint he supported nonobjective art, but from a social standpoint he voiced a preference for utilitarian art. A similar division of loyalties is evident in Arvatov's general literary and artistic critiques of the early and mid-1920s—in which he artfully managed to combine strict formalist analysis and sociopolitical commentary.

Proletarian art, of which so far there is no trace, is possible only as an art that is socially useful and, moreover, consciously useful; an art that, to its very marrow, is bound indissolubly with life, evolving with it and deriving from it—whereas the basic feature of bourgeois art lies in the fact that its forms live and move outside and above concrete reality in a rigidly fixed, "eternally" established form.

It is therefore quite obvious that to proceed from these individualistic forms irrelevant to life is to cut oneself off completely from the road to proletarian art. On the contrary, only their destruction, their pulverization into discrete elements, and their liberation from the fetishism of aesthetic self-sufficiency can build the sole path to organic artistic creation.

It is leftist art that is blazing this trail. Beginning with Cézanne and Picasso and ending, via Carrà, with Tatlin, modern artists have unconsciously been cleaning up the fields of old art and have plowed them ready for the proletarian sowing.

People maintain that such artists represent the ultimate end and death of bourgeois art. Yes, of course—but does that really exclude their historical, social role? Does Marxism not teach us that it is capitalism that, in digging its own grave, throws up right beside it the mound of Socialist society?

It is said that the leftist artists consider their abstract work to be an end in itself. Well, so what? . . . That's what they are supposed to do, that's what they have brains for—but of what concern to the proletariat are their subjective views? . . . Do workers not destroy machines just because they have been installed for the aim of exploitation?

It is declared that the leftists' work has no "content." But content, in fact, is nothing other than the social aim of form. Use this form purposefully; and it will fill itself with content.

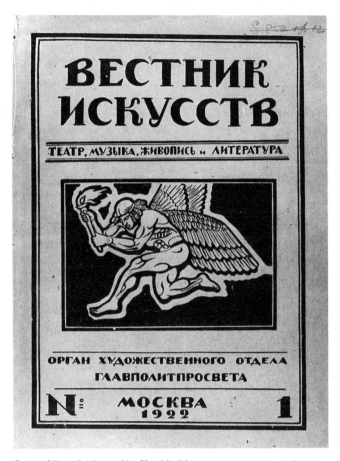

ВЕСТНИК
ИСКУССТВ

ТЕАТР, МУЗЫКА, ЖИВОПИСЬ и ЛИТЕРАТУРА

ОРГАН ХУДОЖЕСТВЕННОГО ОТДЕЛА
ГЛАВПОЛИТПРОСВЕТА

N° МОСКВА 1
1922

Cover of *Vestnik iskusstv* [Art Herald] (Moscow), no. 1, 1922. Artist unknown.

It is shouted that the working class does not understand the leftist artists. I should think so! . . . If you have been brought up on the vulgar, cheap, bad taste of oleographs and postcards, you will not find it very easy to cross over to the latest achievements of a superior culture. Anyway, is this really an argument? Did the Marxists not at one time fight for their own ideas while the proletariat firmly supported different ones?

All these objections stem entirely from a subjective nonacceptance of leftist art by our "ideologists" and their disciples, contaminated as they are by old forms. Fetishists to the marrow of their bones, they behave toward in-

novators in a way absurdly like that of a bourgeois public. It is no secret that all art reformers from Delacroix to the futurists were greeted by the critics with the same senseless howl of resentment: "lunatics," "charlatans," "hangmen of art." You would think that the Marxists would act differently: investigate, elucidate the social and historical significance, discover the roots, and look for the fruits. Not likely! Our intellectual, individualistic psychology is too strong and its essential feature, as far as artistic appreciation is concerned, is a benumbed conservatism. To renounce the conventional, the customary, the historically sanctified is to make a sacrifice that the individual's consciousness is incapable of doing.

Whereas leftist art (whether it be the end, death, disintegration, an end in itself, or not) is the historical bridge over which the working class must inevitably pass to reach the shore of its own art. The point is that we can build socially purposeful forms—not benumbed, but alive and growing—only by proceeding from the material itself and the methods of its processing. But to do that, we must first of all give up the fetishism of ready-made forms. This is just what the abstractionists did. They decomposed the absolute figurativeness of the old art and gradually arrived (via cubism and futurism) at constructions of pure materials. They tore off all formal costumes from the body of art and laid bare its material. They were the first to show that material has its own laws and that to know them is the artist's primary obligation. They, and they alone, advocated the idea of constructivism, ceased to violate material, and raised the question in practical terms of its purposeful (constructivist) utilization. Is it not thanks to them that we now know that form is not a point of departure but a result? . . . Was it not their art that showed that objective and material alter form in any direction? . . . Did it not become possible, beginning with them, to build a form appropriate to every occasion? . . .

And this is, in fact, the central problem of proletarian art. To build not according to form, but according to social objective—that is what the proletariat wants. But such construction demands the rejection of the ready-made stereotype: you would not put a shopwindow mannequin's wig on your head.

Here is a simple example.

A proletarian artist receives an order for a poster. What should he do to make it effective? To make it correspond to the place where it will be hung (e.g., on the surface of a wall), to the spectators to whom it will be shown, to the distance from which they will look at it, to the subject that will be depicted on it (if the poster is figurative), to the ideological influence for which it is intended, etc., etc. . . . ? All this can be accomplished on one

condition: that the artist knows how to make free use of those materials that go to make up the poster as an expressive and actively organizational form; and moreover, not to use them—as was done previously—in one definite direction (in such and such a "style"), but in any way, as a given concrete occasion dictates. Inevitably this command of material presupposes an abstract laboratory or, in other words, a laboratory in which the apprentice would learn to experiment with raw materials in all sorts of ways by applying them to any kind of direction and solving all kinds of problems with their help. This laboratory would become the focal point where the paths of art, science, practice, and theory would come together. And in this is to be found the cardinal difference between contemporary abstraction and proletarian abstraction (still to come). While the problems resolved by the former are posed quite subjectively, are planned haphazardly, and depend ultimately on the personal desires of the individual artist, the comradely collaboration of artists and theoreticians in the proletarian laboratory will create an atmosphere in which each problem will emerge indispensably and objectively from practical and conscious premises.

However, the significance of abstraction is in no way confined to this. There is no need to explain that it is a direct step toward industrial art. A decisive dissociation from applied art, from the invention of "nice motifs" for objects, from the "application" of art to technology is possible only through an organic fusion of the industrial process with the process of artistic design. But there are three points in the industrial process: the raw material, the method of processing, and the purpose of the product. That is why it is quite inconceivable for any artist who is incapable of mastering the raw material, i.e., material used abstractly, to be in a factory. If he does happen to turn up there, then the only results of his "creativity" will be fabrics "à la impressionism," cubist glasses, and futurist plates; [1] that's, at best—at best, because all these articles will be original, albeit senseless; at worst (and this is the predominant case in a bourgeois society), the artist will devote himself to imitations of Egypt, the Renaissance, etc. Because where can he get his originality from, if this "originality" has to be not his own but simply expedient—and if expediency excludes preconceived form (i.e., "originality")? . . . Hence only abstractionists are suitable for industry. But if our contemporary artists and intellectuals arrive at the factory from the polytechnic, i.e., become engineers, this will be the first historic advance—but only the first. The organizer and producer would, as before, remain severed; the design of articles would, to a great extent, be fortuitous and fragmented. And only the proletariat will overcome this—the proletariat, which is destined by history to make the second advance: to fuse the

supervisor and the producer and thereby to subordinate the industrial process—and at the same time the process of artistic design—to the collective's socially conscious and free will, a will that knows not chaos and blind anarchy and that therefore guarantees against the fortuities of the individual. Integralness and organization are the premises of industrial art; purposefulness is its law. Both quite obviously point to the abstractionist as the immediate precursor of the proletarian artist. From the organizational engineer to the organizational worker—this is the path of social development in general and of art in particular.

VIKTOR PERTSOV
At the Junction
of Art and Production, 1922

Born 1898; died Moscow, 1980. Ca. 1920: worked in Ukrainian Narkompros; moved to Moscow, where he joined TsIT (see p. 307, n. 4, to "First Discussional"); member of Moscow Proletkult; 1927–29: active in *Novyi lef* [New Left Front of the Arts]; author of books and many articles dealing with Russian literature, especially poetry; known for his studies of Vladimir Mayakovsky, as well as for his own verse.

The text of this piece, "Na styke iskusstva i proizvodstva," is from *Vestnik iskusstv* [Art Herald] (Moscow), no. 5, May 1922, pp. 22–25 [bibl. R59; for details on the journal see pp. 225–26]. It is one of Pertsov's few articles on art, the bulk of his critical writing being devoted to literature, but it demonstrates his immediate awareness of the central problems of productional art. Amid the general enthusiasm for constructivism and industrial design shared by his colleagues, Pertsov was one of the first of the new critics to indicate the dangers of such an attitude, and his obvious concern for the continued independence of art as an activity outside industry (although not necessarily alien to it) distinguishes his position from that of such figures as Osip Brik and Aleksandr Rodchenko. Indeed, Pertsov is clearly resisting El Lissitzky's contemporaneous formulations, e.g., of "composition" and "construction" (cf. bibl. 246 and bibl. 247, p. 36), and Aleksei Gan's "algebraic" terminology (see pp. 214ff.), as well as the authoritarian attitudes of Kazimir Malevich and Vladimir Tatlin. Pertsov's maxim "Not Ideas but People" anticipates Yakov Chernikhov's

Viktor Pertsov, 1927. He was then working for
the journal *Novyi lef* [New Left] in Moscow.

later call for a more human, more "artistic" interpretation of constructivism (see pp.
254ff.).

The productional view of art has come to occupy our artistic conscious-
ness as a broad but obtuse issue. From this has arisen a sensation of mental
noise—an echo, undoubtedly, of the commotion that ensued after theore-
ticians and artists everywhere had felt a certain guilt before contempo-
raneity, technology, and other weighty pheonomena. Although all the opin-
ions of artists on production share the tone of an apology to somebody and
even of some sort of historical repentance, they do have one good conse-
quence: no longer will anyone be surprised that art can be linked in some
way with production and no longer is there any mention of stupid conversa-
tions about art and craft.

The Organization of an Artistic
and Productional Rapprochement

Hitherto, production and art have not known each other and have lived nur-
tured on the haziest rumors. Despite the fact that history, by its very nature

an incomparable matchmaker, has done everything possible over recent years to bring them together, they have, nevertheless, remained "strangers." The state, in the person of the People's Commissariat for Enlightenment, created for them innumerable rendezvous in the form of all kinds of artistic-technological workshops, but many of these have subsequently been closed down. Nevertheless, despite all these efforts, production remained a complete sphinx for art, and vice versa—with the only difference that art was active and production passive. Without having any positive facts, artists began to engage in wild fantasies about their future life together with industry. And we ought to be still more surprised that artists—who had literally invented their information on technology—could formulate their assumptions more or less diversely and even contrived to argue with each other.

Fashion and Necessity

These arguments were the reflection not so much of fashion as of necessity, thanks to which technology and art now gravitate toward each other. In this case, we are terming fashion that aggregate of new words applied to art that has been put into circulation by the industrial slang of the working class. When the verbal inventions of the Revolution have been taken into account, this baggage will be considered in detail; meanwhile, specimens of this new terminology—"assembled poetics," "constructed theater show," etc.—should be examined only as symptoms and not as motives.

And in fact, the problem of the artist's and engineer's interrelations is obviously becoming much more than a topical craze. How is a link to be established between them, not only with regard to an object of mutual professional use, but also in the general layout of social construction? What does this symbiosis consist of, and how can it be socially utilized? What organic regenerations does art undergo as a result of it—or maybe the results are catastrophic for it, and its death knell has been sounded already?

These are questions that give grounds for unease, not only on a narrow, national scale, but, apparently, throughout Europe, throughout the whole world—because together with the system of political changes throughout the whole world, art has taken an abrupt, new course toward technology.

Our Perception of Industry

Before the very eyes of Russian artists, industry has suddenly taken on huge and disproportionate dimensions, thanks to the particularly auspicious external social conditions created by the Revolution.

Something unexpected has happened—as if a man had been forced to look through a magnifying glass and believe that the bit of reality many times magnified by the glass was the direct, immediate continuation of it. Even the poorest imagination would be bound to be shaken by the picture revealed. But in this case, it would seem that the resultant disruption of the harmony of the parts of reality has been advantageous, i.e., it has proved to be pedagogically reliable, useful. In the search for a stable equilibrium, the artist's psychology was bound to arrive at the new position whereby an aspect previously obscured would acquire its essential efficacy.

Productional Art

However, certain artists grew despondent and rejected art as the inevitable result of this abnormal perception. The straightforward naïveté of these people incited in their hearts a candid envy of the industrial proletariat. An object's direct usefulness and its technological value appeared to them the immediate ideal and legitimate measure of artistic work. As in industry, one must present objects that are obviously practical, and then the artist's efforts will be socially justified and utilized. This diminutive philosophy of art had, willy-nilly, to confine the sphere of its bold activities to a consistent, *evolutionary* transformation of, so to say, the subsidiary parts of our everyday reality, its appurtenances. Apparently, all this was sparked off by the fact that the windows and doors of our homes, the tables and chairs of our rooms, are quite wretched, and the utensils we use every day, our clothes, etc., in no way gladden the eye.

History and technology have brought all this into the world without asking the artist's permission, but now "productional art" has been called upon to improve these objects or to remake them afresh.

This is what the rejection of art came to mean, and essentially, this admirable enthusiasm should not have encountered anything but obvious sympathy.

Constructivism

Efficiently and smoothly—quite incomprehensible considering the discontent that everyone had retained—a new conception of these problems was formulated in Moscow under the name "constructivism." This is what has happened. The scale of work that art-productional workers have set themselves has been extended. If the latter are prepared to help in the production of small articles, then the constructivists are ready to act as counselors to the

state on all questions of its material installations. They are mesmerized by the monumental construction projects of the Revolution's honeymoon (1918–19), and after stuffing themselves on it then, they now talk about it with their mouths full. However, it is easy to talk about an artist's constructing a "material installation" (an algebraic sign that means heaven knows what), but it is difficult and scandalous to set about building a viaduct or a station when your head is full of impressionisms and suprematisms and such technological authorities as Tatlin and Malevich. Such are the "good intentions" of the constructivists.

What Remains to Art

Both productional workers and constructivists, although differing in temperament, recognize the role of artistic tradition. "Meanwhile," it is essential to do at least something with the art that we are accustomed to and familiar with—by the tested means of paint, sound, and gesture. Obviously, from the nature of these means, in different kinds of art, there emerge various degrees of susceptibility to the idea of the orientation of art toward production. This idea has been given its most concrete expression in painting.

The kernel of the matter in question can best be grasped by contrasting the two-dimensional canvas with the three-dimensional world. In particular, to the eye of mass-instructional constructivism, the artist's move away from surface to space (Tatlin's work) and the application of new instruments for textural processing, apart from the commonly recognized paintbrush, already represent elements of constructivism in painting. In such a case, it is usual to contrast "composition" and "construction": composition is taken as a surface concept in the sense that material is distributed on a surface, and construction implies a distribution of volumes.

At first glance, however, it is clear that to create a purely artistic work (cf. sculpture), the artist attains maximum potential by dealing with volumes and not by distributing material on a surface. Death of the picture by no means signifies the death of art. But the work of such an artist-constructivist has, unfortunately, only one thing in common with the work of the turner or the metalworker—namely that they both produce it in three dimensions.

The Flaw in the Equation Art = Production

It can be contended that the designs of "productional art" and constructivism have been born of the artist's poor material situation.

Every industry caters to a certain market. Artists' dreams of a steady and

secure market for the products of their labor—which, as a rule, sell badly—would come true if productional art became "a reality." Not everyone will buy a book or picture, but everyone needs a convenient and elegant table or chair. While people are uncultured enough to prefer an ax to its symbol in the abstract world, and a pot of geraniums to a Cézanne still life, it is impossible to talk of aesthetic needs as a mass fact, the more so since the "good taste" of modern aesthetics forbids this.

Against this background the problem of the interrelations of art and production could not be solved, but merely be dissected. This is what has happened to the now dominant views quoted above, not counting the vast flow of words that have given spice to their little practical content.

Before the very eyes of those thinkers who had attempted to overcome the above problem, objects of art and objects of industry stood *in isolation*—in the forms that the uninitiated had perceived and distinguished most easily. From these two sorts of lumber dumped together in one pile, common features were abstracted; in this way, a fusion was produced all along the line.

The drawback lies in the fact that the methodology of orienting art to production was sought for in an outdated, isolated, and mechanically sealed inventory—with regard both to art an. to production.

Not Ideas But People

In the meantime, it transpired that the principal characters had been left out of all this occupation with ideas. The problem of combining the methods of art and industry could be solved, not in a logical and abstract way, but in a pedagogical and evolutionary way.

The center of gravity lay not in how, at the wave of a magic wand, to draw a satisfactory picture of the coexistence of production and art, but in how to build up a system of educating the engineer and artist by following the objective directions of both art and industry.

These two educational aggregates served as the point of departure for all the opinions of the theoreticians, aggregates accepted as exclusive facts.

If the problem of fusing technology with art is taken not as a subject of topical dispute, but seriously, as a social problem, then it should not be doomed to the amateurish solution of the artist who understands absolutely nothing about production, or of the engineer who, correspondingly, has no artistic training.

It is essential to realize that the enigmatic phenomena of contemporary artistic culture with their ramifications of cubism, suprematism, transsense,[1] etc.—brilliant material for witty rapprochements with the tendencies of con-

temporary technology—do not in themselves bring us any nearer to a solution of the concrete problem. Moreover, they should be taken only as a sign, as the consolidation in artistic experience of the teeming industrial impressions of contemporaneity, as a call to practical reform.

The effect of industry on the art of our century is a fact that has been established many times.

One cannot keep on establishing it, by producing the most piquant contrasts and details, without some authoritative, practical inference. And it is all the more barbaric and uncultured to abolish art before its time and, after burying it alive, to throw reckless conjectures into a void.

The Experience of Creating
an Artist-Engineer

In order not to remain the dubious observers of the curiosities of "art and life," we must make this tendency of art, noted above, the subject of a deliberate culture.

The latter can be achieved after we have attempted to re-create the systems of educating the artist and the engineer, and after we have given them unity in accordance with their new aims. At first this can be done roughly by supplementing the present curricula with missing subjects. Suffice it to remember in this connection that our ordinary engineer-architect, besides the principles of mechanics and practical technology, also used to learn the history of art styles. In this case nobody was surprised at the combination of technological/mathematical abilities and artistic flair and talent.

The historical example of their brilliant combination in Leonardo da Vinci is particularly striking to our age, more than any other.

A broad-based and accurate familiarity with technology should be introduced as an integral part of the system of educating the modern artist. What will he be called in this case? An engineer—of words, an engineer-musician, an engineer-decorator, etc.—it is not important. Which should be taken as the basis of the new educational establishment—the art school or the technological institute? Where will this new kind of social builder draw the necessary people? Will art or industry, in their former appearance, send their delegates here? The future will show us.

But we can already believe that the culture before us will be an unprecedented triumph for principles at present still disparate.

The enviable destiny of this day is to reveal its perspicacity by practical work.

STATEMENTS FROM THE CATALOGUE OF THE "FIRST DISCUSSIONAL EXHIBITION OF ASSOCIATIONS OF ACTIVE REVOLUTIONARY ART," 1924

The exhibition opened in Vkhutemas, Moscow, on 11 May 1924 and comprised eight sections, of which four advanced independent declarations; those without declarations were: the Byt [Life] group, consisting of the artists Ivan Pankov and

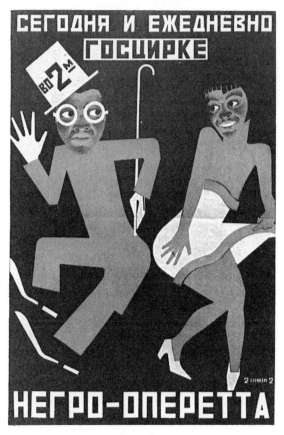

Georgii and Vladimir Stenberg: Poster advertising a "Negro Operetta" in the second State Circus, 1928. One of many posters the Stenberg brothers designed for the circus, the theater, and the cinema in the late 1920s and early 1930s.

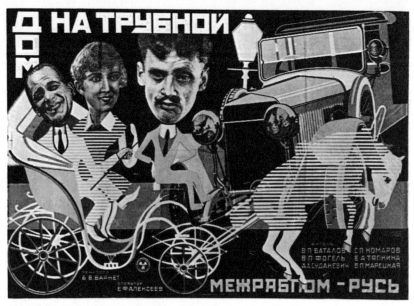

Grigorii Borisov and Nikolai Prusakov: Poster for the movie *The House on Trubnaya Street,* produced by Boris Barnet in 1928.

Konstantin Parkhomenko; the Association of Three—Aleksandr Deineka, Andrei Goncharov, and Yurii Pimenov; a group called the Constructivists—including Konstantin Medunetsky and the Stenberg brothers; and a small one-man show of the sculptor Iosif Chaikov. Most of the contributors were young and had recently graduated from the new art schools, and some of them, e.g., Deineka, Goncharov, Pimenov, Konstantin Vyalov, and Petr Vilyams became founding members of OST (see pp. 279ff.) at the beginning of 1925.

Despite their specific titles, there was little difference between the Concretists and the Projectionists, both of whom favored easel painting and not, as their declarations would imply, applied art. The canvases that they presented were, however, highly imaginative and subjective, betraying the influence of German expressionism and even surrealistic tendencies—particularly in the work of Goncharov, Sergei Luchishkin, Aleksandr Tyshler, and Vilyams. Most members of the seventh section, the First Working Organization of Artists, shortly disappeared from the art scene, although Nikolai Prusakov (formerly a member of Obmokhu—Society of Young Artists) later achieved a reputation as a book and poster designer.

The First Working Group of Constructivists was founded in December, 1920 (judging by Gan's *Konstruktivizm,* p. 3, by an announcement in *Ermitazh,* [Moscow], 1922, No. 13, p. 3, and by the group's own statement in the catalogue to this exhibition, p. 14), and its declaration quoted here repeated some of the ideas in its initial so-called ''Productivist'' manifesto [see bibl. 216, p. 153] and in Gan's book.

According to one source [bibl. R21,.p. 196], Lissitzky took the program of the First Working Group with him when he went to Germany in 1921, thus disseminating constructivist ideas in the West; some Western observers, including Hans Richter, even acknowledged that constructivism had first arisen in Russia [ibid.]. The First Working Group was not fully represented at this exhibition, which did not include the group's productional cell Mass Action and the Kinophot [Cinematography and Photography] cell. Of the First Working Group represented at this exhibition, the Chichagova sisters, Grigorii Miller, and Aleksandra Mirolyubova achieved some recognition in later years, contributing bookplate and other small graphic designs to exhibitions.

Essentially, the exhibition acted as a junction of artistic interests: easel art versus industrial art. The exhibition's title indicated also the quandary in which many artists were finding themselves: the word "discussional" [*diskussionyi*] has the meaning in Russian not only of "concerned with discussion or debate," but also of "open to question, debatable."

The texts of these pieces are from the catalogue of "1-ya Diskussionaya vystavka obedinenii aktivnogo revolyutsionnogo iskusstva" (Moscow, 1924). The whole catalogue is reprinted in *Sovetskoe iskusstvo za 15 let* [Soviet Art of the Last Fifteen Years], ed. Ivan Matsa et al. (Moscow-Leningrad, 1933), pp. 313–18 [bibl. R16], from which this translation is made. The catalogue name list is reprinted in bibl. R152, p. 132, and extracts from the Constructivist declaration together with some comments are in bibl. R22, p. 66. A detailed review of the exhibition is in bibl. R79, 1924, no. 4, pp. 120–29. Parts of the texts have been translated into German in bibl. 209viii, pp. 143–45.

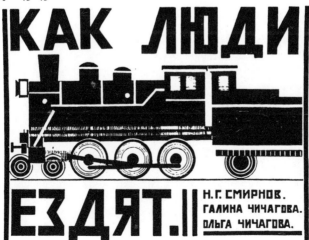

Galina and Olga Chichagova and Nikolai Smirnov: Page design for Smirnov's book *Kak lyudi ezdyat* [How People Travel] (Moscow, 1925).

Concretists

I. Concreteness is the object in itself.
II. Concreteness is the sum of experience.
III. Concreteness is form.
Preconditions for objects:
1. Contemporaneity
2. Clarity of objective
3. Accuracy of execution

Participants in the group: Petr Vilyams, B. Volkov, Konstantin Vyalov, V. Lyushin, Y. Merkulov (18 different items exhibited)

The Projectionist Group

Our primary slogans:
1. Industrial production regulates social attitudes.
2. 1, 2, or 100 artists cannot organize the environment—*only industrial production can.*
3. The artist is the inventor of new *systems* of objects and works with objective meaning.
4. Painting and volumetrical constructions are the most convincing means of expressing (*projecting*) the method of organizing materials.
4a. It is essential and very opportune to be actively engaged in art.
5. The artist is not the producer of consumer objects (cupboard, picture), but (*of projections*) *of the method of organizing materials.*
5a. *Millions of producers will be making normalized objects for everyday life.*
6. Art is the science of an objective system of organizing materials.
7. Every organization is materialized through method.

Participants in the group: S. Luchishkin, S. B. Nikritin, M. Plaksin, Kliment Redko, N. Tryaskin, A. Tyshler (90 various works exhibited: Luchishkin's "analytical painting," Nikritin's "tectonic researches" ["drafts"], painting, maquettes, models, drawings)

===

The First Working Group of Constructivists

1. By taking part in this exhibition, the Constructivists are not rejecting the basic tenets of revolutionary constructivism, which defends the *factual rationalization of artistic labor* as opposed to the now dominant cultivation of the artistic creation of idealistic art.

By appearing in this instance beneath the slogan *"Associations of Active Revolutionary Art,"* the Constructivists are pursuing only agitational aims: to contribute objects they have made and thereby to participate in the demonstrative discussion between the new groups and associations that have arisen within a proletarian society.

This does not mean that we are turning back to art, or that we are retreating from those positions that the First Working Group of Constructivists occupied when, as early as 1920, they shouted forth the slogan *"We declare implacable war on art."*

2. The Constructivists' rationalization of artistic labor has nothing in common with the travails of art makers who are striving, as it were, to "socialize" the flowering branches of art and to compel the latter *to apply itself* to contemporary social reality.

In rationalizing artistic labor, the Constructivists put into practice—not in verbal, but in concrete terms—the real qualifications of the *object:* they are raising its quality, establishing its social role, and organizing its forms in an organic relationship with its utilitarian meaning and objective.

The Constructivists are putting into practice this rationalization of artistic labor by means of material labor—that labor in which the workers themselves are directly involved.

The Constructivists are convinced that, with the growing influence of the

materialist world view, the so-called "spiritual" life of society, the emotional qualities of people can no longer be cemented by abstract categories of metaphysical beauty and by the mystical intrigues of a spirit soaring above society.

The Constructivists assert that all art makers without exception are engaged in these intrigues, and no matter what vestments of realistic or naturalistic art they are invested in, they cannot escape essentially from the magic circle of aesthetic conjuring tricks.

But by applying conscious reason to life, our new young proletarian society lives also by the only concrete values of social construction and by clear objectives.

While constructing, while pursuing these aims *not only for itself, but also through itself,* our society can advance only by concretizing, only by realizing the vital acts of our modern day.

And this is our reality, our life. Ideologically, as it were, consciously, we have extirpated yesterday, but in practical and formal terms we have not yet mastered today's reality.

We do not sentimentalize objects; that is why we do not sing about objects in poetry. But we have the will to construct objects; that is why we are developing and training our ability to make objects.

3. At the "First Discussional Exhibition of Associations of New Groups of Artistic Labor," the Constructivists are showing only certain aspects of their production:

I. Typographical construction of the printed surface

II. Volumetrical objects (the construction of an armature for everyday life)

III. Industrial and special clothing

IV. Children's books

The First Working Group of Constructivists consists of a number of productional cells.

Of those not represented, mention should be made of the productional cell Kinophot (cinematography and photography), the productional cell of material constructions, and the productional cell Mass Action.

The First Working Group of Constructivists states that all other groups that call themselves constructivists, such as the "Constructivist Poets," [1] the "Constructivists of the Chamber Theater," [2] the "Constructivists of the Meierkhold Theater," [3] the "Lef Constructivists," the "TsIT Constructivists," [4] etc., are, from this group's point of view, pseudo constructivists and are engaged in merely making art.

THE FIRST WORKING GROUP OF CONSTRUCTIVISTS

a. The FWGC *productional cell for an armature for everyday life:*
 Grigorii Miller, L. Sanina, and Aleksei Gan

b. The FWGC *productional cell for children's books:*
 Olga and Galina Chichagova and N. G. Smirnov

c. The FWGC *productional cell for industrial and special clothing:*
 A. Mirolyubova, L. Sanina, and Grigorii Miller

d. The FWGC *productional cell for typographical production:*
 Aleksei Gan and Gr. Miller

The First Working Organization
of Artists

Basic Tenets
 Workers of the World, Unite!
 1. The First Working Organization of Artists is striving to make the artist a socially indispensable element of modern life.
 2. By organizing our personal and professional qualities, we organize the production of artistic values as part of the normal relationship between the artist and life.
 3. By personal qualities we mean that spiritual, cultural level of consciousness that is oriented toward the development of new social forms.
 4. By professional qualities we mean that level of artistic culture and artistic consciousness that, while being closely bound up with contemporaneity, is oriented toward the development of new forms in art.
 5. Through our practical and cultural activity we are organizing our psychology in accordance with the basic principles of our organization.

Participants in the group: G. Aleksandrov, Petruzhkov, A. Vanetsian, M. Sapegin, I. Korolev, K. Loginov, N. Menshutin, I. Yakovlev, N. Prusakov (models, maquettes of architectural constructions and monuments, montages, and paintings)

OSIP BRIK
From Pictures
to Textile Prints, 1924

Born St. Petersburg, 1888; died 1945. Ca. 1910: attended law school in St. Petersburg; 1916: member of Opoyaz [Obshchestvo poeticheskogo yazyka—Society of Poetical Language] in Petrograd; husband of Lilya Brik, famous for her association with Vladimir Mayakovsky; 1918: member of IZO Narkompros [Visual Arts Section of Narkompros]; 1919: leading member of Komfut; 1921: member of Inkhuk; 1923: member of Lef [Levyi front iskusstv—Left Front of the Arts] and close to the constructivists and formalists; 1927: cofounder of Novyi lef [New Lef]; interested in photography and film; 1929: wrote scenario for Vsevolod Pudovkin's Heir of Genghis Khan; late 1920s: contributed to many literary miscellanies, e.g., Literatura fakta: pervyi sbornik materialov rabotnikov Lefa [Literature of Fact: First Collection of Materials by Lef Workers] (Moscow, 1929).

The text of this piece, "Ot kartiny k sitsu," is from Lef (Moscow), no. 2, 1924, pp. 27–34 [bibl. R76; for details of the journal see pp. 199ff.]. The same number contained an obituary of Lyubov Popova, who had been one of the first of the avant-garde to concentrate on textile design [see bibl. R475, pp. 82–102; the text is reprinted in bibl. R16, pp. 301–15]. Brik wrote mainly on questions of literature, but his proximity to such artists as Aleksandr Rodchenko and Varvara Stepanova during the 1920s stimulated his interest in applied art. Many others wrote about art in production, but Brik was among the first to indicate the necessity for special training in this area: of the many avant-garde artists who turned from easel work to applied art in the early 1920s, only Stepanova had had professional instruction as a designer (in her case as a clothing designer). Brik's statement can be taken as an expression of Lef policy, and it amplified the statements on textiles and design issued a few months before by Aleksandra Exter and Stepanova [bibl. R449, R463].

———

The propaganda of productional art is being crowned with success.

It is becoming obvious that artistic culture is not confined to objects at exhibitions or in museums, that painting, in particular, is not "pictures," but the sum total of the painterly design of our everyday life.

The textile print is the same product of artistic culture as the picture is—and there is no basis for advancing a dividing line between them.

Moreover, the conviction is gaining ground that the picture is dying, that

Osip Brik, mid-1920s.

it is indissolubly linked with the forms of the capitalist regime, with its cultural ideology, that the textile print is now becoming the center of creative attention, and that the textile print and work on it are the apex of artistic labor.

And in fact, our cultural creation is founded wholly on a specific purpose. We do not conceive of a cultural and educational work unless it pursues some kind of definite, practical aim. The concepts of ''pure science,'' ''pure art,'' ''independent truth and beauty'' are alien to us. We are practitioners—and in this lies the distinctive feature of our cultural consciousness.

There is no place for the easel picture in this consciousness. Its force and meaning lie in its extrautilitarianism, in the fact that it serves no other aim than delighting, ''caressing,'' the eye.

All attempts to turn the easel picture into an agitational picture have been fruitless. And this was not because there was no talented artist around, but because this is essentially inconceivable.

The easel picture is calculated to exist a long time, for years and even centuries. But what agitational subject would last that long? What agit-picture doesn't grow old within a month? And if the subject of the agit-picture grows old, then what remains?

A subject of short-term efficacy cannot be processed by devices calculated to exist a long time.

A one-day show cannot be put on for centuries.

That is why the agit-picture does not stand up to competition from the agit-poster; that is why there are no good agit-pictures.

The "pure" easel painters reason correctly in rejecting agit-subjects. They realize that the easel picture would perish on such a path, that it would lose its basic value—its "extra temporal," "extrautilitarian" meaning, that the poster would outdo it. Therefore they carry out desperate attacks to save it by other means: to impress on everyone that the easel picture in its formal meaning is a great cultural fact and that no artistic culture is conceivable without it.

They affirm that if easel pictures were not made, artistic culture would perish, that the "creative" freedom manifested in the concoction of these easel pictures should not be extinguished for one second—otherwise that is the end of art.

Let the picture's subject be insignificant, let it be nonobjective or a "free" play of painterly forms—that is not important; what is important is the fact that this timeless, extrautilitarian, "purely aesthetic" value will exist, that people will be able to look at it, to instill it in themselves—and artistic culture will be saved.

That is how the monks reason. Their pious life outside the world saves the world.

However, the easel painters are right. If the picture can be saved only in that way.

If it is true that the easel picture is essential to the existence of artistic culture, that artistic culture will perish without it, then, of course, all measures must be taken to ensure its development and prosperity.

But this is not true. The easel picture is not only unnecessary to our contemporary artistic culture, it is also one of the most powerful brakes on its development. And this is why:

Of course, the main evil is not in the monastic reasoning of the "pure" easel painters. That is easily dispersed by the light of antireligious, antiaesthetic propaganda. What is bad is that these monastic dogmas are transformed into productional and pedagogical principles.

The point is that easel painters do not deny the importance and necessity of other forms of artistic culture. They fully tolerate the existence of agit-posters, sketches for textile prints and book covers; they simply affirm that all these "subsidiary" forms are inconceivable without easel painting, that easel painting is the creative base on which painterly culture is built.

Hence the conclusion: if you want to make good textile prints, learn to paint landscapes.

The easel painters say: the artist, no matter where he works or what he does, must master artistic culture, must be artistically educated. And it is easel painting that gives him this artistic culture, this artistic education.

After mastering the "secrets" of easel painting, he thereby masters the "secrets" of any painterly work, whether it is a textile print, a book cover, a poster, or theatrical decor.

And in this the easel painters are deeply mistaken.

A picture is the product of a specific kind of artistic labor. In order to make a picture, a certain number of technical devices and skills have to be employed. Precisely those devices and skills with which a picture can be made. So how does it follow that these devices and skills are universal? How can it suddenly transpire that devices and skills suitable for one craft are also suitable for another?

Let us assume that partial coincidences are possible, that some of the devices can prove to be general; why should one craft prove to be fundamental vis-à-vis another? Why should the making of a still life be more "fundamental" than that of a textile print? Why should one first of all learn how to do a still life and then undertake textile prints, and not vice versa?

The easel painters love to compare pure easel painting with pure mathematics. They say that both provide general principles, general tenets that are then applied in practice.

But the easel painters forget that the picture is not science, but practice, and that it establishes no "general" tenets. The experience of the easel painter is not that of the artist in general, but is only the experience of a single, individual case of painterly labor.

The easel painters want to uphold their right to exist.

If easel painting has died as a kind of socially necessary art craft, then let it be revived as a universal artistic method, as the high school of every artistic practice.

That is how the zealots of classical antiquity advocated the necessity of Greek and Latin in secondary schools.

However, the pedagogical universality of easel painting is overthrown not only by theoretical reasoning but also by everyday practical experience.

We know well the sad fate of artists who finish the easel-painting school and try to apply their knowledge and skill in industry. Nothing comes of their endeavors.

Anyway, easel painters in the main do not care a damn for industry. Recognition of industrial art is an empty phrase on their lips.

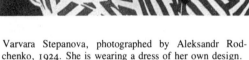

Lyubov Popova: Textile design, ca. 1923. Gouache on paper. Private collection, Moscow. Some of Popova's designs, including this one, were applied to women's dresses.

Varvara Stepanova, photographed by Aleksandr Rodchenko, 1924. She is wearing a dress of her own design.

All the same, work in industry will always be inferior for the easel painter. That is why it is not the easel painters who will discover the methods of this work, and not from easel painting that the solution of productional art problems will ensue.

Only those artists who once and for all have broken with easel craft, who have recognized productional work in practice, not only as an equal form of artistic labor, but also as the only one possible—only such artists can grapple successfully and productively with the solution to the problems of contemporary artistic culture.

Among these artists, still not very numerous, are the Inkhuk members—Rodchenko, Lavinsky, Vesnin, Stepanova, Ioganson, Senkin, Klutsis, and Lyubov Popova (recently deceased).[1]

There is one very serious objection that easel painters make to the productional workers. They say: "In no way does your work differ from the most primitive kind of applied art; you are doing what applied art workers always did when 'applying' easel sketches to objects of factory production. And what would you do if there weren't any easel works? What would you supply?"

Indeed, artistic labor and factory work are still disunited. The artist is still an alien in the factory. People treat him with suspicion. They do not let him come too close. They do not believe him. They cannot understand why he

needs to know technological processes, why he needs information of a purely industrial nature. His job is to draw, to make drawings—and the factory's job is to select suitable ones and to stick them onto the ready-made, finished product.

The basic idea of productional art—that the outer appearance of an object is determined by the object's economic purpose and not by abstract, aesthetic considerations—has still not met with sufficient acceptance among our industrial executives; they think that the artist who aspires to penetrate the "economic secret" of an object is poking his nose into somebody else's business.

Hence the inevitable applied art—the result of the artist's alienation from industry. Not receiving the necessary economic directives, he resorts, willy-nilly, to aesthetic stereotypes.

But what is the conclusion from this?

Forward! To overcome this alienation.

Forward! To the union of the artist and the factory.

And by no means back to pure easel painting, back to pictures.

The progressive artists are already under way—from the picture to the textile print, and of course, they will not turn back. But that is not enough. It is essential that the whole mass of our young artists should realize that this is the only true path and that it is precisely by this path that artistic culture will develop.

It is essential that our industrial executives should understand their role in this matter because the acceleration of our historical process depends on this.

The initiative shown by the director of the First Textile Print Factory in Moscow (formerly Tsindel's), Comrade Arkhangelsky, and by Professor Viktorov, who invited the artists Stepanova and Popova to work there, deserves every attention and praise.

And if it is too early to speak of the results of this first experiment, then it is essential to speak of its immense cultural value.

The artistic culture of the future is being created in factories and plants, not in attic studios.

May the young artists remember this—unless they wish to turn up prematurely in the archives, together with the proud easel painters.

Against the Synthetic Portrait, For the Snapshot, 1928

For biography see p. 148.

The text of this piece, "Protiv summirovannogo portreta za momentalnyi snimok," is from *Novyi lef* [Novyi levyi front iskusstv—New Left Front of the Arts] (Moscow), no. 4, April 1928, pp. 14–16 [bibl. R76; for details of the journal see p. 199].

Rodchenko's first experiments with photography were in photomontage, the most celebrated example of which is his design for Vladimir Mayakovsky's book of poems *Pro eto* [About That], published in 1923. In 1924 Rodchenko turned his attention to photography as a medium, concentrating on urban and social scenes from contemporary Russia and on portraits, of which perhaps the finest example is the close-up of his mother taken in that year—although his masterful renditions of such diverse figures as Nikolai Aseev, Osip Brik, Mayakovsky, Vsevolod Pudovkin, and Sergei Tretyakov (himself a competent photographer) taken during the 1920s deserve every praise. However, Rodchenko did not neglect montage and design and contributed a great deal to the layout and compilation of various publications in the 1920s and 1930s, not least his *Istoriya VKP* (*b*) *v plakatakh* [History of the All-Union Communist Party (Bolsheviks) in Posters], published in Moscow in 1927, his several covers for *Novyi lef,* and his anti-Fascist montages in the journal *Za rubezhom* [Abroad].

Although in transferring his energies to photography, Rodchenko was endeavoring to support a "nonartistic," utilitarian medium, he did not cease to experiment with the purely formal aspects of his new profession. "Rodchenko perspective" and "Rodchenko foreshortening" therefore became current terms in the 1920s, and there is no doubt that his innovative use of light and shadow exerted a certain influence on such filmmakers as Sergei Eisenstein, Lev Kuleshov, and Dziga Vertov. In a constructivist way Rodchenko, at least in the 1920s, attempted to expose the mechanism of the camera and to exploit the photographic method to its maximum, a process in which he was accused of plagiarizing from László Moholy-Nagy (see Rodchenko's reply to this criticism in *Novyi lef,* no. 6, 1928, pp. 42–44) and of presenting reality "upside down and downside up" (see his polemics with Boris Kushner in *Novyi lef,* no. 9, 1928, pp. 31–39). In the 1930s and 1940s Rodchenko's photographic work became less adventurous, and he and his wife, Varvara Stepanova (who had

achieved interesting results in her own photomontage work), concentrated on book and poster design, although Rodchenko also returned to easel painting.

———

I was once obliged to dispute with an artist the fact that photography cannot replace painting in a portrait. He spoke very soundly about the fact that a photograph is a chance moment, whereas a painted portrait is the sum total of moments observed, which, moreover, are the most characteristic of the man being portrayed. The artist has never added an objective synthesis of a given man to the factual world, but has always individualized and idealized him, and has presented what he himself imagined about him—as it were, a personal summary. But I am not going to dispute this; let us assume that he presented a sum total, while the photograph does not.

The photograph presents a precise moment documentarily.

It is essential to clarify the question of the synthetic portrait; otherwise the present confusion will continue. Some say that a portrait should only be painted; others, in searching for the possibility of rendering this synthesis by photography, follow a very false path: they imitate painting and make faces hazy by generalizing and slurring over details, which results in a portrait having no outward resemblance to any particular person—as in pictures of Rembrandt and Carrière.

Any intelligent man will tell you about the photograph's shortcomings in comparison to the painted portrait; everyone will tell you about the character of the Mona Lisa, and everyone forgets that portraits were painted when there was no photography and that they were painted not of all the intelligent people but of the rich and powerful. Even men of science were not painted.

You need not wait around, intelligentsia; even now AKhRR artists will not paint you. True—they can't even depict the sum total, let alone .001 of a moment.

Now compare eternity in science and technology. In olden times a savant would discover a truth, and this truth would remain law for about twenty years. And this was learned and learned as something indusputable and immutable.

Encyclopedias were compiled that supplied whole generations with their eternal truths.

Does anything of the kind exist now? . . . No.

Now people do not live by encyclopedias but by newspapers, magazines, card catalogues, prospectuses, and directionaries.

Modern science and technology are not searching for truths, but are opening up new areas of work and with every day change what has been attained.

Now they do not reveal common truths—"the earth revolves"—but are working on the problem of this revolution.

Let's take: aviation

radio

rejuvenation,[1] etc.

These are not mere platitudes but constitute areas that thousands of workers are expanding in depth and breadth, thanks to their experiments.

And it is not just one scientist, but thousands of scientists and tens of thousands of collaborators.

And hence there will never be eternal airplanes, wireless sets, and a single system of rejuvenation.

There will be thousands of airplanes, motorcars, and thousands of methods for rejuvenation.

The same goes for the snapshot.

Here is an example of the first big collision between art and photography, a battle between eternity and the moment—moreover, in this instance photographs were taken casually, but painting attacked photography with all its heavy and light artillery—and failed miserably. . . .

I mean Lenin.

Chance photographers took his picture. Often when it was necessary, often when it was not. He had no time; there was a revolution on, and he was its leader—so he did not like people getting in his way.

Nevertheless, we possess a large file of photographs of Lenin.[2]

Now for the last ten years artists of all types and talents, inspired and rewarded in all sorts of ways and virtually throughout the world and not just in the U.S.S.R., have made up artistic depictions of him; in quantity, they have paid for the file of photographs a thousand times and have often used it to the utmost.

And show me where and when and of which artistically synthetic work one could say: this is the real V. I. Lenin.

There is not one. And there will not be.

Why not? Not because, as many think, "We have not yet been able to, we haven't had a genius yet, but certain people have at least done something."

No, there will not be—because there is a file of photographs, and this file of snapshots allows no one to idealize or falsify Lenin. Everyone has seen this file of photographs, and as a matter of course, no one would allow artistic nonsense to be taken for the eternal Lenin.

True, many say that there is no single snapshot that bears an absolute resemblance, but each one in its own way resembles him a bit.

I maintain that there is no synthesis of Lenin, and there cannot be one and the same synthesis of Lenin for each and everyone. . . . But there is a synthesis of him. This is a representation based on photographs, books, and notes.

It should be stated firmly that with the appearance of photographs, there can be no question of a single, immutable portrait. Moreover, a man is not just one sum total; he is many, and sometimes they are quite opposed.

By means of a photograph or other documents, we can debunk any artistic synthesis produced by one man of another.

So we refuse to let Lenin be falsified by art.

Art has failed miserably in its struggle against photography for Lenin.

There is nothing left for it but to enlarge photographs and make them worse.

The less authentic the facts about a man, the more romantic and interesting he becomes.

So that is why modern artists are often so fond of depicting events long past and not of today. That is why artists have enjoyed less popularity when they have depicted contemporaneity—they are criticized, it is difficult to lie to their faces . . . and they are acknowledged afterward when their contemporaries have died off.

Tell me frankly, what ought to remain of Lenin:

 an art bronze,
 oil portraits,
 etchings,
 water colors,
 his secretary's diary, his friends' memoirs—

or

 a file of photographs taken of him at work and rest,
 archives of his books, writing pads, notebooks,
 shorthand reports, films, phonograph records?

I don't think there's any choice.

Art has no place in modern life. It will continue to exist as long as there is a mania for the romantic and as long as there are people who love beautiful lies and deception.

Every modern cultured man must wage war against art, as against opium.

Photograph and be photographed!

Crystallize man not by a single "synthetic" portrait, but by a whole lot of snapshots taken at different times and in different conditions.

Paint the truth.

Value all that is real and contemporary.

And we will be real people, not actors.

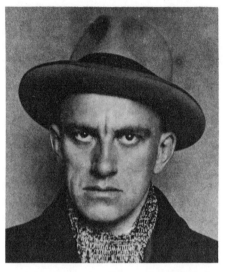

Aleksandr Rodchenko: Photograph of Vladimir Mayakovsky, 1928. Collection The Museum of Modern Art, New York, The Parkinson Fund.

YAKOV CHERNIKHOV

The Construction of Architectural and Machine Forms [*Extracts*], 1931

Born Pavlograd, 1889; died Moscow, 1951. 1906: moved to Odessa, where he entered the Odessa Art School; 1914: entered the St. Petersburg Academy, where he

studied painting and architecture; 1922–33: contributed graphics and designs to many exhibitions in Moscow, Leningrad, and other towns; 1925: finished his academy course with the title of architect-artist; 1926–36: taught in various Leningrad institutes; designed many buildings, especially industrial complexes; 1932: appointed professor at the Leningrad Institute of Railroad Transport Engineers and Academy of Transport; 1935: received the degree of Candidate in Architectural Sciences; moved to Moscow, where he headed the Department of Descriptive Geometry and Graphics at the Institute of Engineering Economy; appointed head of the Department of Architecture of the Mossovet Building Institute.

The translation is of extracts from Chernikhov's book *Konstruktsiya arkhitekturnykh i mashinnykh form* (Leningrad, 1931). The first extract, "The Constitution of Construction," is from pp. 79–87, and the second, "The Formations of Construction," is from pp. 214–21. Part of the text has appeared in English translation in bibl. 235, p. 154, and bibl. 211, pp. 153–69. The book was published under the auspices of the Leningrad Society of Architects, which, while acknowledging the general value of the book, did not hesitate to pronounce in the first preface, dated July 1930, that it was not in "complete agreement with the method and character of the elucidation." There were a second and a third preface, both by Chernikhov, and an introduction by the critic Erik Gollerbakh. Although ostensibly the book was issued as a textbook for students of engineering and architecture, it emerged as the first full explanation of the principles of constructivism (at least, as understood by Chernikhov) and hence was his most important theoretical work. The book achieved some recognition in the West since it was advertised by a prospectus in English with a listing of the contents and a two-page text by Gollerbakh [bibl. 217]. The title page of the book itself was in Russian, French, and German, and the text was complemented by many monochrome illustrations both for specific problems and for full-scale constructions. Chernikhov's plea for the retention of inspiration, intuition, and fantasy within the constructivist world view was extended to his preface in his next (and last published) book *Arkhitekturnye fantazii* [Architectural Fantasies] (Leningrad, 1933) [bibl. R485], in which, significantly, the word constructivism was already absent.

Chernikhov's text betrays the close tie among painting, sculpture, and architecture maintained during the 1920s and, more specifically, the debt of constructivist architecture to Kazimir Malevich's suprematism, to Lyubov Popova's, Aleksandr Rodchenko's, and Aleksandr Vesnin's last paintings and drawings, and of course, to El Lissitzky's Prouns. Chernikhov's own pedagogical and aesthetic theories owe a great deal to the early researches carried out by the Zhivskulptarkh group (see p. 43), in Inkhuk, and in Vkhutemas/Vkhutein. Chernikhov's attribution of certain emotive qualities to certain architectural forms, for example, derived its ultimate inspiration from Vesnin's initial endeavors to create color compositions that would produce invariable, predetermined psychological effects or from Nikolai Ladovsky's categories of "(a) Power and weakness; (b) Grandeur and abasement; (c) Finitude and infinity"

Yakov Chernikhov (second row from bottom, second from right) and a group of students in the early 1920s. Because of his dark, ominous appearance, Chernikhov was nicknamed Mephistopheles by students. Photograph courtesy Mr. Vsevolod Dobujinsky, New York.

["Osnovy postroeniya teorii arkhitektury" (Bases for the Formulation of a Theory of Architecture) in *Izvestiya ASNOVA* (Moscow), no. 1, 1926, p. 3]. Chernikhov's more emotional, more subjective interpretation of these early systems suggests the conclusion that Russian constructivism both began and ended as art. Parts of his text have been translated into English in bibl. 252ix, pp. 41–88.

———

From "The Constitution of Constructivism": The Laws of Construction

Hitherto all those who have been interested in the problems of constructivism have run up against the many unresolved problems concerning which rules, norms, and laws exist or should exist for the interconstruction of solids. Despite the absence of these rules and laws, one can see that at all times people have constructed and continue to construct. There is no doubt that laws of construction do exist and will be deciphered, just as music has been deciphered in all its forms. The force of a blow, the force of a sound, the most subtle changes of musical vibrations, have today been given an explanation. Throughout the ages man has accumulated methods and knowledge in order to construct buildings and machines that are extremely complicated both in their graphic resolution and in their natural visual images. To

84

Yakov Chernikhov: Illustration from his *Konstruktsiya ark-
hitekturnykh i mashinnykh form* [The Construction of Archi-
tectural and Mechanical Forms] (Leningrad, 1931). All the
illustrations in this book were devoted to specific problems
of structural composition and design, although the subjects
themselves were often fanciful and rhetorical. The theme here
is "machine architecture."

obtain a construction, we have at our disposal either very simple objects,
such as line (graphic or material), plane (graphic or material), surface
(graphic or material), volume, or more complex objects that can be utilized
for the aims of construction. But in order to reduce the above elements to a
state of constructive interconnection, certain motives are required to create
this state. At this juncture it stands to reason that in the first place we should
advance the basic laws of construction as such.

•

First law: Everything that can be unified on the principles of constructivism can be material and nonmaterial, but it is always subject to the recording action of our brain by means of sight, hearing, and touch.

•

Second law: Every construction is a construction only when the unification of its elements can be rationally justified.

•

Third law: When elements are grouped together on a basis of harmonic correlation with each other, a complete constructive combination is obtained.

•

Fourth law: Elements unified in a new whole form a construction when they penetrate each other, clasp, are coupled, press against each other, i.e., display an active part in the movement of the unification.

•

Fifth law: Every constructive unification is the aggregate of those percussive moments that in varying degree contribute toward the wholeness of the impression.

•

Sixth law: Every new construction is the result of man's investigations and of his inventive and creative needs.

•

Seventh law: Everything that is really constructive is beautiful. Everything that is beautiful is complete. Everything that is complete is a contribution to the culture of the future.

•

Eighth law: In every constructive unification the idea of the collectivism of mankind is inherent. In the close cohesion of the elements the concord of all man's best aspirations is reflected.

•

Ninth law: Every constructive resolution must have a motive on the basis of which the construction is made.

•

Tenth law: In order to create a constructive image, it is essential to have absolute knowledge, not only of the bases of constructivism, but also of the bases of economic reproduction.

•

Eleventh law: Before assuming its definite form, a constructive representation must pass through all the necessary and possible stages of its development and construction.

Observance of laws in all constructive buildings is based further on the fact that we can prove simultaneously the truth and correctness of the chosen resolution by analytical means. The justifiability of the approach serves as a criterion for the legalization of the elaborated form.

In all cases of construction we encounter the necessity of giving foundation to and, thereby, as it were, legalizing the construction that we have accepted. We must prove that the construction that we are proposing is correct and corresponds to the given case.

From "The Formations of Construction": Conclusion and Inferences

The abundance, variety, and many-sidedness of the phenomena of constructivism prove that it is not some kind of abstract method having limited applicability. On the contrary, we are convinced that constructivism encompasses, and penetrates into, an extremely wide area of man's creative work. Consequently, it is possible to speak of constructivism as a world view.

What are the basic characteristics of this world view? The mechanization of movement and building in life peculiar to our time, the intense development of industrial production and of technology in general have radically changed our way of life and generated new needs, new habits, and new tastes. One of the most urgent needs of our time is the rational organization of objects, their functional justification. And this is the rejection of everything that is superfluous, everything that does not bear on the aim and purpose of the object. In this sense one can say that despite the extreme complexity of our life, despite the diversity of its structure, it is in certain respects being simplified through the perfection of technological achievement. In other words, many processes that previously were complicated and

slow are now being simplified and speeded up. Hence the principles of simplification, acceleration, and purposefulness emerge as the constant attributes of a constructivist world view.

It is characteristic of constructivism that it forms a new understanding of the object and a new approach to the creative process; namely, without denying the value of such forces as inspiration, intuition, fantasy, etc., it places the materialistic point of view in the foreground. This point of view unites phenomena that were previously considered quite separate and disparate: the phenomena of engineering and technology and the phenomena of artistic creation. It is true, we know, that in former times these phenomena sometimes came into contact with each other and appeared together in a harmonic synthesis, as, for example, in the best works of architecture, which satisfy both constructive requirements and the demands of good taste, our aesthetic sense. However, the durable, firm, and logical link between these phenomena envisaged by constructivism was lacking. Only by the absence of this link can we explain the widespread development of decorative motifs devoid of any functional justification (especially in baroque and *art nouveau* architecture).

In former times machinery was considered something profoundly inartistic, and mechanical forms were excluded from the province of beauty as such; people did not talk about them as forms of artistic creation. But now we know and see, thanks to the development of the constructivist world view, that machinery not only lies within the confines of artistic conception but also has its own indubitable and convincing aesthetic norms and canons. These norms and canons are to be found in the fundamentals of constructivism, which—for the first time in the history of man—has been able to unite the principles of mechanical production and the stimuli of artistic creation. One must not consider constructivism something absolutely new, unprecedented, and unheard of. It could be said that in its elementary principles constructivism is as ancient as the building art, as man's creative abilities. Primordial man, in building his dolmens, triliths, crypts, and other edifices was unconsciously a constructivist. These initially primitive trends of constructivism gradually become complex and crystallized in the course of man's centuries-long cultural development. The forms of constructivism differentiated in proportion to the differentiation of culture.

The disunity of artistic and technological forms of which we spoke earlier is gradually taking the shape of a common, integral aspiration toward rational construction, or one could say that we are gradually uniting artistic construction and machine construction; the boundary dividing them is being erased. A new conception of the beautiful, a new beauty, is being born—the

aesthetics of industrial constructivism. If in its general, primary fundamentals its origin is very ancient, it is indebted for the concrete definition of its principles mainly to the artistic and technological research of the last decades in almost all the cultured countries of the world.

It must be recognized that their last role has by no means been played by the achievements of the so-called leftist artists, the revolutionaries of art who are often repudiated and ridiculed. Undoubtedly constructivism has to a certain extent employed the formal and methodological results of modern trends. These directions have contributed a great deal to the understanding of modern architecture and mechanical forms. They have indicated the usefulness of laboratory research and the value of the study and analysis of form connected with contemporary, industrial technology. It is thought that constructivism has significance only as a means of overcoming eclecticism and technological conservatism. In fact, its role is much wider; it is not only destructive in relation to the old, but it is also creative in relation to the new. Furthermore, constructivism by no means denies art or supplants it by technology and engineering, nor does it ignore artistic content and the means of artistic effect, as is maintained by certain art historians of our time. Formal and technological functionalism, as a method of architectural work and analysis, does not exclude the possibility of a harmonic interrelation of the principles of form and content, nor does it exclude the possibility of the coordination of practical, utilitarian tasks and aesthetic attractiveness. Constructivism does not renounce critical utilization of experiment; it does not seek an isolated resolution of the particular aspects of this or that task but aims at the best utilization of all possibilities both formal-compositional and technological-constructional, by linking them together in a creative, synthesizing process.

We are convinced that the correct solution of the problems of constructive forms is equally important for all branches of man's creation—for architecture, mechanical engineering, applied art, the printing industry, etc. Constructivism can, and must, take into consideration all the concrete needs of contemporary life and must answer in full the needs of the mass consumer, the collective "customer"—the people.

VI.
Toward Socialist Realism

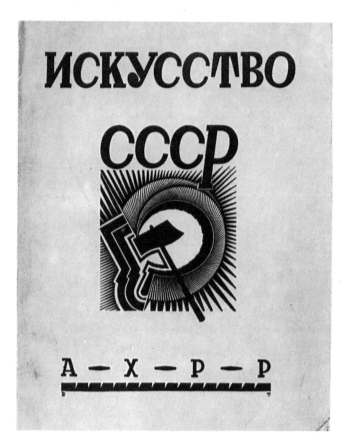

Cover of the book *Iskusstvo SSSR* [Art U.S.S.R.], published by AKhRR, Moscow, 1926. Designed by Boris Titov.

AKhRR
Declaration
of the Association of Artists
of Revolutionary Russia, 1922

Shortly after the forty-seventh exhibition of the Wanderers, in January 1922, a group of artists, among them Aleksandr Grigorev, Evgenii Katsman, Sergei Malyutin, and Pavel Radimov, organized the Assotsiatsiya khudozhnikov, izuchayushchikh revolyutsionnyi byt [Association of Artists Studying Revolutionary Life], which was shortly rechristened Obshchestvo khudozhnikov revolyutsionnoi Rossii [Society of Artists of Revolutionary Russia]. After their first group show, "Exhibition of Pictures by Artists of the Realist Direction in Aid of the Starving," in Moscow (opened May 1), the Society was renamed Assotsiatsiya khudozhnikov revolyutsionnoi Rossii [AKhRR—Association of Artists of Revolutionary Russia]. The primary aim of its members was to present Revolutionary Russia in a realistic manner by depicting the everyday life of the proletariat, the peasantry, the Red Army, etc. In restoring tendentious theme to the picture, they returned to the traditions of the nineteenth-century realists and declared their opposition to the leftists. In addition to older realists, such as Abram Arkhipov, Nikolai Kasatkin, and Konstantin Yuon, AKhRR attracted many young artists, such as Isaak Brodsky, Aleksandr Gerasimov, and Boris Ioganson. In order to acquaint themselves with proletarian reality, many of the AKhRR members visited factories, iron foundries, railroad depots, shipyards, etc. By the mid-1920s AKhRR was the most influential single body of artists in Russia, having affiliates throughout the country, including a special young artists' section called OMAKhR [Obedinenie molodezhi AKhR—Association of AKhR youth], its own publishing house [see bibl. R513], and, of course, enjoying direct government support. In 1928 AKhRR changed its name to Assotsiatsiya khudozhnikov revolyutsii [AKhR—Association of Artists of the Revolution], and in 1929 it established its own journal Iskusstvo v massy [Art to the Masses] [bibl. R70]. In 1932, together with all other formal art and literary groups, AKhR was dissolved by the decree "On the Reconstruction" (see pp. 288ff.).

The text of this piece, "Deklaratsiya Assotsiatsii khudozhnikov revolyutsionnoi Rossii," was published in the catalogue of the AKhRR "Exhibition of Studies, Sketches, Drawings, and Graphics from the Life and Customs of the Workers' and Peasants' Red Army," in Moscow in June and July 1922, p. 120. It is reprinted in *Sovetskoe iskusstvo za 15 let* [Soviet Art of the Last Fifteen Years], ed. Ivan Matsa et al. (Moscow-Leningrad, 1933), p. 345 [bibl. R16], from which this translation is made, and also in bibl. R493, p. 289. For a German translation see bibl. 209viii, pp. 269, 270.

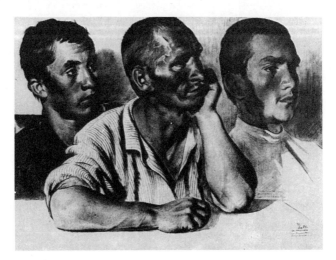

Evgenii Katsman: *Listening (Members of the Communist Faction from the
Village of Baranovka)*, 1925. Charcoal. Collection Tretyakov Gallery,
Moscow. Katsman's classical approach to anatomy and perspective en-
abled him to record many everyday scenes of workers and peasants in a
highly intelligible if rather static manner.

The Great October Revolution, in liberating the creative forces of the peo-
ple, has aroused the consciousness of the masses and the artists—the spokes-
men of the people's spiritual life.

Our civic duty before mankind is to set down, artistically and documen-
tarily, the revolutionary impulse of this great moment of history.

We will depict the present day: the life of the Red Army, the workers, the
peasants, the revolutionaries, and the heroes of labor.

We will provide a true picture of events and not abstract concoctions
discrediting our Revolution in the face of the international proletariat.

The old art groups existing before the Revolution have lost their meaning,
the boundaries between them have been erased in regard to both ideology
and form—and they continue to exist merely as circles of people linked
together by personal connections but devoid of any ideological basis or
content.

It is this content in art that we consider a sign of truth in a work of art,
and the desire to express this content induces us, the artists of Revolutionary
Russia, to join forces; the tasks before us are strictly defined.

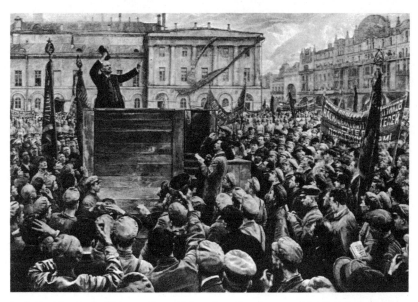

Isaak Brodsky: *Lenin Giving a Farewell Speech to Detachments of the Red Army about to Leave for the Polish Front on May 5, 1920,* 1933. Oil on canvas, 280 x 422 cm. Collection Central Lenin Museum, Moscow.

The day of revolution, the moment of revolution, is the day of heroism, the moment of heroism—and now we must reveal our artistic experiences in the monumental forms of the style of heroic realism.

By acknowledging continuity in art and by basing ourselves on the contemporary world view, we create this style of heroic realism and lay the foundation of the universal building of future art, the art of a classless society.

AKhRR
The Immediate Tasks of AKhRR:
A Circular to All Branches of
AKhRR—An Appeal
to All the Artists
of the U.S.S.R.,[1] 1924

The text of this piece, "Ocherednye zadachi AKhRRRa," was issued as a circular letter in May 1924, after the February exhibition "Revolution, Life, and Labor," and was then published in a collection of articles edited by an AKhRR member, Aleksandr Grigorev, *Chetyre goda AKhRRa* [Four Years of AKhRR] (Moscow, 1926), pp. 10–13. The text is reprinted in *Sovetskoe iskusstvo za 15 let* [Soviet Art of the Last Fifteen Years], ed. Ivan Matsa et al. (Moscow-Leningrad, 1933), pp. 345–48 [bibl. R16], from which this translation is made, and in bibl. R493, pp. 300–302.

The presidium of AKhRR and its Russian Communist Party (Bolsheviks) faction consider it essential—on the second anniversary of the Association of Artists of Revolutionary Russia (May 1, 1924)—to sum up its artistic and social activities and to define its ideological policy in its subsequent practical work, once the immediate tasks facing AKhRR have been solved.

From the very beginning of AKhRR's existence, when it proclaimed in its declaration the need for a creative response to the October Revolution and for a new reality in visual art, it has been quite clear that AKhRR should take the organization of the new elements of social art organically linked to our revolutionary epoch as the basis of its artistic work, and that it should do this by regenerating art on the foundation of a high and authentic level of painterly skill.

The creation of the elements of a social art in the Russian school acted, by the very fact of its existence, as a logical balance to the development of, and enthusiasm for, the extreme, so-called leftist trends in art; it displayed their petty-bourgeois, pre-Revolutionary, decadent substance, which was expressed in their attempt to transfer the fractured forms of Western art— mainly French (Cézanne, Derain, Picasso)—to a soil alien both economically and psychologically.

In no way does this signify that we should ignore all the formal achievements of French art in the second half of the nineteenth century and to a certain extent in the first quarter of the twentieth within the general treasury of world art (the careful, serious study and assimilation of the painterly and formal achievements of modern art is an essential obligation of every serious artist who aspires to become a master). AKhRR objects only to the aspiration to reduce the whole development of art to the imitation and repetition of models of the French school, a school that is nurtured, in turn, on the sources of old traditions in art.

After their two years of work in factories and plants, after the many exhibitions they organized—which laid the foundation for the Museum of the All-Union Central Council of Trade Unions and for the Red Army and Navy Museum—the main group of AKhRR members felt convinced that subject matter, thematic method in the study and conversion of reality, was the main element in organizing form.

It became clear to the AKhRR artists that the factory, the plant, the production worker, electrification, the heroes of labor, the leaders of the Revolution, the new life of the peasants, the Red Army, the Komsomol and Pioneers, the death and funeral of the Revolution's leader—all this contained a new color of unprecedented power and severe fascination, a new interpretation of synthetic form, a new compositional structure; in a word, contained the aggregate of those conditions whose execution would regenerate easel and monumental painting.

For the expression of these new forms created by the Revolution, the frayed, lost forms and lacerated color hired from the masters of the French school are absolutely useless.

For the expression of these new forms created by the Revolution a new style is essential, a strong, precise, invigorating style that organizes thought and feeling, the style that in our short declaration is called heroic realism.

The difficulty of solving and realizing the above tasks lies in the fact that, while aspiring toward content in art, it is very easy to lapse into feeble, simple imitation of a host of outdated art schools and trends.

Those artists, those young artists who wish first and foremost to be sincere, who wish to shake off the yoke of vacuous philosophizing and inversion of the bases of visual art decomposed through the process of analysis, fully realize the necessity to regenerate the unity of form and content in art; and they direct all their strength, all their creative potential, to the ceaseless scientific and completely professional study of the new model, giving it the acutely realistic treatment that our epoch dictates.

The so-called indifference to politics of certain contemporary groups of

artists is a well or badly concealed aversion to the Revolution and a longing for a political and moral restoration.

The harsh material conditions that surround the present-day artist on the one hand deprive the artist of the protection of his professional interests and the safeguarding of his work and on the other hand determine his view of art as a weapon for the ideological struggle and clearly aggravate the difficulty of this path; but if the Revolution has triumphed, in spite of the innumerable obstacles, then the will to express the Revolution creatively will help the contemporary realist artist to overcome all the difficulties he encounters on his path.

It is essential to remember that a creative artistic expression of the Revolution is not a fruitless and driveling sentimentality toward it but a real service, because the creation of a revolutionary art is first and foremost the creation of an art that will have the honor of shaping and organizing the psychology of the generations to come.

Only now, after two years of AKhRR, after the already evident collapse of the so-called leftist tendencies in art, is it becoming clear that the artist of today must be both a master of the brush and a revolutionary fighting for the better future of mankind. Let the tragic figure of Courbet serve as the best prototype and reminder of the aims and tasks that contemporary art is called on to resolve.

The reproaches of formal weakness and dilettantism that were cast at the Wanderers by other art groups can by rights be repaid to those who made them, for if we remember the formal achievements of the best Wanderers (Perov, Surikov, Repin), we can see how much more profound, sincere, and serious they were than their descendants poisoned by the vacuous decorativism, retrospectivism, and brittle decadence of the prerevolutionary era.

Kramskoi's prediction that the ideas of a social art would triumph under a different political regime is beginning to be brilliantly justified; it is confirmed by the mass withdrawal from all positions of the so-called leftist front observable in contemporary art.

Give particular attention to the young artists, organize them, turn all your efforts to giving polish to those natural artists from among the workers and peasants who are beginning to prove their worth in wall newspapers; and the hour is not far off when, perhaps, the Soviet art school will be destined to become the most original and most important factor in the renaissance of world art.

Ceaseless artistic self-discipline, ceaseless artistic self-perfection, unremitting effort in the preparations for the next AKhRR exhibition—this is the only path that will lead to the creation of a genuine, new art on whose

heights form will fuse with content. And the presidium of AKhRR and its Russian Communist Party (Bolsheviks) faction appeal to all artists who hold near and dear the behests and aims set before AKhRR to rally around the association in a powerful, united, artistic, and revolutionary organization.

AKhR
Declaration
of the Association of Artists
of the Revolution, 1928

For details on AKhR see p. 265.

The text of this piece, "Deklaratsiya Assotsiatsii khudozhnikov revolyutsii (AKhR)," was published in the *Bulletin* of the AKhR Information Office dedicated to the First All-Union Convention of AKhR. This convention was held just after the tenth exhibition of AKhRR/AKhR in Moscow, February 1928, which was devoted to ten years of the Workers' and Peasants' Red Army. The text is reprinted in *Sovetskoe iskusstvo za 15 let* [Soviet Art of the Last Fifteen Years], ed. Ivan Matsa et al. (Moscow-Leningrad, 1933), p. 356 [bibl. R16], from which this translation is made; the text is reprinted also in bibl. R493, pp. 320–21. For a German translation see bibl. 209viii, pp. 305, 306.

The Great October Revolution, having emancipated the forces of the worker and peasant masses, has summoned artists to participate in the class struggle and Socialist construction in the ranks of the proletariat and toiling peasantry.

"Art belongs to the people. With its deepest roots it should penetrate into the very thick of the toiling masses. It should be understood by these masses and loved by them" (Lenin).

As artists of the Proletarian Revolution, we have the duty of transforming the authentic revolutionary reality into realistic forms comprehensible to the broad masses of the workers and of participating actively in Socialist construction by our socioartistic work.

The tasks of artistically designing everyday life (architecture, clubs, lei-

sure, mass celebrations) and also of artistically finishing articles of mass consumption (duplicating designs, textiles, ceramics, the processing of wood, metal, etc.) confront the artists of the Proletarian Revolution as urgent, present-day tasks.

The heroic class struggle, the great workdays of construction, should be the mainsprings of the content of our art. The subjects of our immediate work are not only the past and present of the struggle, but also the prospects created by the Proletarian Revolution. We consider this profound content—invested in an artistically perfect, realistic form organically engendered by it—a sign of truth in a contemporary work of visual art.

In actively realizing the slogans of the cultural revolution on the visual-arts front, in organizing the feelings, thoughts, and will of the toiling masses by our artistic and social work, we set as our primary objective: to assist the proletariat in the realization of its class objectives.

In national cultures, October is creating a diverse but united current of revolutionary, realistic art of all republics and autonomous provinces of the U.S.S.R. This is also true of the art of revolutionary artists of other countries; [1] and in setting as our task the development of keen artistic interaction between peoples liberated and those being liberated, we aspire to unite the revolutionary artists of all countries in a single organization—INTERNAKhR.

"Proletarian culture is not something that has come out of the blue; it is not the invention of people who call themselves specialists in proletarian culture. . . . Proletarian culture should be the legitimate development of the reserves of knowledge that mankind produced under the yoke of capitalist society, landowner society, and bureaucratic society."

With these words of V. I. Lenin in mind, and on the basis of continuity and critical assimilation of world artistic culture, we will come to the creation of a proletarian art.

Advancing along this path, perfecting the forms of our language with persistent work and labor, we will come, by means of a new content, to the creation of a monumental style—the expression of our epoch, the style of heroic realism.

Art—to the masses.

October—Association
of Artistic Labor
Declaration, 1928

October was founded in 1928, but its one exhibition did not open until June 1930, in Moscow. October encompassed various artistic activities, although it concentrated on the industrial and applied arts—and this, together with its emphasis on the proletariat and on contemporaneity, recalled the ideas of Proletkult and constructivism. This is confirmed by the association's list of members and by the cosignatories of this declaration, who included: representing poster art and book design—Aleksandr Alekseev, Mecheslav Dobrokovsky, Vasilii Elkin, Paula Freiberg, Paul Irbit, Gustav Klutsis, Alois Kreichik, Nikolai Lapin, El Lissitzky, Dmitrii Moor, Diego Rivera (in Moscow 1927–28), Nikolai Sedelnikov, Sergei Senkin, Solomon Telingater, Béla Uitz, Vikor Toot and, temporarily, Aleksandr Deineka; representing architecture—Aleksei Gan, Moisei Ginzburg, Pavel Novitsky, and two of the Vesnin brothers, Aleksandr and Viktor; representing film and photography—Sergei Eisenstein, Aleksandr Rodchenko, and Esfir Shub; and Alfred Kurella, Ivan Matsa, and Aleksei Mikhailov—theorists of the group.

Deineka, Klutsis, Lissitzky, Rodchenko, Senkin, and Varvara Stepanova were represented at its sole exhibition [for review see bibl. R70, no. 7, 1930, pp. 9–16]. A collection of October declarations and articles by members entitled *Izofront. Klassovaya borba na fronte prostranstvennykh iskusstv* [Visual Arts Front. The Class Struggle on the Spatial Arts Front; bibl. R500] was scheduled to appear at the same time as the exhibition, but the adverse political and artistic climate dictated a number of prepublication changes. When the collection finally appeared in late 1931, the publishers were careful to emphasize in their separate insert and apologetic preface that the collection was being published as "material for creative discussion" despite its numerous "vulgar, materialistic mistakes." In 1932 October was accused of "abolishing art"[see responses of RAPKh (Rossiiskaya assotsiatsiya proletarskikh khudozhnikov—Russian Association of Proletarian Artists) to the decree "On the Reconstruction" (pp. 288ff.) in *Za proletarskoe iskusstvo* [For Proletarian Art] (Moscow), no. 9/10, 1932; reprinted in bibl. R16, p. 650]; in the same year October was, in any case, dissolved as a result of the above decree.

The text of this piece, "Oktyabr. Obedinenie khudozhestvennogo truda. Deklaratsiya," was first published in *Sovremennaya arkhitektura* [SA—Contemporary Architecture] (Moscow), no. 3, March 1928, pp. 73–74 [bibl. R84]. In 1931 a second general declaration, entitled *Borba za proletarskie pozitsii na fronte prostranstvennykh*

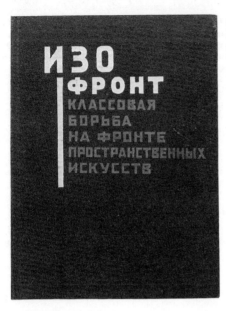

Cover of the book *Izofront* [Visual Arts Front] (Moscow-Leningrad, 1931). Designed by Gustav Klutsis. This was one of the last constructivist book designs to be published in the Soviet Union.

iskusstv [The Struggle for Proletarian Class Positions on the Spatial Arts Front], was published as a separate pamphlet in Moscow. Apart from this, there were three other specific declarations: one by the National Sector of October (dated 1929), which rejected the idealization of pre-Revolutionary art forms and cultures, thereby opposing AKhR's support of nineteenth-century realist traditions; the Program of the Photo Section of October (dated 1930), which rejected the ''abstract'' photography of such artists as László Moholy-Nagy and saw the value of photography to lie in its ''actuality,'' stipulating, moreover, that all members should be linked with industrial production or with collective farms; and an Open Letter (dated 1930) from the young artists' section of October—Molodoi Oktyabr [Young October]—to the central presidium of OMAKhR (see p. 265) criticizing the latter's passive, documentary interpretation of proletarian reality. [These three declarations, together with the first, were published in bibl. R500, pp. 135–60, and are reprinted in bibl. R16, pp. 608–16, 619–23; the first declaration and that of the National Sector are reprinted in bibl. R22, pp. 117–18, 121–22]. For a German translation see bibl. 209viii, pp. 180–83.

At the present time all art forms must define their positions at the front of the Socialist cultural revolution.

We are profoundly convinced that the spatial arts (architecture, painting, sculpture, graphics, the industrial arts, photography, cinematography, etc.) can escape their current crisis only when they are subordinated to the task of

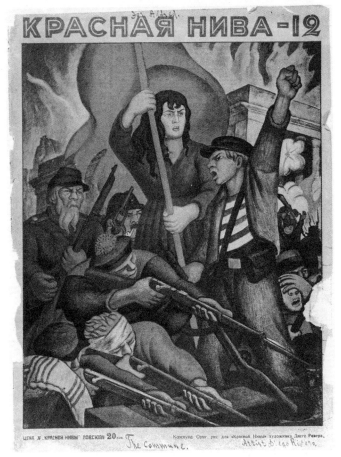

Cover of the journal *Krasnaya niva* [Red Field] (Moscow), no. 12, 1928. Designed by Diego Rivera. Rivera was in Moscow in 1927 and 1928 and was a member of the October group. Photograph courtesy of the late Mr. Alfred H. Barr, Jr., New York.

serving the concrete needs of the proletariat, the leaders of the peasantry, and the backward national groups.

In participating consciously in the proletariat's ideological class struggle against hostile forces and in supporting the rapprochement of the peasantry and the nationalities with the proletariat, the spatial arts must serve the proletariat and the working masses in two interconnected fields:

in the field of ideological propaganda (by means of pictures, frescoes, printing, sculpture, photography, cinematography, etc.);

in the field of production and direct organization of the collective way of life (by means of architecture, the industrial arts, the designing of mass festivals, etc.).

The main task of this artistic service to the proletarian needs of the Revolution is to *raise the ideological, cultural, and domestic level* of the backward strata of the working class and of those workers who are undergoing an alien class influence; their level would be raised to that of the avant-garde, revolutionary industrial proletariat, which is consciously building the Socialist economy and culture on the bases of organization, planning, and highly developed industrial technology.

These principles have already been stipulated as the basis of the whole socioeconomic structure of our government, and only art has remained behind in this respect, because of the narrow, professional artisan traditions it has preserved. The most pressing task today is to eliminate this disproportion between the development of art and the socioeconomic development of our country.

For those artists who are fully aware of these principles, the following immediate tasks await:

1. The artist who belongs to the epoch of the proletarian dictatorship regards himself not as an isolated figure passively reflecting reality, but as an active fighter at the ideological front of the Proletarian Revolution; this is the front that, by its actions, is organizing mass psychology and is helping to design the new way of life. This orientation compels the proletarian artist to take stock of himself continually in order to stand with the revolutionary proletarian avant-garde at the same high ideological level.

2. He must submit to critical examination all formal and technical artistic achievements of the past. Of especial value to proletarian art are the achievements of the last decades, when the methods of the rational and constructive approaches to artistic creation, which had been lost by the artists of the petty bourgeoisie, were restored and developed considerably. It was at this time that artists began to penetrate the creation of dialectical and materialist methodology, of which artists had not been aware previously, and of the methods of mechanical and laboratory scientific technology; this has provided a great deal that can and must serve as material for the development of proletarian art. However, the fundamental task of the proletarian artist is not to make an eclectic collection of old devices for their own sake, but with their aid, and on new technological ground, to create new types and a new style of the spatial arts.

3. The ultimate orientation of the artist who would express the cultural interests of the revolutionary proletariat should be to propagate the world

view of dialectical materialism by the maximum means of expression within the spatial arts, and to design materially the mass, collective forms of the new life. In the light of this, we reject the philistine realism of epigones; the realism of a stagnant, individualistic way of life; passively contemplative, static, naturalistic realism with its fruitless copying of reality, embellishing and canonizing the old way of life, sapping the energy and enervating the will of the culturally underdeveloped proletariat.

We recognize and will build proletarian realism that expresses the will of the active revolutionary class; a dynamic realism that reveals life in movement and in action and that discloses systematically the potentials of life; a realism that makes things, that rebuilds rationally the old way of life and that, in the very thick of the mass struggle and construction, exerts its influence through all its artistic means. But we simultaneously reject aesthetic, abstract industrialism and unadulterated technicism that passes itself off as revolutionary art. For art to affect life creatively, we emphasize that all means of expression and design must be utilized in order to organize the consciousness, will, and emotions of the proletariat and of the working masses with maximum force. To this end, the organic cooperation of all spatial art forms must be established.

4. Proletarian art must overcome individualistic and commercial relationships, which have dominated art up until now. While we reject the bureaucratic concepts of the "social commission," which has gained ground over recent years, we do seek social commissions from consumer collectives; these order works of art for concrete objectives and participate collectively in the preparation of artistic objects. In this respect the industrial arts are assuming more importance, since they are proving to be durable and effective in collective production and consumption.

5. In order to obtain maximum results we are attempting to concentrate our efforts on the following vital points:

a) rational construction, problems of new residential accommodation, social buildings, etc.

b) artistic design of objects for mass consumption manufactured by industry

c) artistic design of centers for the new collective way of life: workers' clubs, reading rooms, canteens, tearooms, etc.

d) organization of mass festivals

e) art education

We are firmly convinced that the paths we have indicated will lead to the intensive development of creative strength among the masses. We support this development of mass creative aspiration, since we know that the basic

process of the development of the spatial arts in the U.S.S.R. is advancing because of the proximity of the independent art of proletarian art circles, workers' clubs, and peasants to highly qualified professional art, and is maintaining the level of artistic technology identifiable with the industrial epoch.

In advancing along these paths, proletarian art leaves behind the slogan of the transitional period—"Art to the Masses"—and prepares the ground for the art of the masses.

In acknowledging organization, rationality, and collectivism as the basic principles of the new artistic and cultural construction in the country of the proletarian dictatorship, the October Association establishes a definite working discipline for bringing together its members on the basis of the above principles. These principles will need a more thorough elaboration in the association's subsequent creative, ideological, and social activity.

In issuing the present declaration, we disassociate ourselves from all existing art groups active in the field of the spatial arts. We are prepared to join forces with some of them as long as they acknowledge the basic principles of our platform in practical terms. We greet the idea of a federation of art societies [1] and will support any serious organizational steps in this direction.

We are embarking at a time of transition for the development of the spatial arts in the U.S.S.R. With regard to the basic forces active in modern Soviet art, the natural process of artistic and ideological self-determination is being hampered by a number of unhealthy phenomena. We consider it our duty to declare that we reject the system of personal and group patronage and protection for individual artistic trends and individual artists. We support wholly the unrestricted, healthy competition of artistic directions and schools within the areas of technical competence, higher quality of artistic and ideological production and stylistic researches. But we reject unhealthy competition between artistic groups for commissions and patronage of influential individuals and institutions. We reject any claim by any one association of artists to ideological monopoly or exclusive representation of the artistic interests of the working and peasant masses. We reject the system that can allow an artificially created and privileged position (moral and material) for any one artistic group at the expense of other associations or groups; this is a radical contradiction of the Party's and the government's artistic policy. We reject speculation on "social commissions," which occurs beneath the mask of revolutionary theme and everyday realism, and which replaces any serious effort to formulate a revolutionary world view and world perception with a simplified interpretation of a hurriedly invented revolutionary subject.

We are against the dictatorship of philistine elements in the Soviet spatial arts and for the cultural maturity, artistic craftsmanship, and ideological consistence of the new proletarian artists, who are quickly gaining strength and advancing to the fore.

The ranks of the proletariat, progressive, active, and artistically concerned, are growing before our very eyes. Mass art summons the vast masses to artistic involvement. This involvement is linked to the class struggle, to the development of industry, and to the transformation of life. This work demands sincerity, high qualifications, cultural maturity, revolutionary awareness. We will dedicate all our strength to this work.

OST [Society of Easel Artists]
Platform, 1929

OST [Obshchestvo khudozhnikov-stankovistov—Society of Easel Artists] arose as an untitled group just after the "First Discussional" (see pp. 237ff.), in late 1924, and was established formally in 1925. Founding members included Yurii Annenkov, Aleksandr Deineka, Yurii Pimenov, David Shterenberg (chairman), and Petr Vilyams, and its membership soon came to encompass many leading figures of young Soviet art. OST had four exhibitions from 1925 to 1928, all in Moscow (Deineka contributed only to the first two, leaving the society early in 1927) before it closed in 1931. Although OST supported easel painting as opposed to industrial design (one reason that Deineka left), it did not reject the achievements of the old avant-garde; Ivan Klyun, for instance, was invited to contribute to the first OST exhibition.

The text of this piece, "Platforma OSTa" (part of the society's code), was formulated in 1929 but not published until 1933 in *Sovetskoe iskusstvo za 15 let* [Soviet Art of the Last Fifteen Years], ed. Ivan Matsa et al. (Moscow-Leningrad), p. 575 [bibl. R16], from which this translation is made. It was based probably on Shterenberg's lecture at the Communist Academy in Moscow in May 1928, entitled "Teoreticheskaya platforma i khudozhestvennaya praktika OSTa" [The Theoretical Platform and Artistic Practice of OST]. OST contributed a great deal to the renewal of easel activity and achieved very interesting results, particularly in the initial work of Pimenov, Aleksandr Tyshler, and Vilyams. In some cases, as in Pimenov's war pictures, the influence of German expressionists such as Otto Dix and George Grosz

Cover of the exhibition catalogue of OST [Society of Easel Artists] (Moscow, 1927). Artist unknown.

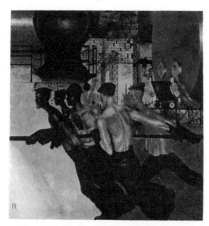

Aleksandr Deineka: *Defense of Petrograd,* 1927. Oil on canvas, 218 x 359 cm. Collection Central Museum of the Soviet Army, Moscow. Although regarded as an important precursor of Socialist Realist painting, this picture derives its subject and composition directly from Ferdinand Hodler's *The Departure of the Volunteers in 1813,* 1908, Friedrich Schiller University, Jena.

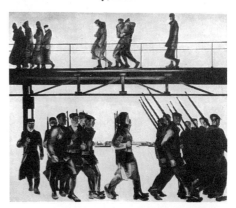

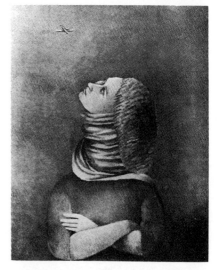

Yurii Pimenov: *Give to Heavy Industry,* 1927 Oil on canvas, 260 x 212 cm. Collection Tretyakov Gallery, Moscow. The graphic linear quality of this work was typical of Pimenov's industrial and athletic scenes of the mid-1920s, and revealed his interest in later German expressionism, especially as interpreted by Otto Dix.

Aleksandr Tyshler: *Woman and an Airplane,* 1926. Oil on canvas, 89 x 71 cm. Private collection, Moscow. Tyshler's work, especially of the mid- and late 1920s, possessed a distinctly surrealist quality—one shared by other members of OST, such as Rostislav Barto and Sergei Luchishkin.

was especially noticeable, although this angular, skeletal quality was also effective in the young Soviet artists' depictions of industrial and mechanical scenes. OST members displayed a technical competence and an intellectual energy lacking in the "sketchy" studies of Four Arts or the academic work of AKhRR. For a German translation see bibl. 209viii, pp. 342, 343.

On the basis of the following program, the Society of Easel Artists aims to unite artists who are doing practical work in the field of the visual arts:

1. In the epoch of Socialist construction the active forces of art must be participants in this construction; in addition, they must be one of the factors in the cultural revolution affecting the reconstruction and design of our new way of life and the creation of the new Socialist culture.

2. Bearing in mind that only art of high quality can envisage such tasks, we consider it essential, within the conditions of the contemporary development of art, to advocate the basic lines along which our work in the visual arts must advance. These lines are:

 a) The rejection of abstraction and peredvizhnichestvo [1] in subject matter
 b) The rejection of sketchiness as a phenomenon of latent dilettantism
 c) The rejection of pseudo Cézannism as a disintegrating force in the discipline of form, drawing, and color
 d) Revolutionary contemporaneity and clarity of subject matter
 e) Aspiration to absolute technical mastery in the field of thematic easel painting, drawing, and sculpture as the formal attainments of the last few years are developed further
 f) Aspiration to make the picture a finished article
 g) Orientation toward young artists

Four Arts Society of Artists
Declaration, 1929

The Four Arts Society was founded in Moscow in 1924 by, among others, Lev Bruni, Vladimir Favorsky, Pavel Kuznetsov, Vladimir Lebedev, Petr Miturich, Kuzma Petrov-Vodkin, and as these names would indicate, the society was espe-

cially interested in the decorative and lyrical aspects of art. Four Arts, however, was eclectic and, apart from the above artists, represented at its four exhibitions (1925, 1926, 1929, in Moscow; 1928, in Leningrad) such diverse artists as Ivan Klyun (1926), El Lissitzky (1926), and unexpectedly, Ivan Puni (1928), and it even numbered architects among its members. A history of Soviet architecture published in 1970 [bibl. R22, p. 115] refers to five state exhibitions and one foreign one, but a 1965 Soviet publication on exhibitions of the visual arts [bibl. R152] does not support this. According to Ivan Matsa's 1933 volume [bibl. R16, p. 338] and Troels Andersen's catalogue of the Malevich collection in Amsterdam [bibl. 160, p. 163], Kazimir Malevich was also represented at one of the Four Arts exhibitions, but the 1965 Soviet book [bibl. R152] does not corroborate this. Already in a state of decline in 1930, Four Arts underwent further disruption when some of its members left to join AKhRR [see bibl. R16, pp. 581–82]; it was, in any case, dissolved by the decree "On the Reconstruction" (see pp. 288ff.).

The text of this piece, "Obshchestvo 4 iskusstva. Deklaratsiya," is from *Ezhegodnik literatury i iskusstva* [Annual of Literature and Art] (Moscow), October 1929, pp. 551–52 [bibl. R15; it is reprinted in bibl. R16, pp. 321–22]. Despite its late date, the declaration indicates that Soviet artists could still enjoy a certain independence from the Party machine. However, the more individualistic conception of art and the general concern with formal rather than with thematic value favored by members of Four Arts gave the society a distinctive and unconventional stance soon criticized both by the political administration and by fellow groups such as OST and AKhR. In general, the Four Arts members favored an art form more delicate and refined than that of OST or AKhR members, and graphics and water colors were their most frequent media. This ethereal quality in the washes of Bruni and Kuznetsov, Petr Lvov, and Nikolai Tyrsa, to mention but a few, prompted comparisons with the French impressionists and symbolists, and it is relevant to note that some of the older members—Nikolai Feofilaktov, Kuznetsov, Martiros Saryan—had been members of the symbolist Blue Rose group in 1907. The code of the society has recently been published in bibl. R515, pp. 169–75.

What the artist shows the spectator above all is the artistic quality of his work.

Only in this quality does the artist express his attitude to the surrounding world.

The development of art and of artistic culture has reached the stage when the most profound characteristic of its specific element is to be found in its simplicity and closeness to human feeling.

Within the conventions of the Russian tradition, we consider painterly realism to be most appropriate to the artistic culture of our time. We consider

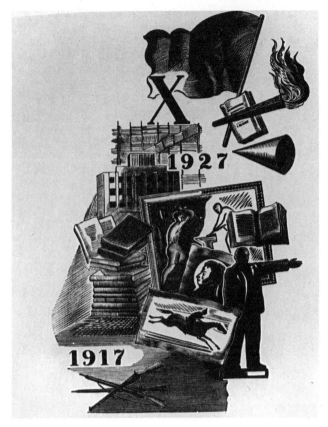

Vladimir Favorsky: *Lenin 1917–1927,* 1927. Woodcut, 17.5 x 12.5 cm.

the French school, a school that is most fully and most universally developing the basic qualities of the painterly art, to be of the greatest value to ourselves.

On the Artist's Tasks

The content of our work is not characterized by subject matter, and therefore, on no account do we give titles to our pictures. The choice of subject characterizes the artistic tasks with which the artist is concerned. In this sense the subject is merely a pretext for the creative transformation of material into artistic form. The spectator perceives confirmation of artistic truth

in the transference undergone by visible forms, when the artist takes their painterly meaning from life and constructs a new form—the picture. This new form is important not because of its similarity to the living form, but because of its harmony with the material out of which it is constructed. This material—the picture's surface and its color—consists of paint, canvas, etc. The effect of an artistic form on the spectator derives from the nature of a given medium, from its qualities and basic elements (music has its own, painting its own, literature its own). The organization of these qualities and the mastery of material for the attainment of this goal comprise artistic creation.

PAVEL FILONOV
Ideology of Analytical Art
[Extract], 1930

Born Moscow, 1883; died Leningrad, 1941. 1897: moved to St. Petersburg; 1897–1901: engaged in house painting, decorating, and restoration work; 1903–1908; at the private studio of the academician Lev Dmitriev-Kavkazsky; 1908–10: attended the St. Petersburg Academy; 1910 and thereafter: close to the Union of Youth, contributing to three of its exhibitions; 1912: traveled to Italy and France; 1913: with Iosif Shkolnik designed decor for Vladimir Mayakovsky's tragedy *Vladimir Mayakovsky;* 1914–15: illustrated futurist booklets and published a long, neologistic poem with his own illustrations [bibl. R347]; propounded the first ideas of his theory of analytical art and his system called "Mirovoi rastsvet" [Universal Flowering]; published his first manifesto, *Sdelannye kartiny* [Made Paintings]; 1916–18: military service; 1923: briefly associated with the Petrograd Institute of Artistic Culture (IKhK); 1925: established the Collective of Masters of Analytical Art (the Filonov School); 1929–30: one-man exhibition planned at the Russian Museum, Leningrad; 1930s: continued to paint according to his theories.

The text of this piece, "Ideologiya analiticheskogo iskusstva," is from *P. Filonov. Katalog proizvedenii nakhodyashchikhsya v Russkom muzee* [P. Filonov. Catalogue of Works in the Russian Museum] (Leningrad, 1930), pp. 41–52 [bibl. R507]. The catalogue was printed in 1929 and issued in 1930, and although the preparations for

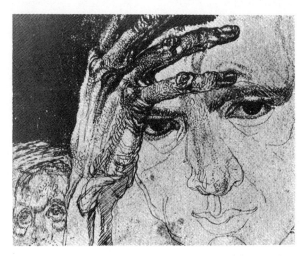

Pavel Filonov: *Self-Portrait,* 1909–10. India ink, 6.8 x 10.5 cm. Collection Russian Museum, Leningrad.

the exhibition reached their final stage, it was not opened ultimately for political reasons and because of pressure from the AKhR artists. The catalogue contained a preface by the critic Sergei Isakov (pp. 3–28), who criticized Filonov for his visual distortion of workers and for his individualism. Filonov wrote the first draft of his theory of analytical art in 1914–15, a second in 1923 (published as ''The Declaration of Universal Flowering'' [bibl. R508]), and thereafter several versions, but as such it did not appear under the specific title ''Ideology of Analytical Art'' until the publication of this catalogue (which, in any case, carried only the short extract translated here). The tension between the concepts of the intellect and the psyche, analysis and intuition, central to Filonov's theory was nowhere more evident than in his frequent recourse to scientific terminology, paralleled in pictorial terms by his application of concrete titles to highly subjective and abstract themes. Both the biological and intuitional concepts favored by Filonov betrayed the influence of Nikolai Kulbin on the one hand, and of Vladimir Markov and perhaps even of Olga Rozanova on the other—all of whom Filonov had known in St. Petersburg. Filonov's theory had a certain following during the mid- and late 1920s, through his students, such as Yuliya Arapova and Alisa Poret, and the Filonov School continued to exist during the early 1930s, contributing, inter al., to the remarkable edition of the Finnish Kalevala in 1933 [bibl. R512]. Filonov's proposed exhibition, his unflinching belief in his own system, and the activity of his students constituted a last open stand against the official and exclusive imposition of realism and socialist realism after about 1930. It was a tragic paradox that Filonov, so deeply concerned with the formulation of a pro-

letarian art, should have been censured during his last decade as a "monstrous hybrid of metaphysics and vulgar materialism . . . manifesting complete confusion in the face of reality" [bibl. R491, p. 60]. For an English translation of similar texts see bibl. 272iii.

———

A work of art is any piece of work made with the maximum tension of analytical madeness.[1]

The only professional criterion for evaluating a piece of work is its madeness.

In their profession the artist and his disciple must love all that is "made well" and hate all that is "not made."

In analytical thought the process of study becomes an integral part of the creative process for the piece being made.

The more consciously and forcefully the artist works on his intellect, the stronger the effect the finished work has on the spectator.

Each brushstroke, each contact with the picture, is a precise recording through the material and in the material of the inner psychical process taking place in the artist, and the whole work is the entire recording of the intellect of the person who made it.

Art is the reflection through material or the record in material of the struggle for the formation of man's higher intellectual condition and of the struggle for existence by this higher psychological condition. Art's efficacity vis-à-vis the spectator is equal to this; i.e., it both makes him superior and summons him to become superior.

The artist-proletarian's obligation is not only to create works that answer the demands of today, but also to open the way to intellect into the distant future.

The artist-proletarian must act on the intellect of his comrade proletarians not only through what they can understand at their present stage of development.

Work on content is work on form and vice versa.

The more forcefully form is expressed, the more forcefully content is expressed.

Form is made by persistent line. Every line must be made.

Every atom must be made; the whole work must be made and adapted.

Think persistently and accurately over every atom of the work you are doing. Make every atom persistently and accurately.

Introduce persistently and accurately into every atom the color you have

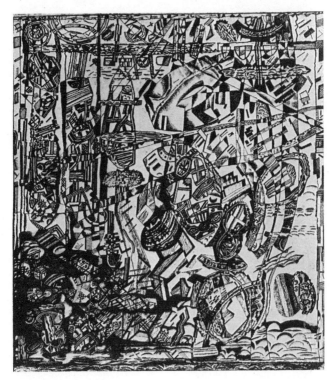

Pavel Filonov: *Untitled,* 1924–25. India ink, 30.5 x 27 cm. Collection Russian Museum, Leningrad. Executed according to his theory of analytical art, this work introduced "all the predicates of the object and its sphere: objective reality, pulsation and its sphere, biodynamics, intellect, emanations, interfusions, geneses, processes of color and form—in a word, life as a whole" [bibl. R508, p. 13].

studied—so that it enters the atom just as heat enters the body or so that it is linked organically with the form, just as in nature a flower's cellulose is linked with its color.

Painting is the colored conclusion of drawing.

Central Committee of the All-Union Communist Party (Bolsheviks) Decree on the Reconstruction of Literary and Artistic Organizations, 1932

This decree, passed April 23, 1932, marked the culmination of a series of measures that had been curtailing the artist's independence (e.g., the decrees "On the Party's Policy in the Field of Artistic Literature," 1925, and "On the Production of Poster Pictures," 1931). Before the 1932 decree there had been attempts to consolidate artistic forces by establishing umbrella societies, such as Vsekokhudozhnik [Vserossiiskii kooperativ khudozhnikov—All-Russian Cooperative of Artists] in 1929, FOSKh in 1930 [see n. 1 to the October "Declaration," p. 308], and RAPKh in 1931 [see ibid.], but such organizations had retained a certain independence of the political machine. The direct result of the 1932 decree was to dissolve all official art groups immediately; and although the proposed single Union of Soviet Artists (i.e., Soyuz khudozhnikov SSSR [Union of Artists of the U.S.S.R.]) was not convoked until 1957, a special committee was organized in 1936 to take charge of all art affairs except those involving architecture and the cinema—Komitet po delam iskusstv pri Sovete ministrov SSSR [Committee for Art Affairs Attached to the Council of U.S.S.R. Ministers]; in turn, the decree prepared the ground for the conclusive advocacy of socialist realism at the First All-Union Congress of Soviet Writers in 1934 (see pp. 290ff.). For reactions to the decree see bibl. R16, pp. 645–51.

The text of this piece, *O Perestroike literaturno-khudozhestvennykh organizatsii*, appeared as a separate pamphlet in 1932; it is reprinted in *Sovetskoe iskusstvo za 15 let* [Soviet Art of the Last Fifteen Years], ed. Ivan Matsa et al. (Moscow-Leningrad, 1933), pp. 644–45 [bibl. R16], from which this translation is made; it has been reprinted several times since Matsa, e.g., in bibl. R493. For a German translation see bibl. 209viii, p. 408.

The Central Committee states that over recent years literature and art have made considerable advances, both quantitative and qualitative, on the basis of the significant progress of Socialist construction.

A few years ago the influence of alien elements, especially those revived by the first years of NEP,[1] was still apparent and marked. At this time, when the cadres of proletarian literature were still weak, the Party helped in

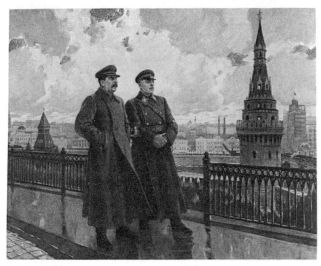

Aleksandr Gerasimov: *Stalin and Voroshilov in the Kremlin Grounds,* 1938. Oil on canvas, 300 x 390 cm. Collection Tretyakov Gallery, Moscow. Gerasimov was Stalin's favorite Soviet artist.

every possible way to create and consolidate special proletarian organs in the field of literature and art in order to maintain the position of proletarian writers and art workers.

At the present time the cadres of proletarian literature and art have managed to expand, new writers and artists have come forward from the factories, plants, and collective farms, but the confines of the existing proletarian literature and art organizations (VOAPP, RAPP, RAPM,[2] etc.) are becoming too narrow and are hampering the serious development of artistic creation. This factor creates a danger: these organizations might change from being an instrument for the maximum mobilization of Soviet writers and artists for the tasks of Socialist construction to being an instrument for cultivating elitist withdrawal and loss of contact with the political tasks of contemporaneity and with the important groups of writers and artists who sympathize with Socialist construction.

Hence the need for the appropriate reconstruction of literary and artistic organizations and the extension of the basis of their activity.

Following from this, the Central Committee of the All-Union Communist Party (Bolsheviks) decrees:

1. Liquidation of the Association of Proletarian Writers (VOAPP, RAPP).

2. Integration of all writers who support the platform of the Soviet government and who aspire to participate in Socialist construction in a single union of Soviet writers with a Communist faction therein.

3. Execution of analogous changes with regard to the other arts.

4. Charging of the Organizational Bureau with working out practical measures for the fulfillment of this resolution.

CONTRIBUTIONS TO THE FIRST ALL-UNION CONGRESS OF SOVIET WRITERS [*EXTRACTS*], 1934

The Union of Soviet Writers, founded in 1932, held its first congress in Moscow August 17 to September 2, 1934. The minutes were published as *Pervyi Vsesoyuznyi sezd sovetskikh pisatelei 1934. Stenograficheskii otchet* [First All-Union Congress of Soviet Writers 1934. Stenographic Report] (Moscow, November 1934) [bibl. R498; English version bibl.. 272]. This congress, under the chairmanship of Maxim Gorky, played a major role in the history of Soviet culture not only because it constituted an impressive symbol of solidarity (almost six hundred delegates from almost fifty Soviet nationalities were present), but also because it advocated socialist realism as the only viable artistic medium for Soviet literature and art. Throughout the 1920s, the ideas of realism and, more specifically, heroic realism had been supported by Party officials as well as by a number of Soviet writers and artists (the latter especially in the context of AKhRR). Although the term socialist realism was coined in the spring of 1932, its meaning remained imprecise as Lunacharsky, for example, indicated: "Socialist realism is an extensive program; it includes many different methods—those we already possess and those we are still acquiring" [from "Sotsialisticheskii realizm"—Socialist Realism—in bibl. R402, vol. 8, 501]. The 1934 congress, particularly in the persons of Gorky and Andrei Zhdanov, attempted to explain the concept of socialist realism and to advance principles such as typicality, optimism, "revolutionary romanticism," "reality in its revolutionary development," as fundamental to the understanding the new doctrine. In literature, in fact, Gorky was regarded as the founder of socialist realism since these qualities could be identified with much of his work, particularly with his plays and with his famous novel *Mat* [Mother] (1906). Within the framework of the visual arts, there was no precursor of Gorky's stature, although the very strong realist movement of the second half of the nineteenth century provided a firm traditional basis, and later realists such as

Abram Arkhipov and Nikolai Kasatkin acted as vital links between the pre-and post-Revolutionary periods. While the emphasis of the congress was, of course, on literature, its general tenets were applicable to all the Soviet arts, especially to the visual arts. Igor Grabar, once a peripheral member of the World of Art but never a radical artist, made this quite clear in his speech: not only did he accept the Party's jurisdiction in matters of art, but also his description of the "distant past" as "dismal" echoed Gorky's condemnation of the period 1907–17 as the "most disgraceful and shameful decade in the history of the Russian intelligentsia" [bibl. R498, p. 12]. Grabar, already an Honored Art Worker and famous for his several pictures of Lenin, was the only professional artist who spoke at the congress. However, some of the literary speakers had been in contact with the more progressive forces of Russian and Soviet art. Viktor Shklovsky and Sergei Tretyakov, for example, once associated with *Lef* and with the constructivists, made substantial contributions to the congress, although Shklovsky was quick to criticize his former artistic sympathies: "we, former members of *Lef,* took what was useful from life, thinking that this was aesthetic; we constructivists created a construction that proved to be nonconstructive . . ." [ibid., p. 155]. Such artists as Filonov, Malevich, and Tatlin were not, of course, present at the congress. What became patently clear there was the degree to which artistic policy in the Soviet Union relied on the political machine, a fact expressed explicitly and implicitly in one of the opening speeches, by Andrei Zhdanov, then secretary of the Communist Party of the U.S.S.R. Although Stalin himself did not speak at the congress, the numerous references to his leadership strewed throughout the speeches, and the formal addresses to Stalin and Marshal Voroshilov that concluded the congress, indicated the power that the governmental hierarchy already exerted in the field of art and literature. The effect of the congress on the evolution of Soviet art was decisive. The ratification of socialist realism as the only artistic style acceptable to a Socialist society and, hence, as an international style, together with the several subsequent decrees that attempted to abolish "formalism" in the arts, led directly to its exclusive application in the U.S.S.R.; and although this led, in turn, to a standardization of form and content, there is no doubt that the portraits of official celebrities, the industrial and collective farm landscapes, the scenes of the Red Army and Navy were immediately intelligible and achieved a lasting popularity among the masses. A parallel is drawn sometimes between Soviet socialist realism and American social realism of the 1930s and 1940s. While there are similarities in method, it should be remembered that the city scenes of Philip Evergood or Louis Lozowick, for example, were much more "actual" than their Soviet counterparts, i.e., they were concerned with a given scene at a given time and not with the potential of reality, with what Zhdanov called "revolutionary romanticism." It was precisely this quality that lent a certain vigor and imaginativeness to the Soviet work of the 1930s, evident, for example, in the scenes of factories under construction, of harvesting, of shipyards, i.e., optimistic scenes that contained a "glimpse of tomorrow" (Zhdanov). Unfortunately, the postwar period has witnessed an adulteration of the original socialist realist principles—revolutionary romanticism

has been replaced often by sentimentalism, optimism by overt fantasy—and few modern works in this idiom still maintain the intensity and single-mindedness of the initial socialist realist work.

There were twenty-six separate sessions at the congress, dedicated to various areas of interest, and there were almost three hundred spoken contributions. Among the Soviet speakers, many famous names figured, such as Isaak Babel, Demyan Bednyi, Kornei Chukovsky, Ilya Ehrenburg, Konstantin Fedin, Fedor Gladkov, Vera Inber, Boris Pasternak, Marietta Shaginyan, and Aleksandr Tairov. In addition, there were also forty-one non-Soviet participants, including Louis Aragon, Robert Gessner, André Malraux, Klaus Mann, Karl Radek, Ernst Toller, and Amabel Williams-Ellis.

The full texts of the above pieces were published in the collection of reports, speeches, and resolutions entitled *Pervyi Vsesoyuznyi sezd sovetskikh pisatelei 1934. Stenograficheskii otchet* [First All-Union Congress of Soviet Writers 1934. Stenographic Report], ed. Ivan Luppol et al. (Moscow, November 1934) [bibl. R498], and the translations are from pp. 2–5, 13–14, 545–46, and 716 respectively. A version of the proceedings appeared in an English translation as *Problems of Soviet Literature* (New York, 1935) [bibl. 272]; although much abridged it contains the full texts of the Zhdanov and Gorky speeches as well as of Karl Radek's "Contemporary World Literature and the Tasks of Proletarian Art" and Nikolai Bukharin's "Poetry, Poetics and the Problems of Poetry in the USSR." For details on the general artistic climate of the 1930s, including commentary on the congress, see bibl. 256, 265, R494, R497, R503.

From Andrei Zhdanov's Speech

Comrades, in the name of the Central Committee of the All-Union Communist Party of Bolsheviks and the Soviet of People's Commissars of the Union of Soviet Socialist Republics, allow me to present our warmest greetings to the first congress of Soviet writers and thereby to all the writers of our Soviet Union—headed by the great proletarian writer Aleksei Maksimovich Gorky [*Loud applause*].

Comrades, your congress is meeting at a time when the basic difficulties confronting us on the path of Socialist construction have already been overcome, when our country has laid the foundation of a Socialist economy—

something that is bound closely to the victorious policy of industrialization and the construction of state and collective farms.

Your congress is meeting at a time when the Socialist way of life has gained final and complete victory in our country—under the leadership of the Communist Party and under our leader of genius, Comrade Stalin [*Loud applause*]. Consequently, advancing from milestone to milestone, from victory to victory, from the time of the Civil War to the reconstruction period, and from the reconstruction period to the Socialist reconstruction of the entire national economy, our Party has led the country to victory over capitalist elements, ousting them from all spheres of the national economy. . . .

In our hands we hold a sure weapon, thanks to which we can overcome all the difficulties besetting our path. This weapon is the great and invincible doctrine of Marx-Engels-Lenin-Stalin, a doctrine that has been put into practice by our Party and by our soviets.

The great banner of Marx-Engels-Lenin-Stalin is victorious. It is thanks precisely to this victorious banner that the first congress of Soviet writers has met together here. If there had been no such victory, then there would have been no congress. Only we Bolsheviks, no one else, could have convoked such a congress as this. . . .

Comrade Stalin has called our writers "engineers of human souls." [1] What does this mean? What obligations does this title impose on us?

First of all, it means that we must know life so as to depict it truthfully in our works of art—and not to depict it scholastically, lifelessly, or merely as "objective reality"; we must depict reality in its revolutionary development.

In this respect, truth and historical concreteness of the artistic depiction must be combined with the task of the ideological transformation and education of the working people in the spirit of Socialism. This method of artistic literature and literary criticism is what we call socialist realism. . . .

To be an engineer of human souls means to stand with both feet on the ground of real life. And this, in turn, denotes a break with the old-style romanticism that depicted a nonexistent life with nonexistent heroes and that spirited the reader away from the contradictions and oppression of life to an unreal world, to a world of utopias. Romanticism cannot be alien to our literature, which stands with both feet on the firm basis of materialism; but it must be a romanticism of a new kind, a revolutionary romanticism. We say that socialist realism is the basic method of Soviet artistic literature and literary criticism, and this presupposes that revolutionary romanticism must enter literary creativity as an integral part, because the whole life of our Party, of our working class and its struggle consists of a combination of the most severe, most sober practical work with supreme heroism and grand

prospects. Our Party has always derived its strength from the fact that it united—and continues to unite—particular activity and practicality with grand prospects, with a ceaseless aspiration onward, with the struggle for the construction of a Communist society. *Soviet literature must be able to show our heroes, must be able to catch a glimpse of our tomorrow. This will not be a utopia, because our tomorrow is being prepared today by our systematic and conscious work.* . . .

Create works with a high level of craftsmanship, with high ideological and artistic content!

Be as active as you can in organizing the transformation of the human consciousness in the spirit of Socialism!

Be in the vanguard of the fighters for a classless Socialist society! [*Loud applause*].

From Maxim Gorky's Speech on Soviet Literature

. . . All of us—writers, factory workers, collective-farm workers—still work badly and do not even grasp *in toto* everything created by us, for us. Our working masses still do not fully comprehend that they are working for themselves and in their own interests. This realization is slowly awakening everywhere, but it has still not burst into a powerful and joyful incandescence. But nothing can burst into flame until it has reached a certain temperature, and nothing has ever raised the temperature of working energy so splendidly as the Party—organized by the genius of Vladimir Lenin—and the present leader of this Party.

We must choose labor as the central hero of our books, i.e., man organized by the processes of labor, who in our country is armed with all the might of modern technology, man who, in turn, is making labor easier, more productive, raising it to the level of art. We must learn to understand labor as creativity. Creativity is a term that we writers use too often—while scarcely having the right to do so. Creativity comes about at that degree of intense mental work when the mind, in its rapidity of work, extracts the more salient and characteristic facts, images, and details from the reserves

of knowledge and transposes them into very precise, vivid, and intelligible words. Our young literature cannot boast of this quality. Our writers' reserves of impressions, their depths of knowledge are not great, and one does not feel that they care much about expanding and deepening their reserves. . . .

From Igor Grabar's Speech

Comrades, we, visual arts workers, have come here to give the congress our warmest proletarian greetings in the name of the entire army of the visual arts front.

Comrades, there are no realms more closely linked than those of Soviet literature and Soviet art. Comrade writers, you depict life as you see it, understand it, and feel it, and we depict it in the same way. You use the method of socialist realism, and we too use this well-tested method—the best of all existing ones.

I don't have to remind you that we are not merely the illustrators of your books; we are also your comrades in arms. We together have fought, are fighting, and will fight our common class enemy [*Applause*]. We both have the same class aspiration. We both have a common past, a common present, and a common future.

It is not worth dwelling on the distant past. It is dismal enough. In those days there did not exist the Socialist direction that emerged only with the Revolution and that alone rouses us to perform real, heroic deeds.

But even in the recent past, in the first years of the Revolution, not everything went smoothly from the start. Our ranks were thin. Slowly but surely they began to expand as decisive progress was made on the front of Socialist construction, and with this gradual expansion these ranks came to assume an impressive force.

Comrade writers, we share with you one very important date—April 23, 1932—the day when the fact of our inclusion in the great edifice erected by the Party was recognized, an inclusion unconditional and unreserved. In this the Party displayed its trust in us and rendered us a great honor.

Comrades, hitherto we have not fully justified this trust and honor, but we

have come here to take a solemn oath that we will justify this trust and honor in the very near future.

Comrades, we have paid great heed to everything that has gone on within these walls over the past weeks. We have listened to so many of you state that this congress has taught you much. Comrades, this congress has taught us a great deal too. We hope to make good use of your experience and of the ideas that you have expressed here at our own congress, which will take place in the near future—a congress of visual arts workers [*Applause*].[2]

For the moment, allow me to state that your congress has already redoubled our belief in the proximity of the final victory of Socialism, that this congress has trebled our conviction and our will to give over our pencil and our chisel to the great creator of Socialism and a classless society—to the mighty Party of Lenin and to its leader, Comrade Stalin [*Applause*].

Comrades, as a sign of our strength of will, allow me to present this congress with a portrait of our leader—done by one of the representatives of our younger generation, Comrade Malkov [*Long applause*].[3]

From the First Section of the Charter of the Union of Soviet Writers of the U.S.S.R.

The great victories of the working class in the struggle for Socialism have assured literature, art, science, and cultural growth as a whole of exceptional prospects for their development.

The fact that non-Party writers have turned toward the Soviet regime and that proletarian artistic literature has achieved gigantic growth has, with urgent insistence, demonstrated the need to unite writers' forces—both Party and non-Party—in a single writers' organization.

The historic resolution of the Central Committee of the All-Union Communist Party (Bolsheviks) on April 23, 1932, indicated that the organizational form of this unification would be the creation of a single Union of Soviet Writers. At the same time, it pointed to the ideological and creative paths along which Soviet artistic literature would advance.

A decisive condition for literary growth, for its artistic craftsmanship, its ideological and political saturation, is the close and direct link of the literary movement with the topical issues of the Party's policies and the Soviet regime, the inclusion of writers in active Socialist construction, and their careful and profound study of concrete reality.

During the years of proletarian dictatorship, Soviet artistic literature and Soviet literary criticism, hand in hand with the working class and guided by the Communist Party, have worked out their own new creative principles. These creative principles have been formulated on the one hand as a result of critical assimilation of the literary heritage of the past and, on the other, on the basis of a study of the experience gained from the triumphant construction of Socialism and the development of Socialist culture. These creative bases have found their chief expression in the principles of *socialist realism*.

Socialist realism, as the basic method of Soviet artistic literature and literary criticism, requires of the artist a true, historically concrete depiction of reality in its Revolutionary development. In this respect, truth and historical concreteness of the artistic depiction of reality must be combined with the task of the ideological transformation and education of the workers in the spirit of Socialism.

Socialist realism assures artistic creation of exceptional prospects for manifesting creative initiative, of a choice of diverse forms, styles, and genres. The victory of Socialism, the intense growth of production forces unprecedented in the history of mankind, the growing process of class liquidation, the abolition of any possibility of man exploiting man and the abolition of the opposition between town and country, and finally the unprecedented progress in the growth of science, technology, and culture—all these factors create limitless opportunities for the qualitative and quantitative growth of creative forces and the flowering of all species of art and literature. . . .

Notes

NOTE TO THE PREFACE

1. Sergei Makovsky, " 'Novoe' iskusstvo i 'chetvertoe izmerenie' (Po povodu sbornika 'Soyuza molodezhi')," *Apollon* (St. Petersburg), no. 7, 1913, p. 53.

NOTES TO THE INTRODUCTION

1. V. Stasov, "Dvadtsat pyat let russkogo iskusstva," *Izbrannye sochineniya* (Moscow-Leningrad, 1937), vol. 2, 27.
2. *Esteticheskie otnosheniya iskusstva k deistvitelnosti* (Moscow, 1948), p. 10.
3. S. Yaremich on Ilya Repin, in *Birzhevye vedomosti* (St. Petersburg), no. 14983, June 24, 1915; quoted in I. Vydrin, "S. Yaremich o Repine-portretiste," *Iskusstvo* (Moscow), 1969, no. 9, p. 60.
4. The *lubok* (plural, *lubki*) was a cheap popular print or woodcut similar to the English broadsheet of the eighteenth and nineteenth centuries.
5. *Vesy* (Moscow), no. 4, 1905, pp. 45–46 [bibl. R44].
6. Ibid., p. 46.
7. V. K[aratygin], "M. Reger," *Zolotoe runo* (Moscow), no. 2, 1906, p. 97 [bibl. R45].
8. Exhibition review by S. Gri[shi]n, *Saratovskii listok* (Saratov), no. 101, May 11, 1904 [bibl. R199].
9. M. Saryan, "Avtobiografiya," *Sovetskie khudozhniki* (Moscow, 1937), vol. 1, 294 [bibl. R177].
10. S. Makovsky, "Golubaya roza," *Zolotoe runo,* no. 5, 1907, p. 27 [bibl. R206].
11. The nearest approach to a group declaration was the preface to *Zolotoe runo*, no. 1, 1906 (see pp. 6ff.). Some statements by former Blue Rose artists appeared in the miscellany *Kuda my idem?* [Where Are We Going?] (Moscow, 1910).
12. He used the term in his polemical tract *Galdyashchie "benua" i novoe russkoe natsionalnoe iskusstvo* [The Noisy "Benoises" and the New Russian National Art] (St. Petersburg, 1913), pp. 4ff. [bibl. R270].
13. A. Osmerkin, "Avtobiografiya," *Sovetskie khudozhniki,* vol. 1, 234. As a challenge to public taste, David Burliuk wore a wooden spoon at some of his lectures; Malevich is reputed to have stuck a wooden spoon to his picture *Englishman in Moscow* (1913/14, Stedelijk Museum, Amsterdam).
14. Quoted in L. Dyakonitsyn, *Ideinye protivorechiya v estetike russkoi zhivopisi kontsa 19–nachala 20 vv.* (Perm, 1966), p. 145 [bibl. R101].

15. Quoted in V. Lobanov, *Khudozhestvennye gruppirovki za 25 let* (Moscow, 1930), p. 62 [bibl. R108].
16. *Rech* (St. Petersburg), November 13, 1914.
17. For details see p. 79.
18. Letter from Larionov to Alfred H. Barr, Jr., in the Victoria and Albert Museum, London. Letter is undated but was probably written in 1930.
19. A. Efros, "N. Sapunov," *Profili* (Moscow, 1930), p. 140 [bibl. R186].
20. N. Aseev, "Oktyabr na Dalnem," *Novyi lef,* no. 8–9 (1927), pp. 38–49 [bibl. R76].
21. For details see Dyakonitsyn, *Ideinye protivorechiya,* pp. 146ff. Kulbin's ideas on the triangle and on the symbolism of colors had close affinities with those of Kandinsky [see bibl. R224, R230].
22. A. R[ostislavo]v, "Doklad N. I. Kulbina," *Apollon* (St. Petersburg), no. 3, 1910, p. 17 [bibl. R41].
23. Quoted in V. Parkin, "Oslinyi khvost i mishen," *Oslinyi khvost i mishen* (Moscow, 1913), p 54 [bibl. R319].
24. Catalogue of the exhibition "No. 4" (Moscow, 1914), p. 54 [bibl. R318].
25. Larionov was wounded at the front at the end of 1914 and recuperated in Moscow; Goncharova returned from Paris (where she and Larionov had gone in May at Diaghilev's invitation) for the production on January 27, 1915, of *The Fan* at the Kamerny Theater, Moscow (for which she designed the costumes and scenery and to which Larionov contributed also); both left Moscow again in the summer of 1915.
26. A. Lentulov, "Avtobiografiya," *Sovetskie khudozhniki,* vol. 1, 161.
27. N. Ya[nychenk]o, "Vystavka 1915 god," *Mlechnyi put* (Moscow), no. 4, 1915, p. 63 [bibl. R54].
28. "Poslednyaya futuristicheskaya vystavka kartin. 0.10" (Catalogue; Petrograd, 1915), p. 3 [R364].
29. Quoted in Dyakonitsyn, *Ideinye protivorechiya,* pp. 143–44.
30. K. Malevich, *O novykh sistemakh v iskusstve* (Vitebsk, 1919), p. 10.
31. Proletkult exerted wide authority from February 1917 until 1925 and was especially active between 1918 and 1921. During these three years, in fact, it ran a network of 1,000 studioworkshops throughout the country and had a membership of more than 400,000. Proletkult published several journals, the most important of which were *Gorn* [bibl. R62], *Gryadushchee* [R63], and *Proletarskaya kultura* [bibl. R80]. The ideological leader of Proletkult was Aleksandr Bogdanov (see pp. 176ff.), and Anatolii Lunacharsky was at least sympathetic to some of his tenets. For further details see the above journals and bibl. 179 and 199.
32. IZO was established within Narkompros in January 1918. For details see bibl. 199, R16, R402, R420.
33. All art schools' subsidized by the state were renamed Svomas. The Moscow Svomas were renamed Vkhutemas [Higher State Art-Technical Studios] in 1920 and Vkhutein [Higher State Art-Technical Institute] in 1926; in 1930 this was changed to the Moscow Art Institute. For details on the structure of Svomas see bibl. R420; on Vkhutemas/Vkhutein see bibl. R16, R21, R390, R419, R431. For a full discussion of Svomas see bibl. 230ix.
34. In 1921. For details see bibl. R2, R16.
35. Quoted in *Sovetskoe iskusstvo za 15 let,* ed. I. Matsa et al. (Moscow-Leningrad, 1933), p. 156 [bibl. R16].
36. For the text of the full program see Matsa, *Sovetskoe iskusstvo,* pp. 126–39. Also see Kandinsky's plan for the Russian Academy of Artistic Sciences (pp. 196ff.) and consult bibl. R393, R394. For translation of the program and other relevant statements see bibl. 101x.
37. V. Kandinsky, "Doklad," *Vestnik rabotnikov iskusstv* (Moscow), no. 4–5, 1921, p. 75 [bibl. R60].
38. For the text of Babichev's plan see Matsa, *Sovetskoe iskusstvo,* p. 139.
39. The words are Malevich's and Matyushin's respectively. Quoted in V. Khazanova,

Sovetskaya arkhitektura pervykh let Oktyabrya 1917–1925 (Moscow, 1970), p. 25 [bibl. R21].

40. For details see A. Ya[nov], "Krizis krasok," *Zhizn iskusstva* (Petersburg, no. 45, 1923, p. 15 [bibl. R65].

41. Statement appended to Exter's contribution to the catalogue of the exhibition "5 × 5 = 25" (Moscow, 1921), n.p. [bibl. R446].

42. Statement appended to Rodchenko's contribution, ibid. The exhibition "Nonobjective Creation and Suprematism" opened, in fact, in January 1919, not 1918 (see p. 138). At the 1920 exhibition in Moscow ("Nineteenth State") Kandinsky, Shevchenko, and Varst (Stepanova) were also among those represented. Despite Rodchenko's assertion that he "proclaimed three basic colors" at "5 × 5 = 25," Kulbin had shown works with the titles *Blue on White* and *White on Green* as early as 1910, at the "Triangle" exhibition in St. Petersburg [bibl. R241; and see p. 12]. In any case, Malevich, had, of course, painted his *White on White* in 1918.

43. Statement appended to Varst's (Stepanova's) contribution, ibid.

44. Quoted in Lobanov, *Khudozhestvennye gruppirovki,* p. 101. Although purist art had still been supported at the constructivists' first session within Inkhuk on March 18, 1921, attended by V. Ioganson, Konstantin Medunetsky, Aleksandr Rodchenko, Varvara Stepanova, and the Stenberg brothers, an industrial approach soon came to be favored. As early as August 1921 Nikolai Tarabukin delivered a lecture at Inkhuk entitled "The Last Picture Has Been Painted" [for details see bibl. 252]. In December of the same year Stepanova gave a talk on constructivism in which she emphasized the value of industrial design.

45. In *Na putyakh iskusstva,* ed. V. Blyumenfeld et al. (Moscow, 1926), p. 3 [bibl. R381].

46. Quoted in Matsa, *Sovetskoe iskusstvo,* p. 310.

47. The Makovets society was named after the hill on which Sergii Radonezhsky built the Troitse-Sergieva Lavra (now the Zagorsk monastery and museum complex) in the fourteenth century, a gesture that expressed its members' emphasis on the spiritual, religious quality of art. This was immediately apparent in the society's manifesto, issued in the journal *Makovets* (Moscow), no. 1, 1922, pp. 3–4 [bibl. R77]. For details on Chekrygin see the catalogue of his recent retrospective [bibl. R163].

48. See, for example, Aleksei Fedorov-Davydov's introduction to the catalogue of Kazimir Malevich's one-man exhibition at the Tretyakov Gallery, Moscow, 1929 [bibl. R366]; see also Sergei Isakov's introduction to the catalogue of the unrealized Pavel Filonov exhibition at the Russian Museum, Leningrad, 1930 [bibl. R507, and see p. 284].

49. *Istoriya russkoi zhivopisi v XIX veke* (St. Petersburg, 1901–1902), p. 274. And see p. 5.

NOTES TO THE TEXTS

BURLIUK, pp. 8–11

1. Member of the Wanderers. His initially tendentious exposés of Russian rural life degenerated into sentimental, historical scenes.

2. Famous for his innumerable seascapes.

3. Regarding Isaak Levitan, Valentin Serov, and Mikhail Vrubel, see Introduction.

KULBIN, pp. 11–17

1. In December 1911, at the All-Russian Convention of Artists, in St. Petersburg, Kulbin gave a lecture entitled "Harmony, Dissonance, and Their Close Combinations in Art and Life," which was later published [bibl. R230].

2. Kulbin was interested in microtone music (what he called "free music") and in the associa-

tions between the color spectrum and the conventional seven-tone scale. The second article in *Studio of the Impressionists* was, in fact, a piece by Kulbin on "Free Music: The Results of Applying a Theory of Artistic Creation to Music" [bibl. R227]; the main ideas of this article had already appeared in Kulbin's booklet *Free Music* [bibl. R226], and later appeared in German as "Die freie Musik" [bibl. 96].

3. By profession both Chekhov and Kulbin were doctors.

MARKOV, pp. 23–38

1. "Logic has deprived Nature of the divine." Reference not traced. Probably a quotation from Novalis or the early Hegel.

2. For explanation of *lubok* see n. 4 to Introduction, p. 298.

3. Presumably a reference to the writer, composer, and painter E. T. A. Hoffmann. Like Novalis and other German romantics, Hoffmann enjoyed a vogue in Russia in the 1900s.

4. Markov's ideas on "texture" [*faktura*] were scheduled to appear in a subsequent issue of *Soyuz molodezhi* [Union of Youth], but since the journal ceased publication after the third issue (March 1913), Markov's essay was published separately [bibl. R233]. At the end of his text Markov also indicated that he would be writing on other principles, such as gravity, surface, dynamism, and consonance, but these essays were never published.

SHEVCHENKO, pp. 41–54

1. For explanation of *lubok* see n. 4 to Introduction, p. 298.

2. Signboards and trays were particularly prized by David Burliuk, who had a large collection of them. Mikhail Larionov was very interested in the *lubok* and in 1913 organized an exhibition of them [see bibl. R252 and bibl. 132, pp. 33–37, where part of the catalogue, including Larionov's and Natalya Goncharova's prefaces, is translated into French]. Shevchenko collected children's drawings, some of which were shown at the "Target" in 1913, together with signboards and naïve paintings by the Georgian primitive Niko Pirosmanashvili.

3. Painter, wood sculptor, and stage designer known for his highly stylized depictions of pre-Petrine Russia.

4. "Grass writing" is presumably a reference to the Chinese *ts'ao shu*, a hieroglyphic style used in the first and second centuries A.D. In appearance *ts'ao shu* resembles intertwined leaves of grass.

5. The title "Old Believers" refers to those members of the Russian Church who disagreed with ecclesiastical reforms instituted by the Patriarch Nikon in the mid-seventeenth century. Among the first to condemn Nikon's preference for the Greek Orthodox and hence more Western conception of Christianity was the famous Petrovich Avvakum, traditionally regarded as the founder of the Old Believers. The general policy of the Old Believers, who were from all classes, was, despite forceful opposition, to maintain the rich, Byzantine traditions of the Church; this affected considerably the outward appearance of their dress, icons, *lubki*, etc.

6. See Larionov's articles, pp. 87ff.

GONCHAROVA, pp. 54–60

1. Goncharova was represented at the first and second exhibitions of "Der Blaue Reiter" in 1911–12; she also contributed to Roger Fry's "Second Post-Impressionist Exhibition" in London in 1912 [bibl. 106, 107, 142].

2. See Larionov's articles, pp. 87ff.

AKSENOV, pp. 60–69

1. Member of the Wanderers. Known for his scenes of factory and prison life. Regarding Repin see Introduction.

2. For further details regarding the Knave of Diamonds members whom Aksenov mentions, the following references may be consulted: Mashkov [bibl. R323], Kuprin [bibl. R324, R331], Rozhdestvensky [bibl. R343], Lentulov [bibl. R309, R322], Konchalovsky [bibl. R316, R317], Falk [bibl. 105, R260, R346], Exter [bibl. 61, 80, R181].

3. Aksenov means, presumably, Cézanne's *Mardi Gras* of 1888, which was in the Sergei Shchukin collection. It is now in the Pushkin Museum, Moscow.
4. Anton Rubinstein's opera *The Merchant of Kalashnikov* was staged by Sergei Zimin's company in Moscow in the winter of 1912/13.
5. In 1909 Petr Konchalovsky was commissioned by the merchant Markushev to execute panels and ceiling decorations for his Moscow villa. The Moscow Salon was the name of an important exhibiting society that held regular shows between 1910 and 1918. Konchalovsky's contribution to the first show in the winter of 1910/11, included his designs for the Markushev villa—*Gathering Olives, Gathering Grapes, Harvest,* and *The Park.*
6. In November 1911 Konchalovsky, together with Georgii Yakulov, designed the decor for a charity ball called "A Night in Spain" at the Merchants' Club, Moscow.
7. The portrait of the artist Yakulov was executed in 1910 and at present is in the Tretyakov Gallery, Moscow. For Konchalovsky's own description of the work see bibl. R103, vol. 2, pp. 434ff.
8. Italian patriot and revolutionary. The reference, presumably, is to Mazzini's almost constant exile from Italy, during which he never ceased to believe in his dogmatic and utopian principles of Italian nationalism and working-class solidarity—despite the fact that for much of his life he was out of touch with the real moods of the Italian populus.
9. A reference to the prehistoric ivory figures of Brassempouy in southern France.

BURLIUK, pp. 69–77
1. "Texture" [*faktura*] in "A Slap in the Face of Public Taste." See p. 69 and bibl. R269.
2. Which Cézanne landscape Burliuk has in mind is not clear, perhaps *La Montagne Sainte-Victoire* (1896–98), which was in the Ivan Morozov collection, and is now in the Hermitage.
3. Poet, philosopher, and lexicographer.
4. Leading futurist poet, cosigner of "A Slap in the Face of Public Taste."

LARIONOV and GONCHAROVA, pp. 87–91
1. The egofuturists were primarily a literary group, formed in 1911 and led by Igor Severyanin.
2. The neofuturists were an imitative and derivative group active in 1913. Their one publication, *Vyzov obshchestvennym vkusam* [A Challenge to Public Tastes] (Kazan, 1913), contained parodies of futurist poems and rayonist drawings.
3. Goncharova and Larionov broke with the Knave of Diamonds after its first exhibition in 1910/11, thereby alienating themselves from David Burliuk—and condemning "A Slap in the Face of Public Taste." Larionov regarded the Union of Youth as a harbor of outdated symbolist ideas, an attitude shared by several artists and critics, although Larionov still contributed to its exhibitions.
4. An allusion to *vsechestvo* [literally, "everythingness"], i.e., the concept that all styles are permissible—an attitude. shared by Shevchenko [e.g., see bibl. R355].

LARIONOV, pp. 91–100
1. The Whitman extracts are from *Leaves of Grass:* the first from "Beginners," in "Inscriptions"; the second from "I Hear It Was Charged Against Me," in "Calamus." Larionov's choice of author is significant: Whitman was known and respected in Russia particularly among the symbolists and futurists, and his *Leaves of Grass* had become popular through Konstantin Balmont's masterful translation (Moscow, 1911). For contemporaneous attitudes to Whitman in Russia, see Balmont, "Pevets lichnosti" in bibl. R44, no. 7, 1904, pp. 11–32; Chukovsky, "O polze broma" in bibl. R44, no. 12, 1906, pp. 52–60, and Chukovsky, *Uot Uitmen: Poeziya gryadushchei demokratii* (Moscow-Petrograd, 1923). Also see nn. 3 and 6 to "Rodchenko's System," p. 305.
2. Undoubtedly Larionov owed some of his ideas, both in his theory and in his practice of rayonism, to the theories of the Italian futurists. He would, for example, have seen the Russian translations of *La pittura futurista* and *Gli espositori al pubblico* (see p. 79).

3. The actual word Larionov uses is *vitro;* this, presumably, is a corruption of the French word *vitraux* (plural of *vitrail*), meaning leaded- or stained-glass windows.
4. Larionov did not, in fact, develop this theory, although a booklet devoted to the subject of pneumorayonism was scheduled for publication, according to an advertisement in the miscellany *Oslinyi khvost i mishen* [Donkey's Tail and Target]; among Larionov's contributions to his exhibition "No. 4," in 1914, one work, *Sunny Day,* was subtitled "Pneumorayonist Color Structure" [bibl. R318]. A further development was "plastic rayonism," which appeared as a subtitle to two still lifes shown by Larionov at the "Exhibition of Painting. 1915" [bibl. R277]; one review of this exhibition also referred to it [bibl. 230, p. 7].

ROZANOVA, pp. 102–110
1. See pp. 69–70.
2. Rozanova has in mind the first cycle of "World of Art" exhibitions (1899–1906) rather than the second (1910–24), since many radical artists—Natan Altman, Natalya Goncharova, Mikhail Larionov, et al.—were represented in the latter. The Union of Russian Artists was a moderate exhibiting society based in Moscow that espoused the ideas of realism and naturalism, although, unexpectedly, the Burliuks and Larionov were represented at its 1906/1907 session in St. Petersburg, and Larionov and Aristarkh Lentulov were at its 1910 session. It held regular exhibitions between 1903 and 1917, and 1922 and 1923.

MALEVICH, pp. 116–35
1. Malevich is referring to "A Slap in the Face of Public Taste." See p. 69.
2. Konstantin Somov: member of the World of Art (see Introduction). Boris Kustodiev: member of the second World of Art society. Known for his colorful scenes of Moscow merchant life.
3. Malevich has in mind the rejection of the nude in painting by the Italian futurists, one of the main points of their *La pittura futurista: Manifesto tecnico* [see bibl. 120, pp. 65–67], which had been translated into Russian and published in *Soyuz molodezhi* [Union of Youth] (St. Petersburg), no. 2, 1912, pp. 23–28 [bibl. R339].
4. The word Malevich uses is *predmetnost* (from the noun *predmet*, which means "object"; cf. *bespredmetnyi*, "nonobjective"). "Objectism" or "objectness" would therefore render the meaning of the Russian.
5. All contributed to the "0.10" exhibition.

KLYUN, pp. 136–38
1. For explanation of *lubok* see n. 4 to Introduction, p. 298.

"TENTH STATE EXHIBITION," pp. 138–58

STEPANOVA, pp. 139–42
1. Stepanova contributed under the pseudonym V. Agarykh.
2. These were titles of unpublished transrational poems by Stepanova herself, or by Olga Rozanova. For examples of Rozanova's verse see bibl. R332. For some details on Stepanova's graphics and poetry see Evgenii Kovtun. 'Varvara Stepanova's Anti-Book.' *From Surface to Space. Russia 1916–24.* Cologne: Galerie Gmurzynska, 1974. Exhibition catalogue, pp. 57–63 (text in English and in German).
3. It is not clear what exactly Stepanova has in mind—perhaps Rozanova's essay "The Bases of the New Creation" (pp. 102ff.).

KLYUN, pp. 142–43
1. Klyun, a friend and one-time disciple of Kazimir Malevich, is here objecting both to Malevich's occasional recourse to "objective" titles for suprematist paintings (e.g., *Painterly Realism of a Football Player*) and to his aerial, more representational phase of suprematism.
2. Klyun means Malevich's *Lackey with a Samovar* (exhibited at the "Shop" in 1916).

3. In 1918 IZO Narkompros established a Museum Bureau and Purchasing Fund with the aim of acquiring works of art and theoretical materials for a complex of diverse museums, among them five so-called Museums of Painterly (sometimes called Artistic or Plastic) Culture in Moscow, Petrograd, Nizhnii-Novgorod, Vitebsk, and Kostroma. Aleksandr Rodchenko was head of the Museum Bureau and by mid-1920 the Bureau had acquired 1,200 paintings and drawings and 106 sculptures, which it dispersed among the museums mentioned above and other provincial museums. The Museums of Painterly Culture were "collections of works of painting, sculpture, applied art, popular art, spontaneous art, and works done by experimental painterly and plastic techniques. These Museums are constructed on the principle of the evolution of purely painterly and plastic forms of expression . . ." [bibl. R420, p. 80]. The largest was the one in Moscow—housed in the same building as Svomas/Vkhutemas. It contained examples of most of the avant-garde, including Aleksandr Drevin (three works), Vasilii Kandinsky (six), Kazimir Malevich (nine), Lyubov Popova (two), Rodchenko (five), Olga Rozanova (six), Vladimir Tatlin (one), and Nadezhda Udaltsova (four); Klyun was represented by two canvases and by a small collection of his research writings and tabulations on color. Although initially the Museum Bureau included Derain and Picasso on its list of wants and stipulated that acquisitions should cover all periods, it concerned itself almost exclusively with Russian art of the early twentieth century. Each museum was divided into four sections—(1) experimental technique, (2) industrial art, (3) drawings and graphics, (4) synthetic art. The museums worked in close conjunction with the local Svomas and, in the case of Moscow, Petrograd, and Vitebsk, with Inkhuk. For further details see bibl. R16, R66, R420. The artist Aleksei Grishchenko presented a list of proposals concerning the museums in February 1919—see bibl. R16, p. 83.

MALEVICH, pp. 143–45

1. I.e., *From Cubism to Suprematism*. See pp. 116ff.

2. Malevich saw the genesis of suprematism in his 1913 decor for the futurist opera *Victory Over the Sun* (see p. 116), one backdrop of which was an apparently abstract composition [reproduced in bibl. 45, pl. 99; bibl. 83, p. 383].

3. I.e., at "0.10," December 19, 1915–January 19, 1916.

ROZANOVA, p. 148

1. An extract from Rozanova's "The Bases of the New Creation" (pp. 102ff.) was also included in this section of the catalogue. Rozanova had died a few months before, and the "First State Exhibition" had been devoted to a posthumous showing of her works; works at the "Tenth State Exhibition" by Ivan Klyun, Aleksandr Vesnin, and others were dedicated to her.

2. The journal *Supremus* never actually appeared, although it was prepared for publication in Moscow early in 1917 under the editorship of Kazimir Malevich. Apart from Rozanova's piece, a contribution by Malevich [bibl. 160, p. 148] and an essay on music by Mikhail Matyushin and the composer Nikolai Roslavets were scheduled.

RODCHENKO, pp. 148–51

1. This is the title of the first section, and the closing line, of Max Stirner's *Die Einzige und sein Eigenthum* [The Ego and His Own], first published in Leipzig in 1845. Max Stirner (pseudonym of Joseph Kaspar Schmidt) had achieved a certain popularity in Russia in the 1900s because of the more general interest in individualism and intuition generated by such varied influences as Bergson, Nietzsche, and Steiner. Stirner's philosophy of extreme individualism had appealed in particular to the symbolists; a Russian translation of *Die Einzige und sein Eigenthum* appeared in St. Petersburg in 1910 under the title *Edinstvennyi i ego dostoyanie*. Just after the Revolution, there was a renewal of interest in Stirner, albeit from a highly critical standpoint, mainly because Marx and Engels had treated him in some detail [see their "Sankt Max," in *Dokumente des Sozialismus*, ed. Eduard Bernstein (Berlin: Verlag der Sozialistischen Monatshefte, 1905), vol. 3, 17ff.].

2. The reference is from a play by the futurist Aleksei Kruchenykh called *Gly-Gly* (a transrational title). Part of the text was published in Kruchenykh's book *Ozhirenie roz* [Obesity of Roses]; this book carries no publication details, although it dates probably from 1918 and was printed in Tiflis. Among the play's motifs are those of painting and the color black, and among the dramatis personae Kazimir Malevich and Kruchenykh figure.

3. The Whitman extract is from Part Four of "Song of the Broad-Axe" (*Leaves of Grass*). For the significance of Whitman in Russia, see n. 1 to Larionov's "Rayonist Painting," p. 302.

4. This is from Otto Weininger's "Aphoristisch Gebliebenes," in *Uber die letzten Dinge* ["Remaining Aphoristic," in On the Latest Things], first published in Vienna in 1907 (the present quotation can be found on p. 56 of the sixth edition, Vienna, 1920). Like Max Stirner, Weininger was known in Russia especially during the 1900s, and his famous treatise *Geschlecht und Charakter* [Sex and Character] had been translated into Russian in 1909, accompanied by several articles in the Russian press [see, for example, Boris Bugaev, "Na perevale. Veininger o pole i kharaktere," in bibl. R44, no. 2, 1909, pp. 77–81].

5. Quotation not traced. Possibly a paraphrase of a passage from Stirner's *Die Einzige und sein Eigenthum*. See n. 1 above.

6. The Whitman extract is from "Gliding O'er All," from "By the Roadside" (*Leaves of Grass*). See n. 1 to Larionov's "Rayonist Painting," p. 302.

LISSITZKY, pp. 151–58

1. Several artists and architects, among them Naum Gabo, directed their energies into designing radio masts. One of the functions of Vladimir Tatlin's Tower was to act as a transmitting and telegraph station. The Moscow radio tower, erected in 1926 after a design by Vladimir Shukhov, is perhaps the most famous.

2. If Lissitzky wrote this essay in 1920 (as indicated by the source from which this text is taken), then Kazimir Malevich's *Black Square*, to which he refers here, would have been painted in 1913, but we have no strong documentary evidence to support this date. The first time that the *Black Square* was exhibited was, apparently, at "0.10" in 1915/16 (see p. 110; also see n. 2 to Malevich, p. 304).

ALTMAN, pp. 161–64

1. The *Chernosotentsy*, or Black Hundreds, were members of a secret-police and monarchist organization set up to counteract the revolutionary movement in 1905–1907. *Chernosotenets* soon became identified with the more general concepts of "rightist" and "extreme conservative."

PUNIN, pp. 170–76

1. Physicist and philosopher.

2. The Russian formalist school was concerned primarily with literature, although critics such as Nikolai Chuzhak, Nikolai Punin, and Sergei Tretyakov might be regarded as supporters of a formalist approach within the sphere of the visual arts: like the industrial constructivists, they aspired to reduce art to a rational, exact aesthetics.

LUNACHARSKY and SLAVINSKY, pp. 182–85

1. The actual word is *chernosotennye*, adjective from *Chernosotenets*. See n. 1 to Altman, above.

2. Glavpolitprosvet (Central Committee of Political Enlightenment): see p. 226.

SHTERENBERG, pp. 186–90

1. Aleksandr Kerensky was head of the provisional government during the revolutionary period from July to November 1917. His moderate Socialism did not satisfy the demands of the Bolsheviks, and he emigrated when they came to power.

2. In the summer of 1918, the Petrograd Academy was abolished, and its teaching faculty was dismissed; on October 10, Pegoskhuma was opened and was replaced in turn by Svomas in

1919; on February 2, 1921, the academy was reinstated. See Introduction for other details.
3. In 1918, both collections were nationalized and became the First and Second Museums of New Western Painting; in 1923 both were amalgamated into a single Museum of New Western Painting; in the early 1930s many of the museum's works were transferred to the Hermitage in Leningrad, and in 1948 all the holdings were distributed between the Hermitage and the Pushkin Museum in Moscow. The idea of establishing a museum of modern painting was not new in Russia: as early as 1909, a group of artists and critics including Ivan Bilibin, Nikolai Rerikh, and Vselovod Meierkhold had favored such a proposal. See Filippov, "Gallereya sovremennykh russkikh khudozhnikov" [A Gallery of Modern Russian Artists] in bibl. R43, no. 4/6, 1909, p. 45; the Union of Youth had also supported the idea—see Shkolnik, "Muzei sovremennoi russkoi zhivopisi" [A Museum of Modern Russian Painting] in bibl. R339, no. 1, 1912, pp. 18–20.

LUNACHARSKY, pp. 190–96
1. Vsevobuch [Vseobshchee voennoe obuchenie—General Military Instruction] was an inclusive title for all bodies concerned with military training of workers. By a decree of 1918, all Soviet citizens, from schoolchildren to the middle-aged, were to receive military instruction.
2. The Second Congress of the Third International opened in Petrograd June 19, 1920, and June 27 was declared a public holiday in honor of it; a parade and procession with representatives of Vsevobuch took place in Moscow.
3. On June 19, 1920, a mass dramatization, *Toward the World Commune*, took place at the former Stock Exchange in Petrograd; Natan Altman was the artistic designer.
4. *The Twelve*, written in 1918, was perhaps Aleksandr Blok's greatest poetic achievement. Ostensibly it was a description of the revolutionary force represented by twelve Red Guards.
5. Lunacharsky was present at Vladimir Mayakovsky's first private reading of the play *Mystery-Bouffe*, September 27, 1918. He was impressed with the work and promoted its production at the Theater of Musical Drama in November of that year. It was taken off after three days and was revived only with Vselovod Meierkhold's production of it in May 1921.
6. I.e., New Economic Policy. The period of NEP (1921–29) was marked by a partial return to a capitalist economic system.
7. This simple yet spacious monument in Petrograd to the victims of the February Revolution was designed by Lev Rudnev in 1917–19 and was landscaped later by Ivan Fomin.
8. In the early 1920s several designs were submitted for a Moscow Palace of Labor—among them one by the Vesnin brothers—but none was executed.

TATLIN, pp. 205–206
1. The reference is to the Yaroslavl Station, Moscow, built in 1903–1904 after a design by Fedor Shekhtel. Its frieze and majolica details were designed by artists who had been close to Abramtsevo, including Konstantin Korovin. Similarly, several moderate artists, including Aleksandr Benois, submitted interior designs for the adjacent Kazan Station between 1914 and 1917 (designed by Aleksei Shchusev, built 1913–26).
2. From May 10 to 14, 1914, Tatlin held a one-man show of synthetic-static compositions in his studio.
3. Documents indicate that the only Moscow exhibition of 1915 to which Tatlin contributed some relief collages (hardly "on the laboratory scale") was the "Exhibition of Painting. 1915" (ex catalogue), although he may have opened his studio to the public at the same time (March–May). In March 1915, he exhibited seven painterly reliefs at "Tramway V," in Petrograd, and in December 1915/January 1916, he contributed reliefs and counterreliefs to "0.10," also in Petrograd. According to bibl. R447, Tatlin showed counterreliefs at a Moscow "sbornaya" [mixed] exhibition in 1915 but this, presumably, was a reference to the "Exhibition . . . 1915."
4. No contribution by Tatlin to a 1917 exhibition has been recorded. It is possible that he means the "Shop" of 1916, which he organized and to which he sent seven reliefs and counterreliefs.

5. I.e., Tatlin's Tower. Iosif Meerzon and Tevel Shapiro helped Tatlin build the first model in Petersburg; P. Vinogradov joined them when the Tower was re-erected in Moscow.

GABO and PEVSNER, pp. 208–14
1. The measurement used in the original Russian is *arshin* (= 28 inches).
2. The measurement used in the original Russian is *pud* (= 36 lbs.).

GAN, pp. 214–25
1. For explanation of Old Believers, see no. 5 to Shevchenko, p. 301.

ARVATOV, pp. 225–30
1. As early as 1918 the State Porcelain Factory had produced items decorated by Natan Altman. In the early 1920s cups, saucers, plates, and pots were being produced with suprematist designs by Ilya Chashnik and Nikolai Suetin.

PERTSOV, pp. 230–36
1. "Transsense" or "transrational" translates the word *zaum*, a new linguistic medium formulated by Aleksei Kruchenykh [see bibl. R284, R295]. Kazimir Malevich, Olga Rozanova, Varvara Stepanova, et al., also wrote *zaum* occasionally. *Zaum* lines, for example, occur at the end of Malevich's essay "O poezii" [On Poetry] in bibl. R66, no. 1, 1919, p. 35 [English translation in bibl. 159, vol. 1, 82]. For Rozanova's transrational verse, see bibl. R332.

"First Discussional," pp. 237–43
1. The Constructivist Poets such as Vera Inber, Ilya Selvinsky, and Kornelii Zelinsky were members of the so-called Literary Center of the Constructivists [Literaturnyi tsentr konstruktivistov, or LTsK], founded in Moscow in 1924 [see bibl. R441] A translation of their manifesto appears in bibl. 211, pp. 123–27.
2. Constructivists of the Chamber Theater (Aleksandr Tairov's Kamernyi teatr) included Aleksandra Exter, the Stenberg brothers, Aleksandr Vesnin, and Georgii Yakulov [see bibl. R187].
3. Constructivists who worked for Vselovod Meierkhold's State Higher Theater Workshop in Moscow included Lyubov Popova and Varvara Stepanova; as director of the Workshop, Meierkhold developed his constructivist theory of so-called biomechanics. [For details see bibl. 190, pp. 183–204; bibl. 193, p. 70; R17 (bk. 2), pp. 486–89.]
4. The Central Institute of Labor [Tsentralnyi institut truda, or TsIT], run by Aleksei Gastev in Moscow, acted as a laboratory for the analysis of the "rhythmic rotation of work" and aspired to create a machine man, an artist of labor. Among the institute's members were the critic Viktor Pertsov and the artist Aleksandr Tyshler [see bibl. 42, pp. 206–14].

BRIK, pp. 244–49
1. For details of Inkhuk see Introduction and bibl. 230ix, R16, pp. 126–43. Lyubov Popova, Aleksandr Rodchenko, and Varvara Stepanova had turned to productional art soon after the conclusive exhibition "5 × 5 = 25," in September 1921 [see bibl. R446]. Popova and Stepanova became particularly interested in textile design, as Stepanova demonstrated in her lecture "Kostyum segodnyashnego dnya—prozodezhda" [Today's Dress Is Productional Clothing], delivered at Inkhuk in the spring of 1923 and published in *Lef* [bibl. R463]. Rodchenko turned to poster art, typography, and photography; Anton Lavinsky to poster art and small-scale construction projects; Gustav Klutsis and Sergei Senkin also favored poster art and typography and later were active in the October group [see pp. 273ff. and bibl. R421, R500].

RODCHENKO, pp. 250–54

1. The term "rejuvenation" refers to the Soviet emphasis on mass gymnastics and health exercises—particularly stressed during the 1920s and 1930s. Rodchenko himself was a keen sportsman and photographed many scenes from sporting life, especially athletics.

2. Lenin was a favorite subject for photographers. The file that Rodchenko has in mind was probably the *Albom Lenina. Sto fotograficheskikh snimkov* [Lenin Album. A Hundred Snapshots], compiled by Viktor Goltsev and published by the State Press in 1927. Rodchenko himself also photographed Lenin, and one of his portraits served as the cover to *Novyi lef,* no. 8–9, 1927.

AKhRR, pp. 265–67

1. Partly as a result of this propaganda measure, several of the old Knave of Diamonds group, including Robert Falk, Aristarkh Lentulov, Ilya Mashkov, and Vasilii Rozhdestvensky, joined AKhRR.

AKhR, pp. 271–72

1. In 1928 a German affiliation was established in Berlin.

October, pp. 273–79

1. The reference is to FOSKh [Federatsiya obedineniya sovetskikh rabotnikov prostranstvennykh iskusstv—Federation of the Association of Soviet Workers in the Spatial Arts], founded in June 1930. This was an organization that sought to unite the many, often contradictory, art groups still active, and it managed to encompass AKhR, OST, and RAPKh (see p. 273), as well as two architectural societies, OSA [Obedinenie sovremennykh arkhitektorov—Association of Contemporary Architects] and VOPRA [Vsesoyuznoe obedinenie proletarskikh arkhitektorov—All-Union Association of Proletarian Architects]. FOSKh issued its own journal—*Brigada khudozhnikov* [Artists' Brigade] [bibl. R58].

OST, pp. 279–81

1. A derogatory reference to the art of the *Peredvizhniki* [Wanderers]. The word might be translated as "hack realism." For details on the Wanderers see Introduction.

FILONOV, pp. 284–87

1. The Russian is *sdelannost,* a noun that Filonov formed from the verb *sdelat*—"to make/do."

"Decree On the Reconstruction," pp. 288–90

1. NEP: see n. 6 to Lunacharsky, p. 306.

2. VOAPP: *Vsesoyuznoe obedinenie assotsiatsii proletarskikh pisatelei* [All-Union Association of Associations of Proletarian Writers]; RAPP: *Rossiiskaya assotsiatsiya proletarskikh pisatelei* [Russian Association of Proletarian Writers]; RAPM: *Rossiiskaya assotsiatsiya proletarskikh muzykantov* [Russian Association of Proletarian Musicians].

First All-Union Congress, pp. 290–97

1. Stalin called Soviet writers "engineers of human souls" in conversation with Gorky and other writers on October 26, 1932. See I. V. Stalin, *Sobranie sochinenii* [Collected Works], vol. 13 (Moscow, 1951), 410.

2. Such a congress did not, in fact, take place until 1957, although an All-Union Congress of Architects was held in 1937.

3. Pavel Vasilevich Malkov, a former pupil of Dmitrii Kardovsky, achieved a certain reputation during the 1930s and 1940s for his paintings and graphics on themes such as Soviet industry and the Red Army. The present whereabouts of the portrait in question is not known.

Bibliography

The Bibliography contains only published items and makes no reference to the many archives relevant to modern Russian art that are in public and private hands. Although the Bibliography is not exhaustive, particular attention has been paid to recent Western and Soviet publications concerned with subjects under discussion. Where sources contain comprehensive bibliographies, this is indicated, and therefore, many titles already listed in these bibliographies, as well as all the texts translated in the main part of the book, are omitted below.

The Bibliography is divided into two sections: A, works in languages other than Russian, and B, works in Russian. Bibliographical information on each contributor will be found in the appropriate division of section A, unless indicated otherwise. For obvious reasons the many minor references to contributors are not given, but for further information on a given artist, critic, or movement, the reader is urged to consult listings within the corresponding theoretical or chronological framework—especially the periodicals.

As a general rule, 1972 was set as the final date for bibliographical entries.

Since the publication of the American edition of this book in 1976, a very large amount of literature, both Western, Japanese and Soviet, has appeared pertaining to the Russian avant-garde. A selection of the more important titles from these many monographs, exhibition catalogues and collections of articles has been added to the original Bibliography below in the form of supplements identified by lower case Roman numerals, e.g. 26i, R23i, etc. As a general rule, 1985 was set as the final date for these supplements.

A: Works Not in Russian

i. General Works on the History of Russian Art (1–26)
ii. General Works Covering the Period ca. 1890–ca. 1930 (27–84)
I. The Subjective Aesthetic: Symbolism and the Intuitive (85–101)
II. Neoprimitivism and Cubofuturism (102–45)
III. Nonobjective art (146–76)
IV. The Revolution and Art (177–209)
V. Constructivism and the Industrial Arts (210–52)
VI. Toward Socialist Realism (253–72)

i. General Works on the History of Russian Art

1. Alpatov, Mikhail. *Russian Impact on Art*. Edited and with a Preface by Martin L. Wolf. Translated from the Russian by Ivy Litvinov. New York: Philosophical Library; Toronto: McLeod, 1950.
2. *L'Art russe des Scythes à nos jours*. Paris: Grand Palais, 1967–68. Exhibition catalogue.
3. Benois, Alexandre. *The Russian School of Painting*. Translated by Abraham Yarmolinsky. New York: Knopf, 1916; London: Laurie [1919].
4. Billington, James H. *The Icon and the Axe: An Interpretive History of Russian Culture*. New York: Knopf; London: Weidenfeld and Nicolson, 1966.
5. Braikevitch, Tatiana. *An Outline of Russian Art Leading to the Period Known as "Mir Iskusstva."* London: Woman's Printing Society, 1950.
6. Bunt, Cyril. *Russian Art. From Scyths to Soviets*. London and New York: Studio, 1946.
7. Chamot, Mary. *Russian Painting and Sculpture*. London: Pergamon, 1969.
8. Eliasberg, Alexander. *Russische Kunst*. Munich: Piper, 1915.
9. Fiala, Vladimir. *Russian Painting of the 18th and 19th Centuries*. Prague: Artia, 1955.
10. Froncek, Thomas, ed. *The Horizon Book of the Arts of Russia*. Introductory essay by James H. Billington. New York: American Heritage, 1970.
11. Gibellino Krasceninnicowa, Maria. *L'Arte russa moderna e contemporanea: pittura e scultura*. Rome: Palombi, 1960.
12. Gibellino Krasceninnicowa, Maria. *Storia dell'arte russa*. Rome: Maglione, 1935–37.
13. Grabar, Igor, ed. *Geschichte der russischen Kunst*. Translated from Russian by Kurt Küppers. Dresden: VEB Verlag der Kunst, 1957–65. Bibl.
14. Hamilton, George Heard. *The Art and Architecture of Russia*. Baltimore: Penguin, 1954. Bibl.
15. Hare, Richard. *The Art and Artists of Russia*. London: Methuen, 1965.
16. Matthey, Werner von. *Russische Kunst*. Zurich-Einsiedeln: Benziger, 1948.
17. Muther, Richard (in collaboration with Alexander Benois). "Russia." In Muther, Richard. *The History of Modern Painting*. Vol. 4. London: Dent; New York: Dutton, 1907, pp. 236–85.
18. Nemitz, Fritz. *Die Kunst Russlands. Baukunst. Malerei. Plastik. Vom 11 bis 19 Jahrhundert*. Berlin: Hugo, 1940.
19. Newmarch, Rosa. *The Russian Arts*. London: Jenkins; New York: Dutton, 1916.
20. Réau, Louis. *L'Art russe des origines à Pierre le Grand*. Paris: Laurens, 1921. Bibl.
21. Réau, Louis. *L'Art russe de Pierre le Grand à nos jours*. Paris: Laurens, 1922. Bibl.

 Bibl. 20 and 21 updated and reprinted as: *L'Art russe*. 3 vols. Paris: Marabout Université, 1968. Bibl.

22. Rice, Tamara Talbot. *A Concise History of Russian Art*. London: Thames and Hudson; New York: Praeger, 1963. Bibl.
23. Rubissow, Helen. *The Art of Russia*. New York: Philosophical Library; London: Crowther, 1946.
24. *A Survey of Russian Painting. 15th Century to the Present*. New York: Gallery of Modern Art Including the Huntington Hartford Collection, 1967. Exhibition catalogue.
25. Woinow, Igor. *Meister der russischen Malerei*. Berlin: Diakow, 1924.
26. Wulff, Oskar. *Die neurussische Kunst im Rahmen der Kulturentwicklung Russlands von Peter dem Grossen bis zur Revolution*. Augsburg: Filser, 1932.
26i. Alpatov, Michail. *Über Westeuropäische und russische Kunst*. Dresden: VEB, 1982.
26ii. Auty, R. and Obolensky, D., eds. *Companion to Russian Studies. 3. An Introduction to Russian Art and Architecture*. Cambridge: Cambridge University Press, 1980, Bibl.
26iii. Bowlt, John E. *Russian Art 1875–1975. A Collection of Essays*. New York: MSS, 1976.
26iv. Jernakoff, Nadja and Bowlt, John E., eds. *Transactions of the Association of Russian-American Scholars in USA*. New York, 1982, vol. 15. Special issue devoted to Russian art.
26v. Kemenov, Vasilii. *The USSR Academy of Arts*. Leningrad: Aurora, 1982.
26vi. Massie, Susan. *Land of the Firebird. The Beauty of Old Russia*. New York: Simon and Schuster, 1980.
26vii. *Russian and Soviet Painting*. New York: Metropolitan Museum, 1977. Exhibition catalogue.
26viii.Williams, Robert: *Russian Art and American Money*. Cambridge, Mass.: Harvard University, 1980.

ii. General Works Covering the Period ca. 1890–ca. 1930

27. Andersen, Troels. *Moderne russisk kunst 1910–1930*. Copenhagen: Borgen, 1967.
Annenkov, Georges. See 68.
28. *Apollo* (London), n.s., vol. 98, no. 142 (December 1973).
Whole issue devoted to Russian art of the Silver Age.
29. *L'Art d'avant-garde russe*. Paris: Musée d'Art Moderne, 1968. Exhibition catalogue.
30. *Aspects de l'avant-garde russe. 1905–1925*. Paris: Galerie Jean Chauvelin, 1969. Exhibition catalogue.
31. *Avantgarde Osteuropa 1910–1930*. Berlin: Die Deutsche Gesellschaft für Bildende Kunst und die Akademie der Künste, 1967. Exhibition catalogue.

32. Benois, Alexandre. *Memoirs*. Translated from the Russian [R92] by Moura Budberg. London: Chatto and Windus; Toronto: Clarke, Irwin, 1960.

33. Berninger, Herman, and Cartier, Jean. *Jean Pougny (Ivan Puni). Catalogue de l'oeuvre*. Tübingen: Wasmuth, 1972. Vol. 1, *Les années d'avant-garde. Russie-Berlin, 1910–1923*. Bibl.

34. Besançon, Alain. *"La dissidence de la peinture russe (1860–1922)." Annales* (Paris), vol. 2, March/April 1962, 252–82.
 Reprinted in English as "The Dissidence of Russian Painting." In *The Structure of Russian History*, ed. by Michael Cherniavsky, pp. 381–411. New York: Random House, 1970.
 Bojko, Szymon. See 65.

35. Bowlt, John E. "The Failed Utopia. Russian Art 1917–32." *Art in America* (New York), vol. 59, no. 4 (July/August 1971), 40–51.
 Bowlt, John E. See 40, 67.
 Brinton, Christian. See 66.

36. Carter, Huntly. "Russian Art Movements Since 1917." *Drawing and Design* (London), vol. 4, February 1928, 37–42.
 Cartier, Jean. See 33.

37. Chatwin, Bruce. "Moscow's Unofficial Art." *The Sunday Times Magazine* (London), May 6, 1973, pp. 36–54.

38. *Cimaise* (Paris), vol. 15, no. 85/86 (February/April 1968).
 Whole issue devoted to the Russian avant-garde.

39. *Il Contributo russo alle avanguardie plastiche*. Milan and Rome: Galleria del Levante, 1964. Exhibition catalogue.

40. *Diaghilev and Russian Stage Designers: A Loan Exhibition of Stage and Costume Designs from the Collection of Mr. and Mrs. N. Lobanov-Rostovsky*. Introduction by John E. Bowlt. Washington, D.C.: International Exhibitions Foundation, 1972. Exhibition catalogue.
 Circulated by the International Exhibitions Foundation, 1972–74.

41. Dreier, Katherine S., and Duchamp, Marcel, comps. *Collection of the Société Anonyme: Museum of Modern Art, 1920*. New Haven: Yale University Art Gallery, 1950. Exhibition catalogue.
 Duchamp, Marcel. See 41.

42. Fueloep-Miller, René. *The Mind and Face of Bolshevism: An Examination of Cultural Life in Soviet Russia*. London and New York: Putnam, 1928. Rev. ed.: New York: Harper, 1965. Bibl.

43. Gray, Camilla. "The Genesis of Socialist Realist Painting: Futurism, Suprematism, Constructivism." *Soviet Survey* (London), no. 27 (January/March 1959), pp. 32–39.

44. Gray, Camilla. "The Russian Contribution to Modern Painting." *The Burlington Magazine* (London), vol. 102, no. 686 (May 1960), 205–11.

45. Gray, Camilla. *The Great Experiment. Russian Art 1863–1922*. London: Thames and Hudson; New York: Abrams, 1962. Reissued as: *The Russian Ex-*

periment in Art: 1863–1922. London: Thames and Hudson; New York: Abrams, 1970. Bibl.

46. Grohmann, Will. *Wassily Kandinsky: Life and Work*. New York: Abrams, [1958]. Bibl.

47. Guercio, Antonio del. *Le Avanguardie russe e sovietiche*. Milan: Fabbri, 1970.

48. Guercio, Antonio del. "Pour une histoire qui reste à écrire: l'avant-garde russe." *Opus International* (Paris), no. 24/25, May 1971, pp. 20–25.

49. Haskell, Larissa. "Russian Paintings and Drawings in the Ashmolean Museum Oxford." *Oxford Slavonic Papers* (Oxford), n.s. vol. 2 (1969), 1–38.

50. Haskell, Larissa. "Russian Drawings in the Victoria and Albert Museum." *Oxford Slavonic Papers* (Oxford), n.s. vol. 5 (1972), 1–51.

51. Hilton, Alison. "When the Renaissance Came to Russia." *Art News* (New York), vol. 70, no. 8 (December 1971), 34–39, 56–62.

52. *Jar-Ptitza (Firebird)* (Berlín), 1921–26.
 This was an émigré journal devoted mainly to the Russian arts. Summaries of the Russian text appeared variously in English, French, and German.

53. Karpfen, Fritz. *Gegenwartkunst: 1. Russland*. Vienna: Verlag Literaria, 1921.

54. Leyda, Jay. *Kino: A History of the Russian and Soviet Film*. London: Allen and Unwin; New York: Macmillan, 1960.

55. Loukomski, George. *History of Modern Russian Painting (1840–1940)*. London: Hutchinson; Toronto, Ryerson, 1945.

56. Lozowick, Louis. *Modern Russian Art*. New York: Museum of Modern Art— Société Anonyme, 1925.

57. Lwoff, Lolly. *L'Art russe à Paris*. Paris: La Russie et le Monde Slave, 1931. Text in French and Russian.

58. Marcadé, Valentine. *Le Renouveau de l'art pictural russe*. Lausanne: L'Age d'Homme, 1971. Bibl.

59. Meyer, Franz. *Marc Chagall*. New York: Abrams; London: Thames and Hudson, 1964. Bibl.

60. Miliukov, Pavel Nikolaevich. *Outlines of Russian Culture*. Edited by Michael Karpovich. Translated from the Russian by Valentine Ughet and Eleanor Davis. Philadelphia: University of Pennsylvania; Oxford: Oxford University, 1942. Vol. 3, 59–100. Translation of R116.

61. Nakov, Andrei. *Alexandra Exter*. Booklet issued for the Exter exhibition at Galerie Jean Chauvelin, Paris, 1972.

62. *Osteuropäische Avantgarde (bis 1930)*. Cologne: Galerie Gmurzynska-Bargera, 1971. Exhibition catalogue.

63. Pleynet, Marcelin. "L'Avant-garde russe." *Art International* (Lugano), vol. 14, no. 1 (January 20, 1970), 39–44.

64. Pougny, Jean. *L'Art contemporain*. Berlin: Frenkel-Verlag, 1922. Published also in Russian: R172.

65. *Progressive russische Kunst*. Preface by Szymon Bojko. Cologne: Galerie Gmurzynska, 1973. Exhibition catalogue.

66. *The Russian Art Exhibition.* Introduction by Christian Brinton. New York: Grand Central Palace, 1924. Exhibition catalogue.

67. *Russian Avant-Garde 1908–1922.* New York: Leonard Hutton Galleries, 1971. Exhibition catalogue. Essays by S. Frederick Starr and John E. Bowlt.

68. *Russian Stage and Costume Designs for the Ballet, Opera and Theatre: A Loan Exhibition from the Lobanov-Rostovsky, Oenslager, and Riabov Collections.* Introduction by Georges Annenkov. Washington, D.C.: International Exhibitions Foundation, 1967. Exhibition catalogue.
 Circulated by the International Exhibitions Foundation, 1967–69.

69. *Russische Künstler aus dem 20 Jahrhundert.* Cologne: Galerie Gmurzynska-Bargera, 1968. Exhibition catalogue.

70. Salmon, André. *L'Art russe moderne.* Paris: Laville, 1928.

71. Schmidt, Werner. *Russische Graphik des XIX und XX Jahrhunderts.* Leipzig: VEB Seemann, 1967.
 This is an enlarged version of *150 Jahre russische Graphik 1813–1963. Katalog einer Berliner Privatsammlung.* Prepared by Winifried Dierske, Glaubrecht Friedrich, and Werner Schmidt. Dresden: Staatliche Kunst-sammlungen, 1964.

72. Seuphor, Michel. "Au temps de l'avant-garde." *L'Oeil* (Paris), no. 11, November 1955, pp. 24–39.

73. Sjeklocha, Paul, and Mead, Igor. *Unofficial Art in the Soviet Union.* Berkeley and Los Angeles: University of California, 1967; London: Cambridge University, 1968.

74. Sotheby and Co. *Catalogue of 20th Century Russian Paintings, Drawings and Watercolours.* Sold July 1, 1970, London.

75. Sotheby and Co. *Catalogue of 20th Century Russian Paintings, Drawings and Watercolours.* Sold April 12, 1972. London.

76. Sotheby and Co. *Catalogue of 20th Century Russian Paintings, Drawings and Watercolours 1900–1930.* Sold March 29, 1972, London.
 Starr, S. Frederick. See 67.

77. Steneberg, Eberhard. "Die Ungeduldigen. Zum Verständnis der Ecole Russe." *Das Kunstwerk* (Baden-Baden), vol. 13, no. 2/3 (August/September 1959), 3–26.

78. Steneberg, Eberhard, ed. *Beitrag der Russen zur modernen Kunst.* Düsseldorf: Wintersheidt, 1959.

79. Steneberg, Eberhard. *Russische Kunst, Berlin 1919–1932.* Berlin: Mann, 1969. Bibl.

80. Tugendhold, Jakob. *Alexandra Exter.* Translated from the Russian [bibl. R181] by Count Petrovsky-Petrovo-Solovovo. Berlin: Sarja, 1922.

81. *Two Decades of Experiment in Russian Art (1902–1922).* London: Grosvenor Gallery, 1962. Exhibition catalogue.

82. Umanskij, Konstantin. *Neue Kunst in Russland, 1914–1919.* Potsdam/Munich: Kiepenheuer/Goltz, 1920.

83. *Výtvarné umění* (Prague), no. 8/9, 1967.
Whole issue devoted to the Russian avant-garde. Partial translation in Russian, English, German, and French.

84. Woroszylski, Wiktor. *The Life of Mayakovsky*. Translated from the Polish by Boleslaw Taborski. New York: Orion, 1970.

84i. *L'altra metà dell'avanguardia 1910–1940*. Milan: Comune di Milano, 1980. (French version: *L'Autre moitié de l'avant-garde 1910–1940*). Exhibition catalogue.

84ii. Amiard-Chevrel, C. *Le Théâtre Artistique de Moscou 1898–1917*. Paris: CNRS, 1979, Bibl.

84iii. *Art and Revolution*. Japan: Seibu Museum of Art, 1982 (in Japanese).

84iv. *Art of the Avant-Garde in Russia. Selections from the George Costakis Collection*. New York: Guggenheim Museum, and other cities, 1981.

84v. *The Avant-Garde in Russia 1910–1930. New Perspectives*. Los Angeles: Los Angeles County Museum, 1980. Exhibition catalogue.

84vi. *L'Avant-Garde au Féminin. Moscou, Saint-Pétersbourg, Paris (1907–1930)*. Paris: Artcurial, 1983.

84vii. Bowlt, John E., ed. *Russian History*. Tempe: Arizona State University, 1981, vol. 8, parts 1–2. Special issue devoted to 20th-century Russian stage design.

84viii. Bowlt, John E. *Russian Stage Design. Scenic Innovation 1900–1930 from the Collection of Mr. and Mrs. Nikita D. Lobanov-Rostovsky*. Jackson: Mississippi Museum of Art, and other cities, 1982. Exhibition catalogue.

84ix. *100 oeuvres du Musée Trétiakov de Moscou*. Geneva: Petit Palais, 1983. Exhibition catalogue.

84x. *Contrasts of Form. Geometric Abstract Art 1910–1980*. New York: Museum of Modern Art, 1985. Exhibition catalogue.

84xi. Cooke, Catherine, ed. *Russian Avant-Garde. Art and Architecture*. Special issue of *Architectural Design*, London, 1983, vol. 53.

84xii. *Invention and Tradition. Selected Works from the Julia A. Whitney Foundation and the Thomas P. Whitney Collection of Modernist Russian Art*. Charlottesville: University of Virginia, and other cities, 1980.

84xiii. Janecek, Gerald. *The Look of Russian Literature. Avant-Garde Experiments 1900–1930*. Princeton: Princeton University, 1984. Bibl.

84xiv. Kean, Beverly. *All the Empty Palaces*. London: Barrie and Jenkins, 1983.

84xv. Kleberg, Lars. *Teatern som Handling. Sovjetisk avantgard-estetik 1917–27*. Stockholm: Kontrakurs, 1980.

84xvi. Kowtun, Jewgenij. *Die Wiedergeburt der künstlerischen Druckgraphik*. Dresden: VEB, 1984.

84xvii. Livshits, Benedikt. *The One and a Half-Eyed Archer*. Newtonville: ORP, 1977. English translation of bibl. R310.

84xviii. Misler, Nicoletta. *Pavel Florenskij. La prospettiva rovesciata e altri scritti*. Rome: Casa del libro, 1984.

84xix. Nakov, Andréi B. *L'Avant-Garde Russe*. Paris: Hazan, 1984.

84xx. Omuka, Toshiharu, ed. *Art Vivant*. Tokyo, 1982, No. 7–8. Special issue devoted to Russian art 1900–1930 (in Japanese).

84xxi. *Paris-Moscou*. Paris: Centre Georges Pompidou, 1979. Exhibition catalogue.

84xxii. Pasternak, Josephine (introd). *The Memoirs of Leonid Pasternak*. London: Quartet, 1982.

84xxiii. Rudenstine, Angelica et al. *Russian Avant-Garde: The George Costakis Collection*, New York: Abrams; London: Thames and Hudson, 1981.

84xxiv. *Russische Kunst des 20 Jahrhunderts*. Sammlung Semjonow, Esslingen am Neclear: Galerie der Stadt, 1984. Exhibition catalogue.

84xxv. *Russische Malerei 1890–1917*. Frankfurt: Städelsches Kunstinstitut, 1976. Exhibition catalogue.

84xxvi. *Russische und sowjetischer Kunst*. *Tradition-Gegenwart*. Düsseldorf: Städtische Kunsthalle, and other cities, 1984. Exhibition catalogue.

84xxvii. *Russisk malerei fra slutten av det 19. og begynnelsen av det 20 arhundre*. Oslo: Munch-Museet, 1983. Exhibition catalogue.

84xxviii. *Sammlung Costakis*. Düsseldorf: Kunstmuseum, 1977. Exhibition catalogue.

84xxix. *Sieben moskauer Künstler/Seven Moscow Artists 1910–1930*. Cologne: Galeria Gmurzynska, 1984. Exhibition catalogue.

84xxx. *Vom Klang der Bilder*. Stuttgart: Staatsgalerie, 1985. Exhibition catalogue.

84xxxi. Zelinsky, Bodo. *Russische Avantgarde, 1907–1921*. Bonn: Grundmann, 1983.

I. The Subjective Aesthetic: Symbolism and the Intuitive

Benois, Aleksandr. Autobiography: 32, R92.
 Other works by: 3, R26, R27, R28, R145i, R159, R193, R218, R244, R261, R262.
 Biography: R216.
 Other works on: 28, 101i, 101iii, 101ix, R194.
 Bibl. information: R216.

85. Bowlt, John E. "The World of Art." *Russian Literature Triquarterly* (Ann Arbor), Fall 1972, pp. 183–218.

86. Bowlt, John E. "Symbolism and Synthesism: The Russian World of Art Movement." *Forum* (St. Andrews, Scotland), vol. 9, no. 1 (January 1973), 35–48.

87. Bowlt, John E. "Russian Symbolism and the Blue Rose Movement." *The Slavonic and East European Review* (London), vol. 51, no. 123 (April 1973), 161–81.

88. Bowlt, John E. "Nikolai Ryabushinsky: A Moscow Maecenas." *Apollo* (London), vol. 98, no. 142 (December 1973).
 Burliuk, David. For bibl. references see II.

89. Guenther, Johannes von. *Ein Leben im Ostwind. Zwischen Petersburg und München. Erinnerungen.* Munich: Biederstein, 1969.
90. Hahl-Koch, Jelena. *Marianne Werefkin und der russische Symbolismus.* Munich Sagner, 1967. Bibl.
91. Jullian, Philippe. *Dreamers of Decadence: Symbolist Painters of the 1890's.* Translated by Robert Baldick. New York: Praeger, 1971.
92. *Kalmakoff.* Paris: Galerie Motte, 1965. Exhibition catalogue.
93. *Kalmakoff.* London: Hartnoll and Eyre, 1970. Exhibition catalogue.
94. Kandinsky, Wassily. *Über das Geistige in der Kunst.* Munich: Piper, 1912.
 First English translation: *The Art of Spiritual Harmony.* London: Constable; Boston: Houghton Mifflin, 1914. Several subsequent editions, under varying titles, e.g., *On the Spiritual in Art, Concerning the Spiritual in Art.*
95. Kandinsky, Wassily. "Über die Formfrage." In *Der Blaue Reiter,* edited by Kandinsky and Franz Marc, pp. 74–100. Munich: Piper, 1912.
 Several subsequent editions.
 English translation: "On the Question of Form." In *The "Blaue Reiter" Almanac,* edited and with an Introduction by Klaus Lankheit. Translated by Henning Falkenstein with the assistance of Manug Terzian and Gertrude Hinderlie, pp. 147–87. The Documents of 20th-Century Art. London: Thames and Hudson; New York: Viking, 1974.
 Kandinsky, Vasilii. Works by: 94, 95, R222, R223, R392–94.
 Biography: 46.
 Other works on: 97, 100.
 Bibl. information: 46.
 Kandinsky, Vasilii, Works by: 94, 95, 101v, 101x, 101xiii, 101xiv, R217iv, R222, R223, R392–94.
 Biography: 46
 Other works on: 84xxiii, 97, 100, 101vi, 101vii, 101viii, 101xi, 101xii, 101xv, 101xvi, 101xvii.
96. Kulbin, Nikolai. "Die freie Musik." In *Der Blaue Reiter,* edited by Wassily Kandinsky and Franz Marc, pp. 69–73. Munich: Piper, 1912.
 Apart from the Russian versions of this essay [R226–27], it had also appeared in French: Nicolas Koulbine. *La musique libre. Application à la musique de la nouvelle théorie de la création.* St. Petersburg: Voennaya tipografiya, 1910. Several subsequent editions.
 English translation: "Free Music." In *The "Blaue Reiter" Almanac,* pp. 141–46. See under bibl. 95.
 Kulbin, Nikolai. Works by: 96, R224–31, R307.
 Biography: R240.
 Other works on: R102, R217iv, R218, R220, R239.
 Some bibl. information: 133, R240.
 Book illustrations: R219, R229, R291, R292, R340.
 Marc, Franz. See 95.

Markov, Vladimir. Works by: R232–35.
 Biography: 98.
 Works on: R217iii, R217v, R217vi.

97. Roethel, Hans Konrad. *Kandinsky. Das graphische Werk.* Cologne: DuMont Schauberg, 1970.
 Ryabushinsky, Nikolai. Works by: R214, R215, R251.
 Biography: 88.
 Other work on: R218.

98. *60 Jahre lettischer Kunst.* Introduction by Roman Suta. Leipzig: Pandora, 1923. Exhibition catalogue.

99. *La Toison d'or.* (Moscow), vol. 1, no. 1–6, (1906).
 The first six numbers of Nikolai Ryabushinsky's *Zolotoe runo* [The Golden Fleece] appeared both in Russian and in French. See R45.

100. Washton Long, Rose-Carol. "Kandinsky and Abstraction: The Role of the Hidden Image." *Artforum* (New York), vol. 10, no. 10 (June 1972), 42–49.

101. Woloschin, Margarite. *Die grüne Schlange.* Stuttgart: Deutsche Verlag-Anstalt, 1956.

101i. *Alexandre Benois.* London: Hazlitt, Gooden and Fox, 1980. Exhibition catalogue.

101ii. Barnett, Vivian Endicott. *Kandinsky at the Guggenheim.* New York: Abbeville, 1983.

101iii. Bowlt, John E. et al. *Mir iskusstva.* Rome: E/O, 1984.

101iv. Bowlt, John E. *The Silver Age. Russian Art of the Early Twentieth Century and the "World of Art" Group.* Newtonville: ORP, 1979.

101v. Bowlt, John E. and Washton Long, Rose-Carol. *The Life of Vasilii Kandinsky in Russian Art.* Newtonville: ORP, 1980. Bibl.

101vi. Hahl-Koch, Jelena, ed. *Arnold Schönberg—Wassily Kandinsky. Briefe, Bilder und Dokumente einer aussergewöhnlichen Begegnung.* Salzburg and Vienna: Residenz, 1980.

101vii. *Kandinsky. Oeuvres de Vassily Kandinsky (1866–1944).* Paris: Centre Georges Pompidou, 1984. Exhibition catalogue.

101viii. *Kandinsky. Trente peintures des Musées soviétiques.* Paris: Centre Georges Pompidou, 1979. Exhibition catalogue.

101ix. Kennedy, Janet. *The "Mir iskusstva" Group and Russian Art, 1898–1912.* New York: Garland, 1977.

101x. Lindsay, Kenneth C. and Vergo, Peter, eds. *Kandinsky. Complete Writings on Art.* Boston: Hall, 1982 (2 vols.).

101xi. Poling, Clark V. *Kandinsky. Russia and Bauhaus Years 1915–1933.* New York: Guggenheim, 1983. Exhibition catalogue. Bibl.

101xii. Poling, Clark V. *Kandinsky. Unterricht am Bauhaus.* Weingarten: Weingarten, 1982. Bibl.

101xiii. Roethel, Hans K. and Benjamin, Jean K. *Kandinsky. Catalogue Raisonné of the Oil-Paintings. Vol. 1, 1900–1915.* Ithaca: Cornell, 1982.

101xiv. Roethel, Hans K. and Benjamin, Jean K. *Kandinsky. Catalogue Raisonné of the Oil-Paintings. Vol. 2, 1916–1944.* Ithaca: Cornell, 1984.

101xv. Washton Long, Rose-Carol. *Kandinsky. The Development of an Abstract Style.* Oxford: Oxford University Press, 1980. Bibl.

101xvi. Weiss, Peg. *Kandinsky in Munich. The Formative Jugendstil Years.* Princeton: Princeton University Press, 1979. Bibl.

101xvii. Zweite, Armin. *Kandinsky und München. Begegnungen und Wandlungen 1896–1914.* Munich: Prestel, 1982.

II. Neoprimitivism and Cubofuturism

Aksenov, Ivan. Works by: R257, R258, R372, R452.
 Some bibl. information: 133.
 Biography: R23i.

Apollinaire, Guillaume. See 119.

102. *Arts Council Exhibition: Larionov and Goncharova.* London, Bristol, Leeds, 1961. Exhibition catalogue compiled by Mary Chamot and Camilla Gray.

103. *Ausstellung Der Sturm: Larionov und Gontcharova.* Berlin, 1914. Exhibition catalogue.

104. Barr, Alfred H., Jr. *Cubism and Abstract Art.* New York: Museum of Modern Art, 1936. Reprinted: New York: Arno, 1966; London: Cass, 1967. Bibl.

105. Besançon, Alain. "Robert Falk." *Cahiers du monde russe et soviétique* (Paris), vol. 3, no. 4 (1962), 564–81.

106. *Der Blaue Reiter.* Munich: Galerie Thannhauser, 1911. Exhibition catalogue.

107. *Der Blaue Reiter.* Munich: Galerie Hans Goltz, 1912. Exhibition catalogue.

108. *Der Blaue Reiter.* Almanac: see 95.

Brinton, Christian. See 122.

109. Burliuk, David, ed. *Color and Rhyme* (Hampton Bays, N.Y.), 1930–66.
Burliuk, David. Works by: 108, 109, 258, R269–76.
 Biography: 117.
 Other works on: 145ix, R102, R256iii, R278.
 Bibl. information: 133.
 Book illustrations: 145iv, R272, R274, R312.

110. Bowlt, John E. "Neo-primitivism and Russian Painting." *The Burlington Magazine* (London), vol. 116, no. 853 (March 1974), 133–40.

111. Calvesi, Maurizio. *L'Arte moderna. Il futurismo russo.* Milan: Fabbri, vol. 5, no. 44 (1967).
 Whole issue devoted to the subject.

112. Carrieri, Raffaele. *Il Futurismo.* Milan: Edizioni del milione, 1961; English edition: *Futurism.* Milan: Edizioni del milione, n.d. Bibl.

113. Chamot, Mary. "The Early Work of Larionov and Goncharova." *The Burlington Magazine* (London), vol. 97, no. 627 (June 1955), 170–71.

114. Chamot, Mary. *Gontcharova*. Paris: La Bibliothèque des arts, 1972. Bibl. Chamot, Mary. See 102.

115. Cooper, Douglas. *The Cubist Epoch*. London: Phaidon, 1971.
Exhibition catalogue: Los Angeles County Museum and Metropolitan Museum of Art, 1971.

116. Davies, Ivor. "Primitivism in the First Wave of the Twentieth-Century Avant-Garde in Russia." *Studio International* (London), vol. 186, no. 958 (September 1973), 80–84.

117. Dreier, Katherine S. *Burliuk*. New York: Museum of Modern Art—Société Anonyme, 1944.

118. *Erster deutscher Herbstsalon*. Berlin: Galerie Der Sturm, 1913. Exhibition catalogue.

119. *Exposition de N. Gontcharova et M. Larionov*. Compiled by Guillaume Apollinaire. Paris: Galerie Paul Guillaume, 1914. Exhibition catalogue.
Fry, Roger. See 142.

120. Gambillo, Maria Drudi, and Fiori, Teresa, eds. *Archivi del futurismo*. Rome: De Luca, 1958.
Selected translations in: Apollonio, Umbro, ed. *Futurist Manifestos*. Translated from the Italian by Robert Brain, R. W. Flint, J. C. Higgitt, Caroline Tisdall. The Documents of 20th-Century Art. London: Thames and Hudson; New York: Viking, 1973. "Futurist Painting: Technical Manifesto" appears on pp. 27–31.

121. George, Waldemar. *Larionov*. Paris: La Bibliothèque des arts, 1966. Bibl.
German edition: Lucerne and Frankfurt: Bucher, 1968.

122. *The Goncharova-Larionov Exhibition*. Introduction by Christian Brinton. New York: Kingore Gallery, 1922. Exhibition catalogue.

123. *Gonjarova-Larjonov-Mansourov*. Bergamo: Galleria Lorenzelli, 1966. Exhibition catalogue.
Goncharova, Natalya. Works by: 149, R252.
Biography: 114.
Other works on: 84xxiii, 102, 103, 113, 119, 122, 123, 127, 132, 137, 145iii, 145xi, 145xii, 146, 148, 150, 176ix, 176xvii, R264, R335, R349, R354, R356, R357.
Bibl. information: 114, 132.
Book illustrations: 145iv, R272, R279, R292, R296, R299, R306, R319.
Gray, Camilla. See 102.

124. Jensen, Kjeld Bjornager. "Marinetti in Russia—1910, 1912, 1914?" *Scando-Slavica* (Copenhagen), vol. 15 (1969), 21–26.

125. Khérumian, Raphaël, et al. *Notes et Documents*. Paris: Société des amis de Georges Yakoulov, no. 1, 2, 3 (1967, 1969, 1972). Bibl.

126. Kriz, Jan. "Pawel Nikolajewitsch Filonow. Mitbegründer und Kritiker der russischen künstlerischen Avantgarde." *Alte und Moderne Kunst* (Vienna), vol. 96 (1968), 32–39.

127. *Larionov-Gontcharova*. Basel: Galerie Beyeler, 1961. Exhibition catalogue.
128. *Michel Larionov*. Lyon: Musée de Lyon, 1967. Exhibition catalogue.
129. *Michel Larionov*. Introduction by François Daulte. New York: Acquavella Galleries, 1969. Exhibition catalogue.
130. *Larionov*. Paris: Galerie de Paris, 1969. Exhibition catalogue.
 A slightly larger version of this exhibition opened in Nevers et la Nièvre, Maison de la Culture de Nevers et la Nièvre, 1972. Separate catalogue with an Introduction by Jean Goldman.
 Larionov, Mikhail. Works by: 145ix, 149, R252, R361.
 Biography: 121.
 Other works on: 84xxiii, 102, 103, 113, 119, 122, 123, 127–30, 132, 141, 144, 145xi, 145xii, 146, 147, 148, 150, R135, R253, R256iv, R286, R319, R321, R349, R356, R357.
 Book illustrations: 145iv, R272, R296, R297, R298, R300, R319.
131. Livchits, Benedikt. *L'Archer à un oeil et demi*. Translated from the Russian [bibl. R310], prefaced, and annotated by Emma Sébald, Valentine and Jean-Claude Marcadé. Lausanne: L'Age d'Homme, 1971.
132. Loguine, Tatiana. *Gontcharova et Larionov*. Paris: Klincksieck, 1971.
133. Markov, Vladimir. *Russian Futurism: A History*. Berkeley: University of California, 1968; London: MacGibbon and Kee, 1969. Bibl.
134. *Neue Künstlervereinigung*. Munich: Moderne Galerie Thannhauser, 1909. Exhibition catalogue.
135. *Neue Künstlervereinigung*. Munich: Moderne Galerie Thannhauser, 1910. Exhibition catalogue.
136. *Neue Künstlervereinigung*. Munich: Moderne Galerie Thannhauser, 1911. Exhibition catalogue.
137. *Rétrospective Gontcharova*. Bourges: Maison de la Culture de Bourges, 1973. This was a condensed and modified version of the exhibition "Nathalie Gontcharova" in Lyon, Musée des Beaux-Arts, 1969.
138. Ripellino, Angelo. *Majakovskii e il teatro russo d'avanguardia*. Turin: Einaudi, 1959.
 French translation: *Maïakovski et la théâtre russe d'avant-garde*. Paris: L'Arche, 1965.
139. Robel, Léon, trans. *Manifestes futuristes russes*. Paris: Editeurs Français Réunis,1972.
140. Rye, Jane. *Futurism*. London: Studio Vista; New York: Dutton, 1972.
141. Schafran, Lynn. "Larionov and the Russian Vanguard." *Art News* (New York), vol. 68, no. 3 (May 1969), 66–67.
142. *The Second Post-Impressionist Exhibition*. London: Grafton Galleries, 1912. Organized by Roger Fry. Exhibition catalogue.
 Shevchenko, Aleksandr. Autobiography: R177 (vol. 1).
 Other work by: R355.
 Biography: R283.

Other works on: R254, R256.

143. Tschiževskij, Dmitrij. *Anfänge des russischen Futurismus.* Wiesbaden: Harrassowitz, 1963.

144. Vergo, Peter. "A Note on the Chronology of Larionov's Early Work." *The Burlington Magazine* (London), vol. 114, no. 832 (July 1972), 476–79. Yakulov, Georgii. See 124.

145. Zdanévitch, Cyrille. *Niko Pirosmani.* Translated from the Russian by Lydia Delt and Véra Varzi. Paris: Gallimard, 1970.

Zdanevich, Ilya. Works by: R356, R357.

Some bibl. information: 133.

Works on: 145vi, 145vii.

145i. Andersen, Troels et al., eds. *Art et poésie russes 1910–1930.* Paris: Centre Georges Pompidou, 1979.

145ii. Bauermeister, Christiane, ed. *Sieg über die Sonne. Aspekte russischer Kunst zu Beginn des 20. Jahrhunderts.* Berlin: Frölich and Kaufman, 1983. Bibl.

145iii. Chamot, Mary. *Goncharova. Designs and Paintings.* London: Oresko, 1979. Bibl.

145iv. Compton, Susan. *The World Backwards. Russian Futurist Books 1912–1916.* London: The British Library, 1978, Bibl.

145v. *Futurismo e futurismi.* Venice: Palazzo Grassi, 1986. Exhibition catalogue.

145vi. *Iliazd.* Paris: Centre Georges Pompidou, 1978. Exhibition catalogue.

145vii. *Iliazd. Maître d'oeuvre du livre moderne.* Quebec: Galerie d'art de l'Université, 1984. Exhibition catalogue. Bibl.

145viii. Khardzhiev, Nikolai and Trenin, Vladimir. *Culture poétique de Maiakovski.* Lausanne: L'Age d'Homme, 1982. French translation of R350.

145ix. Ladurner, H. "David D. Burljuks Leben und Schaffen 1908–1920," *Wiener Slawistischer Almanac.* Vienna. 1978, vol. 1, pp. 27–55.

145x. Marcadé, Jean-Claude, ed. *Michel Larionov. Une Avant-Garde Explosive.* Lausanne: L'Age d'Homme, 1978.

145xi. *Nathalie Gontcharova. Michel Larionov.* Milan: Arte Centro, 1984. Exhibition catalogue.

145xii. Pospelow, Gleb. *Moderne russische Malerei. Die Künstlergruppe Karo-Bube.* Berlin: Kohlhammer, 1985.

III. Nonobjective Art

RAYONISM

146. Berlewi, Henryk. "Michael Larionoff, N. Gontscharova und der Rayonnismus." *Werk* (Zurich), October 1961, pp. 364–68.

147. Daulte, François. "Larionov, le rayonniste." *Connaissance des Arts* (Paris), no. 179 (January 1967), pp. 46–53.

148. Degand, Léon. *"Le Rayonnisme: Larionov—Goncharova."* Art d'aujourd'hui (Paris), série 2, no. 2 (November 1950), pp. 26–29.

149. Larionow, Michele, and Gonciarova, Natalia. *Radiantismo.* Translated from the Russian by Nina Antonelli. Rome, 1917.
Larionov, Mikhail. For bibl. references see II.

150. Steneberg, Eberhard. "Larionov, Gontscharowa und der Rayonnismus." *Das Kunstwerk* (Baden-Baden), vol. 16, no. 8 (February 1963), 11–22.

SUPREMATISM

(Note: entries in this section are highly selective; the reader is referred to 33, 159, and 160 in particular for comprehensive bibliographies.)

151. Andersen, Troels. "Malevich on 'New Art.' " *Studio International* (London), vol. 174, no. 892 (September 1967), 100–105.
Andersen, Troels. See 27, 159, 160.
Boguslavskaya, Kseniya. Some biographical information: 33
Work by: R382.
Book illustration: R406.

152. Bowlt, John E. "Malevich's Journey into the Non-Objective World." *Art News* (New York), vol. 72, no. 10 (December 1973),16–22.
Gray, Camilla. See 43, 44, 45, 161.

153. Habasque, Guy. "Documents inédits sur les débuts du Suprématisme." *Art d'aujourd'hui* (Paris), no. 4, September 1955, pp. 14–16.
Klyun, Ivan. Works by: R289, R290.
Book illustrations: R304
Works on: 84xx, 176iv.

154. *Koudriachov.* Paris: Galerie Jean Chauvelin, 1970. Exhibition catalogue.

155. Kovtun, E. "Malevičova mýslenka plastické beztíže." *Výtvarné pracé* (Prague), no. 2, 1967, p. 10.

156. Lamač, Miroslav. "Malevič a jeho okruh." *Výtvarné umění* (Prague), no. 8/9, 1967, pp. 365ff. See also 83.
Lissitzky, El. For bibl. references see V.

157. Malevich, Kazimir. *Die gegenstandslose Welt.* Bauhausbücher no. 11. Munich: Langen, 1927.
English edition: *The Non-Objective World.* Translated by Howard Dearstyne. Chicago: Theobald, 1959.

158. Malevich, Kazimir. "Autobiographical Fragment." *Studio International* (London), vol. 176, no. 905 (October 1968), 129–33.

159. Malevich, K. S. *Essays on Art 1915–1928.* Edited by Troels Andersen. Translated by Xenia Glowacki-Prus and Arnold McMillin. 2 vols. Copenhagen: Borgen, 1968; London, Rapp and Whiting, 1969; et al.

160. *Malevich.* Compiled by Troels Andersen. Amsterdam: Stedelijk Museum, 1970. Catalogue. Bibl.

161. *Kasimir Malevich, 1878–1935*. Introduced by Camilla Gray. London: Whitechapel Art Gallery, 1959. Exhibition catalogue.

162. *Casimir Malevic*. Rome: Galleria Nazionale d'Arte Moderna, 1959. Exhibition catalogue.

163. *Kasimir Malevic*. Milan: Galleria Breton, 1971. Exhibition catalogue.

164. *Malevitch: Dessins*. Paris: Galerie Jean Chauvelin, 1970. Exhibition catalogue.

165. *Kasimir Malewitsch*. Braunschweig: Kunstverein, 1958. Exhibition catalogue.

166. Kasimir Malewitsch. *Suprematismus—Die gegenstandslose Welt*. Edited by Werner Haftmann. Translated from the Russian by Hans von Riesen. Cologne: DuMont Schauberg, 1962.

 Malevich, Kazimir. Autobiography: 158, R187iv.

 Other works by: 157, 159, 163, 166, 171, 176, 176xii, 176xiii, 176iv, 176xviii, 176xix.

 Biography: 160.

 Other works on: 84xxiii, 151, 155, 156, 161, 162, 164, 165, 170, 176ii, 176iii, 176vi, 176vii, 176xi, 176xxiv, 176xxv, R360, R363, R366.

 Bibl. information: 159, 160.

 Book illustrations: 145iv, R284, R292, R293, R303, R304, R306, R351–53.

167. Nakov, Andréi. "Destination l'infini: la théorie du suprématisme." *XX Siècle* (Paris), n.s., no.33 (December 1969), 171–72. Also see 173.

168. *The Non-objective World, 1914–1924*. London: Annely Juda Fine Art; Paris: Galerie Jean Chauvelin; Milan: Galleria Milano, 1970. Exhibition catalogue. Editions in English, French, and Italian.

169. *The Non-objective World, 1924–1939*. London: Annely Juda Fine Art; Paris: Galerie Jean Chauvelin; Milan: Galleria Milano, 1971. Exhibition catalogue. Editions in English, French, and Italian.

170. Penkula, Eduard. "Malewitschs Oeuvre geborgen." *Das Kunstwerk* (Baden-Baden), vol. 11, no. 10 (April 1958), 3–16.

 Popova, Lyubov. Some biographical details: 45, R184, R435, R475.

 Works on: 84xxiii, 176i, 176ix, 176x, 176xvii, 176xxiii.

171. Pugh, Simon. "An Unpublished Manuscript by Malevich." *Studio International* (London), vol. 183, no. 942 (March 1972), 100–102.

 Puni, Ivan (Pougny, Jean). Works by: 64, 176, R172, R365, R412.

 Biography: 33.

 Other works on: 84xxiii, 176v, R359.

 Bibl. information: 33.

 Book illustrations: 145iv, R273, R406.

 Rodchenko, Aleksandr. For bibl. references see V.

 Rozanova, Olga. Work by: R 332.

 Works on: R186, R290.

 Book illustrations: R273, R291–96, R300, R301, R302, R306, R313, R333, R339, R340.

172. Seuphor, Michel. "Suprématisme et Néo-plasticisme." *Art d'aujourd'hui* (Paris), no. 7/8 (September 1950), pp. 22–24. Stepanova, Varvara. For bibl. references see V.

173. *Tatlin's Dream. Russian Suprematist and Constructivist Art 1910–1923.* London: Fischer Fine Art Limited, 1973. Essay by Andrei Nakov. Exhibition catalogue.

174. Vallier, Dora. "L'Art abstrait en Russie: ses origines, ses premières manifestations 1910–1917." *Cahiers d'Art* (Paris), vol. 33–35, (1960), 259–85.

175. Veronesi, Giulia. *Suprematisti e construttivisti in Russia. L'Arte moderna,* vol. 6, no. 48. Milan: Fabbri, 1967.

176. Westheim, Paul, ed. *Künstlerbekenntnisse. Briefe, Tagebuchblätter, Betrachtungen heutiger Künstler.* Berlin: Propyläen-Verlag, 1925.
Contains statements by Natan Altman, El Lissitzky, Kazimir Malevich, Ivan Puni, et al.

176i. Bowlt, John E. "Liubov Popova, Painter" in bibl. i 26iv, pp. 227–51.

176ii. Bowlt, John E. and Douglas, Charlotte, eds. *Soviet Union.* Tempe: Arizona State University, 1978, vol. 5, part 2. Special issue devoted to Kazimir Malevich. Bibl.

176iii. Douglas, Charlotte. *Swans of Other Worlds.* Ann Arbor: University Microfilms International, 1980. Bibl.

176iv. *Ivan Vasilievich Kliun.* New York: Matignon Gallery, 1983. Exhibition catalogue.

176v. *Iwan Puni (Jean Pougny) 1892–1956.* Berlin: Haus am Waldsee, 1975. Exhibition catalogue.

176vi. *Kasimir Malewitsch.* Cologne: Galerie Gmurzynska, 1978. Exhibition catalogue.

176vii. *Kasimir Malewitsch (1878–1935). Werke aus sowjetischen Sammlungen.* Düsseldorf: Kunsthalle, 1980.

176viii. *Die Kunstismen in Russland/The Isms of Art in Russia.* Cologne: Galerie Gmurzynska, 1977. Exhibition catalogue.

176ix. *Künstlerinnen der russischen Avantgarde/Women-Artists of the Russian Avant-Garde 1910–1930.* Cologne: Galerie Gmurzynska, 1979. Exhibition catalogue.

176x. *Liubov Popova.* New York: Rachel Adler Gallery, 1985. Exhibition catalogue.

176xi. *Malévitch. Oeuvres de Casimir Severinovitch Malévitch (1878–1935).* Paris: Centre Georges Pompidou, 1980.

176xii. Marcadé, Jean-Claude, ed. *K. Malévitch. Le miroir suprématiste.* Lausanne: L'Age d'Homme, 1978.

176xiii. Marcadé, Jean-Claude, ed. *Malévitch. Colloque international Kazimir Malévitch.* Lausanne: L'Age d'Homme, 1979.

176xiv. Marcadé, Jean-Claude (ed.): *K. Malévitch. La lumière et la couleur,* Lausanne: L'Age d'Homme, 1981.

176xv. *Masterpieces of the Avantgarde.* London: Annely Juda Fine Art/Juda Rowan Gallery, 1985. Exhibition catalogue.

176xvi. *Meisterwerke russischer Malerei.* Cologne: Josef-Haubrich-Kunsthalle, 1984. Exhibition catalogue.

176xvii. Nakov, Andréi B. *Abstrait/Concret. Art Non-Objectif russe et polonais.* Paris: Editions de minuit, 1981. Bibl.

176xviii. Nakov, Andréi B., ed. *Malévitch. Ecrits.* Paris: Champ Libre, 1975. Bibl.

176xix. Nakov, Andréi B., ed. *Kazimir S. Malevic.* Scritti, Milan: Feltrinelli, 1977. Bibl.

176xx. *Plastyka radziecka. Sztuka okresu pazdziernika 1917–1930.* Warsaw: Zacheta, 1982. Exhibition catalogue.

176xxi. *Russian Pioneers at the Origins of Non-Objective Art.* London: Annely Juda Fine Art, 1976. Exhibition catalogue.

176xxii. *Russian Suprematist and Constructivist Art 1910–1930.* London: Fischer Fine Art, 1976.

176xxiii. Sarabianov, Dmitrii. "The Painting of Liubov Popova" in bibl. ii 84v, pp. 42–45.

176xxiv. Shadowa [Zhadova, Zsadova], Larissa: *Suche und Experiment. Russische und sowjetische Kunst 1910 bis 1930.* Dresden: VEB, 1978. English translation: *Malevich, Suprematism and Revolution in Russian Art 1910–1930.* London: Thames and Hudson, 1982. Bibl.

176xxv. *The Suprematist Straight Line. Malevich, Suetin, Chashnik, Lissitzky.* London: Annely Juda Fine Art, 1977. Exhibition catalogue.

176xxvi. *Vanguardia Rusa 1910–1930. Museo y coleccion Ludwig.* Madrid: Fundacion Juan March, 1985. Exhibition catalogue.

176xxvii. Vesnin, Aleksandr. For bibl. references see V.

176xxviii. *Von der Fläche zum Raum/From Surface to Space. Russland/Russia 1916–1924.* Cologne: Galerie Gmurzynska, 1974. Exhibition catalogue.

IV. The Revolution and Art

PROLETKULT

177. Bogdanow, Alexander. *Die Kunst und das Proletariat.* Leipzig: "Der Kentaur," 1919.
Bogdanov, Aleksandr. Works by: 177, 180, 209x, R367.
Biography: 179.
Bibl. information: 179.

178. Eastman, Max. *Education and Art in Soviet Russia in the Light of Official Decrees and Documents.* New York: Socialist Publication Society, 1919.

179. Grille, Dietrich. *Lenins Rivale. Bogdanov und seine Philosophie.* Cologne: Wissenschaft und Politik, 1966. Bibl.

180. Lorenz, Richard, ed. *Proletarische Kulturrevolution in Sowjetrussland*

1917–1921. Dokumente des "Proletkult." Translated from the Russian by Uwe Brügmann and Gert Meyer. Munich: Deutscher Taschenbuch, 1969.

181. Paul, Eden, and Paul, Cedar. *Proletcult.* London: Parsons, 1921.

GENERAL ASPECTS

Altman, Natan. Work by: 176.
 Biography: R185, 209v.
 Other works on: R186, R259, R434v.
 Bibl. information: R185.

182. *Art in Revolution: Soviet Art and Design since 1917.* London: Arts Council/Hayward Gallery, 1971. Exhibition catalogue.
 Shown in Bologna, New York, Ontario, 1971–72, under same title; in Frankfurt, Stuttgart, and Cologne as *Kunst in der Revolution*, 1972–73. Texts in English catalogue by Camilla Gray-Prokofieva et al.

183. *Arte nella Russia dei Sovieti; il padigloione dell'U.R.S.S. a Venezia.* Text by Vinicio Paladini. Roma: La Bilancia, 1925. Exhibition catalogue. See 198.

184. Barooshian, Vahan. "The Avant-garde and the Russian Revolution." *Russian Literature Triquarterly* (Ann Arbor), Fall 1972, pp. 347–60.

185. Barr, Alfred H., Jr. "The 'LEF' and Soviet Art." *Transition* (New York), no. 14, (Fall 1928), pp. 267–70.

Bodine, Sarah. See 205.

186. Bojko, Szymon. "L'Affiche révolutionnaire." *Opus International* (Paris), no. 5, (February 1968), pp. 29–33.

187. Boyko, Szymon. *New Graphic Design in Revolutionary Russia.* Translated from the Polish by Robert Strybel and Lech Zembrzuski. London: Lund Humphries; New York: Praeger, 1972. Bibl.

188. Bowlt, John E. "Russian Art in the 1920s." *Soviet Studies* (Glasgow), vol. 22, no. 4 (April 1971), 574–94.

189. Bowlt, John E. "Russian Formalism and the Visual Arts." *20th Century Studies* (Canterbury), no. 7/8, December 1972, pp. 131–46.

190. Braun, Edward, trans. and ed. *Meyerhold on Theatre.* New York: Hill and Wang; London: Methuen, 1969.

191. Bringas, Esperanza Velázquez. *El Arte en la Rusia actual.* Mexico City: 1923.

192. Carter, Huntly. *The New Theatre and Cinema of Soviet Russia.* London: Chapman and Dodd, 1924; New York: International, 1925.

193. Carter, Huntly. *The New Spirit in the Russian Theatre, 1917–1928.* London: Brentano's, 1929.

194. Congrat-Butler, Stefan, comp. *Russian Revolutionary Posters, 1917–1929.* New York: Grove Press, 1971.

195. Cossío del Pomar, Felipe. "El arte ruso y la revolución." In *La rebelión de los pintores,* pp. 271–328. Mexico City: Editorial Leyenda, 1945.

196. "Dans la foulée d'Octobre: Les arts soviétiques des premières années." *Les*

Lettres françaises (Paris), no. 1207 (November 8–14, 1967), pp. 22–26.

197. *Erste Russische Kunstausstellung*. Introduction by David Shterenberg. Berlin: Galerie van Diemen, 1922. Exhibition catalogue.

198. Esposizione internazionale d'arte. XIV biennale internazionale d'arte della città di Venezia. Catalogue of the Russian section. Text by Boris Ternovetz. Venice, 1924.
See also 183.

199. Fitzpatrick, Sheila. *The Commissariat of Enlightenment. Soviet Organization of Education and the Arts Under Lunacharsky, October, 1917–1921*. Cambridge: Cambridge University, 1971. Bibl.
Gray-Prokofieva, Camilla. See 43, 44, 45, 182.

200. Gregor, Joseph, and Fueloep-Miller, René. *Das Russische Theater. Mit besonderer Berücksichtigung der Revolutionsperiode*. Vienna: Amalthea, 1927.
English edition: *The Russian Theatre*. Translated by Paul England. London: Harrap; Philadelphia: Lippincott, 1930.

201. Higgens, Andrew. "Art and Politics in the Russian Revolution." *Studio International* (London), vol. 180: no. 927 (November 1970), 164–67; no. 929 (December 1970), 224–27.

202. Jelenski, K. A. "Avant-garde and the Revolution." *Arts* (New York), vol. 35, no. 1 (October 1960), 36–41.
Komfut. Works by: consult R73 and references to Osip Brik, Boris Kushner, and Nikolai Punin.
Works on: R497, R499.
Kushner, Boris. Works by: R395–97, R470, and consult R73, R76.
Some bibl. information: 133.
Lef. Works by: R76.
Works on: consult 84, 133, R16, R341.

203. Lunacharski, Anatoli Vasilievich. *Las Artes plásticas y la política artística de la Rusia revolucionaria*. Translated by José M. Güell. Barcelona: Editorial Seix y Barral, 1969.
Russian texts in R402–403.

204. Lunatscharski, Anatoli. *Die Revolution und die Kunst: Essays, Reden, Notizen*. Selected and translated by Franz Leschnitzer. Dresden: VEB Verlag der Kunst, 1962.
Russian texts in R402–403.
Lunacharsky, Anatolii. Works by: 203–204, R402–403, R434i, R471.
Biography: 199, 209xv.
Bibl. information: 199, R402–403.
Pertsov, Viktor. Work by: R434xi.
Punin, Nikolai. Works by: R253, R410, R413–19, R444–45, and consult R66, R73, R82, R434vi.
Some biographical information: 230ix, R435.

205. *Russian Art of the Revolution*. Compiled by Sarah Bodine. Cornell: Andrew

Dickson Museum of Art; Brooklyn: Brooklyn Museum of Art, 1971. Exhibition catalogue.

206. Shterenberg, David. "Die künstlerische Situation in Russland." *Das Kunstblatt* (Berlin), no. 11, November 1922, pp. 485–92.
Shterenberg, David. Autobiography: R177 (vol. 1).
Other works by: 197, 206, and consult R66, R73, R489.
Works on: R186, R434, R434ix.
Ternovetz, Boris. See 198.

207. Umanskij, Konstantin. "Die neue Monumentalskulptur in Russland." *Der Ararat* (Munich), no. 5/6, 1920, pp. 29–33.
Reprinted in modified form in bibl. 82.

208. Westheim, Paul. "Die Ausstellung der Russen." *Das Kunstblatt* (Berlin), no. 11, November 1922, pp. 493–98.

209. Wollen, Peter. "Art in Revolution: Russian Art in the Twenties." *Studio International* (London), vol. 181, no. 932 (April 1971), 149–54.

209i. *Art for the Masses. Russian Revolutionary Art from the Merrill C. Berman Collection.* Williamstown: Williams College Museum of Art, and other cities, 1985. Exhibition catalogue.

209ii. Bowlt, John E., ed. *Soviet Union.* Tempe: Arizona State University, 1980, vol. 7, parts 1–2. Special issue devoted to Soviet art of the 1920s.

209iii. *Dada Constructivism.* London: Annely Juda Fine Art, 1984. Exhibition catalogue.

209iv. Dragone, Pier Giorgio et al., eds. *Arte e rivoluzione. Documenti delle avanguardie tedesche e sovietiche 1918–1932.* Milan: Unicopli, 1978.

209v. Etkind, Mark. *Nathan Altman.* Dresden: VEB, 1984. Bibl.

209vi. *The First Russian Show.* London: Annely Juda Fine Art, 1983. Exhibition catalogue.

209vii. Flaker, Aleksandr et al., eds. *Knijevnost avangarda revolucija.* Zagreb: University of Zagreb, 1981.

209viii. Gassner, Hubertus and Gillen, Eckhart, eds. *Zwischen Revolutionskunst und Sozialistischen Realismus. Dokumente und Kommentare. Kunstdebatten in der Sowjetunion von 1917 bis 1934.* Cologne: DuMont, 1979. Bibl.

209ix. Gleason, Abbott et al., eds. *Bolshevik Culture.* Bloomington: Indiana University Press, 1985.

209x. Graham, Loren R. and Stites, Richard, eds. *Red Star. The First Bolshevik Utopia by Alexander Bogdanov.* Bloomington: Indiana University Press, 1985.

209xi. Guerman, Michail. *Art of the October Revolution.* New York: Abrams, 1979. Editions also in Russian, German and French.

209xii. Magarotto, Luigi et al., eds. *L'Avanguardia a Tiflis.* Venice: Università degli Studi, 1982.

209xiii. Milner, John. *Russian Revolutionary Art.* London: Oresko, 1979.

209xiv. Nilsson, Nils Ake, ed. *Art, Society, Revolution. Russia 1917–1921.* Stockholm: Almqvist and Wiksell, 1979.

209xv. O'Connor, Timothy Edward. *The Politics of Soviet Culture. Anatolii Lunacharskii.* Ann Arbor: University Microfilms International, 1983. Bibl.

209xvi. Peters, Jochen-Ulrich. *Kunst als organisierte Erfahrung.* Munich: Fink, 1980.

V. Constructivism and the Industrial Arts

(Note: in addition to the specific titles listed below and in the Russian section of the Bibliography, the reader is advised to consult the journals R61, R71, R76, and R84.)

CONSTRUCTIVISM

Andersen, Troels. See 27, 230.

210. *Architectural Design* (London), vol. 40, no. 2 (February 1970).

Whole issue devoted to constructivist architecture in the U.S.S.R.

211. Bann, Stephen, ed. *The Constructivist Tradition.* New York: Viking, 1974. Bibl.

212. Elderfield, John. "Constructivism and the Objective World: An Essay on Production Art and Proletarian Culture." *Studio International* (London), vol. 180, no. 923 (September 1970), 73–80.

213. Elderfield, John. "Line of Free Men: Tatlin's 'Towers' and the Age of Invention." *Studio International* (London), vol. 178, no. 916 (November 1969), 162–67.

214. Elderfield, John. "On Constructivism." *Artforum* (New York), vol. 9, no. 9 (May 1971), 57–63.

215. Gabo, Naum. "The Constructive Idea in Art." In *Circle,* edited by J. L. Martin, Ben Nicholson, N. Gabo, pp. 1–10. London: Faber and Faber, 1937. Reprint; 1971; also New York: Praeger, 1971.

216. Gabo, Naum. *Gabo: Constructions, Sculpture, Paintings, Drawings, Engravings.* London: Lund Humphries; Cambridge, Mass.: Harvard University Press, 1957.

Essays by Herbert Read and Leslie Martin.

Gabo, Naum. Works by: 211, 215, 216.

Biography: 222.

Other works on: 216, 221, 230iii.

Bibl. information: 216, 226.

Gan, Aleksei. Some biographical information 230ix.

Works by: 211, R372, R437, R438, R465, R466.

217. Gollerbakh, Erich. *Prospectus. The Construction of Architectural and Machine Forms by Jacob Tchernikhov.* Leningrad: Society of Architects of Leningrad, 1931.

218. Kállai, Ernst. "Konstruktivismus." *Jahrbuch der Jungen Kunst* (Leipzig), vol. 5, 1924, 374–84.
219. Massat, René. *Antoine Pevsner et le Constructivisme.* Paris: Caractères, 1956.
220. Matsa, Ivan. "Constructivism: an Historical and Artistic Appraisal." *Studio International* (London), vol. 183, no. 943 (April 1972), 142–44.
 Shortened translation of R442.
221. Olson, Ruth, and Chanin, Abraham. *Naum Gabo—Antoine Pevsner.* New York: Museum of Modern Art, 1948.
222. Pevsner, Alexei. *Naum Gabo and Antoine Pevsner: A Biographical Sketch of My Brothers.* Amsterdam: Augustin and Schoonman, 1964.
 Pevsner, Antoine. Biography: 222.
 Other works on: 219, 221.
 Bibl information: 226.
223. Quilici, Vieri. *L'Architettura del construttivismo.* Bari: Laterza, 1969.
224. Rathke, Ewald. *Konstruktive Malerei, 1915–1930.* Hanau: Peters, 1967.
 Reprint of catalogue for exhibition at Frankfurter Kunstverein, November 1966–January 1967. With introduction by Eckhard Neumann.
225. Rathke, Ewald, and Neumann, Eckhard. "Constructivism 1914–1922." *Art and Artists* (London), vol. 5, no. 4 (July 1970), 12–15.
226. Rickey, George. *Constructivism: Origins and Evolution.* New York: Braziller; London: Studio Vista, 1967. Bibl.
227. Rodtchenko, Alexandre. "Vladimir Tatlin." *Opus International* (Paris), no. 4, December 1967, pp. 15–18.
228. Sharp, Dennis, ed. "Constructivism." *RIBA Journal* (London), vol. 78, no. 9 (September 1971), 382–92.
229. Sprague, Arthur. "Chernikov and Constructivism." *Survey* (London and New York), no. 39, December 1961, pp. 69–77.
230. *Vladimir Tatlin.* Compiled by Troels Andersen. Stockholm: Moderna Museet, 1968. Exhibition catalogue. Bibl.
 Tatlin, Vladimir. Works by: 211, R447.
 Biography: 230.
 Works on: 213, 227, 230, 230ii, 230x, 230xiii, R184, R444, R445, R450i.
 Bibl. information: 230.
 Book illustrations: R296, R312.
230i. Bowlt, John E., ed. *Soviet Union.* Pittsburgh: University of Pittsburgh, 1976, vol. 3, part 2. Special issue devoted to Constructivism.
230ii. Bowlt, John E. "Un voyage dans l'espace: l'oeuvre de Vladimir Tatlin," *Cahiers du Musée d'Art Moderne.* Paris, 1979, no. 2, pp. 216–27.
230iii. *Gabo.* Dallas: Dallas Museum of Art, 1985. Exhibition catalogue. Bibl.
230iv. Goheen, Ellen, ed. *The Nelson-Atkins Museum of Art Bulletin.* Kansas City: Nelson-Atkins Museum, 1982. Special issue devoted to Constructivism and the geometric tradition.

230v. Grübel, Rainer Georg. *Russische Konstruktivismus.* Wiesbaden: Harrassow-itz, 1981. Bibl.

230vi. Harrison, Gail. *Ex Libris 6. Constructivism and Futurism in Russian and Others.* New York: TJ Art, 1977. Bibl.

230vii. Kopp, Anatole. *Constructivist Architecture in the USSR.* London: Academy Editions, 1985. Bibl.

230viii. Leclanche-Boule, C. *Typographies, Photomontages Constructivistes.* Paris: Papyrus, 1984.

230ix. Lodder, Christine. *Russian Constructivism.* New Haven: Yale University, 1983. Bibl.

230x. Milner, John. *Vladimir Tatlin and the Russian Avant-Garde.* New Haven: Yale University, 1983. Bibl.

230xi. *2 Stenberg 2. The "Laboratory" Period (1919–1921) of Russian Constructivism.* Paris: Galerie Jean Chauvelin, 1975. Exhibition catalogue.

230xii. Tellini, Anna, ed. *Il'ja Erenburg. Eppur si muove! Per una internazionale construttivista.* Rome: Officina Edizioni, 1983.

230xiii. Zsadova, Larisza et al. *Tatlin.* Budapest: Corvina, 1984. Bibl.

THE INDUSTRIAL ARTS AND ARCHITECTURE

Arvatov, Boris. Works by: 211, R259, R373–77, R455–58, R490, and consult R76, R79.
Some biographical details: 230ix, R435.

231. Badovici, Jean, et al. *L'Architecture russe en URSS.* 1ère et 2me séries. Paris: Albert Morancé, n.d.

232. Birnholz, Alan. "El Lissitzky." *Artforum* (New York), vol. 11, no. 1 (September 1972), 70–76.

233. Birnholz, Alan. "Lissitzky's Writings on Art." *Studio International* (London), vol. 183, no. 942 (March 1972), 90–92.

234. Bojko, Szymon. "Collages et photomontages oubliés de A. Rodtchenko." *Opus International* (Paris), Fall 1970, pp. 30–35.

Brik, Osip. Works by: R383, R460, R461, and consult R73, R76.
Biography: 252v.

Chernikhov, Yakob. Works by: 235, R483–85.
Work on: 229.

235. Conrads, Ulrich, and Sperlich, H., eds. *The Architecture of Fantasy.* Translated from the German by Christiane Crasemann Collins and George R. Collins. New York: Praeger, 1962; London: Architectural Press, 1963.
German edition: *Phantastische Architektur.* Stuttgart: Hatje, 1960.

236. dal Co, Francesco, et al. "L'Architecture et l'avant-garde artistique en URSS de 1917 à 1934." *VH 101* (Paris), no. 7/8, Spring 1972.
Whole issue devoted to early Soviet architecture.

237. *Exposition Internationale des Arts décoratifs et industriels modernes: Section*

russe: l'art décoratif et industriel de l'URSS. Paris: Ministère du Commerce et d'Industrie des Postes et des Telegraphes, 1925. Exhibition catalogue.

238. de Feo, Vittorio. *URSS. Architettura 1917–1936.* Rome: Editori Riuniti, 1963.

239. Fiz, Simón. "El Lissitzky (1890–1941): de la pintura a la arquitectura." *Goya* (Madrid), no. 108, 1972, pp. 362–69.

240. Frampton, Kenneth. "Notes on a Lost Avant-Garde: Architecture, U.S.S.R., 1920–30." In *Avant-Garde Art,* edited by Thomas B. Hess and John Ashbery, pp. 107–24. New York and London: Collier-Macmillan, n.d.
 Volume based on: *The Avant-Garde. Art News Annual,* no. 34. New York: Macmillan, 1968.

241. Jadova, L. "Rodtchenko." *Les Lettres françaises* (Paris), no. 1162 (December 22–29, 1966), pp. 17–19.

242. Khan-Mahomedov, Selim. "Creative Trends 1917–1932 in Russia." *Architectural Design* (London), no. 40, February 1970, pp. 71–76.

243. Kopp, Anatole. *Town and Revolution: Soviet Architecture and City Planning 1917–1935.* Translated from the French by Thomas Burton. London: Thames and Hudson; New York: Braziller, 1970. Bibl.
 French edition: *Ville et Révolution.* Paris: Anthropos, 1967.

244. Licht, Jennifer. "Rodchenko, Practicing Constructivist." *Art News* (New York), vol. 70, no. 2 (April 1971), 60–63.

245. Linhart, Lubomir. Alexander Rodčenko. Prague: Státní nakladatelství krasne literatury a umění, 1964.

246. Lissitzky, El. "New Russian Art—a Lecture Given in 1922." *Studio International* (London), vol. 176, no. 904 (October 1968), 146–51.

247. Lissitzky-Küppers, Sophie. *El Lissitzky: Life, Letters, Texts.* Translated from the German by Helene Aldwinckle and Mary Whittall. London: Thames and Hudson; Greenwich, Conn.: New York Graphic Society, 1968. Bibl.
 German edition: *El Lissitzky—Maler, Architekt, Typograf, Fotograf.* Dresden: Verlag der Kunst, 1967.

248. Lissitzky, El. *An Architecture for World Revolution.* Translated from the German by Eric Dluhosch. Cambridge, Mass.: MIT, 1970. This edition also contains an appendix of reports concerning architecture and urbanism, 1928–33.
 German edition: *Russland. Die Rekonstruktion der Architektur in der Sowjetunion.* Vienna: Schroll, 1930. Reissued as: *Russland: Architektur für eine Weltrevolution.* Berlin: Ullstein, 1965.

Lissitzky, El. Works by: 176, 211, 246, 247, 248, 252xiii.
 Biography: 247.
 Works on: 232, 233, 239, 247, 252xiv, 252xvi.
 Bibl. information: 247.

249. Nakov, Andrei. "Alexander Rodcenko. Beyond the Problematics of Pictorialism." *Arts Magazine* (New York), vol. 47, no. 6 (April 1973), 26–33.

Nakov, Andréi. See 249, 252.

Rodchenko, Aleksandr. Work by: 227, R489vi.

Biography: 245, 252x.

Other works on: 234, 241, 249, 252xii, 252xvii, 252xviii, 252xix, 252xx, 252xxii, R451, R452, R463, R474, R488.

250. Rosa, Alberto, et al. *Socialismo, città, architettura URSS 1917–1937*. Rome: Officina, 1971.

Stepanova, Varvara. Works by: R436, R463.

Some biographical information: R475.

Works on: 176ix, 176xvii, 252xi, 252xxii.

251. Shidkovsky, Oleg, et al. *Building in the USSR, 1917–1932*. London: Studio Vista, 1971.

252. Taraboukine, Nikolai. *Le Dernier Tableau*. Presented by Andréi Nakov; translated from the Russian by Andréi Nakov and Michel Pétris. Paris: Editions Champ Libre, 1972.

Vesnin, Aleksandr. Works by: R489i, R489ii.

Works on: 252vi, 252xxiv, R489vii, R489viii.

252i. *Architettura nel paese dei Soviet 1917–1933*. Rome: Palazzo dell 'Esposizioni, 1982. Exhibition catalogue.

252ii. *Art into Production*. Oxford: Museum of Modern Art, 1984. Exhibition catalogue.

252iii. Bablet, Denis. *Revolutions in Stage Design of the XXth Century*. Paris and New York: Ameil, 1977.

252iv. Bablet, Denis, ed. *Les Voies de la Création Théâtrale. Mises en scène années 20 et 30*. Paris: CNRS, 1979. Bibl.

252v. Barooshian, Vahan. *Brik and Mayakovsky*. The Hague: Mouton, 1978. Bibl.

252vi. Chan-Magomedov, Selim. *Pioniere der sowjetischen Architektur*. Dresden: VEB, 1983. Bibl. English translation: *Pioneers of Soviet Architecture*. London: Thames and Hudson, 1987. Bibl.

252vii. Chernikhov, Andrei: "Artist Show Us Your World. Iakov Chernikhov 1889–1951" in Catherine Cooke, ed. *Russian Avant-Garde. Art and Architecture*. London: Academy Editions, 1983.

252viii. *La Città Macchina. Progetti di Sant'Elia e Tchernikov*. Vicenza: Assessorato Cultura, 1973.

252ix. Cooke, Catherine. *Chernikhov. Fantasy and Construction*. London: Architectural Design Profile, 1984. Bibl.

252x. Karginov, German. *Rodcsenko*. Budapest: Corvina, 1975 (and subsequent editions in Fench and English). Bibl.

252xi. Lavrentiev, Alexander. "The Graphics of Visual Poetry in the Work of Varvara Stepanova" in *Grafik*. Budapest, 1982, no. 1, pp. 46–51.

252xii. Lavrentjev, Aleksandr and Gassner, Hubertus. *Rodčenko. Fotografien*. Munich: Schirmer/Mosel, 1982. Bibl.

252xiii. Lissitzky, El: *Proun und Wolkenbügel*. Dresden: VEB, 1981.

252xiv. *Lissitzky*. Cologne: Galerie Gmurzynska, 1976. Exhibition catalogue.

252xv. *Maiakovski. 20 ans de travail.* Paris: Centre Georges Pompidou, 1975. Exhibition catalogue.

252xvi. Mansbach, Steven. *Visions of Totality.* Ann Arbor: University Microfilms International, 1980. Bibl.

252xvii. *Rodchenko and the Arts of Revolutionary Russia.* Oxford: Museum of Modern Art, 1978. Exhibition catalogue.

252xviii. *Rodcenko/Stepanova.* Perugia: Palazzo dei Priori, and elsewhere, 1984. Exhibition catalogue.

252xix. *Rodtschenko. Fotografien 1920–1938.* Cologne: Museum Ludwig, 1978. Exhibition catalogue.

252xx. Rodtschenko, Warwara and Lawrentjew, Alexander. *Alexander Rodtschenko.* Dresden: VEB, 1983.

252xxi. Sasaki, Hiroshi. "The Best of the Constructivists. Tchernykhov and His Design" in *Process. Architecture.* Tokyo, 1981, no. 26, pp. 7–22. Bibl. (In Japanese).

252xxii. *Von der Malerei zum Design/From Painting to Design.* Cologne: Galerie Gmurzynska, 1981. Exhibition catalogue.

252xxiii. *Die 20er Jahre in Osteuropa/The 1920s in Eastern Europe.* Cologne: Galerie Gmurzynska, 1975. Exhibition catalogue.

252xxiv. Khan-Magomedov, Selim. *Alexander Vesnin and Russian Constructivism.* New York: Rizzoli, 1986.

VI. Toward Socialist Realism

(Note: for detailed references to the development of socialist realism in the visual arts, the reader is advised to consult the Soviet art publications of the 1930s, 1940s, and 1950s that deal specifically with the history and interpretation of Russian and Soviet painting and sculpture, particularly the journals *Iskusstvo* [Art] (Moscow), 1933– and *Tvorchestvo* [Creation] (Moscow), 1934–. For an interesting perspective on the formation and advocacy of socialist realism, the reader is advised further to consult the catalogues of Soviet art exhibitions not only in the U.S.S.R., but also in Western Europe and the United States, of which there were many during the late 1920s and early 1930s; references to such exhibitions can be found in bibl. R152, vols. 1, 2, and 3.)

AKhRR. Works on: R493, R496, and consult 264, R16, R58, R70.
 Bibl. Information: R493.

253. Alpetin, M., ed. "Painting, Sculpture and Graphic Art in the USSR." *VOKS. Bulletin of the USSR Society for Cultural Relations with Foreign Countries* (Moscow), vol. 9/10, 1934.
 Whole issue devoted to the subject.

254. Andersen, Troels. "Pavel Nikolajevič Filonov." *Signum* (Gyldendal), no. 4, 1963, pp. 20–31.
255. Annenkov, Yuri. "Soviet Art and Socialist Realism." *Studies on the Soviet Union* (Munich), vol. 7, no. 2 (November 1967), 152–57.
256. Bowlt, John E. "The Virtues of Soviet Realism." *Art in America* (New York), vol. 60, no. 6 (November 1972), 100–107.
257. Bowlt, John E. "Pavel Filonov." *Studio International* (London), vol. 186, no. 957 (July/August 1973), 30–36.
258. Burliuk, David. "Filonov." *Color and Rhyme* (Hampton Bays, N.Y.), no. 28, 1954.
 Whole issue devoted to Filonov.
259. Davies, Ivor. "Red Art 1917–1971." *Art and Artists* (London), vol.6., no. 1 (April 1971), 10–15.
 Filonov, Pavel. Works by: 257, 272iii, R508, R509.
 Biography: 263, 272iii.
 Bibl. information: 263.
 Book illustrations: R273, R347, R353.
 Four Arts Society. Some details: R22, R108, R515.
260. Hiepe, Richard. *Die Kunst der neuen Klasse.* Munich: Bertelsmann, 1973.
261. Higgens, Andrew. "The Development of the Theory of Socialist Realism in Russia, 1917 to 1932." *Studio International* (London), vol. 181, no. 932 (April 1971), 155–59.
262. Holme, Charles, ed. *Art in the USSR.* London: Studio Special, 1935.
263. Křiž, Jan. *Pavel Nikolajevič Filonov.* Prague: Nakladatelství československých výtvarných umělců, 1966. Bibl.
264. Lamač, Miroslav. "Filonov a jeho škola." *Výtvarné umění* (Prague), no. 3, 1967, pp. 126–45.
265. Lehmann-Haupt, Hellmut. *Art Under a Dictatorship.* New York: Oxford University, 1964.
266. London, Kurt. *The Seven Soviet Arts.* London: Faber and Faber, 1937; New Haven: Yale University, 1938.
 October Association. Works by: R500, R501.
 Some details: R16, R22.
 Society of Easel Artists (OST). Some details: R108, R182.
 Works on: 272i, R515iii.
267. *Soviet Painting. 32 Reproductions of Paintings by Soviet Masters.* Moscow and Leningrad: State Art Publishers, 1939.
268. Vaughan James, C. *Soviet Socialist Realism: Origins and Theory.* London: Macmillan, 1973. Bibl.
269. Weidle, Vladimir. "Art Under the Soviet Régime." *Studies on the Soviet Union* (Munich), vol. 7, no. 2 (November 1968), 135–51.
270. Winter, Ella. "Art under Communism Today." *Art News* (New York), vol. 57, no. 8 (December 1958), 34–37, 58–59.

271. Wright, A. "Some Aspects of Twentieth Century Russian Painting." *Canadian Slavonic Papers* (Ottawa), vol. 11, no. 4 (1969), 407–23.

272. Zhdanov, Andrei, et al. *Problems of Soviet Literature. Reports and Speeches at the First Soviet Writers' Congress*. Edited by H. G. Scott. New York: International Publishers, 1935.
 This is a much abridged version, in translation, of bibl. R498.

272i. Bowlt, John E. "The Society of Easel Artists (OST)" in *Russian History*. Tempe: Arizona State University, 1982, vol. 9, parts 2–3, pp. 203–26.

272ii. Fitzpatrick, Sheila, ed. *Cultural Revolution in Russia, 1928–1931*. Bloomington: Indiana University Press, 1978.

272iii. Misler, Nicoletta and Bowlt, John E. *Pavel Filonov. A Hero and His Fate*. Austin: Silvergirl, 1983. Bibl.

272iv. Koch, Hans. *Zur Theorie des sozialistischen Realismus*, Berlin: Dietz, 1974.

272v. Willett, John. *L'Avanguardia europea. Anni venti a Mosca e a Weimar*. Rome: Editori Riuniti, 1983 (a translated version of *The New Sobriety*. London: Thames and Hudson, 1978). Bibl.

Библиография: второй отдел

i. Источники. Библиография.

R 1. Аркин. Д. и др. (ред.): «Мастера искусства об искусстве; избранные отрывки из писем, дневников, речей и трактатов в 4 томах», т. 4, М., 1937.

R 2. Белоусова, Н. и др.: «Материалы к библиографии по истории Академии художеств. 1757-1957», Л., 1957.

R 3. Беляев, Л. и др.: «Библиография периодических изданий России, 1901-1916», Л., 1958-1961.

R 4. Бродский, Н. (ред.): «Литературные манифесты (от символизма к Октябрю)». Сборник материалов. М., 1929; Гаага, Голландия, 1969.

R 5. Вольценбург, О.: «Библиография изобразительных искусств», Пг. 1923.

R 6. Вольценбург, О. и др. (ред.): «Художники народов СССР. Биобиблиографический словарь в шести томах», т. I (ААВИК-БОЙКО), М., 1970; т. 2 (БОЙЧЕНКО-ГЕОНДЖИАН), М., 1972.

R 7. Губер, А. и др. (ред.): «Мастера искусства об искусстве», кн. 7 (Искусство народов СССР, XIX-XX вв.), М., 1970.

R 8. Дульский, П.: «Обзор журналов по искусству», Казань, 1914.

R 9. Жевержеев, Л.: «Опись памяти русского театра» (с биографиями художников), Пг., 1915.

R10. Зыкин, В. (ред.): «Летопись печатных произведений изобразительного искусства», М., 1934- (4 раза в год).

R11 «Книжная летопись Главного Управления по делам печати», СПб., 1908 + После июня, 1917 вторая часть названия переименовывается; после августа, 1920 выходит в М.

R12. Лаврский, Н.: «Указатель книг и статей по вопросам искусства», М., 1919.

R13. Лебедев, П. (ред.): «Борьба за реализм в изобразительном искусстве '20х годов». Материалы, документы, воспоминания, М., 1962.

R14. Марков, В. (ред.): «Манифесты и программы русских футуристов», Мюнхен, 1967.

R15. Маца, И. и др. (ред.): «Ежегодник литературы и искусства», М., 1929.

R16. Маца, И. и др. (ред.): «Советское искусство за 15 лет», М.-Л., 1933.

R17. Мейерхольд, В.: «Статьи, письма, речи, беседы». Две книги, М., 1968.

R18. Муратова, К.: «Периодика по литературе и искусству за годы революции, 1917-1932», Л., 1933.

R19. Острой, О.: «Русские справочные издания по изобразительному и прикладому искусству», М., 1972.

R20. «Центральный государственный архив литературы и искусства СССР», выпуск 1 (театр, музыка, кино, живопись), М., 1960; выпуск 3 (литература, живопись, театр), М., 1968.

R21. Хазанова В.: «Советская архитектура первых лет Октября 1917-1925 гг.», М., 1970.

R22. Хазанова, В. (сост.): «Из истории советской архитектуры, 1926-1932». Документы и материалы, М., 1970. Библ.
 Также см. «Из истории советской архитектуры 1917-1925», М., 1963, которая является основой R21.

R23. Юфин, А. (ред.): «Русский советский театр». Документы и материалы, 1917-1921, Л., 1968.

R23i. Абдусаматов, Ш. и др. (ред.): «Краткая литературная энциклопедия». М., 1978. Доб. том.

R23ii. Денисова, Л. и Беспалов, Н. (ред.): «Русская советская художественная критика 1917-1941». М., 1982.

ii. Общие труды по истории русского искусства

R24. Айналов, Д.: «История русской живописи от 16-го века», Спб., 1913.

R25. Асафьев, Б.: «Русская живопись», Л.-М., 1966.

R26. Бенуа, А.: «История живописи в XIX веке: Русская живопись», СПб., 1901. Продолжение: «История русской живописи в XIX веке», СПб., 1902. Библ.

R27. Бенуа, А.: «Русская школа живописи», Спб., 1904.

R28. Бенуа, А.: «История живописи всех времен и народов», СПб., 1912 (-17).

R29. Глаголь, С.: «Очерк истории искусства в России», М., 1913.

R30. Голлербах, Э.: «История гравюры и литографии в России», М.-Пг., 1923; Анн Арбор, США., 1948. Библ.

R31. Грабарь, И.: «История русского искусства», тт. 1-6, М., 1910-1915.

R32. Грабарь, И. (ред.): «История русского искусства», тт. 1-13, М., 1953-1969. Библ.

R33. Зотов, А. и Сопоцинский, О.: «Русское искусство. Исторический очерк», М., 1963.

R34. Иоффе, И.: «Синтетическая история искусств», Л., 1933.

R35. Никольский, В.: «Русская национальная живопись», Пг., 1916.

R36. Никольский, В.: «История русского искусства», Берлин, 1923. Библ.

R37. Новицкий, А.: «История русского искусства с древнейших времен». В двух томах, М., 1903. Библ.

R38. Пикулев, И.: «Краткая история русского изобразительного искусства», М., 1962.

R39. Тагер, Е.: «Русское искусство», М.-Л., 1938.

R40. Эфрос, А.: «Два века русского искусства», М., 1969.

R40i. Милотворская, М. (ред.): «История русского искусства». М., 1981. 2 тт.

R40ii. Сыркина, Ф. и Костина, Е.: «Русское театрально-декорационное искусство». М., 1978.

iii. Журналы по искусству:
1890-1917 гг.

R41. Аполлон, Спб., 1909-1917 (1918).
R42. Баян, М., 1914.
R43. В мире искусств, Киев, 1907-1910.
R44. Весы, М., 1904-1909.
R45. Золотое руно, М., 1906-1909 (1910).
R46. Искусство, М., 1905.
R47. Искусство. (живопись, графика, художественная печать), Киев, 1911-1912.
R48. Искусство, Пг., 1916.
R49. Искусство в южной России, Киев, 1913-1914.
R50. Искусство и жизнь, Пг., 1915-1916.
R51. Искусство и печатное дело, Киев, 1909-1910.
R52. Искусство и художественная промышленность, Спб., 1898-1902.
R53. Мир искусства, Спб., 1898-1904.
R54. Млечный путь, М., 1914-1916.
R55. Московские мастера, М., 1916 (один номер).
R56. Перевал, М., 1906-1907.
R57. София, М., 1914.

1917-1930 гг.

R58. Бригада художников, М., 1931-1932.
R59. Вестник искусств, М., 1922.
R60. Вестник работников искусств (РАБИС), М., 1920-1934.
R61. Вещь, Берлин, 1922.
R62. Горн, М., 1918-1923.
R63. Грядущее, Пг., 1918-1921.
R64. Жар птица, Берлин, 1921-1926.
R65. Жизнь искусства, М., 1921-1922; Л., 1923-1929.
R66. Изобразительное искусство, Пг., 1919.
R67. Искусство (Вестник отдела ИЗО Наркомпрос), М., 1919.
R68. Искусство, Витебск, 1921.
R69. Искусство (Журнал Гос. Акад. Худ. Наук), М., 1923-1928.
R70. Искусство в массы, М., 1929-1930.
R71. Искусство и промышленность, М., 1924.
R72. Искусство и труд, М., 1921-1922.
R73. Искусство коммуны, Пг., 1918-1919.
R74. Искусство трудящихся, М., 1924-1926.
R75. Куранты, Тифлис, 1919.
R76. Леф, М., 1923-1925; Новый леф, М., 1927-1928.
R77. Маковец, М., 1922.
R78. Нова генерация, Харьков, 1927-1930 (на украинском яз.).

R79. Печать и революция, М., 1921-1930.
R80. Пролетарская культура, М., 1918-1921.
R81. Революция и культура, М., 1927-1930.
R82. Русское искусство, М.-Л., 1923.
R83. Советское искусство, М.-Л., 1926-1928.
R84. Современная архитектура, (СА), М., 1926-1930.
R85. Творчество, М., 1918-1922.
R86. Художественная жизнь, М., 1919-1920.
R87. Художественный труд, М., 1923.

iv. Общие труды по периоду 1890-1930 гг:
 1890-1920 гг.

R88. «История русского искусства», том X (Русское искусство конца XIX-нач. XX века), Академия наук, кн. 1, М., 1968; кн. 2, М., 1969. Библ.
R89. Аладжалов, С.: «Георгий Якулов», Ереван, 1971.
R90. Альфонсов, В.: «Слова и краски», М.-Л., 1966.
R91. Антонова, А. и Пружан, И. (сост.): «Русский и советский натюрморт», Каталог выставки, Л., 1969.
R92. Бенуа, А.: «Жизнь художника. Воспоминания», тт. I и II, Нью-Йорк, 1955.
R93. Бердяев, Н.: «Кризис искусства», М., 1918.
R94. Воинов, В.: «Русская литография за 25 лет», Пб., 1923.
R95. Головин, А.: «Встречи и впечатления. Письма. Воспоминания о Головине» (сост. А. Мовшенсон), Л.-М., 1960.
R96. Гомберг-Вержбинская, Э.: «Русское искусство и революция 1905 г.», Л., 1960.
R97. Грабарь, И.: «Моя жизнь. Автомонография», М.-Л., 1937. Библ.
R98. Грищенко, А.: «О связях русской живописи с Византией и Западом XIII-XX вв. Мысли живописца», М., 1913.
R99. Грищенко, А.: Вопросы живописи. Вып. 2. «Как у нас преподают живопись и что под ней надо разуметь», М., 1915.
R100. Грищенко, А.: Вопросы живописи. Вып. 4. «'Кризис искусства' и современная живопись. По поводу лекций Н. Бердяева», М., 1917.
R101. Дьяконицын, Л.: «Идейные противоречия в эстетике русской живописи конца 19-нач. 20 вв.», Пермь, 1966.
R102. Евреинов, Н.: «Оригинал о портретистах. К проблеме субъективизма в искусстве», М., 1922.
 Отделы о Д. Бурлюке, Добужинском, Кульбине и др.
R103. Зильберштейн, И. и Самков, В.: «Валентин Серов в воспоминаниях, дневниках и переписке современников», Л., 1971 (2 тт.).
R104. Коваленская, Т.: «Искусство второй половины XIX-начала XX века», М., 1970.
R105. Коровин, К.: «Жизнь и творчество. Письма. Документы. Воспоминания» (сост. Н. Молева), М., 1963.
R106. Комарденков, В.: «Дни минувшие. Воспоминания», М., 1972.
R107. Лаврский, Н.: «Искусство и евреи», М., 1915.

R108. Лобанов, В.: «Художественные группировки за последние 25 лет», М., 1930.

R109. Лобанов, В.: «Кануны. Из художественной жизни Москвы в предреволюционные годы», М., 1968.

R110. Маковский, С.: «Страницы художественной критики», кн. II, Спб., 1909; кн. III, СПБ., 1913.

R111. Маковский, С.: «Силуэты русских художников», Прага, 1922.

R112. Маковский, С.: «Портреты современников», Нью-Йорк, 1955.

R113. Маковский, С.: «На парнасе серебряного века», Мюнхен, 1962.

R114. Маковский, С. (ред.): «Современная графика. Сборник», Пг., 1917.

R115. Машковцев, Н. и Соколова, Н. (ред.): «Очерки по истории русского портрета конца XIX-начала XX века», М., 1964.

R116. Милюков, П.: «Очерки по истории русской культуры», т. II, ч. II, Париж, 1931, стр. 533-602.
 Английский перевод — 60.

R117. «Мир искусства». Выставки. Каталоги, СПб. и М., 1899-1906.

R118. Молева, Н. и Белютин, Э.: «Русская художественная школа второй половины XIX-нач. XX века», М., 1967.

R119. «Московское товарищество художников». Выставки. Каталоги, М., 1894-1924.

R120. «Новое общество художников». Выставки. Каталоги, СПб., 1904-1915.

R121. Перцов, П.: «Литературные воспоминания, 1890-1902», М.-Л., 1933.

R122. Подобедова, О.: «Игорь Грабарь», М., 1964.

R123. Пожарская, М.: «Русское театрально-декорационное искусство конца XIX-начала XX века», М., 1970.

R124. Пружан, И.: «К. А. Сомов», 1972.

R125. Пружан, И. и Пушкарев, В.: «Натюрморт в русской и советской живописи», Л., 1971.

R126. Пушкарев, В. и др.: «Русский эстамп конца XIX-начала XX вв.» Каталог выставки, Л., 1967.

R127. Пяст, В.: «Встречи», М., 1929.

R128. Радлов, Н.: «От Репина до Григорьева», Пб., 1923.

R129. Ракова, М. (автор вступ. статьи): «Русский натюрморт конца 19-начала 20 века», М., 1970.

R130. Редько, А.: «Литературно-художественные искания в конце XIX-начале XX века», Л., 1924.

R131. Рылов, А.: «Воспоминания», Л., 1960.

R132. «Салон». Каталог Интернациональной выставки картин, скульптуры, гравюры и рисунков. Выставка орг. В. Издебским, Одесса и др. города, 1909-1910.

R133. «Салон 2». Международная художественная выставка орг. В. Издебским. Каталог, Одесса, 1910-1911.

R134. «Салон». Орг. С. Маковским. Каталог, СПб., 1909.

R135. Сарабьянов, Д.: «Очерки русской живописи конца 1900-х-нач. 1910-х гг.», М., 1971
 Отделы о В. Серове, Петров-Водкине, П. Кузнецове, Сарьяне, Ларионове и Фальке.

R136. Сарьян, М.: «Из моей жизни», М., 1970.

R137. Сидоров, А.: «Записки собирателя», М., 1969.

R138. Сидоров, А.: «Русская графика начала XX века», М., 1970. Библ.

R139. Соколова, Н. и др.: «Пути развития русского искусства конца XIX-начала XX века», М., 1972.

R140. «Союз русских художников». Выставки. Каталоги, М., СПб. и Киев, 1903-1923.

R141. Стернин, Г.: «Художественная жизнь России на рубеже XIX-XX веков», М., 1970.

R142. «Труды Всероссийского съезда художников в Петрограде. Дек., 1911-янв., 1912», Пг., 1914-1915, тт. I-III.

R143. Федоров-Давыдов, А.: «Русское искусство промышленного капитализма», М., 1929. Библ.

R144. Щербатов, С.: «Художник в ушедшей России», Нью-Йорк, 1955.

R145. Эткинд, М.: «Русское искусство конца XIX-начала XX века», М., 1968.

R145i. Александрова, Н. (ред.): «Александр Бенуа. Мои воспоминания». М., 1979. 2 тт.

R145ii. Власова, Р.: «Русское театрально-декорационное искусство начала XX века». Л., 1984.

R145iii. Добужинский, М.: «Воспоминания». Нью-Йорк, 1976.

R145iv. Зильберштейн, И. и Самков, В. (сост.): «Сергей Дягилев. Литературное наследие». М., 1982. 2 тт.

R145v. Каждан, Т. и др. (сост.): «Игорь Грабарь. Письма». М., 1974, т. I, 1891-1917; 1977, т. 2, 1917-1941; 1983, т. 3, 1941-1960.

R145vi. Пастернак, Л.: «Записи разных лет». М., 1975.

R145vii. Подкопаева, Ю. и др. (сост.): «Константин Андреевич Сомов». М., 1979.

1910-1930 гг.

R146. «История русского искусства», т. II (Искусство 1917-1920 годов; Искусство 1921-1934 годов), Академия наук, М., 1957. Библ.

R147. Анненков, Ю.: «Портреты» (текст Е. Замятина), Пг., 1922.

R148. Анненков, Ю.: «17 портретов» (пред. А. Луначарского), М.-Л., 1926.

R149. Бубнова, Л. (ред.): «Петр Митурич», М., 1973.

R150. Буш, М. и Замошкин, А.: «Путь советской живописи, 1917-1932», М., 1933.

R151. Воинов, В. (и др.): «Графическое искусство в СССР., 1917-1927». Сборник статей, Л., 1927. Библ.

R152. «Выставки советского изобразительного искусства», т. 1, 1917-1932, М., 1965.

R153. Гиляровская, Н.: «Театрально-декорационное искусство за 5 лет», Казань, 1924.

R154. Голлербах, Э.: «Русская современная гравюра», Пб., 1922.

R155. Голлербах, Э.: «Современная обложка», Л., 1927.

R156. Голлербах, Э. и др.: «История искусств всех времен и народов», Л., 1929, кн. 5 и 6.

R157. Докучаева, В.: «Игнатий Игнатьевич Нивинский», М., 1969.

R158. Загянская, Г.: «Артур Фонвизен», М., 1970.

R159. Зильберштейн, И. и Савинов, А. (ред.): «Александр Бенуа размыш-
ляет...» (литературное и эпистолярное наследие Александра Бенуа
1917-1960), М., 1968.

R160. Иоффе, И.: «Кризис современного искусства», Л., 1925.

R161. Костина, Е. (автор вступ. ст.): «50 лет советского искусства: худож-
ники театра», М., 1969.

R162. Краснопольский, О.: «Абстрактивизм в искусстве новаторов (постим-
прессионизм и неоромантизм)», М., 1917.

R163. Левитин, Е. и др.: «Василий Николаевич Чекрыгин». Выставка. Ка-
талог, М., 1969. Библ.

R164. Маковский, С.: «Новое искусство и четвертое измерение» — *Аполлон*,
СПб., 1913, № 7, стр. 53-60.

R165. Маковский, С.: «Последние итоги живописи», Берлин, 1922.

R166. Маца, И.: «Творческие вопросы советского искусства», М., 1933.

R167. Милашевский, В.: «Вчера и позавчера. Воспоминания художника»,
М., 1971.

R168. Невский, В.: «Современная живопись», М., 1922.

R169. Новожилова, Л.: «Социология искусства» (из истории советской
эстетики 20-х годов), Л., 1968.

R170. Петров, В.: «Владимир Васильевич Лебедев», Л., 1972. Библ.

R171. Полонский, В. (ред.): «Мастера современной гравюры и графики».
Сборник материалов, М.-Л., 1928.

R172. Пуни, И.: «Современная живопись», Берлин, 1923.

R173. Пунин, Н.: «Новейшие течения в русском искусстве». Две части:
Традиция новейшего русского искусства. Предмет и культура. Л.,
1927-1928.

R174. Рубинштейн, Я.: «Каталог выставки картин, рисунков и акварелей
русских художников из собрания Я. Е. Рубинштейна», Таллин, 1966.
С предисловием Д. Сарабьянова на эстонском и русском языках.

R175. Сегаль, С.: «Новая живопись в ее истоках и развитии», Берлин, 1923.

R176. Сидоров, А.: «Современная живопись», М.-Пг., 1923.

R177. «Советские художники. Автобиографии», М., 1937, тт. 1-2.
Древин, П. Кузнецов, Куприн, Машков, Осмеркин, Петров-Вод-
кин, Сарьян, Тышлер, Удальцова, Шевченко, Штеренберг и др.

R178. Стебницкий, Г., Голлербах, Э. (и др.): «Театрально-декорационное
искусство в СССР., 1917-1927», Л., 1927.

R179. Тарабукин, Н.: «Новые течения в русской живописи», М.-Пг., 1923.

R180. Тарабукин, Н.: «Современные рисовальщики и граверы», М.-Пг., 1923.

R181. Тугендхольд, Я.: «Творчество Александры Экстер», Берлин, 1922.

R182. Тугендхольд, Я. и др.: «Искусство октябрьской эпохи», Л., 1930.

R183. Тэрстон, Л.: «Интерес к авангардному искусству прошлого» —
Америка, Нью-Йорк, 1972, № 192, стр. 44-48.

R184. Хазанова, В. и др.: «Вопросы советского изобразительного искусства
и архитектуры», М., 1973. (включает ст. А. Стригалева «О проекте
памятника III интернационала художника Татлина»).

R185. Эткинд, М.: «Натан Альтман», М., 1971. Библ.

R186. Эфрос, А.: «Профили», М., 1930.
Отделы об Альтмане, Бенуа, П. Кузнецове, Розановой, Сапунове, Шагале, Штеренберге и др.

R187. Эфрос, А.: «Камерный театр и его художники. 1914-1934», М., 1934.

R187i. Кузьмин, Н.: «Давно и недавно». М., 1982.

R187ii. «Москва-Париж». Каталог выставки в Гос. Музее изобразительных искусств им. А. С. Пушкина, М., 1981.

R187iii. Флейшман, Л. и др.: «Русский Берлин». Париж, 1983.

R187iv. Харджиев, Н.: «К истории русского авангарда». Стокгольм, 1976.

I. Символизм и интуитивизм.

символизм.

R188. Алексеев, А. и др. (ред.): «Русская художественная культура конца XIX — начала XX века (1895-1907), кн. 1; М., 1968; кн. 2, М., 1969; кн. 3, М., 1977; кн. 4, М., 1980.

R189. «Алая роза». Выставка. Каталог, Саратов, 1904.

R190. Белый, А.: «Символизм», М., 1910.

R191. Белый, А.: «На рубеже двух столетий», М.-Л., 1930.

R192. Белый, А.: «Начало века», М.-Л., 1933.

R193. Бенуа, А.: «Возникновение 'Мира искусства'», Л., 1928.

R194. Бернандт, Г.: «Александр Бенуа и музыка», М., 1969.

R195. Блок, А.: «Автобиография» (1915), «Дневники, 1901-1921», в Собр. соч., т. 7, М.-Л., 1963.

R196. Брюсов, В.: «Дневники, 1891-1910», М., 1927.

R197. «Голубая роза». Выставка. Каталог, М., 1907.

R198. Грабарь, И.: «Голубая роза», *Весы*, 1907, № 5, стр. 93-96.

R199. Гришин, С.: статья о выставке, «Алая роза», в газ. «Саратовский листок», 1904, 11 мая, №101.

R200. Гусарова, А.: «Мир искусства», Л., 1972.

R201. Имгардт, Д.: «Живопись и революция» — *Золотое руно*, М., 1906, № 5, стр. 56-59.

R202. Койранский, А.: «Выставка картин, 'Голубая роза'», — *Перевал*, М., 1907, № 5.

R203. Костин, В.: «К. С. Петров-Водкин», М., 1966. Библ.

R204. Л., Б. (Липкин, Б.): «Эмоциализм в живописи» — *Искусство*, М., 1905, № 2, стр. 54-56.

R205. Лапшин, Н.: «Мир искусства», М., 1977.

R206. Маковский, С.: «Голубая роза», — *Золотое руно*, М., 1907, № 5, стр. 25-28.

R207. Мидлер, В. (автор вступ. статьи): «Мастера 'Голубой розы'», Каталог выставки, М., 1925.

R208. Муратов, П.: «Выставка картин, 'Голубая роза,' — «Русское слово», М., 1907, 1 апреля, № 75.

R209. Петров, В.: «Мир искусства» — см. № R88, кн. I, стр. 341-485.

R210. Русакова, А.: «В. Э. Борисов-Мусатов, 1870-1905», Л.-М., 1966. Библ.

R211. С-н, А. (Скалон, А.): «Выставка «Голубой розы»» — *Русские ведомости*, М., 1907, 25 марта, № 69.

R212. Соколова, Н.: «Мир искусства», М.-Л., 1934. Библ.

R213. Столица, Л.: «Радуга. О выставке, «Голубая роза», в журн. *Золотое руно*, М., 1907, № 7-9, стр. 88-90.

R214. Шинский, Н.: «Стихи», М., 1907.

R215. Шинский, Н.: «Искусство, его друзья и враги» — *Золотое руно*, М., 1908, № 7/9, стр. 120-123.

R216. Эткинд, М.: «Александр Бенуа», Л.-М., 1965. Библ.

R217. Эткинд, М.: «Мир, как большая симфония» (о Чюрленисе), М., 1970.

R217i. Гиппиус, З.: «Петербургские дневники 1914-1919». Нью-Йорк, 1982.

R217ii. «Каталог юбилейной выставки». 90 летие со дня рождения Вольдемара Матвея, Рига, 1967.

R217iii. Ковтун, Е.: «Владимир Марков и открытие африканского искусства» — *Памятники культуры. Новые открытия.* Л., 1980, вып. 7, стр. 411-16.

R217iv. Ковтун, Е.: «Письма В. В. Кандинского к Н. И. Кульбину» — *Памятники культуры. Новые открытия.* Л., 1980, вып. 7, стр. 399-410.

R217v. Кожевникова, И.: «Варвара Бубнова. Русский художник в Японии». М., 1984.

R217vi. Лозовой, А.: «Варвара Бубнова». М., 1984.

ИНТУИТИВИЗМ.

R218. Бенуа, А.: «Восторженные глупости» (по поводу выставок Кульбина и Рябушинского) — *Речь*, СПб., 1912, 12 окт.

R219. Евреинов, Н.: «Театр как таковой. Обоснование театральности в смысле положительного начала сценического искусства в жизни», СПб., 1913 (с илл. Кульбина).
 Книга была переделана и потом вышла как: «Театр для себя» (в трех частях, с илл. Кульбина в чч. I и III и с илл. Анненкова в ч. II), Пг., 1915-1916).

R220. Игнатьев, И.: «Выставка картин Кульбина» — *Петербургский глашатай*, СПб., 1912, 14 ноября.

R221. «Импрессионисты». Выставка. Каталог, СПб., 1909; Вильнюс, 1909/1910.

R222. Кандинский, В.: «О духовном в искусстве» — *Труды Всероссийского съезда художников в Петрограде, дек. 1911 — янв. 1912 гг.*, Пг., 1914, т. I, стр. 47-76.

R223. Кандинский, В.: «Куда идет «новое» искусство» — *Одесские новости*, 1911, 9 февр.

R224. Кульбин, Н. и др.: «Студия импрессионистов», СПб., 1910.

R225. Кульбин, Н.: Статья в каталоге «Салона», Одесса и др. города, 1910-1911, стр. 9.

R226. Кульбин, Н.: «Свободная музыка», СПб., 1909 (второе, дополненное изд., 1911). (ср. 96).

R227. Кульбин, Н.: «Свободная музыка» — *Студия импрессионистов*, СПб., 1910, стр. 15-26. (ср. 96).

R228. Кульбин, Н.: «Время и нагота в искусстве» — *Сборник. Нагота на сцене*, СПб., 1911, стр. 125.

R229. Кульбин, Н.: «Серия литографий», СПб., 1913.

R230. Кульбин, Н.: «Гармония, диссонанс и тесные сочетания в искусстве и жизни» — *Труды Всероссийского съезда художников в Петрограде, дек. 1911 — янв. 1912 гг.*, Пг., 1914, т. I, стр. 35-40.

R231. Кульбин, Н.: «Что есть слово», СПб., 1914.

R232. Марков, В.: «Искусство острова Пасхи», СПб., 1914.

R233. Марков, В.: «Принципы творчества в пластических искусствах. Фактура», СПб., 1914.

R234. Марков, В.: «Искусство негров», СПб., 1919.

R235. Марков, В. и Егорьев, В.: «Свирель Китая», СПб., 1914.

R236. «Союз молодежи». Выставки. Каталоги, СПб., Рига и М., 1910-1914.

R237. «Союз молодежи». Кн. 1-3, СПб., 1912-1913.

R238. Спандиков, Э.: «Лабиринт искусства» — *Союз молодежи*, СПб., 1913, № 3, стр. 6-9.

R239. Спандиков, Э.: «Анархист в искусстве» (о Кульбине) — *Искусство коммуны*, Пг., 1919, № 18, стр. 2-3.

R240. Судейкин, С. и др.: «Кульбин. Каталог — книга», СПб., 1912.

R241. «Треугольник». Выставка. Каталог, СПб., 1910.

II. Нео-примитивизм, кубо-футуризм.

НЕО-ПРИМИТИВИЗМ.

R242. Амиранашвили, Ш.: «Нико Пиросманашвили», М., 1967.

R243. Бакст, Л.: «Пути классицизма в искусстве» — *Аполлон*, СПб., 1909-1910, № 2, стр. 63-78; № 3, стр. 46-61.

R244. Бенуа, А.: «Поворот к лубку» — *Речь*, СПб., 1909, 18 марта.

R245. «Венок-Стефанос». Выставка. Каталог, М., 1907 (-1908).

R246. «Венок». Выставка. Каталог, СПб., 1908.

R247. «Венок-Стефанос». Выставка. Каталог, СПб. и Херсон, 1909.

R248. Герчук, Ю.: «Живые вещи» — *Декоративное искусство*, М., 1972, № 4, стр. 20-27.

R249. «Звено». Выставка. Каталог, Киев, 1908.

R250. Зданевич, К.: «Нико Пиросманашвили», Тбилиси, 1965.

R251. «Золотое руно». Выставка. Каталог, М., 1909 (с предисловием Н. Рябушинского) и 1909 (-1910).

R252. Ларионов, М.: «Выставка иконописных подлинников и лубков организованная М. Ф. Ларионовым». Каталог, М., 1913.

R253. Пунин, Н.: «Импрессионистский период в творчестве М. Ф. Ларионова» — *Материалы по русскому искусству*, Л., 1928, т. I, стр. 287-291.

R254. Рожин, А.: «Александр Шевченко» — *Искусство*, М., 1973, № 5, стр. 39-46.

R255. «Салон «Золотого руна»». Выставка. Каталог, М., 1908.

R256. Шевченко, А.: «Выставка произведений Александра Васильевича Шевченко (1883-1948). Живопись. Графика». Каталог, М., 1966.

R256i. «Александр Шевченко, 1883-1948». Каталог выставки, М., 1978.

R256ii. Каганская, Ж. и др. (сост.): «А. В. Шевченко. Сборник материалов». М., 1980.

R256iii. Кузьминский, К.: «Титька родины». Оранж, США, 1982.

R256iv. Поспелов, Г.: «М. В. Ларионов» — *Советское искусствознание 79*, М., 1980, т. 2, стр. 238-66.

КУБО-ФУТУРИЗМ.

R257. Аксенов, И.: «Неуважительные основы», М., 1916 (2 офорта А. Экстер).

R258. Аксенов, И.: «Пикассо и окрестности», М., 1917 (обл. А. Экстер).

R259. Арватов, Б.: «Натан Альтман», Берлин, 1924.

R260. Аркин, Д.: «Р. Фальк и московская живопись» — *Русское искусство*, М.-Пг., 1923, № 2-3, стр. 21-32.

R261. Бенуа, А.: «Дневник художника» — *Речь*, СПб., 1913, 21 окт. (о Гончаровой).

R262. Бенуа, А.: «Кубизм или кукишизм?» — *Речь*, 1912, 23 ноября.

R263. Бобров, С.: «Основы новой русской живописи» — *Труды Всероссийского съезда художников в Петрограде. Дек. 1911 — янв. 1912*, Пг., 1914, т. I, стр. 41-43.

R264. Б., С. П. (Бобров, С.): «Наталия Гончарова. Война I. 14 литографий». Рецензия — *Второй сборник центрифуги*, М., 1916, стлб. 92.

R265. «Бубновый валет». Выставки. Каталоги, М. и СПб., 1910-1918.

R266. «Бубновый валет». Альбом, М., 1911.

R267. «Бубновый валет». Устав общества художников, М., 1911.

R268. «Бубновый валет». Сборник статей по искусству Издания Общества художников «Бубновый валет». Выпуск I, М., 1913.

R269. Бурлюк, Д.: «Фактура» — *Пощечина общественному вкусу*, М., 1912, стр. 102-110.

R270. Бурлюк, Д.: «Галдящие «бенуа» и новое русское национальное искусство», СПб., 1913.

R271. Бурлюк, Д.: «Пояснения к картинам Давида Бурлюка, находящимся на выставке, 1916, Москва», Уфа, 1916.

R272. Бурлюк, Д., Гуро, Е. и др.: «Садок судей», СПб., 1910; «Садок судей II», СПб., 1913 (с илл. Бурлюков, Гончаровой, Гуро, Ларионова, Матюшина).

R273. Бурлюк, Д. и др.: «Рыкающий Парнас», М., 1914 (с илл. Пуни, Розановой и Филонова).

R274. Бурлюк, Д., Бурлюк, В. и др.: «Сборник единственных футуристов мира поэтов», М., 1914 (с илл. В. и Д. Бурлюка).

R275. Бурлюк, Д., Крученых, А., Кандинский, В. и др.: «Пощечина общественному вкусу», М., 1912.

R276. Бурлюк, Н.: «Владимир Давидович Бурлюк» — *Союз молодежи*, СПб., 1913, № 3, стр. 35-38.

R277. «Выставка живописи. 1915 год». Каталог, М., 1915.

R278. Голлербах, Э.: «Искусство Давида Д. Бурлюка», Нью-Йорк, 1930.

R279. Гончарова, Н.: «Мистические образы войны. 14 литографий», М., 1914.

R280. «Н. С. Гончарова. Выставка картин 1900-1913». Каталог, М., 1913.

R281. «Н. С. Гончарова. Выставка картин 1900-1913». Каталог, СПб., 1914.

R282. Грищенко, А. «О группе художников «Бубновый валет» — *Аполлон*, СПб, 1913, № 6, стр. 31-38.

R283. Грищенко, А. и Лаврский, Н.: «А. Шевченко. Поиски и достижения в области станковой живописи», М., 1919.

R284. Гуро, Е., Крученых, А и Хлебников, В.: «Трое», СПб., 1913 (с илл. Малевича).

R285. Зданевич, К.: «А. Крученых как художник» — *Куранты*, 1919, Тифлис, 1919, № 3-4.

R286. Исарлов, Г.: «М. Ф. Ларионов» — *Жар птица*, Берлин, 1923, № 12, стр. 26-30.

R287. Каменский, В.: «Путь энтузиаста», М., 1931.

R288. Каменский, В.: «Жизнь с Маяковским», М., 1940.

R289. Клюн, И.: «Кубизм как живописный метод» — *СА*, М., 1928, № 6, стр. 194-199.

R290. Клюн, И.: Предисловие к «Каталогу посмертной выставки картин, этюдов, эскизов и рисунков О. В. Розановой», М., 1919.

R291. Крученых, А.: «Бух лесинный», СПб., 1913 (с илл. Кульбина, Крученых и Розановой).

R292. Крученых, А.: «Взорваль», Спб., 1913 (с илл. Гончаровой, Кульбина, Малевича и Розановой).

R293. Крученых, А.: «Возропщем», СПб., 1913 (с илл. Малевича и Розановой).

R294. Крученых, А.: «Война», Пг., 1915 (с илл. Розановой). Другой вариант: «Вселенская война», Пг., 1916 (с илл. Розановой).

R295. Крученых, А.: «Заумная гнига», М., 1915 (с илл. Розановой).

R296. Крученых, А.: «Мирсконца», М., 1912 (с илл. Гончаровой, Ларионова, Роговина, Розановой и Татлина).

R297. Крученых, А.: «Полуживой», М., 1913 (с илл. Ларионова).

R298. Крученых, А.: «Помада», М., 1913 (с илл. Ларионова).

R299. Крученых, А.: «Пустынники», М., 1913 (с илл. Гончаровой).

R300. Крученых, А.: «Старинная любовь», М., 1912 (с илл. Ларионова и Розановой).

R301. Крученых, А.: «Тэ Ли Лэ», Спб., 1914 (с илл. Розановой).

R302. Крученых, А.: «Утиное гнездышко дурных слов», СПб., 1914 (с илл. Розановой).

R303. Крученых, А.: «Поросята», СПб., 1913 (с илл. Малевича).

R304. Крученых, А., Клюн, И. и Малевич, К.: «Тайные пороки академиков», М., 1915.

R305. Крученых, А. и Малевич, К.: «Первый Всероссийский съезд баячей будущего (поэтов-футуристов)» — *Журнал за 7 дней*, СПб., 1913, № 28 (122), стр. 605-606.

R306. Крученых, А. и Хлебников, В.: «Игра в аду», М., 1912 (с илл. Гончаровой).
 Переиз. в СПб. в 1914 с илл. Малевича и Розановой.

R307. Кульбин, Н.: «Кубизм» — *Стрелец*, Пг., 1915, № I, стр. 197-216.

R308. Лапшин, В.: «Маяковский — художник» — *Искусство*, М., 1963, № 7, стр. 43-53.

R309. Лентулова, М.: «Художник Аристарх Лентулов», М., 1969.

R310. Лившиц, Б.: «Полутораглазый стрелец», Л., 1933.

R311. Маяковский, В.: «Живопись сегодняшнего дня» — *Новая жизнь*, М., 1914, май; перепеч. в кн. *Владимир Маяковский. Полное собрание сочинений*, М., 1955, т. I, стр. 286-293.

R312. Маяковский, В. и др.: «Требник троих», М., 1913 (с илл. В., Д. и Нади Бурлюка и Татлина).

R313. Маяковский, В.: «Стихи В. Маяковского», СПб., 1914 (с илл. Розановой).

R314. Мидлер, В. (предисловие): «Выставка произведений художников 'Бубновый валет'». Каталог, М., 1927.

R315. «Мишень». Каталог выставки, М., 1913.

R316. Муратов, П.: «Живопись Кончаловского», М., 1923.

R317. Нейман, М.: «П. П. Кончаловский», М., 1967.

R318. «№ 4». Каталог выставки, М., 1914.

R319. «Ослиный хвост и мишень». Сборник, М., 1913.

R320. «Ослиный хвост». Каталог выставки, М., 1912.

R321. Оцуп, Н.: «О Ларионове» —*Числа*, Париж, 1931, кн. 5, стр. 183-186.

R322. Павлов, П.: «Станковая живопись Аристарха Лентулова» — *Искусство*, М., 1972, № 5, стр. 27-37.

R323. Перельман, В.: «Илья Машков», М., 1957.

R324. Полевой, В.: «Куприн», М., 1962.

R325. Р. (=Раковский, М.): «Выставка картин Н. С. Гончаровой» — *Петербургская газета*, 1914, 18 марта.

R326. Радин, Н.: «Футуризм и безумие. Параллели творчества и аналогии нового языка кубофутуристов», СПб., 1914.

R327. Радлов, Н.: «Будущая школа живописи» — *Аполлон*, СПб., 1915, № I, стр. 14-23.

R328. Радлов, Н.: «О футуризме и «Мире искусства»» — *Аполлон*, Пг., 1917, № I, стр. 1-17.

R329. Радлов, Н.: «О футуризме», Пг., 1923.

R330. Ракитин, В.: «Лев Александрович Бруни», М., 1970.

R331. Рассудина, Р. (автор вступ. статьи): «А. Куприн», М., 1971.

R332. Розанова, О.: Стихи — *Искусство*, Вестник московского отдела изобразительных искусств Наркомпроса, М., 1919, № 4, стр. 1.

R333. Розанова, О. и Крученых, А.: «Балос», Тифлис, 1917.

R334. Ростиславов, А.: «Сверкающий талант» (Выставка картин Н. С. Гончаровой), *Речь*, СПб., 1914, 23 марта.

R335. Сарабьянов, Д.: «Несколько слов о Н. Гончаровой» — *Прометей*, М., 1969, кн. 7, 201-203.

R336. Сахаров, В.: «Солнценосная эстетика» — *Декоративное искусство*, М., 1970, № 6, стр. 44-47.
О Г. Якулове.

R337. Сонгайло, В.: «О выставке картин Н. Гончаровой», М., 1913.

R338. «Союз молодежи». Выставки. Каталоги, СПб., Рига и М., 1910-1914.

R339. «Союз молодежи». Кн. №№ 1-3, СПб., 1912-1913.

R340. «Стрелец». Сборник статей по искусству, кн. 1, Пг., 1915; кн. 2, Пг., 1916; кн. 3, Пб., 1922.

R341. Терентьев, И. и Крученых, А.: «15 лет русского футуризма», М., 1928.

R342. «Трамвай В.» Выставка. Каталог, Пг., 1915.

R343. Третьяков, Н.: «В. Рождественский», М., 1956.

R344. Тугендхольд, Я.: «Выставка картин Наталии Гончаровой. Письмо из Москвы» — *Аполлон,* СПб., 1913, № 8, стр. 71-73.

R345. Тугендхольд, Я.: «Современное искусство и народность» — *Северные записки,* СПб., 1913, № 11, стр. 153-160.

R346. Р. Фальк. «Выставка произведений». Каталог, М., 1966. Статьи М. Сарьяна, С. Чуйкова, Д. Сарабьянова.

R347. Филонов, П.: «Проповень о проросли мировой» (с илл. автора), Пг., 1915.

R348. Харджиев, Н.: «Маяковский и живопись» — *Маяковский. Материалы и исследования,* М., 1940, стр. 337-400.

R349. Харджиев, Н.: «Памяти Н. Гончаровой и М. Ларионова» — *Искусство книги,* М., 1968 (выпуск 5, 1963-1964), стр. 306-318.

R350. Харджиев, Н. и Тренин, В.: «Поэтическая культура Маяковского», М., 1970.

R351. Хлебников, В. и Крученых, А.: «Слово как таковое», СПб., 1913 (с илл. Малевича).

R352. Хлебников, В.: «Ряв. Перчатки», СПб., 1914 (с илл. Малевича).

R353. Хлебников, В.: «Изборник стихов», СПб., 1914 (с илл. Малевича и Филонова).

R354. Цветаева, М.: «Н. Гончарова» — *Прометей,* М., 1969, стр. 144-201.

R355. Шевченко, А.: «Принципы кубизма и других современных течений в живописи всех времен и народов», М., 1913.

R356. Эганбюри, Э. (= Зданевич, И.): «Михаил Ларионов и Наталья Гончарова», М., 1913.

R357. Эганбюри, Э.: «Гончарова и Ларионов» — *Жар птица,* Берлин, 1922, № 7, стр. 39-40.

III. Беспредметное творчество.

(Источники в этом отделе весьма выборные: для более полных библиографий студенту советуется сослаться на №№ 33, 159, 160.)

R358. «Беспредметное творчество и супрематизм» (X Государственная выставка). Каталог, М., 1919.

R359. Боулт, Д.: «Иван Пуни» — *Русская мысль,* Париж, 1972, № 2910, стр. 9.

R360. Корницкий, И.: «К. Малевич: *От Сезанна до супрематизма.* Рецензия» — *Печать и революция,* М., 1921, кн. 2, стр. 211-212.

R361. Ларионов, М.: «Лучизм», М., 1913.

R362. «Магазин». Выставка. Каталог, М., 1916.

R363. Матюшин, М.: «О выставке последних футуристов» — *Очарованный странник,* Альманах весенний, Пг., 1916, стр. 16-18.

R364. «Последняя футуристическая выставка картин, 0.10». Каталог, Пг., 1915.

R365. Пуни, И.: «Искусство жизни» — *Сполохи*, Берлин, 1921, № 1, стр. 36-38.

R366. Федоров-Давыдов, А.: Вступление. Каталог выставки произведений К. С. Малевича, М., 1929.

IV. Революция и искусство.

ПРОЛЕТКУЛЬТ.

R367. Богданов, А.: «Искусство и рабочий класс», М., 1918.

R368. Луначарский, А.: «Пролетариат и искусство» — *Пролетарская культура*, М., 1918, № 2, стр. 23.

R369. Лаврова, Н.: «Пролеткульт. Рабочие студии и «теория»» — *Творчество*, М., 1971, № 1, стр. 14-15.

ОБЩИЕ АСПЕКТЫ.

R370. Аболина, Р.: «Советское искусство периода гражданской войны и первых лет строительства социализма, 1917-1932», М., 1962.

R371. «Агитационно-массовое искусство первых лет октябрьской революции». Выставка. Каталог, М., 1967.

R372. Аксенов, И., Арватов, Б., Ган, А., и др.: «О театре». Сборник, Тверь, 1922.

R373. Арватов, Б.: «Изобразительные искусства» — *Печать и революция*, М., 1922. кн. 7, стр. 140-146.

R374. Арватов, Б.: «Пролетариат и левое искусство» — *Вестник искусств*, М., 1922, № 1, стр. 10-11.

R375. Арватов, Б.: «На путях к пролетарскому творчеству» — *Печать и революция*. М., 1922, кн. 1, стр. 65-75.

R376. Арватов, Б.: «Искусство и классы», Пг.-М., 1923.

R377. Арватов, Б.: «Утопия или наука?» — *Леф*, М., 1924, № 4, стр. 16-21.

R378. Бескин, Э.: «Искусство и класс» — *Вестник работников искусств*, М., 1920, № 1, стр. 6-9.

R379. Бескин, Э.: ««Свобода» и «правда» искусства» — *Вестник работников искусств*, М., 1921, № 4/6, стр. 8-14.

R380. Бибикова, И.: «Как праздновали десятилетие октявря» — *Декоративное искусство*, М., 1966, № 11, стр. 5-9.

R381. Блюменфельд, В. и др. (ред.): «На путях искусства». Сборник статей, М., 1926.

R382. Богуславская, К.: «Марк Шагал» — *Сполохи*, Берлин, 1921, № 2, стр. 33-34.

R383. Брик, О.: «Художник и коммуна» — *Изобразительное искусство*, Пг., 1919, № 1, стр. 25-26.

R384. Галушкина, А. и др. (ред.): «Агитационно-массовое искусство первых лет Октября», М., 1971.

R385. *ГАХН Отчет 1921-1925*, М., 1926.

R386. Государственные выставки в Москве. (1-21). Каталоги, М., 1918-1921.

R387. Гущин, А.: «Изо-искусство в массовых празднествах и демонстрациях», М., 1930.

R388. Гущин, А.: «Оформление массовых празднеств за 15 лет диктатуры пролетариата», М., 1932.

R389. «Декрет № 1 о демократизации искусства». Манифест летучей федерации футуристов — *Газета футуристов*, М., 1918, № 1.

R390. Жадова, Л.: «Вхутемас — Вхутеин» — *Декоративное искусство*, М., 1970, № 11, стр. 36-43.

R391. Иоффе, И.: «Культура и стиль», Л., 1928.

R392. Кандинский, В.: «Музей живописной культуры» — *Художественная жизнь*, М., 1920, № 2, стр. 18-20.

R393. Кандинский, В.: «О великой утопии», — *Художественная жизнь*, М., 1920, № 3, стр. 2-4.

R394. Кандинский, В.: «К реформе художественной школы», М., 1923.

R395. Кушнер, Б.: «Сто три дня на Западе, 1924-1926 гг.», М., 1928.

R396. Кушнер, Б. «Демократизация искусству». Тезисы, предлагаемые в качестве основания для программы блока левых деятелей искусства, Пг., 1917.

R397. Кушнер, Б. и др.: «Искусство и народ». Сборник статей, Пг., 1922.

R398. Лаврова, Н.: «Страницы художественной критики (1918-1920)» — *Творчество*, М., 1970, № 11, стр. 5-6 и третья обл.

R399. Лапшин, В.: «Страницы художественной жизни Москвы и Петрограда в 1917 году». — *Искусство*, М., 1969, № 4, стр. 32-42.

R400. «В. И. Ленин о литературе и искусстве». (Сост. Н. Крутикова. Вступ. ст. Б. Рюрикова), М., 1967.

R401. Лукомский, Г.: «Художник в русской революции. Записки художественного деятеля», Берлин, 1923.

R402. Луначарский, А.: «Собрание сочинений в восьми томах», М., 1963-1967 (ред. И. Анисимов и др.).

R403. Луначарский, А.: «Об изобразительном искусстве», тт. 1-2, М., 1967.

R404. Матюшин, М.: «Спроба нового видуття просторни» — *Нова генерация*, Харьков, 1928, № 11, стр. 311-22. (на украинском яз.).

R405. Матюшин, М.: «Закономерность изменяемости цветовых сочетаний. Справочник по цвету», М.-Л., 1932.

R406. Маяковский, В. (автор текста): «Герои и жертвы революции», Пг., 1918.
С рисунками Богуславской, Козлинского, Маклецова и Пуни.

R407. Миклашевский, К.: «Гипертрофия искусства», Пг., 1924.

R408. Михайлов, А.: «В. И. Ленин и борьба с пролеткультовскими и футуристическими извращениями, 1919-1920», — *Искусство*, М. 1970, № 9, стр. 32-40.

R409. Невский, В.: «Художественные выставки и ознакомление широких народных масс с живописью», Кострома, 1920.

R410. Полетаев, Е. и Пунин, Н.: «Против цивилизации», Пг., 1918.

R411. Полонский, В.: «Русский революционный плакат», М.-Л., 1925.

R412. Пуни, И.: «Творчество жизни» — *Искусство коммуны*, Пг., 1919, №5, 5 января.

R413. Пунин, Н.: «Бомбометание и организация» — *Искусство коммуны*, Пг,. 1918, № 2, 15 дек., стр. 2-3.

R414. Пунин, Н.: «Новое и новенькое» — *Искусство коммуны,* Пг., 1919, № 5, 5 янв., стр. 1.

R415. Пунин, Н.: «Пролетарское искусство» — *Искусство коммуны,* Пг., 1919, № 19, 13 апреля, стр. 1.

R416. Пунин, Н.: «Искусство и пролетариат» — *Изобразительное искусство,* Пг., 1919, № 1, стр. 8-24.

R417. Пунин, Н.: «Русский плакат, 1917-1922», Пг., 1922.

R418. Пунин, Н.: «Обзор новых течений в искусстве в Петербурге» — *Русское искусство,* М.-Пб., 1923, стр. 17-23.

R419. Ракитин, В.: «Вхутемас. Традиции и эксперименты» — *Творчество,* 1970, № 12, стр. 7-8.

R420. *РСФСР. Справочник Изо. Нар. Ком. Прос.,* М., 1920.

R421. Сенкин, С. и Клуцис, Г.: «Мастерская революция» — *Леф,* М., 1924, № 1 (5), стр. 155-159.

R422. Сидоров, А.: «Революция и искусство», М., 1918.

R423. Сидоров, А.: «Русская графика за годы революции», М., 1923.

R424. Сидоров, А.: «Графика первого десятилетия, 1917-1927», М., 1967.

R425. Стригалев, А.: «Произведения агитационного искусства '20-х годов» — *Искусство,* М., 1968, № 5, стр. 29-30.

R426. Сурис, Б.: «Страница художественной жизни России в 1917 году» — *Искусство,* М., 1972, № 4, стр. 62-67.

R427. Третьяков, С.: «Искусство в революции и революция в искусстве» *Горн,* М., 1923, № 8, стр. 111-118.

R428. Третьяков, С.: «Откуда и куда?» (Перспективы футуризма) — *Леф,* М., 1923, № 1, стр. 192-203.

R429. Тугендхольд, Я.: «Современный плакат» — *Печать и революция,* М., 1926, кн. 8, стр. 56-74.

R430. Францев, М.: «Революционные задачи искусства», Орел, 1923.

R431. Хлебников, Л.: «Борьба реалистов и футуристов во Вхутемасе» — *Литературное наследство,* М., 1971, т. 80, стр. 704-719.

R432. Чужак, Н.: «Через головы критиков», Чита, 1922.

R433. Шишло, Б.: «Улицы революции» — *Декоративное искусство,* М., 1970, № 3, стр. 4-12.

R434. «Д. Р. Штеренберг. Выставка картин». Каталог, М., 1927.

Нео-примитивизм, кубо-футуризм.

R434i. Ермаков, А. и Сац, И. (ред.): «А. В. Луначарский об искусстве». М., 1982. 2 тт.

R434ii. Золотницкий, Д.: «Академические театры на путях Октября». Л., 1982.

R434iii. Золотницкий, Д.: «Зори театрального Октября». Л., 1976.

R434iv. Лапшин, В.: «Художественная жизнь Москвы и Петрограда в 1917». г., М., 1983.

R434v. «Натан Альтман». Выставки. Каталог, М., 1978.

R434vi. Пунина, И. (ред.): «Н. Н. Пунин. Русское и советское искусство». М., 1976.

R434vii. Толстой, В. (ред.): «1917-1932. Агитационно-массовое искусство. Оформление празднеств». М., 1984. 2 тт.

R434viii. Толстой, В.: «У истоков советского монументального искусства 1917-1923». М., 1983.

R434ix. «Давид Петрович Штеренберг, 1881-1948». Каталог выставки, М., 1978.

R434x. Юфит, А.: «Революция и театр». Л., 1977.

R434xi. Перцов, В.: «Современники», М., 1980.

V. Конструтивизм и производственные искусства.

КОНСТРУКТИВИЗМ.

R435. Ангелов, В.: «Конструктивизмъм в изобразителното изкуство и архитектурата», София, 1972 (на болгарском яз.).

R436. Варст (= Степанова, В.): «О работах конструктивистской молодежи» — *Леф*, М., 1923, № 3, стр. 53-56.

R437. Ган, А.: «Конструктивизм в типографическом производстве» — *Альманах пролеткульта*, М., 1925, стр. 116-119.

R438. Ган, А.: «Что такое конструктивизм?» — *СА*, М., 1928, № 3, стр. 79.

R439. Гинзбург, М., «Стиль и эпоха», М., 1924.

R440. Гинзбург, М.: «Конструктивизм как метод лабораторной и педагогической работы», в журн. *СА*, М., 1927, № 6, стр. 160-166.

R441. Зелинский, К. и И. Сельвинский (ред.): «Госплан литературы». Сборник Литературного центра конструктивистов (Л.Ц.К.), М., 1924.

R442. Маца, I.: «О конструктивизме» — *Искусство*, М., 1971, № 8, стр. 40-47.
 Английский перевод — 220.

R443. «Обмоху» (Общество молодых художников). Каталоги выставок, М., 1919, 1920, 1921, 1923.

R444. Пунин, Н.: «Памятник III Интернационала. Проект В. Татлина», Пб., 1920.

R445. Пунин, Н.: «Татлин (против кубизма)», Пб., 1921.

R446. «5 × 5 = 25». Каталог выставки, М., 1921.

R447. Татлин, В.: «Владимир Евграфович Татлин», Пг., 1915.

R448. Чичагова, О.: «Конструктивизм» — *Корабль*, Калуга, 1923, № 1-2, стр. 44.

R449. Экстер, А.: «В конструктивной одежде», в журн. *Ателье*, М., 1923, № 1, стр. 4-5.

R450. Эренбург, И.: «А все-таки она вертится», Берлин, 1922.

R450i. Стригалев, А.: «О проекте Памятника III Интернационала художника В. Татлина» — *Вопросы советского изобразительного искусства*. М., 1973, стр. 409-52.

ПРОИЗВОДСТВЕННЫЕ ИСКУССТВА.
ПРИКЛАДНЫЕ ИСКУССТВА. АРХИТЕКТУРА.

R451. Абрамова, А.: «А. М. Родченко» — *Искусство*, М., 1966, № 11, стр. 51-59.

R452. Аксенов, И.: «Пространственный конструктивизм на сцене» — *Театральный Октябрь. Сб. 1*, М.-Л., 1926, стр. 31-37.

R453. «Александр Родченко». Каталог выставки, М., 1968.

R454. Александров, П.: «Иван Леонидов», М., 1971. Библ.

R455. Арватов, Б.: «Искусство и производство» — *Горн*, М., 1923, № 8, стр. 119.

R456. Арватов, Б.: «Быт и культура вещи» — *Альманах пролеткульта*, М., 1925, стр. 75-82.

R457. Арватов, Б.: «Сегодняшние задачи искусства в промышленности» — *Советское искусство*, М.-Л., 1926, № 1, стр. 83-89.

R458. Арватов, Б.: «Об агит- и прозискусстве», М., 1930.

R459. Аркин, Д.: «Искусство вещи» — *Ежегодник литературы и искусства на 1929*, М., 1929, стр. 428-471.

R460. Брик, О.: «В производство!» — *Леф*, М., 1923, № 1, стр. 105-108.

R461. Брик, О.: «От картины к фото» — *Новый леф*, М., 1928, № 3, стр. 29-33.

R462. Бутник-Сиверский, Б.: «Советский плакат эпохи гражданской войны, 1918-21», М., 1960.

R463. Варст (= Степанова, В.): «Костюм сегодняшнего дня — прозодежда» — *Леф*, М., 1923, № 2, стр. 65-68.

R464. Волков-Ланнит, Л.: «А. Родченко рисует, фотографирует, спорит», М., 1968.

R465. Ган, А.: «Новому театру — новое здание» — *СА*, М., 1927, № 3, стр. 81.

R466. Ган, А.: «Справка о Казимире Малевиче» — *СА*, М., 1927, № 3, стр. 104-106.

R467. Земенков, Б.: «Оформление советских карнавалов и демонстраций», М., 1930.

R468. Ильин, М.: «Веснины», М., 1960.

R469. Кириллов, В.: «Путь поиска и эксперимента (из истории советской архитектуры 20-х — начала 30-х годов)», М., 1972.

R470. Кушнер, Б.: «Организаторы производства» (Доклад читанный в Инхуке, 30-го марта, 1922) — *Леф*, М., 1923, № 3, стр. 97-103.

R471. Луначарский, А.: «Промышленность и искусство» — *Жизнь искусства*, Л., 1923, № 4, стр. 8-12.

R472. Ляхов, В.: «Советский рекламный плакат 1917-1932», М., 1972 (текст на русском, английском и немецком языках).

R473. М., И. (= Маца, И.?): «Художник и производство» — *Вестник искусств*, М., 1922, № 5, стр. 25-26.

R474. Маца, И.: «Александр Родченко» — *Искусство*, М., 1972, № 7, стр. 31-36.

R475. Стриженова, Т.: «Из истории советского костюма», М., 1972.

R476. Стриженова, Т.: «У истоков советского массового костюма» — *Декоративное искусство*, М., 1972, № 6, стр. 40-43.

R477. Тарабукин, Н.: «Опыт теории живописи», М., 1923.

R478. Тарабукин, Н.: «От мольберта к машине», М., 1923.

R479. Тарабукин, Н.: «Искусство дня», М., 1925.

R480. Тарабукин, Н.: «Художник в клубе», М., 1926.

R481. Тугендхольд, Я.: «Искусство в быту», М., 1925.

R482. Хан-Магомедов, С.: «М. Я. Гинзбург», М., 1972.

R483. Чернихов, Я. «Основы современной архитектуры», Л., 1930. (второе изд. 1931).

R484. Чернихов, Я.: «Орнамент», Л., 1931. (текст основан на кн. Чернихова, «Искусство начертания», Л., 1927).

R485. Чернихов, Я.: «Архитектурные фантазии», Л., 1933.

R486. Чиняков, А.: «Братья Веснины», М., 1970. Библ.

R487. Чужак, Н.: «К диалектике искусства. От реализма до искусства как одной из производственных форм», Чита, 1921.

R488. Шкловский, В.: «Александр Родченко — художник-фотограф» — *Прометей*, М., 1966, № стр. 387-417.

R489. Штеренберг, Д. и др.: «Искусство в производстве», М., 1921.

R489i. «Архитекторы братья Веснины». Каталог выставки, М., 1983.

R489ii. Васютинская и др. (ред.): «Каталог-путеводитель по фондам музея. Веснины». М., 1981.

R489iii. Гофман, А. и др. (ред.): «Техническая эстетика ВНИИТЭ». М., 1983, № 41. Спец. выпуск, посвященный советскому дизайну 1920-ым гг.

R489iv. Гуляев, В.: «Русские художественные промысли 1920-ых годов». Л., 1985.

R489v. Золотницкий, Д.: «Будни и праздники театрального Октября». Л., 1978.

R489vi. Родченко, В. и др. (сост.): «А. М. Родченко». М., 1982.

R489vii. Хан-Магомедов, С.: «Александр Веснин». М., 1983.

R489viii. Чиняков, А.: «Братья Веснины». М., 1970.

VI. По пути к социалистическому реализму

(Для подробных сведений о развитии социалистического реализма в изобразительных искусствах студенту следует обратиться к тем советским публикациям 30-ых, 40-ых и 50-ых гг., которые посвящены русской и советской живописи и скульптуре, в частности к журналам «Искусство» [М., 1933-] и «Творчество» [М., 1934-]. За сведениями относительно создания и пропаганды социалистического реализма студенту следует проконсультировать каталоги советских художественных выставок не только в СССР., но и в Западной Европе и в США, многие из которых имели место во конце 20-ых и в начале 30-ых гг. Ссылки на такие выставки можно найти в библ. R152, тт. 1 и 2.)

R490. Арватов, Б.: «Почему не умерла станковая картина» — *Новый леф*, М., 1927, № 1, стр. 38-41.

R491. Бескин, О.: «Формализм в искусстве», М., 1933.

R492. Вейдле, В.: «Искусство при советской власти» — *Безымянная страна*, Париж, 1968, стр. 108-136.

R493. Гронский, И. и Перельман, В. (сост.): «Ассоциация Художников Революционной России», М., 1973. Библ.

R494. Зингер, Л. и Орлова, М. (ред.) «Искусство народов СССР от Великой Октябрьской Революции до 1941 г.» в кн. «История искусств народов СССР», т. 7, М., 1972.

R495. Кауфман, Р.: «Советская тематическая картина, 1917-1941», М., 1951.

R496. Князева, В.: «АХРР», Л., 1967.

R497. Лейзеров, Н.: «В поисках и борьбе». Из истории эстетических воззрений и эстетического воспитания в советской России, М., 1971.

R498. Луппол, И., Розенталь, М. и Третьяков, С. (ред.): «Первый Всесоюзный съезд советских писателей 1934. Стенографический отчет», М., 1934.

R499. Маца, И.: «Из истории советской эстетической мысли», М., 1967.

R500. Новицкий, П. (ред.): «Изофронт. Классовая борьба на фронте пространственных искусств». Сборник объединения, «Октябрь», М.-Л., 1931.

R501. Новицкий, П.: «Идеологическая платформа и практика художественного объединения Октябрь» — *Вопросы развития пролетарского искусства. Материалы дискуссий*, М., 1931, стр. 117-130 (131-151).

R502. Пельше, Р.: «Проблемы современного искусства», М., 1927.

R503. Сопоцинский, О. и др.: «Становление социалистического реализма в советском изобразительном искусстве», М., 1960.

R504. Тугендхольд, Я.: «Живопись» — *Печать и революция*, 1927, кн. 7, стр. 158-182.

R505. Федоров-Давыдов, А.: «Тенденции современной русской живописи в свете социального анализа» — *Красная новь*, М., 1924, № 6 (23), стр. 329-348.

R506. Федоров-Давыдов, А.: «Марксистская история искусств», Иваново-Вознесенск, 1925.

R507. «П. Филонов. Каталог произведений находящихся в Русском музее с объяснительным текстом С. Исакова», Л., 1930.

R508. Филонов, П.: «Декларация Мирового рацвета» — *Жизнь искусства*, М., 1923, № 20, стр. 13. (перепеч. в журн. *Výtvarné umění*, Prague, 1967, No. 3).

R509. Филонов, П.: «О причинах творчества» — *Výtvarné umění*, Prague, 1967, No. 3.

R510. Филонов, П.: «Павел Филонов. Первая персональная выставка». Каталог, Новосибирск, 1967 (2 издания).

R511. Фриче, М. и др.: «Искусство в СССР и задачи художников», М., 1928.

R512. Школа Филонова (под управлением Филонова): «Калевала», М., 1933 (с илл. Борцовой, Ропет и др.).

R513. Щекотов, Н.: «Искусство СССР. Новая Россия в искусстве», М., 1926.

R514. Юшкевич, П. и Столпнер, Б. (ред.): «Искусство и литература в марксистском освещении». Сборник статей, М., 1931.

R515. Яблонская, М.: «Константин Николаевич Истомин», М., 1972.

R515i. Ванслов, В. и Денисова, Л. (ред.): «Из истории советского искусствоведения и эстетической мысли». М., 1977.

R515ii. Василенко, В. и др. (ред.): «Советское декоративное искусство 1917-1945». М., 1984.

R515iii. Костин, В.: «ОСТ». Л., 1976.

R515iv. Розанова, Н.: «Московская книжная ксилография 1920-30-ых годов». М., 1982.

Index